FIELDWORK

AUSTRALIAN ART 1968–2002

curated by

Jason Smith and Charles Green

AUSTRALIAN ART 1968–2002

FIE
W D
ORK

ngv

We well remember the inaugural exhibition held at the National Gallery of Victoria in St Kilda Road in 1968. It was called *The Field* and it has since been viewed as one of the defining moments in Australian contemporary art.

It seems fitting to us that, as a follow up to the 1968 exhibition, the inaugural exhibition at Federation Square will be called *Fieldwork*. This will highlight the work of some eighty artists produced over the past thirty years, most of it being part of the NGV collection.

We have had a close personal relationship with the NGV over all of these thirty years, and it is with considerable pleasure that we asked if we could support and sponsor this 2002–2003 exhibition, *Fieldwork*. We hope it brings the same critical acclaim that its predecessor achieved thirty years ago. ¤

Joan and Peter Clemenger

field
of vision

Since our establishment in 1861, the National Gallery of Victoria has assumed a responsibility to collect contemporary Australian art. Throughout most of our history this was reinforced by the fact that the NGV ran its own school of art and many of the most talented Australian artists of the nineteenth and twentieth centuries were trained here. There is a strong bond between the NGV and the community of artists, and we have always viewed the acquisition of the best contemporary Australian art as a key priority within our collecting strategies. Indeed, the major part of all curatorial effort in the acquisitions area is dedicated to expanding our collections of contemporary Australian visual practice. The recent establishment within the endowment of the NGV Foundation of the Victorian Foundation for Living Australian Artists, launched in November 2002 with a grant of $5 million provided by the Government of Victoria (to be matched with a further $5 million to be raised by the NGV), underlines our own, and the Government's, commitment.

The very limited space previously available in our St Kilda Road building meant that we could never do justice to this effort and concentration of resources, but at last, the opening of The Ian Potter Centre: NGV Australia, with its twenty large galleries, means that contemporary art can now assume a very high profile. It is appropriate therefore that our inaugural exhibition, *Fieldwork*, will occupy the entire Level 3 of the new building, with its focused examination of some of the most profound and influential developments in Australian art from 1968 to the present, following the now legendary *Field* exhibition of 1968. *The Field* took Melbourne by surprise and we hope that this important new show will also surprise and challenge in the same way.

The primary objective of the NGV is to represent the history and ongoing development of Australian and international art in all media, from antiquity to the present day. Collecting contemporary art requires of any curator a lateral view across a vast field of disparate practices. Since 1976 this process has been sustained by several generous endowments for supporting the work of young and emerging Australian artists. These endowments have provided the NGV with the freedom to acquire widely, and in a brave and experimental manner. They have also enabled the NGV to acquire major works that were produced early in the careers of some of the most acclaimed Australian artists.

The G. H. Michell Endowment was established for the NGV by Howard and Christine Michell in 1974 with a capital sum of $100,000. Between 1976 and 1987 this endowment acquired 389 works of art, a magnificent contribution to the NGV's collections of contemporary art and, in addition, a significant direct benefit to the artist community.

In 1986 Mrs Margaret Stewart AM proposed to continue the work of the Michells, establishing the Margaret Stewart Endowment with a similar aim and structure of annual funding. This endowment continued to encourage emerging artists by progressively building a collection that reflected the outstanding achievements of the 1980s and 1990s, and moments of innovation or change in artists' careers. Between 1987 and 1997 the Margaret Stewart Endowment purchased 278 works of art.

In February 1999 Mrs Joan Clemenger agreed to continue this work by establishing the Joan Clemenger Endowment, providing an annual fund for a term of five years. This endowment has sought to acquire fewer works and to represent young artists who have been identified as priorities for the collection. In 2000 Mrs Loti Smorgon AO commenced an annual fund to enable the acquisition of works by emerging Australian photographers.

Each of these very generous endowments has been opportune for young artists producing new works that critically engage with contemporary social and cultural forces. In addition to these endowments, the NGV has been generously supported by groups such as the NGV Women's Association, the NGV Foundation, and the Gallery Society (now NGV Members), each of which has enabled the acquisition of major works.

The NGV can only flourish as an active and relevant force in contemporary Australian visual culture by extending the collaborative interaction between artists, curators and writers through publications like *Fieldwork*. We are committed to continuing this lively dialogue for the benefit of our broad public and all those who work in the visual arts. ¤

Gerard Vaughan
Director

left field

fieldwork in context

:: 01

Frances Lindsay

Fieldwork takes as its starting point August 1968 and *The Field*, the exhibition that ushered in a new era for the new National Gallery of Victoria and boldly demonstrated the NGV's commitment to contemporary art. *The Field* was a courageous gesture, but within a few years Melbourne artists were protesting against the NGV's attitude to contemporary art and its inadequate allocation of resources to local art.[1] An August 1975 'sit in' at the NGV was a culmination of a number of events involving contemporary artists and the NGV, and it was also a reflection of the times—artists responding to prevailing political and social conditions. *Fieldwork* tracks their responses from 1968 to the present.

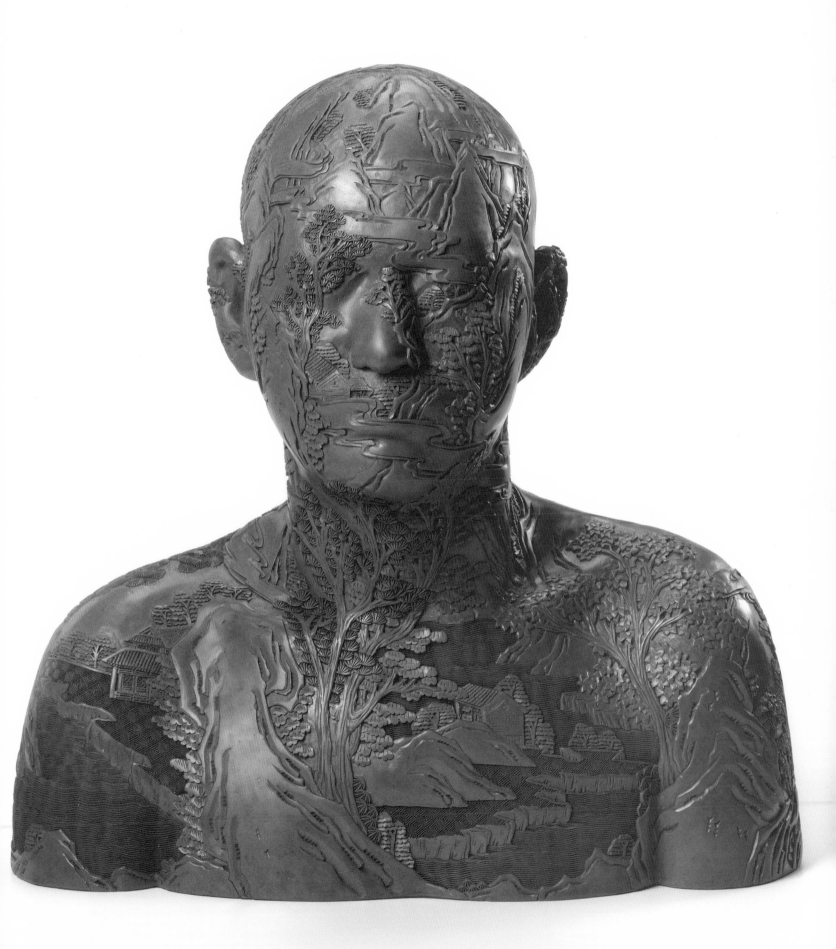

01.01 Ah Xian, *Human, human-landscape (bust 5)*, 2000–02

01.02 Marina and Ulay Abramovic, *Untitled #1*
(Documentary photograph of performance in
Lindsay Court, National Gallery of Victoria), 1982

In 1968 it seemed that *The Field* was a watershed exhibition, but few could predict the dramatic changes that would occur over the next few years and in the decades to come. None of this was apparent then, although the clues were present, for the 'pluralist', 'anything goes' 1970s had already begun. Australia was at war in Vietnam and anti-conscription protests were being staged across the country. By August when the NGV opened its new doors, the year had witnessed in quick succession the assassinations of Martin Luther King and Robert Kennedy. The year had also witnessed the development of a youth counter-culture epitomised by the Woodstock Music Festival, which had advocated peace and love over war. At the beginning of the 1960s Bob Dylan had heralded that 'the world was rapidly changing' and, as the decade closed and US astronauts walked on the surface of the moon, few doubted this was the case, or that the 'children of the revolution' would transform the world.

Protest, as a way of achieving change, became part of the Age of Aquarius, as did collaboration, experimentation and finding alternative solutions. For some this meant dropping out and adopting a hippie lifestyle; for others it meant making art that was process-based, ephemeral and outside the established art market/system. Artists' collectives such as Pinacotheca in Melbourne (at least for a while) and Inhibodress in Sydney became an established part of the contemporary scene. Over the next three decades alternative spaces such as these would continue to provide an important arena for experimental art and emerging artists.[2] In 1969 the musical *Hair*, directed by Jim Sharman, opened in Sydney at Kings Cross, just around the corner from The Yellow House, where Brett Whiteley, Martin Sharp and others had collaborated on an art installation best described as an ongoing happening. In the same year the wrapping of the coast at Little Bay by the international artist Christo gave Australia its first major landscape installation and inspired a new generation of post-studio artists who understood that the field for art could be outside the museum walls and located in the landscape itself.[3] There it might operate beyond the confines of an established system that demanded to be challenged. Furthermore it could operate through new forms and alternative practices such as performance where the body itself became the arena for art, or through poster art where inexpensive, screenprinted multiples could reach a broad, diversified audience.[4]

The Field displayed works by two women and thirty-eight men. *Fieldwork* comprises thirty women artists and forty-nine men.

01.03 Richard Long, *Driftwood circle*, 1977–78

1 The removal by the NGV director of an installation work by Domenico de Clairo and the transfer of a project by the Art & Language collective to the Art School because of possible embarrassment to the International Council of the Museum of Modern Art, New York, whose exhibition *Modern Masters: Manet to Matisse* was being held at the NGV, were key events that underscored the protest.

2 Pinacotheca operated as a collective for a short period when its founding director Bruce Pollard was overseas for a year; even before, however, Pollard's non-commercial approach meant that Pinacotheca filled the functions of alternative spaces elsewhere. The prime movers behind Inhibodress were artists Mike Parr and Peter Kennedy.

3 The visit to Australia by Christo was the first of many projects undertaken by the Sydney collector John Kaldor who brought artists such as Gilbert & George, Charlotte Moorman, Nam June Paik, Sol Le Witt and Richard Long to Australia for specific installation works.

4 The main producers of political and feminist art posters during the 1970s were the Earthworks Poster Collective at Sydney University's Tin Sheds and the Progressive Art Movement in Adelaide.

5 Published 1976–84.

01.04 Domenico de Clario, *Elemental landscapes (Installation detail)*, 1975

The Field displayed works by two women and thirty-eight men. *Fieldwork* comprises thirty women artists and forty-nine men, thereby reflecting the improvement in the status of women, though not the complete revolution thought achievable at the height of the feminist movement. At the beginning of the 1970s the Women's Liberation Conference in Melbourne had advocated equal pay for equal work and the cessation of war. In 1971, as Australian troops withdrew from Vietnam, Germaine Greer's *The Female Eunuch* was published, and later in 1975, the Women's Art Movement was given impetus by the visit of the American feminist critic Lucy Lippard. The magazine *Lip*, published by a feminist collective emanating from the Ewing and George Paton Galleries at the University of Melbourne, was also successful in helping to alter discriminatory attitudes and in making women artists, curators and writers more visible.[5] Women artists were now liberated to explore themes and content that had a personal relevance or narrative previously deemed unacceptable, and to utilize methods that had once been denigrated as traditional, women's craft. On a government level, help was also on the way: 1972 ushered in the Whitlam era, which, in the following year, saw the establishment of the Australia Council and the instigation of a system of support for artists and cultural institutions with emphasis on diversity, equity, and importantly, gender balance.

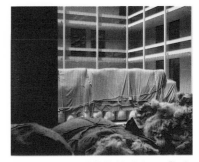

01.05 Christo & Jeanne-Claude,
Woolworks – wrapped wool bales, 1969

In 1972 the Aboriginal Tent Embassy was established opposite Parliament House in Canberra. Its presence highlighted a simple fact: Australia's Indigenous people were estranged in their own land. It also signalled their determination to achieve land rights, social justice and legal and moral recognition. At the same time, at Papunya in Central Australia, the contemporary Aboriginal art movement was about to surface; it would increasingly elicit national and international recognition by non-Indigenous people of the significance of Aboriginal culture. Nonetheless, it was not until the 1980s that the land rights movement began to have effect. Uluru was transferred to its traditional owners in 1985, but it was not until 1993 that the *Native Title Act* dispensed with the doctrine of *terra nullius* with the landmark Mabo decision that declared the Meriam people owners of Murray Island. Though undoubtedly a progressive ruling, it was a first step only. There is no doubt that the success of Australia's Indigenous artists has helped to highlight the significance of their spiritual connection to the land, and thereby, the importance of land rights, even though the *Native Title Amendment Bill* of 1998 abolished the right for Aboriginal people to negotiate with those holding pastoral leases. Throughout the 1980s and 1990s the work of Indigenous artists, many from urban backgrounds, also focused attention on other key issues such as identity, poverty and Aboriginal deaths in custody. And against the background of the growing movement for reconciliation, the ongoing suffering of the stolen generation was brought to the forefront.[6]

6 In 1997 the stolen generation report *Bringing them Home: The Report of the National Inquiry into the Separation of Aboriginal and Torres Strait Islander Children from their Families* was tabled in Parliament.

01.06 Harald Szeeman, *Harald Szeeman in Australia: I want to leave a well done child here*, 1971

Alongside the land rights movement and the growing awareness of Indigenous Australian culture, many non-Indigenous artists sought a symbiotic relationship with the land and nature. Suspicion of the capitalist system, growing distrust and cynicism about government after Watergate in 1972, the French nuclear testing in the Pacific and the dismissal of the Whitlam Government in 1975 led many Australian artists to examine other political and social issues, including those relating to ecology and the environment. George Miller's 1979 film *Mad Max* envisioned a world rendered bleak and desolate after nuclear explosion, while closer to reality, the anti-dam protesters at the Franklin River in Tasmania worked to prevent one of the world's greatest natural treasures being lost forever. Over the following decades, concern about the degradation of the land, the extinction of species and global warming would find expression in the work of many artists whose fears are well placed as the breaking away of the Larsen B ice shelf from Antarctica in March 2002 illustrates.[7]

If the 1970s had enjoyed a liberated approach to drugs and sex, by the beginning of the 1980s the first reports of AIDS had surfaced, ushering in a shift in community values accompanied by, on one hand, a new conservatism, and on the other, a gradual broadening of attitudes. By the end of the decade the Australian and international art world had tragically lost a number of key artists, curators and administrators, but their legacy would be evidenced by society's growing acceptance, and indeed celebration, of those with a so-called 'alternative' lifestyle. The Sydney Gay and Lesbian Mardi Gras that started life as a protest march has evolved into one of the largest general-audience events in Australia. The 2000 Sydney Olympics opening ceremony gave equal time to Ned Kelly, bronzed Aussies, and the drag queens of *The Adventures of Priscilla, Queen of the Desert* as icons of Australian life. This was an occasion for national euphoria. Later, Australians collectively basked in the pride of Cathy Freeman's win in the 200 metres sprint, and in the inherent symbolism of her triumph as she paraded with both the Australian and Aboriginal flags.[8]

The 1980s witnessed a revival of figurative painting, complete with metaphor and meaning achieved through the postmodern strategies of appropriation and quotation, with images scavenged from a range of sources. For some artists popular culture held the clues, and, in looking back to the 1960s with 'second-degree' manipulation of the icons of that era, they created a new model of 'Popism'.[9] Installation art now became the domain of the international biennale circuit with painting becoming the commodity of the more conservative market forces. With the booming economy of this 'decade of greed', private and corporate sector support for the arts reached unprecedented heights. But it was not to last and the Wall Street crash of October 1987 was to have its echo later in Australia with the collapse of the building society Pyramid in 1990 and the fall from grace of a number of infamous entrepreneurs.[10] With tougher times for artists, the number of artist-run collectives and alternative spaces gathered force.

...we are a country of immigrants with successions of refugees and others who have sought to make a fresh start here.

In 2001, in an Australia Day address in Melbourne, the writer Peter Carey reminded us that we are a country of immigrants with successions of refugees and others who have sought to make a fresh start here. By the late 1970s a new wave of refugees, the so-called 'boat people' from Vietnam, were beginning to arrive on Australian shores. At the same time second-generation artists of post-World War II immigrants were beginning to make their mark, as were those whose heritage lay not with Europe but with Asia. During the 1980s the position of Australia in the Asia–Pacific region became a focus for government and for those artists with a heightened understanding of the value of regionalism in a postcolonial world. Understanding Australia's role and place in the region was part of the process of understanding and coming to terms with our national identity. This, and the national navel-gazing that was concomitant with the 1988 Australian Bicentenary, inevitably raised the question of our continuing link to the British monarchy and gave rise to the republican movement that steadily gained momentum until defeated by referendum in 1999.

7 G. O'Neill, 'The Heat is On', *Sunday Herald Sun*, 31 March 2002. Scientists fear this could see a catastrophic increase in sea levels.

8 The Land Rights flag was designed by Harold Thomas, a Luritja man from Central Australia in 1971.

9 The exhibition *Popism* was curated by Paul Taylor for the NGV in 1982.

10 The collapse of the Victorian building society Pyramid was one of several catastrophic corporate failures in the 1990 fallout. Christopher Skase was the most notorious of the failed entrepreneurs of that decade.

01.07 Aleks Danko, *Art stuffing*, 1970

The republican movement was a reflection of Australia's increasing understanding of its history and place in the world, and throughout the 1980s Australian artists sought to reconcile their sense of identity with their realisation of the increasing globalisation of culture. This realisation was heightened by world political events so astonishing as to have been unimaginable at the beginning of the decade: the release of Nelson Mandela, the Tiananmen Square massacre, the fall of the Berlin Wall in 1989, followed by the Gulf War in 1990 and the break-up of the Soviet Union in 1991. If momentarily there seemed promise of a new world order, this was to prove unfounded as the battlegrounds in Kosovo, Rwanda, East Timor, and the rise of the Taliban in Afghanistan would sadly demonstrate. Before the twenty-first century had completed its first year, Australian troops would again be at war and a new wave of boat people would seek refuge on our shores, only to find themselves interned as unlawful immigrants under Australia's mandatory detention policy.

01.08 Mike Parr, *Do Padera Coco (self portrait as a pear)* TO HAVE DONE WITH THE JUDGEMENT OF GOD, (1983)

In 1968 fax machines, personal computers, e-mail, video and mobile phones did not exist, but the technological revolution that would see extraordinary changes in science and health and in the lives of ordinary people was well underway. If postmodernism signalled the demise of the absolute, the exponential explosion of information via the Web led to increasing postcolonial multiplicity. Artists increasingly experimented with a plethora of new techniques, including digital and computer technology, and in the face of increasing mass-manipulated imagery and consumerism, sometimes paradoxically returned to the notion of the handmade and the miniature. By 1993 millions of people around the world would be linked through the Internet to create a 'global village' with an ever-

Fieldwork is a survey of Australian art since 1968, drawn largely from the National Gallery of Victoria's immense collection, but Fieldwork, unlike the NGV's holdings, is not encyclopedic. This exhibition deliberately omits many important Australian artists and movements, and the NGV will redress these omissions during regular reinstallations of the collection over the next few years, thoroughly representing recent Australian art in a way that would have been impossible had an inclusive, encyclopedic acquisitions policy ever been rejected. Instead, Fieldwork shows the trajectory linking contemporary art in 2002 to The Field, the famous exhibition that opened the NGV's grand new building on St Kilda Road in 1968.

This trajectory is not as obvious as it sounds, for the history of recent Australian art is not an evolutionary succession of styles and movements that belatedly parallel the sequence of artistic movements overseas. That would be, of course, an easy, explanatory route for this exhibition to follow, and would go something like the following: colour-field abstraction gives way to minimalist painting; which in turn is succeeded by conceptualisms; which are in turn superceded by performance and political art; which are then obliterated by a return to painting and appropriation; which are then roundly criticized by postcolonial art, and so on, with Indigenous art appearing as a separate celebration of unique identity.

Even though all of these movements, and more, do appear in Fieldwork, they don't make much sense as a story unless we understand—and this is what the exhibition aims to show—that there weren't smooth transitions from one movement to another, that art has been a disputed field and that the chief disputes were already latent in The Field back in 1968. Far from representing the triumph of abstract painting and the arrival of internationalist art, The Field looks more and more, in retrospect, like a battleground: colour-field painters who, far from representing the newest and the brightest, were out of step with the late 1960s; minimalists already escaping field painting via a clever fusion of decoration and austere minimalism; conceptualists who fiercely dismissed both abstraction and minimalism as old-fashioned and irrelevant, and who had arrived at their work before most Australian colour-field painters or minimalists ever bought acrylics and cotton canvas. This complexity wasn't very clear at the time, of course, and The Field was an enormous public success. But The Field was an isolated event; partly because the NGV was not able to follow up with further large, contemporary art surveys; partly because colour-field painting was not a sustainable, cutting-edge style (though the global lineage of abstract painting was at this moment about to shift, unseen, from New York to Central Australia), and partly because the work that artists do was even then being redefined, from colour field to fieldwork, carried out away from an artist's studio without paint or brushes.

02.01 Louise Weaver, *Sparkling dew-covered branch*, 1998

fieldwork | an overview

The exhibition's first room shows *The Field*'s three opposing but not mutually exclusive directions: pop, minimalism and conceptualism. (None of these chronologically preceded the other—at least, not in 1968.)

In the centre of Australia, during the period immediately after *The Field*, Papunya Tula artists staked an ambitious claim to an alternative vision of Australian art based in their profound adaptation of local Indigenous traditions and images. They seized the materials of western abstract painting and took them in a totally unanticipated direction.

Another of the three directions evident in *The Field*, conceptualism, led directly to both politicized art and to anthropological art during the 1970s. The conceptualist rethink of artistic work as research and the artist as part of a collaboration or collective was deeply influential, but already so well under way by the mid 1970s that classic conceptual art looked quite conservative compared with body art or with conceptual systems applied to the real world, recording indexical representations of traumatic ecological and social events. Other artists sought the limits of art's expanded field, combining real-time systems with a minimalist avoidance of art as expressive of society or self at all, no matter how representative of the period and place such works look a couple of decades later.

Australian artists consistently tested the limits of art during the 1970s through examinations of self, for whether Aboriginal or white, 'self' meant ownership and home.

Into the Darkening 1980s. Melbourne artists intertwined the same elements—self, ownership and home—through the excavation of psychic and social trauma.

At about the same time, other artists tested the limits of art in didactic, theory-driven examinations of these selves, in a series of more or less clearly articulated artistic programs that blur from Melbourne *Art and Text* popism into Sydney postmodernism, and in which the representation of gender, sexual difference, and masculinity and femininity was a cipher.

Then, in the matrix of the 1990s, fiercely combative and irreconcilable conceptions of history, identity and place jostled for attention. Eventually, this action solidified into a reassessment of the use of the body in art that harks back to the 1970s. This rejection of this 1980s postmodern theory occurred at the very moment that it became the belatedly scandalous subject of culture wars.

When we think about something as apparently amorphous as art in the twenty-first century, we have to acknowledge increasingly different factors: the inexorability of the new-media paradigm shift; the vast, chaotic power of globalization (which is reflected in the decentralized and highly mobile nature of artmaking); recent art's fascination with the gigantic, the miniature and modelmaking; and finally, the continuity that binds *The Field* to the present. From the early 1980s onwards, if artists saw their work as contemporary, they acknowledged art's nature as a discursive field of representations, and so they were acknowledging *The Field*'s conceptual artists. From the late 1990s on, artists did fieldwork, organizing their work according to systems (here constructing and elaborating minimalist structures through either decorative or kinetic processes, as had particular artists in *The Field*), arcane anthropological research, or quasi-archaeological reconstructions.

02.02 Installation photograph of entrance to *The Field* exhibition, 1968

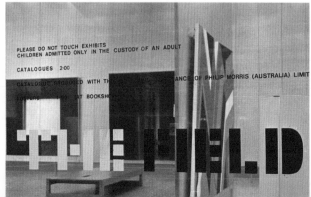

In 1968, according to the newspapers of the time, many of the trustees would have favoured a more conservative exhibition choice—an Arthur Streeton retrospective, for example. Such an exhibition would have been popular, of high quality, and the artist's principal theme—the Australian landscape—seemed of eternal contemporary relevance. Instead, NGV curator Brian Finemore and exhibitions officer John Stringer, with the backing of director Eric Westbrook, presented *The Field*. Why? The reason they wanted to produce *The Field* and not a Streeton retrospective is the same reason that *Fieldwork* focuses on certain art. The answer revolves around the definition of contemporary art, which might plausibly and simply just refer to art made recently. On the other hand—and this is a more debatable definition—'contemporary art' refers to art that self-consciously identifies itself with an unambiguously modern, global network of art museums, huge exhibitions, art fairs, and a definite idea of art as fieldwork.

Contemporary art is located at the end of a narrative that can't be explained by a recipe or a formula, for Australian art is reflective of wide shifts in international art, reflecting without doubt the massive changes in international art after 1968 in which the author of a work of art is no longer necessarily its actual maker, and in which contemporary artists and critics now assume that their works are embedded in theory and the wider field of consumer culture rather than in an intellectual Moulin Rouge, an ethereal space of spiritualized, bohemian creativity. But Australian art also exhibits crucial and productive differences from the global narrative, so much so that the history of world art is incomplete without, at the very least, Australian conceptual art, popist appropriation and, above all, the efflorescence of Aboriginal art that appears, for western audiences, to have leapt into view right on time in the evolution of modern painting with the magisterial works of 1970s Western Desert painting. These—incorporated decisively within the NGV's collection of Australian art since 1968—are now housed in Lab architecture studio + Bates Smart's radiant building at Federation Square. ¤

02.02 John Mawurndjul (Kuninjku), *Mardayin burrk-dorreng* (1990)

the field

John Stringer

The dramatic Melbourne Gateway on the Tullamarine Freeway (03.01) which greets visitors these days embodies much of the spirit that motivated artists in *The Field* three decades earlier (03.02). This thrilling monument provides a graphic demonstration of how far the emotionally biased pendulum of taste swings from generation to generation, for it is not just the expectations of the artists but also the reactions of their audience that develop and change with the passage of time. Although times have changed quite significantly since 1968 when the National Gallery of Victoria's premises were inaugurated on St Kilda Road, it is hardly surprising to find the opening of The Ian Potter Centre: NGV Australia at Federation Square also marked by a significant exhibition.

On this particular occasion *Fieldwork* reviews a period of three decades from the fresh perspective of the twenty-first century. Because it commences with notable works from *The Field* now in the NGV's collection, *Fieldwork* provides a good opportunity to review some of the background and context that produced these works, for the harvest that confronted the public in 1968 had germinated from seeds planted during the course of the preceding decade.

Among the catalysts for *The Field* nobody has a more important place than Eric Westbrook who established special exhibitions as a regular feature of the NGV program long before the NGV moved to St Kilda Road. Among his various duties as director he believed he had a particular responsibility to enable his constituents to understand and appreciate the culture of their own era; contemporary art, consequently, was indispensable in the exhibitions line-up. While the special-exhibitions program was essentially educational in aim and directed primarily to enrich the general public at large, it also helped the specialized agenda of the art community both by importing overseas material and promoting local practitioners. Artists were participants in the program and their opinions were especially important in questions of taste and artistic judgement.

Although *The Field* included a number of recent converts, far more significant and influential among the participants were the artists already committed to the new aesthetic, and especially the small elite who had actually lived and worked overseas, providing authentic links to the source and leading by example. Within the hierarchy of the emergent minimal movement, New York enjoyed supreme status for a number of reasons. Though not without challenge, Manhattan's position as the leading centre of world culture was gradually winning acceptance. The minimal art, which was currently succeeding pop, was only the latest in a sequence of developments commencing with abstract expressionism that had wrested artistic leadership from Paris. Due to colonial legacies and cultural allegiances, most artists up until mid century were inclined to seek their artistic nemesis in Europe—which for most Australians meant London—but with the 1960s this monopoly was broken. Not surprisingly, the adventurous souls drifting to the renowned centre of New York became important catalysts, and in this sense Clement Meadmore was pre-eminent. Heading the advance guard in 1963 he earned considerable prestige among younger Australians as the first expatriate of his generation to take up permanent residence in the Big Apple.

Admired not merely for achieving success overseas, Meadmore had already been an influential advocate for abstract art and industrial design in Melbourne during the decade that preceded *The Field*. Under his direction Gallery A became the first local space to develop a house style emulating advances in international architecture and showcasing fine, modern furniture alongside simple, frameless paintings in clean, uncluttered white spaces. While his subsequent appearances in Australia were rare following his departure, Meadmore was nevertheless able to share vital experiences and make crucial introductions for numerous compatriots and colleagues taking the increasingly popular trek to or through New York. In this competitive environment Meadmore flourished; his work quickly matured and gained volume in monumental block and slab monoliths that were followed by curved configurations—which Melbourne saw for the first time in the maquettes he let us have for *The Field* (03.03). Meadmore established a unique identity for himself and was highly respected for the originality of his work. Naturally urbane and a committed city dweller, he was accepted as an equal not only among famous artists but also with influential friends, including the American critic Clement Greenberg.

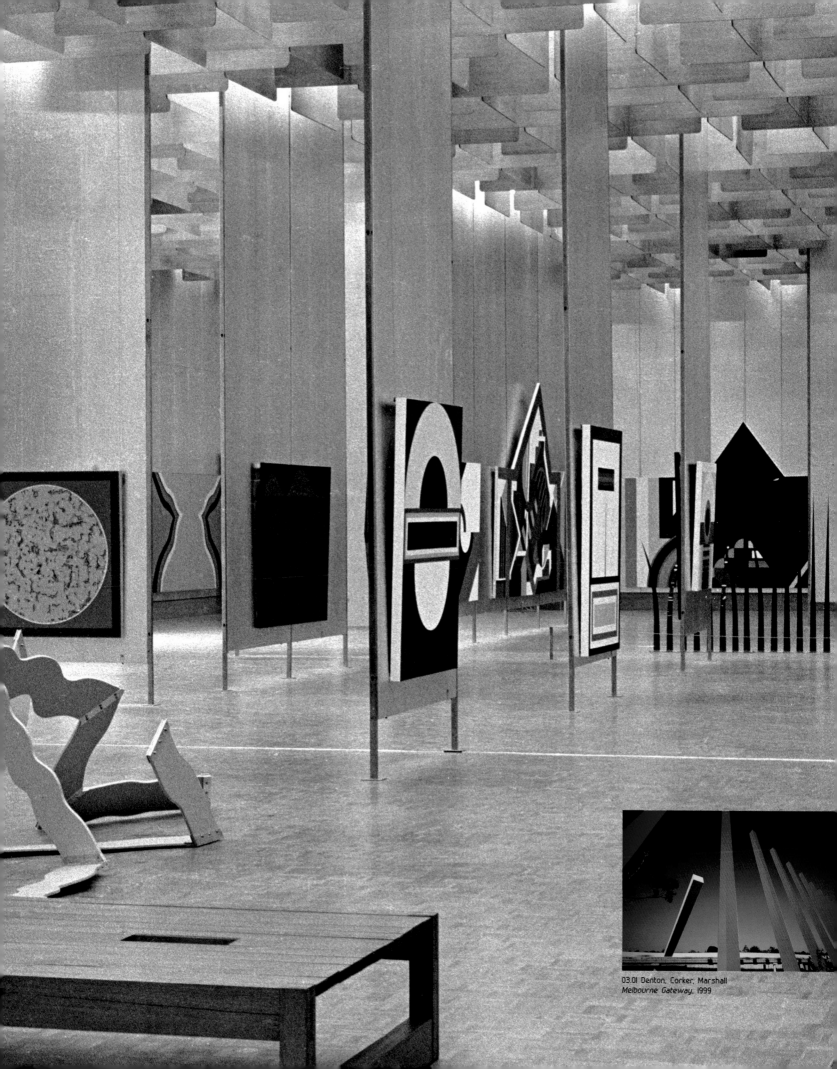

03.01 Denton, Corker, Marshall
Melbourne Gateway, 1999

It was Meadmore who urged me that the NGV should try to get Greenberg's celebrated exhibition *Post-Painterly Abstraction* for Melbourne when I caught up with him during August in 1964. Although this particular exhibition had already been dispersed, fortune smiled and ultimately we did even better. Few names were familiar to me among the many guests at Meadmore's party that greeted my own arrival in New York and I was rather overwhelmed; I can, however, recall chatting to Greenberg, Jules Olitski, Doug Ohlson and above all, Barnett Newman. Newman introduced me to Waldo Rasmussen, Director of the International Program at the Museum of Modern Art—a fortunate and timely connection that eventually enabled the NGV to snare his thrilling and authoritative *Two Decades of American Painting* direct from MoMA.

Of all the milestones in the NGV exhibition program none was a more significant catalyst for *The Field* than *Two Decades of American Painting*—they were barely a year apart. The American show was welcomed with a high degree of curiosity as so many artists had long awaited a physical confrontation with original paintings by figures who were famous overseas. Many even regarded the names Jackson Pollock, Mark Rothko, Willem de Kooning and Andy Warhol to be secure in history already. *Two Decades of American Painting* is still revered as classic among the numerous exhibitions circulated by the Museum of Modern Art during its evangelical years. Fastidious and highly discriminatory in its choice of artists and works, the selection laid out a tight and focused summary of three recent movements that had taken place over a twenty-year period. Isolated and often hanging alone, paintings were presented with a reverence and authority appropriate to masterpieces—it was a challenge to local taste that invited critical response, and the Australian public responded with unprecedented passion in the pages of the dailies. While the more informed were generally impressed and very supportive of the exhibition, far more significantly, the young found they had an unprecedented opportunity to pass judgement on the entire preceding generation of painters. Though not without admiration, the vanguard quickly concurred that abstract expressionism had already run its course. It was equally apparent that the abrasive commercialism of pop art was being eclipsed by the more disciplined, cool, pure and restrained formalism of minimal art. In terms of timing it could not have been better for those already on the path of abstraction but bewildered by the alternatives. The path was clear.

It is a surprising fact therefore that one of Melbourne's most respected, progressive artists had already abandoned her brief flirtation with hard-edge painting prior to the advent of either *The Field* or *Two Decades of American Painting*. Janet Dawson was a role model among her peers, not merely for her technical knowledge and proficiency in various media but especially for her professional, serious, analytical and intellectual approach to painting. A close friend, associate and protégée of Meadmore, she took over directing Gallery A after his departure and subsequently ran its visionary but short-lived print atelier. The most discernable stylistic influence on Dawson's work when she returned to Melbourne in 1961 was the noted Japanese master Kumi Sugai whose lithographs she had printed in Paris (03.04). While her pale, bleached canvases introduced a radical new degree of simplification to Australian painting, their preoccupation with expressive gesture and the manipulation of surface is quite European in style when compared with the flat, industrial finishes of minimal art. Dawson's cool but expressive formula was briefly interrupted by a small group of canvases with raucous stripes in bright primaries which must have been among the first hard-edge works painted in Australia. Dissatisfied with the results, the artist never pursued the aesthetic further and had destroyed the paintings without ever exhibiting them by the time *The Field* took place. The only vestiges to survive of this early precedent are the Formica patterns (including target-like motifs with concentric circles) that Dawson devised for coffee tables manufactured and marketed by Gallery A (03.05). She was heading back to more painterly, illusionistic and hybrid designs by the time our selection commenced, but as a pioneer and major influence, her inclusion was a foregone conclusion.

Sydney Ball, another significant influence, returned after two years in New York and became the focus of a lively contingent in Adelaide that included the sculptors Tony Bishop and Nigel Lendon. Unlike Meadmore, who departed Australia in the same year, Ball went overseas in 1963 essentially to study and his most significant contacts were with artists from the expressionist generation such as Mark Rothko, Philip Guston and Willem de Kooning. He nevertheless quickly identified with the new reductive aesthetic and even exhibited with the New Edge Group in the year of his arrival alongside

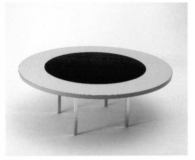

03.05 Janet Dawson, *Coffee table*, 1968

03.04 Kumi Sugai, *Composition*, c. 1955

03.03 Clement Meadmore, *Duolith III*, (1962)

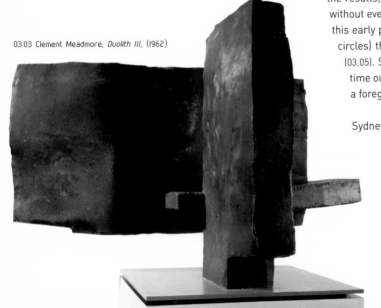

colleagues who included Carl Andre. Ball established himself as a prophet at home by generating large canvases dominated by bold pattern and flat, opaque colour that seemed to have no precedent in Australian culture (03.06). Despite regional subservience to Melbourne and Sydney, Adelaide was known for its own lively character and subjective influences. Charles Reddington and Udo Sellbach were typical of outside forces that were felt first in Adelaide before they eventually moved interstate. Though he was overshadowed by Kym Bonython—who was not merely a celebrity, a nationally known collector and art dealer but also director of the country's largest gallery in Sydney in the late 1960s—Richard Llewellyn operated the most focused and progressive gallery in Adelaide. Sydney Ball exhibited extensively interstate, won prestigious prizes and was probably the best known of all the new hard-edge artists Australia-wide; easy-going and generous of disposition but with high professional standards, he provided an example worth emulating.

03.06 Sydney Ball, *Canto no. 21*, 1966

Running parallel with Ball's trajectory is the influence of another artist from New York who arrived in Australia during the same year and who had a comparable significance for Melbourne painters. As someone born in the

Running parallel with Ball's trajectory is the influence of another artist from New York who arrived in Australia during the same year and who had a comparable significance for Melbourne painters.

United States, James Doolin was credited with a stylistic authority that no Australian could emulate. However, extensive periods of travel in different parts of Europe followed his graduation and separated him from significant developments taking place in New York, so the assertive, hard-edge style that he introduced was not indebted to American forces

03.07 James Doolin, *Artificial landscape 67/5*, 1967

alone. Nevertheless, what Doolin produced was uncompromisingly abstract, usually symmetrical and strikingly unfamiliar in its manipulation of pattern. Australian canvases like *Artificial landscape 67/5*, 1967, appeared so confrontational, uncompromising and focused that it surprises me now to encounter an unexpected complexity in their shape, hue, tone and structure that links with tradition (03.07).

Welcomed into the restricted stable and discriminating exhibitions calendar of Sydney's Central Street Gallery prior to *The Field*, Doolin broke the formidable interstate barrier. Nationally admired, his structural and chromatic preferences can certainly be detected in the opaque pigment and geometric design of paintings by Melbourne artists such as Dale Hickey, Robert Hunter, Robert Jacks and Robert Rooney. More significantly, Doolin's skilful control of surface design set an example that, whether it was emulated or not, fitted well with local tastes and tradition. Though *Artificial landscape 67/5* was the smallest of Doolin's three canvases in *The Field*, it remains one of the finest examples. Appealingly buoyant in colour and intensely focused in design, this classic work is immediately striking for its simple forms and axial symmetry. After a period of three decades, however, what now stands out so clearly is its inherent polyphony, for though *Artificial landscape 67/5* is executed entirely in flat acrylic rigidly demarcated into geometric zones, its dense and centralized composition relies on numerous diverse elements. Unlike minimal art which presents material and form as ends sufficient unto themselves, *Artificial landscape no. 7* (03.08) adopts a dynamic, descriptive composition and has not entirely separated itself from the shackles of representation or illusion. Its layered tints and gradations hint at a preoccupation with atmosphere well before Doolin's return to figuration in the 1970s.

Even more than its pale tints, the composition of *Artificial landscape no. 7* seems prophetic of the arch-shaped, abstract works painted after Doolin settled in Los Angeles. Restricted in colour and usually bi-chromatic, these atmospheric paintings had identical compositions that did no more than echo the curved top of the stretcher. Although their uniformity was possibly due less to rigorous artistic discipline than the exigencies of efficient shipment from California to Central Street, these final abstract paintings were undoubtedly Doolin's closest approach to minimal art. Though almost featureless and sprayed only with glowing gradations of clear, intense colour, these serene, spiritual works induce an unusual sense of illusion suggesting open space and moody, crepuscular light. At this time an interest in light is highly characteristic of work by Californians, including Larry Bell, Robert Irwin, Kraig Kaufmann, Fred Eversley, James Turrell and Dewain Valentine who all resorted to three-dimensional formats. Together with Doolin, who chose to stay with canvas, these abstract artists were distinguished from their New York counterparts by the degree of illusion implicit in their work. Such distinctions may previously have been used as value judgements but the artistic diversity of recent decades has encouraged us now to applaud variety. Even though they share certain illusionist affinities with art from the West Coast, the paintings by both Robert Hunter and John Peart included in *Fieldwork* have quite distinctive personalities that seem similarly rooted in the specific character of Australian light.

03.08 James Doolin, *Artificial landscape no. 7*, 1969

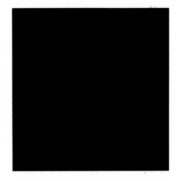

The content of this painting is invisible; the character and dimension of the content are to be kept permanently secret, known only to the artist.

03.09 Mel Ramsden, *Secret painting*, 1967–68

Though they settled in New York only a year before *The Field* took place, Ian Burn and Mel Ramsden had both left Melbourne in 1964, so it was outside Australia that the most significant changes in their work took place. Because the rapid evolution of their aesthetic led both artists through a rigorous process of formal simplification in their painting, it is scarcely surprising that their work shared certain superficial affinities with minimal art. Receiving only marginal information about their careers since their departure, we nevertheless believed they each had a vital place in *The Field*—which was more than justified by the reductive trajectory their work was following. The piece that Ramsden submitted *No title*, 1996, in fact, appeared to be the epitome of minimal art. It was already two years old and distinguished by a featureless, neutral surface, unusually attenuated format and deep, block-like stretcher. From what the artist told us, however, it was clear that his intentions were quite different and that he was already seriously questioning the prevailing aesthetic. Combining reflective black enamel with a stretched format intentionally too wide for conventional viewing, Ramsden further compounded a formalist reading of his work by positioning it at eye level where close reading or examination of the glossy, reflective surface would result only in confusion or frustration.

Executed a year later, Ramsden's *Secret painting*, 1967–68 (03.09), in *Fieldwork* belongs to another subversive group that once again put a conceptual spin on minimalism. What could be more quintessentially characteristic of minimal art than a square, all-black canvas? This time, because the painting is dwarfed by the explanation which accompanies it, we are faced with a new hierarchy; art is both subservient and inferior to information.

Executed a year later, Ramsden's *Secret painting*, 1967-68, in *Fieldwork* belongs to another subversive group that once again put a conceptual spin on minimalism. What could be more quintessentially characteristic of minimal art than a square, all-black canvas?

Balancing between fact and fiction Ramsden presents a conundrum; his caption declares the content of this painting is invisible—the character and dimension of the content are to be kept permanently secret, known only to the artist. While the statement is perplexing because the evidence is inconclusive, it is quite unmistakable that the artist is not only asserting his prerogative but simultaneously rejecting alternative interpretations for his work. Encouraging close scrutiny of his painting, Ramsden repudiates a formalist analysis and implies that affinities with minimalism are merely coincidental. Entirely subservient in size and meaning, the canvas has lost its autonomy to a text, which unequivocally confirms the superiority of mind over matter. Driven by an analytical bent, conceptual artists looked beyond mere coincidences of style to challenge the very principles and processes driving cultural diffusion, and their works frequently critique existing evaluation and marketing systems where even minimal art had been contaminated by its success. It is especially in the work of artists who turned to written language that we detect disillusion not merely with the formal traditions of illusion or abstraction but especially the accompanying marketing, mythology (or hype) and exploitation in the industry at large.

Even more perplexing for us were Ian Burn's two mirror pieces, both made in 1967, since they arrived in the mail from New York as a series of diagrams with typed instructions directing us how to manufacture the work ourselves (03.10). It was an unusual request even though the idea of prefabrication was not entirely new. We were aware of precedents in the early twentieth century as well as their recent consequences in New York where artists such as Carl Andre and Dan Flavin made their work from common hardware simply purchased over the counter. The inclusion of pages of text as a component of Burn's piece initially caused some anguish to those

of us whose taste was conditioned from an essentially formalist point of view. Despite Burn's and Ramsden's own reservations about the mixed context of *The Field*, we believed that their participation could still be justified on the grounds that their work was generally reductive in character. I remain grateful that Burn and Ramsden agreed to participate, although it has been highlighted subsequently that the anti-materialist character of their contributions ran contrary to the predominately formalist nature of the selection.

Four glass/mirror piece is not intended to be judged by minimalist criteria of scale, materials or finish, but like Ramsden's *Secret painting*, is directed instead towards the intellect; it presents an equation that needs to be understood rather than admired.

03.10 Ian Burn, *Four glass/mirror piece*, 1967

Burn had already sent back a suite of six identical paintings that he exhibited with Rudy Komon in Sydney during 1966. Fastidiously made, monochromatic in hue and geometric in design, it is easy to bracket these works with the serial and sequential imagery pioneered by New York artists such as Donald Judd. Repetition of near identical units also becomes a vital feature shortly afterwards in Burn's *Four glass/mirror piece*, but here the artist has moved beyond mere allegiance to the perfection of industrial materials and formal design. By placing progressively more sheets of clear glass in front of a conventional mirror, he allows image interference and subtle distortion to illustrate the fallibility and shortcomings of industrial materials. *Four glass/mirror piece* is not intended to be judged by minimalist criteria of scale, materials or finish, but like Ramsden's *Secret painting*, is directed instead towards the intellect; it presents an equation that needs to be understood rather than admired. The work is obsessed with physical fact and reveals flaws in materials that we normally accept as perfect; it functions like an experiment or demonstration apparatus. Challenging the accepted fidelity and accuracy of the mirror image, Burn also proves that the qualities of clarity and transparency that we routinely expect from glass are similarly fractured.

While the essence of its appearance rests in radical simplification, in attitude or philosophy, minimal art simultaneously sought to replace the precious, traditional substances of art with materials that were more commonplace and currently available with minimum or minimal effort. Turning to routine methods of contemporary manufacture, artists could not only exploit the superior skills of specialist technicians but also ensure that their objects would be professionally finished yet intrinsically unremarkable and devoid of the mystique traditionally associated with fine art. Although it made sense for artists in New York to use sophisticated industrial products, Burn himself was well aware of the paradox this would present in a less metropolitan environment—consequently, in devising *Four glass/mirror piece* it was critical for him to select materials and processes that he knew would be easily available in Melbourne. Due to his previous work experience in a frame shop the artist was well qualified to issue explicit, precise instructions for replication.

Although in formal terms *Four glass/mirror piece* was comfortable alongside other works in *The Field*, it is significant that Burn declined to show the entire suite of ten variations which would have made it more akin to the serial suites favoured by minimal artists. Disillusioned with the existing value-judgement system, Burn was among the artists convinced that the ultimate validity of the work of art rested less in its physical execution or completion than the governing premise or idea of its motivation. Because uniqueness was a hangover from an outmoded and corrupted tradition, it was entirely irrelevant in matters of artistic quality and subservient to the message or meaning of the work. Physical completion itself was no longer a necessity when both the nature and rationale of the work could be conveyed by a blueprint. Joining Art & Language—a radical posse of artists which included Terry Atkinson, Michael Baldwin and Joseph Kosuth—Burn and Ramsden both graduated as fully-fledged conceptual artists in 1971. Admired for his artistic integrity as well as his intellect, Burn, even more than his talented associate, exerted an influence on his compatriots that became even greater in subsequent decades.

Another pivotal influence was Tony McGillick who established Central Street Gallery in Sydney in 1966 shortly after returning from five years in London. Under his management the gallery not only became a flagship of international art reflecting the strong pop and minimal bias in McGillick's own painting but eventually contributed no less than a third of the participants in *The Field*. Though a number were only part-time painters who shared McGillick's successful career in advertising, the selection in general reflected the more established status of abstraction in Sydney where painters were less intimidated by the Antipodeans' figurative heritage. Of primary importance therefore were the artists Gunter Christmann, Noel Dunn, Michael Johnson, Wendy Paramor, Rollin Schlicht and, above all, Dick Watkins, whose work enjoyed unusual prestige among his contemporaries.

Revered as a pioneer who produced some of the earliest and most exciting hard-edge works in Australia, Watkins is an artist whose career is marked by unusual stylistic innovation and diversity. The retro feeling in both of his pieces in *The Field* betrays an informed admiration for constructivist art of the early twentieth century. *The Mooche*, 1968, (03.11) in particular, is a painting that immediately found a consensus of opinion amongst his artist peers, and was promptly purchased by the collector John Caddy; this well-known work was subsequently on extended loan for years to the Art Gallery of New South Wales before coming finally to the NGV. Though its tilted, diagonal format, large scale, and opaque, flat pigment are typical of the era, *The Mooche* to some extent surprised the organizers who had anticipated existing and earlier hard-edge works from this founding father of abstraction in Australia. It has an energy and informality showing that Watkins is another of those who had already moved beyond the constrictions of minimal art and was looking for fresh sensations. Loosely geometric fragments and elements tumble and scatter across its surface, echoing the cut and torn forms of collage pioneered by constructivist and cubist innovators early in the twentieth century. Multichromatic and uninhibited, *The Mooche* is not only too expressive and complex to be confused with minimalism but is an essentially descriptive design that also revives certain illusionist implications of depth and movement.

If something of the character of Sydney and Central Street is captured by the liberation and abrasiveness in *The Mooche*, the subtlety, precision and stability of Robert Hunter's *Untitled no. 8* (03.12) are qualities that seem more applicable to the personality and tempo of Melbourne. Similarly, the influence and attitudes of gallerist and collector Bruce Pollard in Melbourne were an effective counterpoint to the views of Tony McGillick in Sydney, although Hunter is one of the artists who did not join him until after *The Field*. Pollard's gallery, Pinacotheca, consequently had a unique position in the southern vanguard and, though he was not an artist, the young director was well informed and held in great esteem as a prophet of change, a champion of the progressive and an important stimulus to all concerned. Purchasing key pieces such as Michael Johnson's *Frontal 2*, c. 1968 (which he loaned to *The Field*), Pollard set an early example and was virtually unique among Australian collectors by building a nucleus of key works from the era.

Aged just twenty-one, Robert Hunter was not only the youngest of the participants in *The Field* but also one of the most controversial. Bewildered members of the public despaired over his all-white, almost featureless canvases while rivals dismissed his neutral aesthetic as simply being a polarized rip-off from the New York artist Ad Reinhardt—substituting white for the all-black paintings that had been such a scandal in *Two Decades of American Painting*. Against the predominately figurative heritage of Victoria, Hunter has a brave and unusual position as a loner who not only emerged as an abstract artist but has maintained this exclusivity throughout his entire career. Though *Untitled no. 8* is about a third smaller than his canvas in *The Field*, it is a classic and contemporaneous example whose square format typifies the artist's early phase.

> Aged just twenty-one, Robert Hunter was not only the youngest of the participants in *The Field* but also one of the most controversial.

Hunter's works in pale, synthetic acrylic are never entirely blank or featureless but depend on the palest of tints and the clean precision of masking tape for their subtlety. *Untitled no. 8* uses a composition that divides the canvas into quarters with a circle superimposed in each of the four segments. Like most of his oeuvre this work is based on a grid underpainted with different primaries and finished with successive neutral coats. There are major differences, however, between *Untitled no. 8* and the large six-panel work on paper in *Fieldwork* which Hunter painted two years later.

Finished in a uniform grey and secured to the wall with masking tape, *Untitled*, 1970 (03.13), uses low-grade and inexpensive materials; the composition, instead of taking place within the confines of the separate sheets, through the relationships between the different component pieces is enacted in large scale directly on the wall surface. This ambitious work follows the artist's first trip to New York and it is an interesting coincidence that it uses precisely the same number of units as the suite of identical canvases that Ian Burn showed with Rudy Komon in Sydney during the previous decade. Significantly, *Untitled*, 1970, has notable affinities in format and

03.13 Robert Hunter, *Untitled*, 1970 (detail)

material with the work of Robert Ryman who was one of the artists chosen by Waldo Rasmussen for the United States pavilion in the New Delhi Triennale in 1971 when Hunter represented Australia. Even more significant was the personal friendship that commenced in India with Carl Andre (also among the United States contingent) for this led Hunter to a more active dialogue and engagement with New York during the following decade.

With the benefit of hindsight it is fascinating to find in the pale, bleached works of Hunter's early career a preoccupation with light and illumination, for a similar phenomenon can also be felt in the works which his Sydney contemporary, John Peart, submitted to *The Field*. Among the participants Peart was second only to Hunter in youth, but his career is usually characterized by the free and uninhibited application of paint and allied to abstract expressionism. Though, in fact, he produced very few minimal works, Peart was among the most radical contributors to the show. On our initial visit to his Balmain studio, Brian Finemore (NGV Curator of Australian Art and co-curator of *The Field*) and I were struck by a square canvas entitled *Cool corner*, 1967, which was so high-keyed tonally that it was difficult to detect any surface variations or design, however, prolonged viewing revealed a slightly paler central diamond surrounded by triangular corners in which broad bands of flat and opaque pigment ran parallel to the central motif (03.14). Infused with sensuous atmosphere and distinctively evocative of the idyllic summer light and dazzling reflection from the harbour, this bleached prototype provided the centralized motif for both of Peart's works in *The Field*.

03.12 Robert Hunter, *Untitled no. 8*, 1968

03.15 John Peart, *Corner square diagonal*, 1968

03.14 John Peart, *Cool corner*, 1967

Unlike its monochromatic antecedent, *Corner square diagonal*, 1968, defines its composition not through differentiations in tint and tone but with the linear junctions that separate its component parts (03.15). In contrast to its companion work in *The Field*, which had a dynamic, diamond-shaped centre, *Corner square diagonal* is stabilized and window-like in composition. Because they each consisted of five separate modules bolted together, these two works have the distinction of being structurally unique in Peart's career. Carefully handcrafted and constructed so that their corners are considerably deeper and thicker than the main body of the work, each painting has a hypnotic intensity and atmospheric drama derived from its large scale, centralized design, sensuous colour and austerity. Although the effect is nebulous and lacks definition, both works are brushed and graded to be darkest at the perimeters and palest in the centre, with subtle gradations that give an almost blinding sensation of looking directly into the light. This illusion of recession is intensified by the frame-like format of bordering canvases, which increases the feeling of depth and inward focus. Frustrated by the difficulties of handcrafting different stretchers that would fit with precision, the artist was unable to achieve an appropriate uniformity in the gaps and mitres between elements. Peart quickly returned to simple, monolithic, square formats as his technique, palette and compositions became increasingly free and informal.

Although *The Field* was quite diverse in its stylistic make-up, it was especially by bolting block-like canvases together that participants released their work from the pictorial conventions which had previously dominated both figurative and abstract painting in Australia. Even more than the Sydney delegation, which included not only Peart but also Michael Johnson, Tony McGillick, Rollin Schlicht and Vernon Treweeke, it is my opinion that it was Melbourne artists who most successfully exploited this development.

While experience and connections overseas added considerable lustre to local reputations, Trevor Vickers and Paul Partos were typical of the artists who were admired for their record of distinguished production. Already they were able to show Waldo Rasmussen accomplished minimal works in their studios when he visited Melbourne with *Two Decades of American Painting*. A year later their monumental canvases in *The Field* were commanding

in scale and simplicity, and outstanding for their adherence to the minimalist code. These artists not only adopted aggressively physical formats intended to overwhelm or engulf the spectator, but they stood alone by incorporating internal voids into their designs which established a fresh, reciprocal dynamic with the wall surface. While Vickers was one of the first Melbourne artists to be admired for minimal works, he had already moved beyond circle-and-square monochromes to larger constructions with separate canvases bolted together by the time of *The Field*. Much respected by his artist peers at the time, Vickers based both of his contributions on simple progressions of forms which he coated in opaque, leathery acrylics; for me, *Untitled*, 1968 (03.16), remains among the most compelling and memorable works in the show. More centralized, though similar in scale, were the two modular pieces including *Vesta II*, 1968 (03.17), by Partos which owe their mystic and poetic mood to the combination of sonorous colour and delicate texture. Sprayed with carefully alternated, subtle gradations, these two bi-chromatic works gained their particular character from the clever use of counterpoint, and represent a unique, early moment in the artist's lifelong engagement with colour and surface.

03.16 Trevor Vickers, *Untitled*, 1968

Seeking a visual dialogue unconfined by the limitations of geography, artists in *The Field* adopted ideas of structure and sequence that were pioneered overseas, and dedicated themselves to radical forms of abstraction.

Seeking a visual dialogue unconfined by the limitations of geography, artists in *The Field* adopted ideas of structure and sequence that were pioneered overseas, and dedicated themselves to radical forms of abstraction. Though it was an era when regional distinctions were of little concern, a distinctively local flavour is nevertheless discernable if the work of Australian artists is viewed in the genuinely international context which they admired. While local character is not always linked to atmospheric nuances, as in the work of Hunter and Peart, it is frequently revealed by the survival of relatively conventional pictorial solutions. Simple misunderstanding of what was really happening in New York may have been a factor, but the high degree of individuality within *The Field* may equally be due to a larrikin aversion to conformity. Against such a boisterous background of innovation and change, few of us detected that minimalism, despite its radical visual program, was, to a great extent, a revival of older values. In formal terms it reinstated the order, clarity, stability, rationality and belief in idealism which are traditional hallmarks of classical art. ¤

03.17 Paul Partos, *Vesta II*, 1968

John Stringer was the Exhibitions Officer at the National Gallery of Victoria from 1968 to 1970.

03.18 Robert Rooney, *Corners*, 1972

the conundrum of a mirror piece

Ann Stephen

Ian Burn's mirror pieces have a close yet critical relation to painting. When Burn conceived the idea in 1967 he intended the 'pieces of ordinary glass placed face to face in front of an ordinary mirror ... fitted into an ordinary frame' be seen 'the same as painting, not sculpture or objects'.[1] Over the following decade the mirror pieces came to be regarded as proto-conceptual art which largely eclipsed this earlier but overlapping narrative of painting. To recover the circumstances of their first exhibition (which was in Australia) suggests why the necessity for language emerged in art that confronted the crisis of late-modernist painting in the 1960s.

Having left home four years earlier, Burn was working in New York when he was invited in February 1968 to participate in *The Field*, the exhibition that would institutionalize American-type painting in contemporary Australian art. He proposed *Blue reflex*, 1966–67, a reflective, monochrome painting, and two mirror pieces to demonstrate how these works 'though in appearance very different to each other, are virtually the same, only [the] emphasis has been placed differently'.[2] Only the latter—*Two glass/mirror piece*, 1968, and *Four glass/ mirror piece*, 1968 (04.01) —were selected. They were exhibited without their accompanying notes and diagrams because the curator, John Stringer, equated them with preparatory studies. The mirror pieces appear to have been a risky selection, however, Stringer's decision may have been pragmatic as the *Blue reflex* painting required transport whereas the mirror pieces were to be fabricated in Melbourne. Burn had argued unsuccessfully for the wall text to be included, and later explained that

> unlike most works, one can look at the mirror pieces for hours without ever gaining any indication of what it is about (anyway I don't like people to spend any time looking at the works, I never do myself). The idea is not available visibly in the works it only exists in a system.[3]

Burn shared with his close friend and collaborator Mel Ramsden the paradoxical condition of being a painter deeply suspicious of the visual. Their iconophobia had developed in defiance of the regime of opticality in American modernist painting. Earlier, Burn had been fascinated by Ramsden's reflective, black paintings of 1965–66, one of which was exhibited also for the first time in *The Field*, and he began to work with automotive enamels and other reflective materials, making paintings that draw attention to their context.

The mirror pieces were considerably smaller than all other work in *The Field*, akin to an ordinary bathroom mirror with the height of the frame being one and a half times its width, to match the scale of a body. Their understated, bland aesthetic was consistent with the circumstances of their production: they were assembled by a picture-framing business from specifications sent by the artist. Accepting the deceptively simple invitation to look at the mirror pieces as painting, there is no internal structure or fixed appearance, but a precarious instability that, as Burn noted:

> Demands concentrated effort, which may be assisted by focusing on imperfections, dust, smears, haze, steam (that is, by the mirror's inability or failure to be a perfect mirror). The extent to which we are able to see the mirror surface irrespective of these incidental factors depends on a self-consciousness of the possibilities of seeing: on being able to look at ourselves seeing, and on being able to interpret our not-seeing [sic] of the surface.[4]

1 Ian Burn, letters to John Stringer, 20 March 1968 & 26 March 1968. Burn's correspondence is the most extensive of the participating artists in *The Field* exhibition. National Gallery of Victoria files.
2 Burn, letter 26 March 1968. The first *Mirror piece*, 1967, accompanied by thirteen sheets of notes and diagrams was a limited edition of thirty-five, a further twelve different works made between 1967 and 1969 bear the words 'mirror piece' in their title. The two works in *The Field*, *Two glass/mirror piece*, 1968, and *Four glass/ mirror piece*, 1968, accompanied by eight sheets of notes and diagrams, were made specifically for exhibition in Australia and do not form part of an edition. Each has a signed label on the reverse side specifying the title, date and place of manufacture and certifying that the work 'is in no way unique and might be reproduced at any time or place by myself or any other person (either acting on my behalf or acting independently)'.
3 Burn, letter to Stringer, 29 April 1968. Burn subsequently insisted that Stringer make the notes available on request 'so anyone who could be interested is able to pick it up'. Burn, letter 25 July 1968. A similar misunderstanding confronted the photograph that Burn sent for reproduction in the catalogue, which shows his face reflected on the surface of *Blue reflex*. It was rejected on technical grounds.
4 See Burn, *Looking at Seeing and Reading* (exh. cat.), Ivan Dougherty Gallery, Sydney, 1993, paragraph 3.

'on being able to look at ourselves seeing'

04.01 Ian Burn, *Four glass/mirror piece*, 1968 (detail)

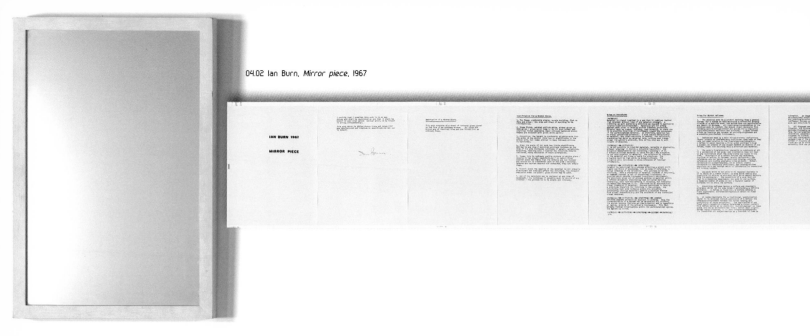

04.02 Ian Burn, *Mirror piece*, 1967

The perceptual dilemma was compounded in *The Field* by the exhibiting of two similar but slightly different works, only distinguished by varying the numbers of sheets of glass, which imperceptibly blur the reflection. Burn's notes conclude that

> there is still little chance of very much about the structure of the mirrors being deduced by looking at them…perception then becomes an arbitrary process and appreciating the structure becomes a matter of knowing about it—rather than seeing it or deducing it.[5]

Burn began photographing the mirror pieces to give some presence to their low visibility. His documentation took a turn in the direction of performance, posing with an electric shaver in front of a mirror piece in response to problems he encountered in their reception:

> I don't see why people don't look at my mirror pieces in the same way that they look into a bathroom mirror, a perfectly normal and natural human action, something within our ordinary existence, not outside of it, isolated, remote, museum-ised.[6]

In spite of Burn's polemic for the ordinary, estrangement occurs when a mirror piece is viewed in the museum. The historian John Roberts warns that the claims of conceptual art in the late 1960s should not be taken on face value as

> its dominant theoretical voice was also, in a sense, not to be trusted, was not what it seems…[for] what made conceptual art's theoretical excursions so liberating: that seriousness and ambition might also be a form of delinquency and malingering.[7]

5 Burn, unpublished notes, 1967.

6 Burn, letter, 1969, cited in *Ian Burn: Minimal-Conceptual Works 1965–70* (exh. cat), Art Gallery of Western Australia, Perth, 1992, p. 73.

7 J. Roberts (ed.), *The Impossible Document: Photography and Conceptual Art in Britain 1996–76*, London, 1997, p. 10.

8 A. Piper, 'Ian Burn's Conceptualism', inaugural Ian Burn Memorial Lecture, Sydney, July 1996, republished in *Art in America*, December 1997, p. 76. In *The Field*, the mirror pieces provoked interest among artists but confounded critics. Since the 1992–93 national tour of *Ian Burn: Minimal Conceptual Works 1965–70* local commentaries have proliferated, launched by Michiel Dolk's Lacanian reading in his accompanying catalogue essay, 'It's Only Art Conceptually'. Both Charles Green, *The Third Hand: Collaboration in Art from Conceptualism to Postmodernism*, New South Wales, 2001, and Keith Broadfoot have applied insights from 1980s appropriation art and postcolonial writing. The mirror pieces are read as prophetic works that reverse the terms of Australian provincialism by confronting the paradox that 'it is the nothing-to-see which is Australian'. K. Broadfoot, 'Landscape as Blank: Australian Art after the Monochrome', *Australian Journal of Art*, vol. XIV, no. 2, 1999, p. 6.

9 *Art & Language*: 'Moti Memoria', in *The Impossible Document*, Roberts, p. 63. Art & Language, with whom Burn worked from 1970 to 1976, now comprises Michael Baldwin, Charles Harrison and Mel Ramsden. A comparable early work by Michael Baldwin, *Untitled painting*, 1965, consisting of a mirror mounted on canvas, is included in *Art & Language in Practice, Illustrated Handbook*, vol. 1, Barcelona, 1999, p. 125.

10 J. Rose, 'Sexuality in the Field of Vision', 1985, reprinted in *Art in Theory 1900–1990*, Oxford, 1992, p. 1103.

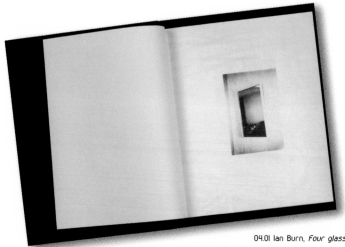

04.01 Ian Burn, *Four glass/mirror piece*, 1968 (detail)

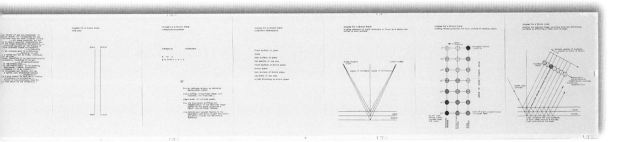

Recent commentaries on the work have refocused attention on 'the status and circumstances of the self—particularly the artist's self'.[8] Certainly the mirror pieces do not individualize the artist any more than any other viewer, and the notions of subjectivity associated with self-portraiture appear implausible. In considering a closely related work, Burn's former collaborators in Art & Language conclude that 'a queer consequence of speculation … about "invisibility" or dematerialised objects … [means] the author or the artist is no longer alone; that a socialised base of art just might be developed … as a necessary internal development of *the work*'.[9] It is ironic, given Burn's disavowal of psychological insight, that the act of viewing such mirror pieces uncannily matches Jacqueline Rose's description of the encounter between psychoanalysis and artistic practice [as one that] gives back to repetition its proper meaning and status … as the constant pressure of something hidden but not forgotten—something that can only come into focus now by blurring the field of representation where our normal forms of self-recognition take place.[10]

The mirror pieces were largely hidden in *The Field* exhibition as no critic engaged with them as works of art. As norms of representation have shifted, their imperceptible visibility focuses speculation on art as both a perceptual and a conversational activity. ¤

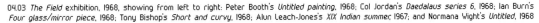

04.03 *The Field* exhibition, 1968, showing from left to right: Peter Booth's *Untitled painting*, 1968; Col Jordan's *Daedalaus series 6*, 1968; Ian Burn's *Four glass/mirror piece*, 1968; Tony Bishop's *Short and curvy*, 1968; Alun Leach-Jones's *XIX Indian summer*, 1967; and Normana Wight's *Untitled*, 1968

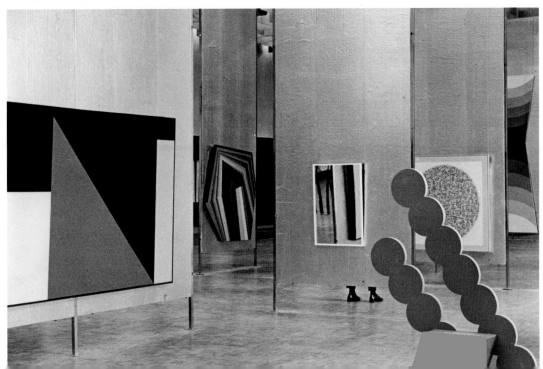

The Aboriginal renaissance in art has been with us now for thirty years.[1]

The years since 1971 have been a momentous period of revolutionary change in Aboriginal art that represents a historic contribution to the global history of art. The artist Imants Tillers has likened the most recent history of Aboriginal art to an artistic renaissance, however, the idea of a rebirth creates the wrong impression, for this is not quite what we have been witnessing. Aboriginal artists have created new art forms through durable painting media that express a vital, constantly evolving culture that never disappeared. The past three decades are not a revival of an ancient or classical tradition from an earlier time, but rather, a dramatic birth of something new, which has in turn given birth to other new art forms in a markedly diverse range of media.

The exponential growth of Aboriginal art since 1971 is, in large part, a product of the phenomenal achievements of the Papunya Tula artists over the whole thirty-year period surveyed by this exhibition.[2] From 1971 to 1973 the founding Papunya artists laid the groundwork for what emerged as 'an important contemporary art movement, Australia's equivalent to, say, European cubism or American abstract expressionism'.[3] In fact, as Tillers points out, due to the 'big bang' effect of the Papunya Tula movement, Aboriginal art, in all its diverse forms, 'unexpectedly and incredibly became the mainstream of Australian contemporary art practice',[4] and leapt onto the international stage. As with other forms of modern art, the local audience was slow to grasp the brilliance of the Papunya Tula movement, failing to register its power and significance and doubting the authenticity and validity of an Aboriginal art form that was not on bark or stone. Now it seems impossible to deny that 'from [out of] the deserts the prophets [have indeed] come',[5] transforming the way we see the land and the history of art in this country.

In hindsight it is impossible to overestimate the importance of the founding years in assessing the meaning and significance of Papunya Tula art. In mid 1971, a little over a decade after Albert Namatjira's death at the same government settlement of Papunya, thirty or so senior Aboriginal men, separated from what they called their own 'dear' countries, took up painting as part of a fight to save their culture from the threat of extinction. It is important to remember that these were heady days in relation to Aboriginal affairs, precipitated by the election of the Whitlam Government, the Woodward Land Rights Commission and the creation of the Land Rights flag for Indigenous Australians in 1971.[6] Stimulated by the Australia Council for the Arts and the growth of Aboriginal land rights, the early 1970s was a period of intense cultural activity and political resurgence for Indigenous Australians. The political and social climate was right for the genesis of a new Aboriginal art movement, but the paintings themselves had to wait another two decades before they were fully appreciated by a contemporary art audience more receptive to Indigenous Australian art and culture.[7]

The first Papunya artists took extreme risks in rendering permanent an ephemeral art made only for use in closed and secret ceremonial contexts on bodies, objects or the ground. The senior men, exiled from their homelands and fearful of their future, dared to invent a permanent visual language to communicate the essence of their *jukurrpa* (Dreaming) to *kartiya* (non-Aboriginal) colonisers and controllers of their destiny. They took discarded materials from the settlement—fruit-box ends, floor tiles, scraps of composition board—and unlocked ancient ritual designs that until 1971 had been kept hidden from the uninitiated. The closeness of the first paintings to their source in men's business give the works a solemn liturgical power, and a sense that they point to unknowable cosmological and religious secrets. Yet, because of the permanent materials of their construction, they demand to be seen as works of art, and not as artefacts.

1 Imants Tillers to Ian North, quoted in North, 'Imants Tillers and Positive Value', *Artlink*, vol. 21, no. 4, December 2001, p. 37.
2 For a comprehensive and detailed account of the movement, please see H. Perkins & H. Fink (eds), *Papunya Tula: Genesis and Genius* (exh. cat.), Sydney, 2000.
3 J. Kerr, 'Papunya Tula: A Great Contemporary Art Movement', *Art Asia Pacific*, issue 31, 2001, p. 33.
4 Tillers to Ian North.
5 A. D. Hope, *Australia*, verse 6, line 4.
6 The Land Rights flag was designed by Luritja artist, Harold Thomas.
7 The National Gallery of Victoria purchased its first Papunya Tula works in 1984–85 when funds were first allocated for the purchase of contemporary Aboriginal art. Peter Fannin brought early Papunya paintings to the NGV in the early 1970s, which were declined because at that time the NGV had no policy for the purchase of Aboriginal art.

05.03 Yala Yala Gibbs Tjungurrayi (Pintupi), *Snake and water Dreaming*, (1972)

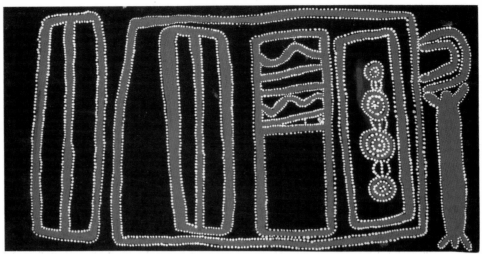

05.01 Charlie Tarawa Tjungurrayi (Pintupi), *Old man's Dreaming at Mitukatjirri*, (1972)

8 Charlie Tarawa Tjungurrayi to Andrew Crocker quoted in
 A. Crocker, *Charlie Tjaruru Tjungurrayi: A Retrospective
 1970–1986* (exh. cat.), Orange City Council, 1987, p. 11.
9 Ground paintings are composed of identical red-ochre
 designs with tufts of white organic matter used as a
 ground on a vast scale.

05.09 Walter Tjampitjinpa (Pintupi),
Water Dreaming, (1971)

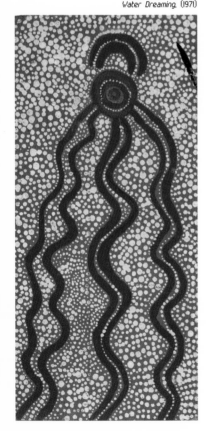

Artists including Uta Uta Tjangala, Mick Namarari Tjapaltjarri, Johnny Warangkula Tjupurrula and Shorty Lungkarda Tjungurrayi forged a new art form that is startling in its directness and energy. Their first paintings were raw and exploratory, as they discovered new kinds of materials—pencils, brushes, shiny enamels and synthetic polymer paints—and learned to fit their designs on crooked-sided squares and rectangles. The interest and encouragement shown by the first two art advisers, Geoffrey Bardon and Peter Fannin, their only outside audience, kindled their enthusiasm and cultural pride and challenged them to seek new solutions. In one of many such instances of reconciliation in the history of Aboriginal art, and what has been termed its 'commodification', artists met Bardon and Fannin halfway and shared their joys in painting and their towering compassion for their homelands. Their urgency to paint is linked to cultural survival. As Charlie Tarawa Tjungurrayi put it, 'If I don't paint this story some whitefella might come and steal my country'.[8]

Many compositions ideally suited to the small format, such as Mick Wallangkarri Tjakamarra's *Old man's Dreaming on death or destiny*, 1971 (05.02), Yala Yala Gibbs Tjungurrayi's *Snake and water Dreaming*, 1972 (05.03), or Charlie Tarawa Tjungurrayi's *Old man's Dreaming at Mitukatjirri*, 1972 (05.01), are compelling one-offs, not repeated by the artists concerned. Each of these works encapsulates one main subject, place or concept and is marked by a totality of gesture and a bold simplicity of form. Their seemingly abstract iconography of lines, geometric shapes, markings and symbols together encode many layers of meaning and reveal the inner or spiritual power, the essence, of the artists' country and cultural identity.

Charlie Tarawa Tjungurrayi's *Old man's Dreaming at Mitukatjirri* tells a complex story in the very simplest of visual language—red-ochre glyphs edged with white dotting to make them stand out on a black background (05.01). Two men, indicated by 'U' shapes, participate in a ceremony at Mitukatjirri (Ligertwood Cliffs), relating an ancestral story of sexuality. The motif on the far right is a ground painting. The linked concentric circles represent the Dreaming journey that is part of the story. Linear patterns possibly represent ritual string and women's digging sticks. Apparently there are mountains nearby and this occasion takes place in winter. Mick Wallangkarri Tjakamarra's *Old man's Dreaming on death or destiny* is another work that stands out in the artist's oeuvre for its completeness. The strong design depicts ceremonial men as 'U' shapes, in ritual position, contemplating the end of life as old people. According to traditional custom, Aboriginal persons are left behind if they cannot travel. Curvilinear motifs at the top and bottom represent windbreaks; concentric circles are fireplaces. The dotting indicates bush tucker and prepared ceremonial earth. The two oval *tjurunga* forms are disguised and do not reveal secret and/or sacred information.

Yala Yala Gibbs Tjungurrayi's *Snake and water Dreaming*—in red-ochre with white dotting—reads like a miniaturized ground painting.[9] The artist represents a snake in its profound elemental power. The concentric circles are the coiled up body of the snake and its camp or waterhole, and also denote a place of living water. The white dotting indicates the earth. The main elements of this story stand out in space and can be viewed from any direction. The dots used in this and other works as edging or ground have their source in body paintings, cave art, men's shields and the wild-cotton down attached to ground designs and the human body in ceremonial contexts: they heighten or intensify the hieroglyphic signs and symbols.

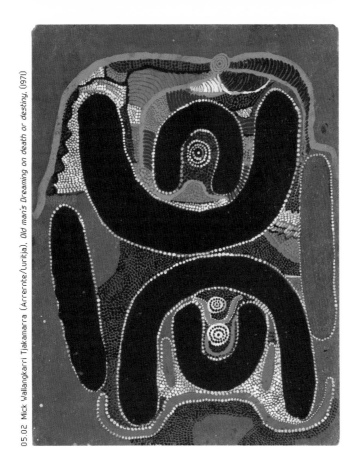

05.02 Mick Wallangkarri Tjakamarra (Arrernte/Luritja), *Old man's Dreaming on death or destiny*, (1971)

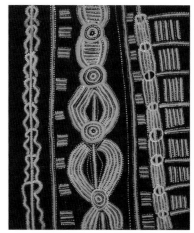

05.10 Mick Namarari Tjapaltjarri (Pintupi), *Untitled (Water Dreaming)*, (1971)

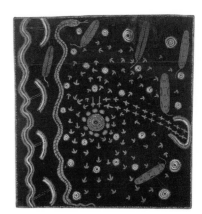

05.04 Long Jack Phillipus Tjakamarra, (Warlpiri/Luritja), *Emu Dreaming*, (1972)

These and the other synthetic polymer paintings on board produced in the first two and a half years at Papunya are some of the most sought-after Australian paintings ever made, as recent Sotheby's auction records attest. They render tangible and permanent an ephemeral art formerly confined to ceremony, transforming it into something new. The configuration of circles, arcs and meanders, also found on ancient Aboriginal petroglyphs (rock carvings) from Central Australia, seem to issue from within the continent itself. The conjunction of archetypal designs and modern materials results in a rich and potent art form that transforms our understanding of the Australian landscape and speaks with a new voice. But it is questionable whether the works are landscape paintings, as we understand the term in the context of European art history, or something else more rich and strange. Through the vision of Papunya Tula painters, the land and its oral literature becomes art of a very particular, celebratory and revelatory kind, what Geoffrey Bardon has termed a 're-perception of the Australian landscape'.[10]

The land is generally viewed from a bird's-eye or planar perspective, like that of a hunter-gatherer aware of the presence of game or the ripening of bush plants from marks in the earth. Hence in Long Jack Phillipus Tjakamarra's *Emu Dreaming*, 1972, we can see the tracks of many emus as arrow-like marks and the presence of many men as circles that denote their headdresses seen from above (05.04). A creek appears as a meander, signifying a Water Dreaming. The baldness of the visual marks on a black ground derives from the Western Desert tradition of telling stories by drawing with fingers in the sand.

The absence of a horizon in this and other Papunya Tula works expresses the artists' spatial affinity with the land: there is no separation between land and sky. The artists bring the horizon into the landscape as clouds, rain, rainbow, hail or atmospheric disturbance. A set of signs and symbols is used to conceptualize place and the presence or trace of creator ancestors who entered into and became the land. Infinity is understood as the depicted land itself, which the artist paints from the position of knowing intimately as part of himself. The artists paint the land from inside it, not perched on the outside using their brush as a camera. Theirs is a tactile art of feeling in which knowing, sensing and touching country and the ancestral world transcend the European imperative to see. The land is known and sung into being through names of sites and *kuruwarri* (signs of ancestral beings in a mythological topography). The visual language of circles and paths used to encode named places of resting and travelling paths of ancestral beings, and to map large tracts of land, has now etched its way into our consciousness.[11]

The artists paint the land from inside it, not perched on the outside using their brush as a camera.

10 G. Bardon, opening speech, 'Circle Path Meander', National Gallery of Victoria, 14 December 1988.
11 The following year the same artist produced *Possum man and possum woman travelling*, a layered and complex work that no longer has a plain ground.

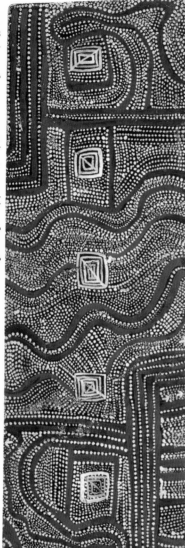

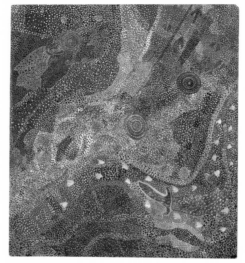

05.08 Johnny Warangkula Tjupurrula (Luritja),
Nintaka and the mala men, (1973)

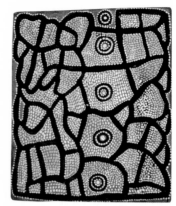

05.11 Walter Tjampitjinpa (Pintupi),
Water Dreaming at Kalipinypa, (1971)

The Papunya artists, however, took risks in rendering permanent the ephemeral marks of ceremony, the incisions on stone *tjurunga*, or in depicting ceremonial performers and their paraphernalia, as in Uta Uta Tjangala's *Big snake ceremonial travelling Dreaming*, 1972 (05.05). Other senior Aboriginal men from different communities saw the first paintings in the marketplace and rioted, regarding them as acts of dangerous sacrilege. Once this occurred, the artists were cautioned, curtailed and could no longer paint with cheeky abandon, just for their own eyes. They were forced to disguise and censor the sacred designs from body, ground and artefact and create quieter images for public viewing. From mid 1971 to late 1973 senior men invented a public art form that communicated Dreaming truths and philosophies to *kartiya* outsiders and colonisers and then modified it so that it did not break secret and/or sacred taboos. They also became captivated by the process of making art and began to experiment with colour mixing, new supports and brushes, and different ways of expressing their Dreaming subjects.

Some of these developments in style and technique may be charted in the works of one of the founding artists, Johnny Warangkula Tjupurrula. This waterman, who was able to sing the songs in ceremony to promote rain and fertility in desert wilderness, was a foremost artist whose career could be said to have peaked in 1972 when his painterly technique of colour mixing and layering with filigree brushwork is seen at its finest in works such as *A bush tucker story*, 1972 (05.06). The dots that were subsidiary elements in the equation, confined to edging or background, as in the artist's *Water Dreaming at Kalipinypa*, 1971 (05.07), come to the fore in the later work as compelling visual elements used brilliantly to evoke a minutiae of vegetation, a spatial affinity with the land and to celebrate the power of the Water Dreaming. Works such as these from 1972, embellished with an outpouring of colours mixed with white in irregular massings of dots, differ from those of 1973 where dots are no longer in layers but more spaced out, as seen in *Nintaka and the mala men*, 1973 (05.08).[12]

The founding artists, intent on selling their work, succeeded in forming their own company in 1972. Papunya Tula Artists Pty Ltd has operated successfully as an independent business ever since. If painting began at Papunya as a symptom of cultural change, it ultimately became an artistic product, subject to the effects of market forces. As Peter Fannin, the first salaried art coordinator recalls:

> I was confronted with a shed full of company capital on completely undocumented, peeling masonite cut into fascinating shapes. Rejoice! The world's never seen art like this before! Weep! It's fragile and in colours the marketers say won't sell. More to the point, those wondrous irregular quadrilaterals will be a nightmare ... to pack.

12 For a detailed and informative discussion of Johnny Warangkula's art over time see J. Kean, 'Johnny Warangula [sic] Tjupurrula: Painting in a changing landscape', *Art Bulletin of Victoria*, no. 41, Melbourne, December 2001.

13 Letter from Peter Fannin to author, 19 July 1988.

Eventually, after failing to sell a great deal of early works on board, some of which are in this exhibition, Fannin notes, 'We moved from pine chipboard to stretched canvas to make the despatch for consignment practicable'.[13] The transition to canvas marked a new phase, leading to a succession of radical departures from the small-scale works of 1971–73 that is still unfolding in unexpected directions. There could be no going back to the beginning, yet the first works are magical seeds that have germinated in the Papunya Tula movement and have cross-fertilised in other manifestations of Western Desert art that is being made today.

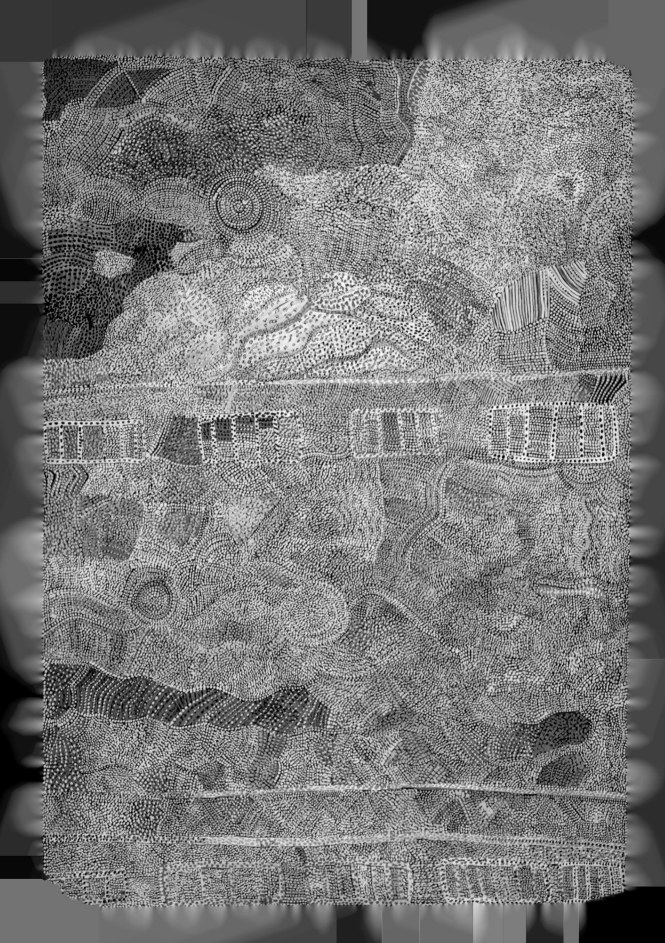

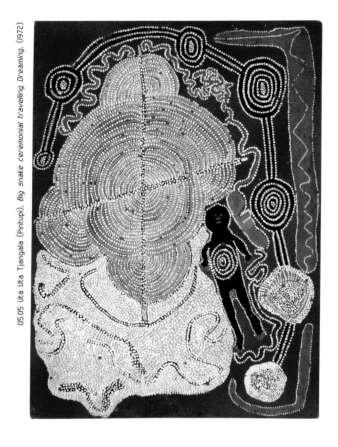

05.05 Uta Uta Tjangala (Pintupi), *Big snake ceremonial travelling Dreaming*, (1972)

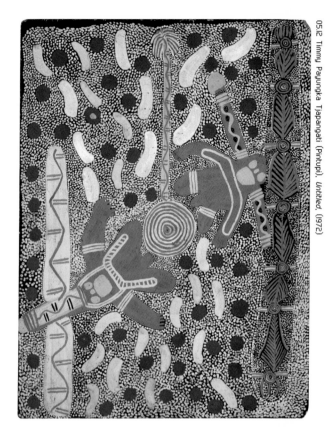

05.12 Timmy Payungka Tjapangati (Pintupi), *Untitled*, (1972)

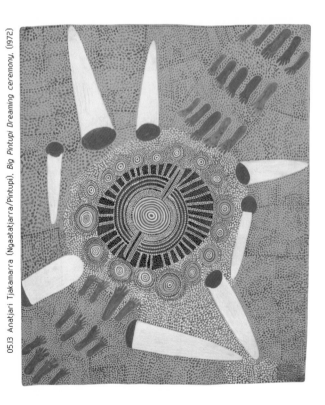

05.13 Anatjari Tjakamarra (Ngaatatjarra/Pintupi), *Big Pintupi Dreaming ceremony*, (1972)

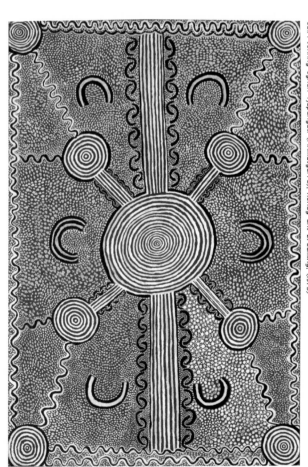

05.14 Johnny Lynch Tjapangati (Anmatyerre), *Honey ant Dreaming*, (1973)

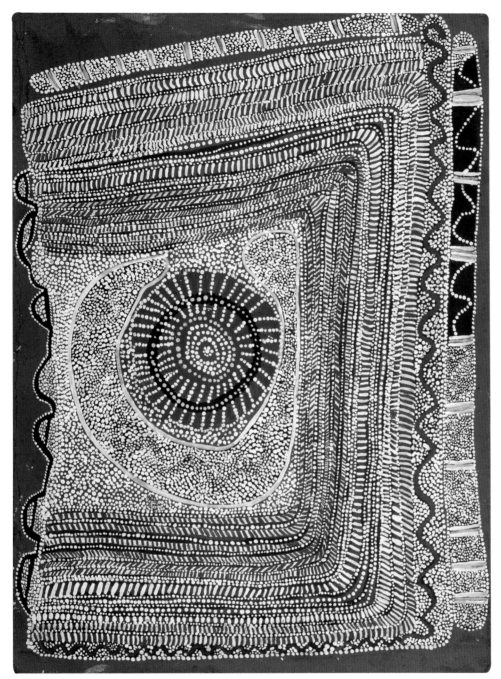

05.15 Shorty Lungkarda Tjungurrayi (Pintupi), *Waterhole in a cave*, (1972)

In confronting the astonishing power of the first boards, most of which were unsaleable in the early 1970s, it is worth returning to the essence of what Geoffrey Bardon wrote:

> In 1980, I sometimes thought, among those new fires and shattered expectations, that an older Australia was passing away forever, that our own symmetries had been set aside and made helpless and that a new visualisation and idea of the continent had come forth, quite literally, out of that burning or freezing red sand. It is hard to be clear about an entire continent wondrously re-perceived by the brutally rejected, and sick, and poor. Yet this is what occurred. This was the gift that time gave, and I know this in my heart, for I was there.[14]

The whole history of Australian art has been irrevocably changed by what thirty or so senior men achieved at Papunya, a dismal 'sit-down' place that has since been largely abandoned as a centre for making art. The achievements of Papunya Tula and other Aboriginal artists since the ground was laid in the first two years at Papunya has made it impossible to exclude Aboriginal art from any survey of Australian art post-1970. ¤

14 G. Bardon, 'The Gift that Time Gave: Papunya Early and Late, 1971–72 and 1980,' in *Mythscapes: Aboriginal Art of the Desert*, J. Ryan, Melbourne, 1989, p. 16.

Polynesian 100, 1973 (06.01) is about 100 days in 1973 when the French government tested nuclear weapons over Mururoa Atoll in Tahiti. Upon independence, the Algerian desert was no longer used as a bomb test-site so France turned to French Polynesia instead. Public anger at the French was greatest in 1973. That year the Australian unions stopped postal services with France and diplomatic activity was scaled back. The Australian and New Zealand governments applied to the International Court in The Hague to stop the French nuclear experiments, which were causing radioactive fallout to drift over countries in the South Pacific. Their application was successful in that from 1974 onwards France detonated its bombs underwater, deep in the coral reef of Mururoa Atoll.

Ti Parks and the painter John Firth Smith were commissioned, through the Australia Council for the Arts, to represent Australia at the Eighth Biennale de Paris in 1973, when Parks first exhibited *Polynesian 100*. Initiated under Andre Malraux in 1959, and held in October, the Biennale was specifically for artists between the ages of twenty and thirty-five, with the objective of presenting a panorama of young international creators. The Biennale de Paris was popular as it specialized in showing new directions in art—from British pop in 1961 to American minimalism and Italian art povera in 1969. As director from 1971, the critic Georges Boudaille modelled the biennale on Documenta at Kassel, Germany, with themes and artists selected by a commission of young critics and artists. Entries from individual countries were still included to keep a sense of an international survey.[1] Ti Parks's radical working methods, reminiscent of art povera and minimalist and serial art, made him an appropriate Australian representative among the French avant garde. His theme was apt for a federal Labor government. In 1975 Ti Parks wrote a description of *Polynesian 100*:

> One hundred colour photographs were taken of patches of beach showing sand, pebbles, shells, refuse, etc. Each patch was 'treated' before it was photographed. Firstly it was paint-sprayed with a red, a white, and a blue strip (in some prints this is clear, in others the three colours are very diffused and missed), the patch was lightly sprayed all over with black paint, and lastly sprinkled with many-coloured sugar balls (100s and 1000s). The colour prints themselves were each vertically creased into three equal parts (tricolour flag—relating to red, white, and blue spray), scattered with cut up pieces of their own negatives which were taped down with transparent tape (very sharp looking shrapnel-like pieces), occasionally 'patched' with small taped rectangles of brown paper, finger smears of bitumen were added, and lastly each print was masked with a smaller rectangular piece of paper and sprayed silver giving each a diffused silvery frame...an attempt at a direct political protest work (rather alien to me) about bomb tests in the Pacific, hence the tricolour flag, the carbon spray, the 'fallout' of 100s and 1000s, the negative slivers.[2]

Ti Parks writes with hindsight that *Polynesian 100* was more than 'an attempt at direct political protest',[3] as it engages, among other ideas, with the future of the environment. However, by 1975, confrontational political art, apart from feminist art, was beginning to lose its potency in Australia and, besides, Ti Parks was back in London.

The artist had met Pat and Richard Larter in 1974 when Larter and Parks were visiting senior lecturers at the Elam Art School, University of Auckland, New Zealand. Richard Larter and Ti Parks each held exhibitions in Auckland; the Larters made films of Ti Parks's installations and they became close friends. Richard Larter, the most political of artists, believed that you don't get anywhere by making art which is overtly political. No-one is converted and the art is usually bad.

> Guernica was mainly famous because the Luftwaffe used the most modern aircraft...to kill women and children in an undefended town...[T]hat painting, even though it is a good Picasso painting...it's trite in comparison with [what happened]...[A]rt does not convert politically.[4]

1 K. Lavaur, 'Historique de la Biennale de Paris', Archives de la Critique d'Art website, <www.archivcriticart.org/pages/ fiche_article.php?ID=0000000000000014>.
2 T. Parks, letter to J. Phipps, February 2002.
3 ibid.
4 Helen Topliss, interview with Pat and Richard Larter, 11 February, 1995, oral history tape, National Library of Australia; Richard Larter discussion with author, December, 2001.

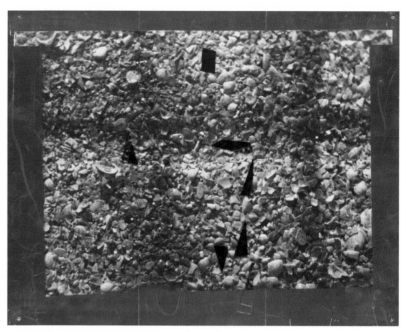

06.01 Ti Parks, *Polynesian 100*, 1973 (detail)

From a distance the photographs are an elegant silvery line of brown and pink repetitive forms.

Richard Larter's strategy to make people look into his painting is to use sexy images as attractive, or attention-grabbing high points of his compositions. This strategy is

> like in music playing grace notes which are always nice to hear and so you can take a visual vocabulary which is the equivalent of grace notes and you can actually get people to look at what you've done, get people to try and make out what you are actually on about ... Not everything you say is political but in the end ... everything you say is political, morality, sexuality, perception.[5]

The photographs that make up *Polynesian 100* are displayed pinned close together in a line, placed in the order in which they were taken. Ti Parks's instruction for viewing his installation is that it be '... displayed at a height which makes people wishing to examine a photo stoop in the way the artist stooped when he took it'.[6] His strategy for making people stoop to move along his installation is not so different from Richard Larter's 'grace notes' of sexy images.

In 1973 the political message conveyed in *Polynesian 100* depended on the viewer's knowledge of current affairs, and it still remains there for anyone who bends down to view the work as they walk alongside the gallery wall when it is displayed. Parks's micro world is of black spikes of negatives, creases, coloured sand cliffs, 100s and 1000s like boulders, ripple marks like river valleys, flotsam and jetsam like crashed space junk. From a distance the photographs are an elegant silvery line of brown and pink repetitive forms. Look for what is Polynesian and find, even without knowing about the nuclear tests, a dirty barren world. Each photograph symbolizes an island.

Polynesian 100 is full of visual jokes and overturned conventions. The 'Polynesian' mask drawn on the back of most of the 100 photographs is like an emblem or crest embossed onto official papers, as well as a mask of a culture behind a ruling culture. Sometimes the mask itself is 'masked' with masking tape and electrical insulation tape, that is masked again with transparent tape. Masking symbolizes secrecy and hidden agendas of power. All photographs are masked by a silver-sprayed stencil frame. The frame acts in two ways. In one way it makes each photograph look like a still from a film, so that the whole space in which *Polynesian 100* is displayed acts out the projection of the film, and, as *Polynesian 100* must be displayed within one space, you are surrounded. A reversal is going on in the magnitude of nuclear detonations played out against an enlarged photograph of tiny sections of beach. In another reversal the frame stencils are silver, while those on film strips are black. The second way the frame works is that the silver introduces the idea of light — and by overextending

5 ibid.
6 T. Parks, artist's statement to accompany display of *Polynesian 100* at the National Gallery of Victoria, 1974.

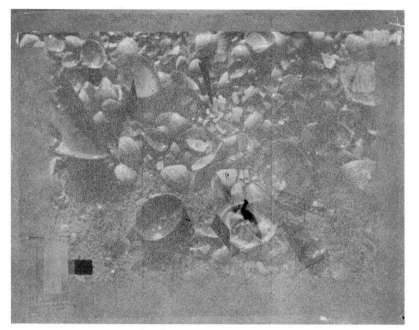

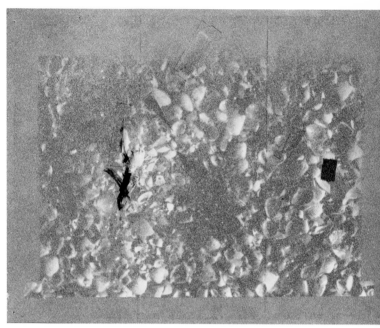

06.01 Ti Parks, *Polynesian 100*, 1973 (detail)

06.01 Ti Parks, *Polynesian 100*, 1973 (detail)

this idea, probably beyond the artist's intention, introduces the white flash of nuclear explosions. In reverse, it is a view from a bright world to a damaged world. The cut-up negatives are literally about negation — the end.

Ti Parks often uses numbers as a way of ordering — the work of art, the world or time. He 'practises disorientation of the spectator' by creating works of art which have 'a rambling casual air', and which resemble the ordinary chaos of the world.[7] In *1,000 drawings*, 1973, Parks pinned 1000 drawings together to hang in one sheet over a pole beside a drum full of 100s and 1000s. This was commissioned for the group exhibition *Object and Idea*, at the National Gallery of Victoria. In 1982 he began a project to make 10,000 collages.

Ti Parks studied at Bromley School of Art, Kent, and at the Slade School, London. Two lasting impressions from the Slade School were a lecture by Larry Rivers, 'just rubbishing everything about the holiness of art', and a six-hour slide and tape lecture by Eduardo Paolozzi, master of collage and the found object, on his film *The History of Nothing*.[8] Newly graduated, Ti Parks migrated to Australia in 1964. His first exhibitions of paintings and painting constructions used opposition, difference and alternatives within them, often based on halves. The *Paintings* exhibition, shown at Watters Gallery, 1969, consisted of ten geometric, bright and uncomfortably coloured paintings, numbered 1 to 10 (and 'number 11', which was a wood painting stretcher), where one system of design based on lino patterns was put on top of another system based on door panels. These paintings were also shown in the exhibition *Virginia's*, Tolarno Gallery, in the same year. Here the gallery acted as a spatial installation divided by a very large wooden sculpture of a painting stretcher with corner vestiges of its canvas. In one half the viewer looked at the painting — by stepping through the frame the viewer was in the painting.[9]

In the late 1960s, Parks began to use found objects: 'I just wanted to make three-dimensional things that could be packed up at the end and thrown away'.[10] His Argus Gallery exhibition, *The Tent, The Tent, The Table, The Mattress, The Robe*, was of five sculptures made from found objects arranged to use the volume of the gallery space. This included two tents — one a real tent and the other, in opposition, an idea of a tent: 'A warm, soft sleeping rug, and a tent skeleton of blue mohair, held up by two eight-foot poles, and two rigid, triangular guys with serrated edges'.[11] The ziggurat — shaped red and blue painted panels at each end of the 'tent' — the only solid part of the sculpture — represented vibrating guy ropes. From the mid 1970s until the early 1980s Parks exhibited artist books and assemblages in Australia and in England. He currently lives in London and continues to exhibit minimal performance pieces, artist books and installations based around the idea of artist books. ¤

7 M. Plant, 'A Reading of Robert Morris (with Notes on Paul Partos, Guy Stuart and Ti Parks)' in *Other Voices*, October–December 1970, p. 141.

8 T. Parks, De Berg Tapes 433–34, 23 November 1969, National Library of Australia.

9 ibid.

10 ibid.

11 T. Parks, *The Tent, The Tent, The Table, The Mattress, The Robe* (exh. cat.), Argus Gallery, 1969.

clockwork

sue ford: time series 1962–74 ::07

Kate Rhodes

Sue Ford is one of the most important practitioners of the wave of 1970s Australian feminist photographers. These artists—Micky Allan, Virginia Coventry, Sandy Edwards, Ponch Hawkes, Helen Grace and Ruth Maddison—regularly took pictures of friends and family for social and political ends. Like them, Ford frequently turned the camera on herself, her circle of friends and acquaintances. Her raw, simple and personal photographic style was a determined, alternative response to both the masculine emphasis on the mastering of technique (which dominated photography studies in Melbourne the 1960s) and to the camera's capacity for the objectification of its subjects. The *Time* series, 1962–74, shows Ford as the producer of local histories and demonstrates how these were generated from her private life.

Between 1962 and 1964 Ford made photographic records of friends and other people. Around ten years later when studying at the Victorian College of the Arts, she saw one of her subjects, noticed how much they had changed and decided to take their picture again. This started her *Time* series portrait project. All the pictures were taken without props or special lighting, with each person formally facing the camera and with the barest of expressions. While the five pairs of black and white images are significant records in their own right, the mutations in the companion works establish broad and often dramatic leaps through time—hair styles, clothes and skin change. In *Camera Lucida* the French academic Roland Barthes wrote of the capacity for photography to extract time away from the world and store it in a single image. In a similar way Ford has referred to the camera as a time machine. In the *Time* series the camera's mechanical precision describes the metamorphosing of youth with quasi-scientific results.[1]

A photograph is still, but with a nod to her background in film-making, Ford introduces flux into the *Time* series—the gap between 1962 and 1974 is traversed in the flicker of an eye. Ford has rarely produced single photographic images, instead, she prefers a fluid, filmic way of working, creating works of art in pairs or extended sequences. In these photographs Ford uses the passage of time like glue: each parallel pair works together and relies on the other for the development of narrative, in a similar way to the annual photographic portraits of the Brown sisters, 1975–, by the American portrait photographer Nicholas Nixon, or the extended series of *Up* films (*7Up*, *42Up*, and so on), 1964–, by British film-maker Michael Apted. Like them, Ford controls the camera as a social eye. She records life in the 1960s and 1970s, documenting the inner circle of an artist and the youth of a rapidly changing Australia. Ford has also used the camera as a reliable recording device to investigate the appearance of change in films such as *Faces*, 1976–96, *Time changes*, 1978, the photographic series, *Growth*, 1975, and *My faces*, 1975.

The *Time series* is a sequence of documentary-style images for a public audience, rather than private images to be cherished by Ford. Even though they are printed to an intimate scale (11.0 x 20.0 cm), these subject studies are neither sentimental nor self-confessional. As viewers we might look at the *Time* series in an imaginary shared space with the sitters and wonder what changes have also occurred to ourselves in the last ten years. The titles of the photographs—*Ross* (07.01), *Lynne* (07.02)—are not only identification labels but characterizations. We might use them to call out to the person if we recognized them on the street; we feel we know something about them just by looking at their faces. In the way that portraitists such as J. W. Lindt, August Sander, Richard Avedon and Rineke Dijkstra have created 'signs of the times', physiognomic approaches to making and viewing photographs are also appropriate to understanding the *Time* series.

The photographed face is a symbol for the nature of impermanence and a slate to which we may attach readings of the human condition. As the *Time* series subtly implies, photographers do not show how things look since there is no one way that anything looks. What a photograph shows us is how a particular thing could be seen, or could be made to look at a specific moment, in a specific context. ◻

1 S. Ford, *Time Series: An Exhibition of Photographs by Sue Ford* (exh. cat.), Brummels Gallery of Photography, Melbourne, 1974.

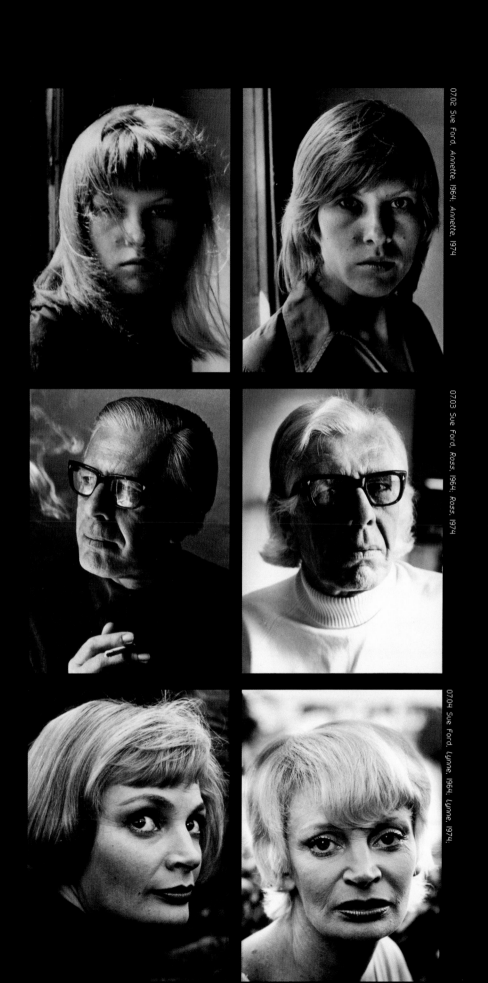

07:02 Sue Ford, Annette, 1964; Annette, 1974

07:03 Sue Ford, Ross, 1964; Ross, 1974

07:04 Sue Ford, Lynne, 1964; Lynne, 1974

'if you don't fight you lose' Cathy Leahy

the political poster as alternative practice in the 1970s[1]

1 The title of this article appropriates the title of an exhibition of political posters mounted in Adelaide in 1977: *'If you don't fight you lose.' An Exhibition of Posters on Current Australian Issues.* Contemporary Art Society Gallery, Adelaide, 18 September–5 October 1977.

2 The writings of theorists such as Herbert Marcuse and Theodor Roszak informed the utopian aim of radically changing society through the transformation of consciousness. Marcuse's *One Dimensional Man: Studies in the Ideology of Advanced Industrial Society*, 1964, was widely read in this period, as was Roszak's *The Making of a Counter Culture*, 1970. These theorists were known in Australia, either through their primary texts or through such articles as D. Altman's 'The politics of cultural change', *Other Voices*, vol. 1, no. 2, August–September 1970, pp. 22–28.

3 A term devised by Peter Burger to characterize the determination of works of art by the institutional apparatuses which govern their production, dissemination and reception, see P. Burger, *Theory of the Avant-Garde*, trans. M. Shaw, Minneapolis, 1984, p. 12.

4 Donald Brook was an English art historian and critic who believed that the teaching of art theory and history should not be segregated from an understanding of, and tuition in, the practice of art for fine art students. Marr Grounds was an Australian–American architect and sculptor who had taught in Berkeley, California, where he had encountered the counterculture and alternative teaching methods. See T. Kenyon, *Under a Hot Tin Roof: Art, Passion and Politics at the Tin Sheds Art Workshop*, Sydney, 1995, pp. 10–16; D. Brook, 'Sydney: Art in the Universities', *Studio International*, vol. 182, no. 935, July–August 1971, pp. 9–13; C. Mackinolty, 'The Tin Sheds: A Rose by Another Name?' in C. Merewether & A. Stephen (eds) *The Great Divide*, Melbourne, 1977, pp. 131–139.

5 Smith, quoted in Kenyon, p. 12.

The political poster flourished in Australia in the 1970s in the radical climate ushered in by a new generation of young artists and left-wing activists committed to social change. The social turmoil that swept America and Europe in the late 1960s reverberated in Australia in increased student radicalism, demonstrations and the politicization of sectors of the population, including the artistic avant-garde. Opposition to Australia's involvement in the Vietnam War was followed by the championing of a plethora of new causes from women's rights, Aboriginal land rights, gay rights and environmental issues to alternative lifestyles. An optimistic belief that society could be changed through political activism and the transformation of consciousness was underpinned by knowledge of the counter-culture movement in America of the late 1960s.[2]

This gave rise to a pervasive climate of anti-institutionalism, which in avant-garde circles spurred many artists to critically analyse the social and structural conditions governing the production and consumption of art in bourgeois society. New art forms were devised to circumvent the 'institutions of art'[3] crucial to upholding the bourgeois art system such as the commodity status of the art object, the division of art from life and the construction of artist-as-hero. Performance art, conceptual art, post-object art, community arts and political art were all forms that aimed at developing new relationships between artists and their audiences outside the established gallery system.

It was in this climate that the Earthworks Poster Collective was established in Sydney in 1971. The first of the poster collectives formed in the 1970s, Earthworks operated out of the Tin Sheds, a cluster of old sheds at the University of Sydney in which the Power Institute of Fine Art had initiated a creative workshop for its students. Inspired by the alternative educational philosophies of two of its founders, Donald Brook and Marr Grounds,[4] the Sheds provided a venue where students and artists could experiment freely, gain tuition in a variety of art forms and participate in the free-ranging debates and discussions conducted there. The Sheds quickly emerged as a focus for radical art in Sydney, becoming in the early 1970s the centre for the development of post-object art. Following the sacking of Gough Whitlam in 1975, the climate at the Sheds became more politically strident as opposition to social conservatism became more organized, and as movements such as the women's movement and the community arts movement gained force. The location of Earthworks Poster Collective within this hotbed of radical ferment, political activism and trenchant critique of the 'institutions of art' is important to an understanding of its philosophy and practices.

Established as the Earthworks Poster Company in 1971 by Colin Little, Earthworks changed its name and became a collective in 1972. The collective nature of Earthworks reflected the genuine attempts by many at the Sheds to 'piece together a practice that didn't have profile, didn't have signature and was in fact genuinely collective'.[5] The posters produced at Earthworks were all signed with the collective's logo (an Egyptian eye in a triangle), rather than individuals' names, in an attempt to undermine the mythology of the single artist. Another strategy employed by collective members to undermine the art system's valorization of originality was to quote other art works in their posters. The poster for the 1977 May Day ball in Balmain (08.01), for example, appropriates the imagery

1940's PEGGY, MOTHER OF EIGHT. newmarch

WOMEN HOLD UP HALF THE SKY!

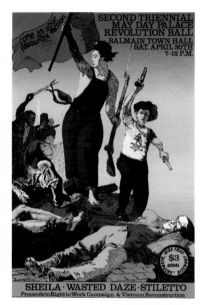

08.01: Earthworks Poster Collective, Chips Mackinolty, *Second triennial May Day palace revolution ball*, 1977

from Delacroix's famous revolutionary painting *Liberty leading the people*, 1830. Similarly the 1977 poster for the Workers' Health Centre uses the iconic symbol of the workers' struggle (the fist superimposed on the factory roofline) that had been popularized through the posters of the May 1968 revolution in France (08.02 & 08.03).

The collective members were all highly politically motivated. In fact, two members, Chips Mackinolty and Toni Robertson (08.04), who joined in 1974 and 1975 respectively, were not trained artists at all but political activists when they joined Earthworks.[6] Other members who were formally trained, such as Michael Callaghan, were disillusioned with the mainstream art world: 'I was looking for a more politically direct means of vengagement...The reason I became involved in posters was that I wanted to use my skills in some way that I considered to be politically viable.'[7] Because the poster operated outside the gallery system and could reach a much broader audience, it had a greater ability to affect social change than the traditional forms of art. As Mackinolty simply pointed out in 1977: 'A poster placed in a strategic position can be seen by thousands of people every day.'[8] Earthworks not only created posters for clients, but collective members also produced their own posters about social or political issues that concerned them. For example, Toni Robertson's poster about public billboard space (08.05) prompts reflection upon why it is that only big business can afford access to public space in a capitalist society.[9]

Projecting political messages into the everyday domain was one way that the Earthworks Poster Collective worked to bring about social change. Another was to foster greater access to art within the broader community. Members of Earthworks, like many of the staff at Tin Sheds, rejected the division of art from life within bourgeois society, and sought ways to break down the perception of art as a specialized field of endeavour. Chips Mackinolty saw this as one of the greatest successes of the Tin Sheds:

> But perhaps the major reason for the success of the Tin Sheds as a viable place is that it hasn't necessarily concerned itself with and become preoccupied with 'art' with a capital 'A'. Rather, its general aim has been to provide, for as many different people as possible, a place that they can come and do what the hell they want to without having to operate within the context of 'being' or 'aspiring to be' an 'Artist'.[10]

In 1976 the Tin Sheds received government funding to extend the number of community art classes that it conducted. Classes were held in a wide variety of art forms, and Earthworks members were involved in teaching screenprinting, fabric printing and the use of the copy camera.[11] By participating in the Sheds' community program, Earthworks members were able to make the collective's skills and equipment accessible to the broader community. These community classes also furthered the collective's aims of promoting social change by empowering people to make posters themselves, as Mackinolty pointed out:

> [I]n addition to making posters, the collective [is] interested in teaching as many people as possible the skills of postermaking. Political posters are a very cheap and technically easy method of communication available to groups without much money or power.[12]

Earthworks created posters for a multitude of groups and organizations: feminist groups, for example, the posters for the Women's Domestic Needlework Group's *D'Oyley Show* (08.06), resident action groups, student organizations, political groups (such as the Communist Party, International Socialists, the Anarchist Movement etc.), anti-uranium groups, workers' groups, community organizations and so forth. When printing for these groups, the collective charged according to hourly rates set by the Printing and Kindred Industries Union;[13] further aligning themselves as workers rather than artists. This was consistent with the group's attempts at establishing their postermaking as 'work' outside the domain of art.

Earthworks, however, was not to escape the fate that awaited all radical art forms of this period—namely, the co-option of their practice by the very system they had hoped to circumvent. The ability of capitalist society to absorb and commodify any cultural manifestation, no matter how critical in content or form, became increasingly apparent in the 1970s. In 1973, the National Gallery of Australia began a comprehensive collection of posters produced at Tin Sheds, and other cultural institutions were to follow suit. The postermakers themselves contributed to this commodification of the political poster by beginning to exhibit their work in commercial galleries. The first such exhibition, *Walls Sometimes Speak: An Exhibition of Political Posters*, was organized by Chips Mackinolty and Toni Robertson in 1977, and toured the country to sell-out success. However, the decision to

6 Chips Mackinolty came from a background in radical student politics, while Toni Robertson was involved with the Sydney University Feminists and active in other feminist groups.

7 Quoted in Kenyon, p. 48. Another collective member, Jan Fieldsend, recalled, 'Screen-printing was part of the left political repertoire. It was a time of "Don't Agonise—Organise!". We were part of a milieu that organised demonstrations, printed the posters, raised the money and then marched. It was a time of trying to organise in a different way—non-hierarchically, collectively and with the common good in mind'. Quoted in Kenyon, p. 49.

8 Mackinolty, quoted in the review of the exhibition *Walls Sometimes Speak: An Exhibition of Political Posters* at the Ewing and George Paton Galleries. M. Geddes, 'The posters here are "intellectual"', *The Age*, 24 October 1977. National Gallery of Victoria files.

9 See L. Dauth, *Political Posters of the 70s. Work from the Tin Sheds: A Partial Survey* (exh. cat.), Flinders University Art Museum, Adelaide, 24 July–10 August 1991, p. 6.

10 Mackinolty, p. 138.

11 ibid. p. 139.

12 Quoted in Geddes.

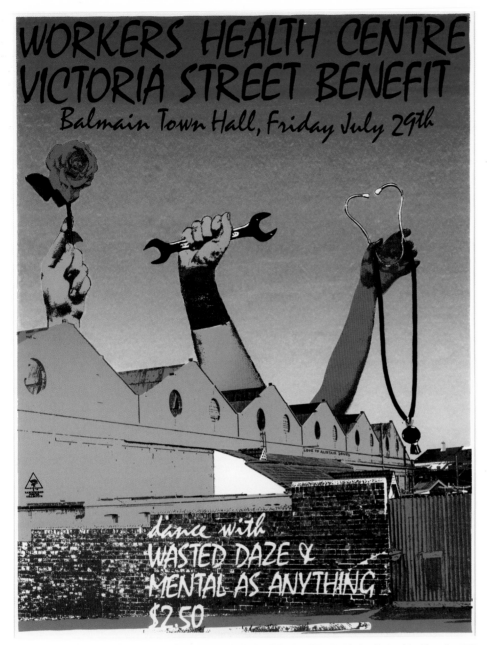

08.02 Earthworks Poster Collective, Chips Mackinolty, *Workers' health centre*, 1977.

08.03 Unknown, Atelier Populaire, Paris *Renault avec Billancourt 5 Decembre: La lutte continue*, 1968

08.04 Earthworks Poster Collective, Toni Robertson and Chips Mackinolty, *Hiroshima Day anti-uranium rally*, 6 August 1977

exhibit the posters in a gallery was not without its critics, as the graffiti on the front wall of the Watters Gallery in Sydney (the show's first venue) attested: 'Posters are for the street, not art galleries'.[14] Mackinolty himself acknowledged the contradiction of businessmen buying the posters as investments,[15] although Michael Callaghan subsequently claimed that the postermakers consciously and subversively used the funds raised to continue the work they were doing.[16] The exhibition and sale of these posters through the commercial gallery system does appear as a contradiction of many of Earthworks' original tenets, although the fact does remain that these posters were created first and foremost for the street. Their later co-option by the art system does not negate the role they played in meeting the immediate needs of the community groups and assorted organizations that Earthworks supported, and in conveying alternative political messages to a broad audience.

The critical issue of forging a new role for the artist within society was also central to the activities of another major group involved in the production of political posters in the mid 1970s, the Progressive Art Movement (PAM). This group formed in Adelaide in the wake of a controversy sparked by the Museum of Modern Art touring exhibition *Some Recent American Art* held at the Art Gallery of South Australia in June 1974. Protesters against the exhibition decried the cultural imperialism of the USA, and an ensuing debate over the political and social responsibility of the artist waged by two Flinders University academics, Donald Brook and Brian Medlin, led to the formation of PAM and the Experimental Art Foundation. Medlin, Professor of Philosophy, who had introduced the influential Art and Politics and Women's Studies courses at the university, emerged as the theoretician for PAM.

13 This charging philosophy was outlined in the flyer accompanying the 1977 exhibition, *Walls Sometimes Speak: An Exhibition of Political Posters*.

14 Quoted in R. Butler, *The Streets as Art Galleries—Walls Sometimes Speak: Poster Art In Australia*, National Gallery of Australia, Canberra, 1993, p. 55.

15 Mackinolty in an interview with Roger Butler in c. 1986, quoted in Butler, ibid., p. 55.

16 'The gallery system bought into the poster scene of its own accord, and that from the perspective of the poster makers, the use of this channel of funds was a fundamentally and consciously subversive tactic. We weren't too fussed where we got money from to continue to help fund the work we were doing.' Callaghan, quoted in Kenyon, p. 50.

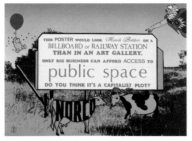

08.05 Toni Robertson, *Definitely*, 1977

17 B. Medlin, 'Cultural imperialism', *CAS Broadsheet*,
 vol. 4, no. 3, September 1974, pp. 10–11.

18 A. Newmark, 'Six Women Artists', *Meanjin*, vol. 38,
 no. 3, September 1979, p. 318.

19 There was a prolonged dispute in the 1970s in South
 Australia's Chrysler car assembly plant. This was one of the
 issues addressed by PAM members in their screenprints.

20 'Through my art work I aim to express the contradictions
 inherent in society. Therefore the content of my work
 is as important as the form. My images are public, not
 private. I want as many people to see them as possible
 so I have chosen to work in multiples, silkscreen print.'
 Mandy Martin, artist's statement, 8 August 1977,
 Artist's file, National Gallery of Victoria.

21 Newmarch.

22 For example, see Newmarch's screenprints that were
 produced as fundraisers: *Will Heidt*, 1976; *Gaol bosses;
 not workers*, 1976; *Nationalize the car industry*, c. 1975;
 Vietnam Madonna, 1975, reproduced in J. Robinson,
 Ann Newmarch: The Personal is Political (exh. cat.), Art
 Gallery of South Australia, pp. 43–44.

23 This quote is taken from Peter Ward's review of Mandy
 Martin's exhibition of ten screenprints at Bonython
 Gallery in 1977, 'Work that Makes an Art Clique
 Uncomfortable', *The Weekend Australian Magazine*,
 17 September 1977.

24 The full quote is as follows: 'In fact, the Adelaide Group's
 output is entirely intended for domestic use. Their
 posters never appear on the street—and it must
 be clear to the reader by now that this is hardly desirable
 in works whose functions is to change opinions. Some
 members of the group acknowledge that the emphasis
 on content of the individual posters, which has been the
 Group's main concern has been unfortunate. They agree
 that more consideration should have been given to the
 perennial danger of merely "preaching to the converted"'.
 J. Ewington, 'Political Postering in Australia', *Imprint*,
 no. 1, 1978, p. 4.

25 Newmarch.

ABORIGINALAND. LAND RIGHTS, NOT MINING

Narau of Yirrkalla, Arnhem Land, demonstrates one of over two hundred distinctive string figure designs she knows.

Poster Six in a series of ten posters designed and printed by the Womens Domestic Needle-work Group, Sydney 1979. Assisted by the Crafts Board, Australia Council

08.06 The Women's Domestic Needlework Group, Marie McMahon, *Aboriginal land rights, not mining*, 1979

Comprising about thirty members, PAM was not a poster collective like Earthworks, but rather a gro[u] artists, musicians, theatre workers and writers who shared a common political philosophy. The concerns galvanized the group were outlined by Medlin:

> Those of us who oppose U.S. imperialism, reject the nihilism, hedonism and elitism underlying [S]
> Recent American Art. We demand a different art. We demand a robust popular art that speaks fro[m]
> to the real concerns of the world's men and women. We reject an art that does not serve the people
> reject pleasure that confirms the 'cultivated' in their elitism and hence in their enmity to the ma[ss]
> human beings—we recognise that the most important pleasure to be derived from art is that of corr[ect]
> understanding the world.[17]

Artists of PAM's visual art group, Robert Boynes, Mandy Martin and Ann Newmarch among others, turned to the screenprint medium because of its democratic qualities, its ability 'to make work available at a low price'.[18] They produced screenprinted posters and political prints that addressed issues ranging from the Australian independence movement, the nationalization of the car industry, workers' struggles, the anti-uranium movement and feminism. Martin's *Big boss* of 1977 (08.07), for example, exemplifies one of these concerns in its juxtaposition of a car assembly-line worker with the American 'big boss' profiting from the Australian automotive industry.[19] Martin said she wanted to highlight 'the contradictions inherent in society',[20] an aim that also underpinned many of Newmarch's prints and posters (08.08). Her print of 1975, *Look rich* (08.09) juxtaposes glamorous media representations of women with the reality of women's oppression, exemplifying her concern with 'showing the contradiction between the image we are "sold", and what we really are'.[21]

Unlike the productions of Earthworks, very few of the posters or prints produced by PAM members were ever intended for pasting up in the street. Some of the group's prints were produced in unlimited editions that were given away, or sold as fundraisers for particular causes.[22] Others, however, were produced in signed and limited editions that the artists exhibited in commercial art galleries. The inherent problems of trying to critique 'society and its conflicts ... within the conventional framework of works of art made for displaying and collecting' was not lost on contemporary audiences and reviewers of these exhibitions.[23] Julie Ewington, in one of the earliest appraisals of the political poster movement in 1978, pointed out the primary contradiction of this approach:

> Some members of the group acknowledge, that more consideration should have been given to the problems of audience and distribution, to the perennial danger of merely 'preaching to the converted'.[24]

08.07 Mandy Martin, *Big boss*, 19

Ann Newmarch tried to circumvent this problem by exhibiting her work in 'shopping malls [and] open air venues, where the work is available to a wide public'. Ultimately, her strong commitment to 'the belief that art should serve the people and be available for all, with no one owner',[25] led her into a variety of community projects, including mural painting and working as a community artist.

By the end of the 1970s both the Earthworks Poster Collective and Progressive Art Movement had folded due to a variety of reasons that included ideological differences, burn-out and illness. Many of the artists involved, however, went on to other activities that continued their commitment to community access. Ann Newmarch in Adelaide moved directly into community art, while former Earthworks members Colin Little, Chips Mackinolty, Michael Callaghan, Toni Robertson, Marie McMahon and Jan Mackay went on to found other printing workshops (poster, fabric and graphics) throughout Australia. These continued the model of the collective-run establishment in service of the community as a viable alternative practice.

Although unable to avoid eventual co-option by the gallery system, the political poster of the 1970s did successfully establish a model for an art practice that was non-elitist, that was engaged with social and political issues of everyday life and that intersected with the needs and activities of the community. In so doing, it not only established a new role for the artist, but also ensured a broader audience for the works that were produced. ¤

08.09 Ann Newmarch, *Look rich*, 1

08.10 Robert Boynes, *Laid out*, 1978

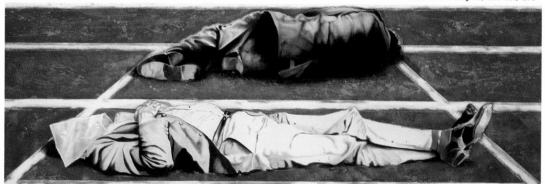

and the alternate architecture of the artistic body

Stelarc and Charles Green

Body-based performance and installation art can be seen as the final stage of a general, agoraphobic disillusion with the horizons of conceptual art, which rapidly became a mainstream rather than a marginal artistic activity.

Stelarc was one of the first Australian artists to work exclusively with performance, electronics, installation and, later, with digital and Web-based media. The significance of his work has been global: he has been one of the forces driving the invention of new technologies in art, and he is now internationally recognized as one of the key precursors in electronic, body and performance art. The materialization of such work in the permanent collections of art museums, however, presents special problems, both intentional and dysfunctional in nature. First, performance art flourished in a period of active reaction against incorporation into museum structures, hierarchies and logic during the late 1960s and 1970s. Second, since performances are ephemeral, they survive in photographs, videos and written descriptions; they linger in a museum's archives as props or documents—in effect, as memory traces. The reproducibility of video and photography, the deterioration and increasing illegibility of images in reproduction and replay, the inevitably severe editing of a time-based medium in text and images, and the false memory of artists and critics, all appeared at the time to be accidental, dysfunctional by-products of an originary action.

Frequently, the intersection of documentation and event even allowed an amplification of experience more significant than the performance itself. Stelarc, though, always took both effect and affect as given, incorporating them into his works. He often worked collaboratively with technicians and engineers, and also created cooperative international links with artist networks in Europe, Japan and the United States. He sometimes moved beyond the horizons of art institutions altogether, working in scientific laboratories. He has wandered backwards and forwards across the borders of art, music, theatre and science, transmuting the conceptualist idea of dialogue into an aggressively psychological body art, in a violent version of dematerialisation. Mike Parr, another Australian performance art pioneer, observed:

> I think one can go further. You continually bring language up against the object until the conflict operates in a self-referring way, so that not just one word but language itself operates as effectively in a total situation. Like my wall piece [a wall covered with the word 'wall']. Language is being torn apart, right down the centre. Language is no longer a label, but is fighting it out with its literal location—this is the new sort of abstraction you asked about.[1]

How were artists to sustain this critical praxis within the institutions and exhibiting spaces of art? Could the figure of the artist himself or herself be stretched, expanded and redefined? Stelarc's insight was to attempt this redefinition quite literally. He used his own body.

1 M. Parr, in *The Situation Now: Object or Post-Object Art?* (exh. cat.), eds T. Smith & T. McGillick, CAS, Sydney, 1971, p. 17.

09.01 Stelarc, *Untitled*, 1979

09.02 Stelarc, *Untitled*, c. 1974

CG: Did you see *The Field* in 1968? What art publications and magazines were your sources of information at the start of your career?

S Yes, I did see *The Field* and it was influential then, although I have no specific memories of it now. At the time though, I was impressed by the tough performances of the Viennese Actionists. During the 1960s the Australian artist who intrigued me most was Stan Ostoja-Kotkowski, from Adelaide, whose multimedia presentations with lasers and electronic media were intense and memorable. I guess the only magazines I consistently read were *Flash Art* and *Artforum*. *Flash Art* later ran a feature on my early suspensions in an article titled 'Danger in art'. Because my performances have always been about how bodies and machines move, there was interest amongst the dance community with this approach of improvised, alternate and automated choreography. So, I've sometimes been invited to do presentations and performances for experimental dance festivals. Similarly, the amplified body performances (using body signals to produce sound) attracted interest in the new music area. I've performed at New Music America in Houston, and the Stockholm Electronic Music Festival, amongst others. More surprisingly, since I see the body more as a structure with empty spaces, my performances have appeared in publications on architecture.

CG You made some of the earliest performances and multimedia environments in Australia at the end of the 1960s.

S These early works were more like multimedia presentations, rather than performances. I choreographed and participated in actions at the Hamilton Art Gallery and the Open Stage in Melbourne, using three-screen projection and electronic music. More importantly, given my future direction, I was constructing helmets that split the body's binocular vision with seven different optical structures. They were collectively titled *Helmets Put on and walk*. I guess that was about 1968. Visitors placed the helmets over their heads and walked around the performance space. Each eye saw a different set of fragmented images. The brain tried to put the two together, but instead of one three-dimensional image, two sets of superimposed images drifted across each other as the participant moved. I also made *Sense compartment*, 1968, a three-metre diameter, three-metre high, hexagonal dome environment. You sat inside, completely immersed in kinetic images, electronic soundscapes and flickering lighting. The dome rotated, reflecting both the striped images at its base and also fragmentary glimpses of the participant inside. The helmets and the sense compartment were very much an emphasis on constructing objects and environments for direct and immediate aesthetic experiences. I oscillated between exploring the physical parameters of the body and constructing prosthetic attachments to extend the body. Between 1973 and 1975 I completed a series of film-probes into my stomach, lungs and colon (videotaping approximately three metres of internal space). The *Third hand* project began in 1975, a year before my first suspension event.

CG Why did you leave Australia for Japan in 1970? What happened when you got there?

S I have a Greek background and I'd grown up in Australia. My art education was essentially European and American, and I mostly read western philosophy. I yearned to experience an oriental culture. Remember, this was the late 1960s, and I had grown up reading about Zen meditation and yoga, reading Cage and Ginsberg. And I did know about the Gutai Group and Butoh dance. I decided to go to Japan partly because of its high-tech reputation, and Expo '70 was on in Osaka. The Japanese Steel Pavilion had an interesting laser installation (I think by Mario Shinoda). The electronic composer Stockhausen took over the West German pavilion for the duration of the Expo. When I first arrived in Japan I taught English. Fortunately, I was able to get a job teaching art soon after. I was naïve thinking I could live off my artwork, and I certainly didn't intend to stay there for almost twenty years. I guess it's fair to say that there wasn't much awareness of Australian art in Japan at all in the early 1970s. But that soon changed—at least in the Japanese art community—when exchange shows were organized with the assistance of Ken Scarlett and Emiko Namikawa. Soon after that, Melbourne artists like John Davis and Tony Figallo held Tokyo exhibitions, as did Diane Mantzaris. Emiko's gallery and Nobuo Yamagishi's Maki and Tamura Galleries hosted Australian exhibitions. The Australia Council's Tokyo studio accelerated this impact, enabling Australian artists to do residencies there. Peter Callas had considerable influence in that development, and an Australian journalist, Rod O'Brien, wrote art columns in the English-language newspapers (the *Asahi Evening News*, for example), where he previewed and promoted artists like John Davis.

CG Your 1972 performance at Pinacotheca in Melbourne?

S I remember very little about how that performance and installation came about. The Pinacotheca gallery was awkward because it was long, with partitions dividing the space into three equal areas. The audience was able, though, to walk freely around the space. I decided to suspend rocks in the first section of the space. The body was suspended from scaffolding in the centre space. We dug up a tree (with roots intact) and propped it up above the floor in the last space. To unify these elements we directed a laser beam beneath the rocks, the body and the tree, from one end of the space to the other through holes in the partitions, constructing a kind of horizon line. The body was held up in a harness with amplified body sounds. Strobe light bursts visually disoriented the view of the suspended body. The strobe light also affected the amplified body sounds, altering brain activity, for example. The amplified sounds also reflected the physical condition of the body over the duration of the performance. I think it lasted for about an hour, whilst the audience circulated between the three installations. Incidentally, we replanted the tree outside Pinacotheca after the performance.

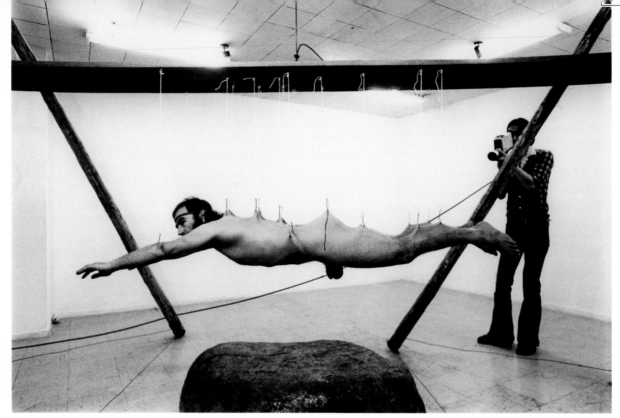

Your 1975 Ewing Gallery performance?

This performance lasted for ten days. The body sat on a steel plate, with an identical steel plate suspended just above it. We replayed the video probe into my stomach on the two suspended monitors, exposing the body's inner spaces and structures. The gallery lights were on continuously, twenty-four hours a day. I experienced people as an ebb and flow of activity as they entered and explored the space, but I have no idea how many attended. I do know that it generated a wide spectrum of audience response, from bemusement to bewilderment. It was also a very contemplative experience for some people. The body was a kind of living sculpture plugged into a steel plate and electonic structure. Although I did not speak for the duration of the performance, I was able to switch my body sounds on and off. The body was no longer the container of its body functions. The body was now the cuboid space of the gallery. In one corner, we placed an ECG [electrocardiogram] machine spewing out a continuous roll of paper, monitoring my heart activity.

The suspensions?

My first suspension event (with hooks inserted into the skin) was attempted at the Experimental Art Foundation (EAF) in Adelaide. Unfortunately, the media found out what was about to happen. All the sensational, negative hype put a lot of pressure on directors Noel Sheridan and Donald Brook to cancel the performance, which they did only thirty minutes before the piece was due to start. They went further though than withdrawing their support. The EAF staff dismantled my suspension installation altogether. (Ironically, about four years later the Art Gallery of South Australia held a retrospective of my subsequent suspensions.) I was traumatized, for the media belittled the attempted suspension as a stunt. Remember, this was the period of Ivan Durrant's severed-hand hoax in Melbourne.

The first Australian suspension that I was able to actually realise was in Melbourne, in 1980, in an abandoned lift well at artist Steve Turpie's Hardware Street studio. Tom McCullough, who was then directing Pitspace, the college gallery at Preston Institute of Technology, made this work, *Up/down: Event for shaft suspension*, 1980, possible. The body was lifted up and lowered down the fifty-seven-foot-deep shaft. A very small, invited audience of students and artists attended because there was general concern that the artists in the building might lose their studios if news of the event hit the media. Ingo Kleinert then invited me to participate in *Act 3*, a large performance event in Canberra. I made *Prepared tree suspension: Event for obsolete body, no. 6*, 1981. It took us several days to find the right tree on a property in the foothills of Black Mountain. We dug around the tree's roots, and the body was supended with cables strung over forks in the tree's branches, and then tied to the individual roots of the tree. It made the suspension more dynamic and circular, and the tree less stable with roots exposed.

I began with the hooks inserted while the body was on the concrete floor, surrounded by about 400 people. When everything was ready, and with control-box in hand, the body hoisted itself up and moved through the audience, navigating around the warehouse space.

The later suspensions?

One of the last suspensions, *Remote controlled suspension*, 1987, was made in Brisbane for MOCA in 1987. Ken Scarlett, I think, introduced me to Jim Baker, who invited me to create a performance. His gallery was not a suitable venue, but by coincidence, an adjacent warehouse had recently become empty—a great space with a gantry crane. The body was vertically suspended from a steel hoop connected to the overhead crane. I was able to choreograph the movements of the suspended body across the space. So, it was not only an up-and-down job. I began with the hooks inserted while the body was on the concrete floor, surrounded by about 400 people. When everything was ready, and

with control-box in hand, the body hoisted itself up and moved through the audience, navigating around the warehouse space. I had been concerned about whether I could pull this performance off successfully because the previous time I had been suspended vertically—for the *Japanese lateral suspension*—I passed out after only a minute. Fortunately, the Brisbane performance lasted for about twenty minutes, which was enough time for me to traverse the space, stopping and starting suddenly in order to get the body swinging. One of the Brisbane tabloids titled its report on my performance as 'A Pain in the Arts'.

In fact, 'pain' was not the subject of the action. It never has been. The piece just happened to be physically difficult, but it wasn't about inflicting pain on myself. But this is the difference between painting and performance: you have to accept the physical consequences of your ideas.

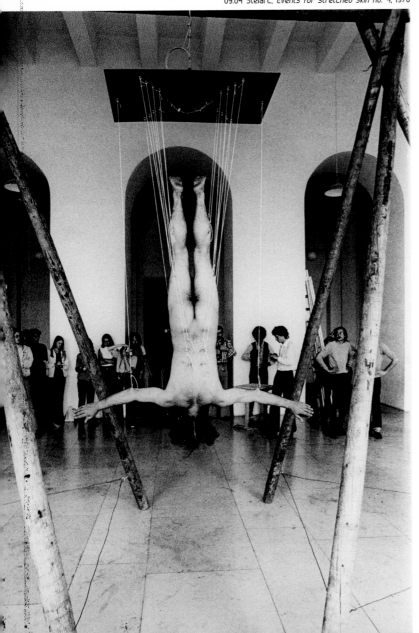

09.04 Stelarc, *Events for stretched skin no. 4*, 1976

I made *Seaside suspension: Event for wind and waves*, 1981, at Jogashima in Japan. The body was inserted into a primal landscape—as it had been in *Prepared tree suspension* at the foothills of Black Mountain in Canberra —amplifying its obsolescence. The body was suspended side-on, looking out to sea from a wooden structure on an outcrop of rocks, alone and isolated for about twenty minutes. It was windy, so I was swaying and the wooden structure supporting me was creaking. The waves broke on the rocks below, splashing the body. Aside from the ten assistants, the only audience was a group of fishermen on another outcrop of rocks nearby. They were fishing before we arrived, during the performance, and they were still fishing after we left. Some boats also went by, but I can't say that they were close enough for anyone to know what we were doing. We almost cancelled the event because it became so stormy that the weather was very threatening, with a blustery wind and large waves. But because we couldn't wait another day, we did the hooks on shore, then I waded out with the hooks inserted, ready to be strung up from the support structure. It was not an easy procedure.

Street suspension, 1984, followed a swinging suspension in Los Angeles two weeks earlier. At the LA event, the body was suspended horizontally, face-up. In New York, it was suspended face-down, arms and legs raised and lowered, so the body wouldn't look too static. We didn't even try to get police permission and went ahead anyway. I think the event was mentioned in the *Village Voice*, but most of the crowd were innocent bystanders or neighbours looking out of their apartments. About 400 people gathered in the street below. We made the insertions in private, in a fourth-floor apartment room, and when we finished, I was connected to a pulley structure, allowing the body to roll out of the window along a cable stretched between the two buildings. It stopped about midway over East Eleventh Street. After about five minutes police cars arrived from all directions, and the police stopped the suspension after only twelve minutes. This was supposed to be a thirty-minute event. I could hear the traffic and people below on the street, and there was some yelling. Apparently, drug dealers on the corner threw steel nuts and bolts at me as they were unhappy with the disruption of their drug dealing. In the confusion when the police pulled me in, a cable still connected to my body dropped to the street below and got tangled in a moving van. I was fortunate that Dragan Ilic, an Australian artist who lives in New York, was able to stop the vehicle. A few days later I had to appear in court charged with being a danger to the public (had I fallen on someone and caused injury!). I ended the suspensions in 1988. The last one was titled *Stretched skin/third hand*, which occurred at an abandoned monorail station. My third hand was attached, activated by muscle signals. The contro-box in its left hand allowed the body to control its up-and-down motion. The body was suspended face-down, spinning on its axis, and sound amplification provided the stretched skin with its acoustical aura. Again, there was no invited audience, but a small group of friends came to help out. People passing in the nearby trains or on the street were my only audience.

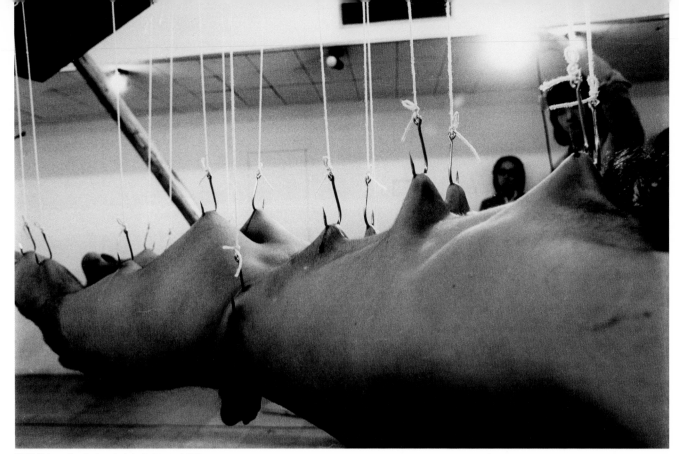

09.05 Stelarc, *Events for stretched skin no. 1*, 1976

CG What was the motivation for stretching your skin?

S The suspensions were made so that I could consider the body as an evolutionary object available for operation and awareness in the world. There was also a more physiological concern: I wanted to show how the engineering and architecture of the body not only fashions its form, but also its functions. I wasn't interested in the body as a site for the psyche or as an object of desire, but as an object of design. There are no personal narratives, nor any narratives about the psychoanalytic construction of the subject. During my twenty-five suspensions, the body was suspended in different positions, across different spaces and in many situations. I had a structural interest in constructed, site-specific spaces. The body was a sculptural medium inserted in space, positioned in relation to other objects and elements. Between 1972 and 1975 I completed a series of body suspensions with harnesses and ropes; the body was more supported than suspended. So when I became aware that Hindu *sadhus* (holy men) pierced their bodies, I decided that suspending my body by hooks inserted into the skin would be the most minimal, powerful way to support the body, for stretched skin then becomes part of the body's gravitational landscape. The skin is the visual manifestation of the body suspended in a 1-G gravitational field. We can't completely separate the technical from the artistic. Therefore, when I speculate about redesigning the body, it's not about social engineering or a utopian, perfect body, but rather about alternate architectures. And since it's our physiology, augmented by our imaging instruments and on-board computers, that largely determine our philosophies, then altering our body architectures will also adjust our orientation in the world. ¤

I wanted to show how the engineering and architecture of the body not only fashions its form, but also its functions. I wasn't interested in the body as a site for the psyche or as an object of desire, but as an object of design.

09.06 John Davis, *Greene Street piece*, 1973-75

tim leura and clifford possum tjapaltjarri

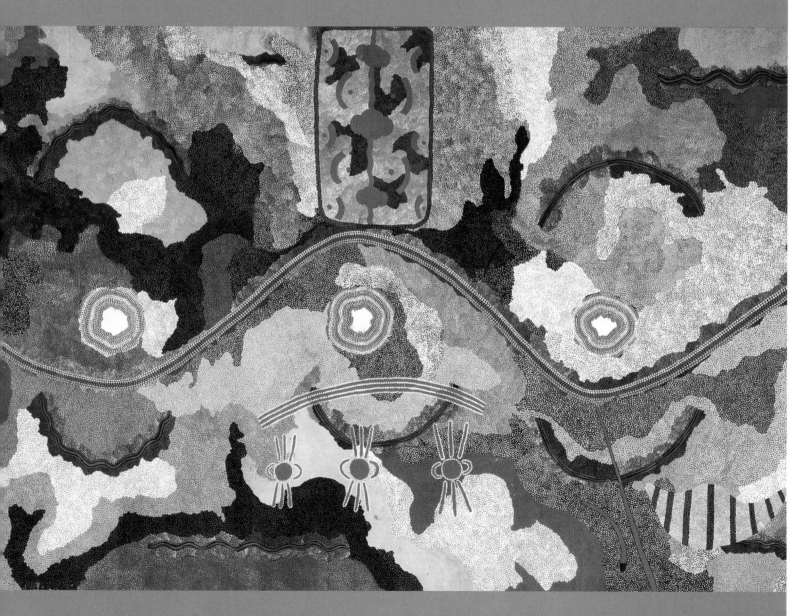

Bernice Murphy

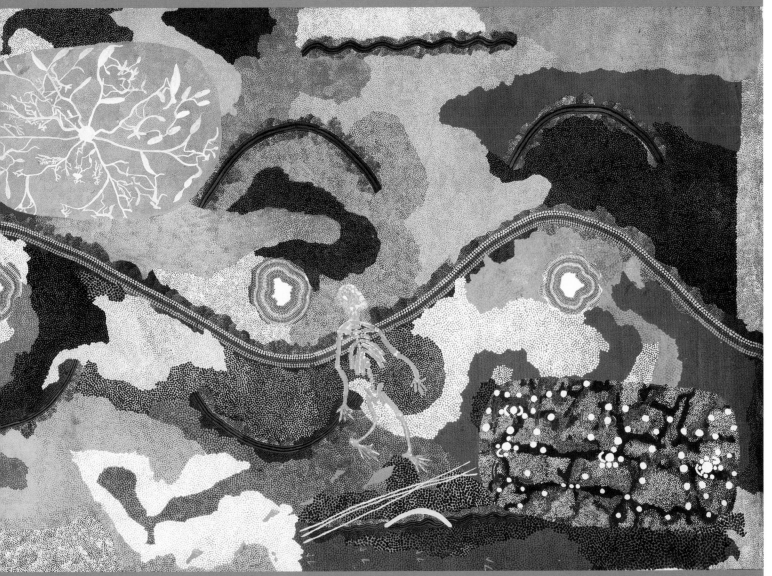

10.01 Tim Leura Tjapaltjarri (Anmatyerre) and Clifford Possum Tjapaltjarri (Anmatyerre), *Napperby death spirit Dreaming*, 1980

10.02 Tim Leura Tjapaltjarri (Anmatyerre)
Sun, moon and morning star Dreaming, 1973

When Tim Leura Tjapaltjarri—assisted by his brother, Clifford Possum Tjapaltjarri[1]—created his monumental painting, *Napperby death spirit Dreaming*, 1980, the Western Desert 'Papunya Movement' was barely a decade old (10.01). The painting describes the land surrounding Napperby station, north-west of Alice Springs in the Northern Territory where both artists were born.

Napperby death spirit Dreaming sets out a huge landscape with precision and intimate knowledge. However, it synthesizes different kinds of knowledge in a formalized representation that reaches beyond any visual experience available at a single place or moment. The painting employs graphic systems that are both conceptual and mnemonic. The mnemonic aspects of representation are animated by the accompanying song cycles. These contribute narrative structures and interpretative meaning to the delineation of clan country. The land is understood as socially and spiritually embodied by creator beings who primordially formed its character, and are commemorated in the ceremonial life of Aboriginal people. The land is intelligible in all its parts through connection to the footfall, speech, physical activities, kinship and spatial memory of all those who have inherited the country in a continuous, unbroken lineage.

Such paintings are therefore never silent or inert. They are alive with story and song. They affirm a social and law-giving framework that is not hierarchical or selective. It is comprehensively inclusive. The visual language employed to carry such a complex network of associations is highly encoded.

Napperby death spirit Dreaming ... is both affirmatively traditional and audaciously innovative. It is anchored in traditional Aboriginal cultural life in its use of an inherited repertoire of graphic signs and mapping devices derived from body painting, decorated objects and large ground-sculptures created in ceremonial life.

Tim Leura and Clifford Possum Tjapaltjarri were among the last artists to join the early group of painters that gathered around art teacher Geoffrey Bardon at the Papunya settlement late in 1971.[2] The background to their life and work is detailed in Vivien Johnson's invaluable monograph, *The Art of Clifford Possum Tjapaltjarri*.[3] Significant in this study is Clifford Possum's youthful encounter with Albert Namatjira in the 1950s, and his conscious decision to resist an overture to join the painting circle of the famous watercolourist and senior artist from Hermannsburg. Instead, Clifford Possum resolved to develop his own art out of the more traditional language of Aboriginal desert culture's religious life. He would work with its own vocabulary of markings and designs. Nevertheless, Namatjira offered a striking precedent: the model of a celebrated tribal man who had become famous within the wider European world as a so-called 'artist', who earned recognition and financial reward through paintings of his country.[4]

Napperby death spirit Dreaming was first exhibited publicly in Australian Perspecta, 1981, the inaugural biennial exhibition of the Perspecta series,[5] which arose in Sydney at the Art Gallery of New South Wales in response to the scarcity of contemporary Australian exhibitions in major institutions during the 1970s.[6] The work was borrowed in 1981 from Geoffrey Bardon, its commissioner and first owner.[7]

Napperby death spirit Dreaming, which appeared in the Perspecta exhibition alongside the smaller, but equally complex, *Warlugulong*, 1976, by Clifford Possum (assisted by Tim Leura), is both affirmatively traditional and audaciously innovative. It is anchored in traditional Aboriginal cultural life in its use of an inherited repertoire of graphic signs and mapping devices derived from body painting, decorated objects and large ground-sculptures created in ceremonial life. It is also traditional in the knowledge and belief systems it projects, but this work is, most significantly, directed to an audience outside its own community.

In comparison with other Papunya painters in the early years, the Tjapaltjarri brothers adopted an important innovation in their work, especially after a change in materials that occurred in 1973, when canvas was introduced to the painters. Canvas, made from cotton or linen, cut in varying sizes, permitted a more expansive and flexible format of designs than was possible on the early, confined supports of cardboard, hardboard or scrap materials used in 1971–72. The new opportunity for intensified representation in the hands of the Tjapaltjarri

1 The sudden passing away of Clifford Possum on 21 June 2002 during the finalization of this text brought a sharpened memorial sadness to this reflection on the contribution of these two remarkable Tjapaltjarri men to both their own culture and people's history, and to Australian art.

2 See G. Bardon, *Papunya Tula: Art of the Western Desert*, Melbourne, 1991.

3 V. Johnson, *The Art of Clifford Possum Tjapltjarri*, Sydney, 1994.

4 ibid., p. 47.

5 The Art Gallery of New South Wales began a series of biennial surveys of Australian art—Australian Perspecta—in 1981 as a means of placing a recurrent focus on Australian contemporary art within Sydney's state gallery in alternating years to the Biennale of Sydney, which has an international focus.

6 It was inevitable that Aboriginal art would become included within contemporary art manifestations in the 1980s, as various people became interested in exploring such connections more actively throughout the 1970s.

7 The painting was later bought by Margaret Carnegie, from whom it was finally purchased by the National Gallery of Victoria through the Felton Bequest in August 1988, to mark the Australian Bicentennary. It was the first work by an Aboriginal artist to be acquired through the Felton Bequest.

10.03 Tim Leura Tjapaltjarri (Anmatyerre), *Yam spirit Dreaming*, 1972

brothers gradually enabled a profound expansion of content, and a shift in the complexity of representation possible within a single work. This is amply demonstrated in *Napperby death spirit Dreaming*, Tim Leura's largest painting, and still imposing by any standards today.

Dick Kimber, an art adviser at Papunya in the later part of the 1970s, commented on a significant aspect of the Clifford Possum-controlled *Warlugulong* painting in a text he contributed to the 1981 Perspecta catalogue.[8] Kimber emphasized that 'no other painting in the [then] six-year history of this adapted art had illustrated such a complex array of "dreaming trails"'.[9] This potent observation was later explored fully by Vivien Johnson in her study of the artist in 1994. However, the point applies equally to Tim Leura, and there was a close interaction between the tribally fraternal Anmatyerre men born in the same country, as evident in their collaboration on certain key works of the first decade of painting at Papunya.

> During the '70s only the artist's brother Tim Leura Tjapaltjarri shared with Clifford Possum the idea of combining many Dreaming sites and stories in their geographical relationship to each other on the one canvas…Tim Leura used to employ the term 'topographical' to describe this kind of painting, which is exactly the right word. Like western topographical maps, these paintings are large-scale maps of land areas, based on ground surveys, with great attention to accuracy in terms of the positional relationships…They can be used for site location, and…are Western Desert graphic equivalents of European deeds of title.[10]

A variety of Dreamings, a multiplicity of subjects and narratives, and a vastly expanded referential content could now be mobilized within a single, large work. A more elaborate kind of 'mapping' employing a complex series of topographical overlays was inaugurated. Disparate sites could be linked and edited conceptually within paintings that now reached beyond the strict compositional formats of the ground-sculptures and body markings on which they were based (which formerly would have been restricted to requirements of actual ceremonies performed at specific sites).

8 Clifford Possum's *Warlugulong* was purchased for the Art Gallery of New South Wales in 1981, after its exhibition in the Australian Perspecta of that year.

9 See E. G. Kimber, 'Warlugulong', in *Australian Perspecta* 1981 (exh. cat.), (ed.) B. Murphy, Sydney, May 1981, p. 136.

10 Johnson, p. 24.

While the works emerging from Papunya continued to be animated by political and social purpose—affir▮
the traditional cultural life that supplied their content—the images increasingly showed a movement int▮
new realm of painting. They became engaged by an activity that opened up novel, expressive resources in a
medium. They explored subtleties of pictorial construction and optical resonance before a broader audi▮
that would not have been possible in the sanctioned (and often secret and/or sacred) conditions of cerem▮
life from which they originated.

Napperby death spirit Dreaming amply demonstrates the symphonic complexity opened up in the r▮
composite type of representation introduced by the Tjapaltjarri brothers. Tim Leura's imagination is ev▮
in the build-up of subsidiary narratives and formal effects that elaborate upon (and change) the fou▮
tional symmetry of the main journey lines. Across the connecting plane of country that establishes▮
literal and metaphoric ground of the painting, a great variety of geographic features, narrative episodes▮
superimposed Dreamings are interwoven. The expansive Possum Dreaming tracks (painted carefully ir▮
trails by Clifford Possum) provide an inaugural symmetry and arterial movement along the huge, se▮
metre axis of the painting.

Some themes occur as insert Dreamings, spliced into the infinitely expanding space around them. V▮
pictorial elements—altering focus, detail and scale—amplify the painting's energy and drama. The ▮
orchestrates spiritual journeys in prehistoric time within a cumulative structure and social interpretation▮
opens out like a flood plain upon the present.

Above the Possum Dreaming lines (tracing the journey of Upambura, the old Possum man of Napperb▮
inserted the subtly tonal Old Man's Dreaming.[11] Further to the right is the intensely lyrical Yam Drean▮
loosely brushed, with its radial design organically connecting plant life and human beings. The l▮
design (invariably in yellow monochrome) forms ▮
This painting has the formal grandeur and richness, interweaving tragic | autonomous subject of small, early panels by Tim L▮
human presence within an inexorably larger set of forces, through which we | (10.03). Below the Possum Dreaming, again as an inse▮
can recognize a work of epic imagination. | the Sun and Moon Dreaming, with stars dotting the r▮
sky and the acrylic hues constrained to greyscale ton▮
There are also superimposed dots and washes, incorporating black and white, and varying greys, that con▮
this Dreaming to the warmth of the rest of the canvas.

The formal diversity of the composition is enriched by repeated, curved windbreaks indicating sa▮
corroborrees, and the undulating Water Dreamings recurring near the longitudinal edges of the canvas▮
concentric roundels, marking ancient resting places (perhaps painted by Clifford Possum), are regularly pl▮
either side of the bold curves of the main Possum Dreaming. The roundels accentuate the axis and sweep o▮
whole design. Camp sites, sacred weapons and other iconic elements are linked through a complex applic▮
of washes and dotted detailing of the land (including vegetation types), area by area, feature by feature. ▮
use of delicate washes demonstrates the fuming build-up of atmospheric effects strongly characteristic of ▮
Leura's poetic style of painting.

Non-Aboriginal audiences are often misled by folkloricized commentary and see Papunya works as static▮
'outside time'. On the contrary, *Napperby death spirit Dreaming* is, in a sense, a historical painting. Util▮
new materials and the opportunity of a grand commission,[12] the work responds to conditions of trauma▮
dislocation by asserting a representation of wholeness and integrity. It is tensioned by the stress of an e▮
people's evacuation from their country and divorce from their own history. This painting has the formal gran▮
and richness, interweaving tragic human presence within an inexorably larger set of forces, through whic▮
can recognize a work of epic imagination.[13]

Within a few years of the completion of this grand work, Tim Leura was so deeply disillusioned and sca▮
by the social dislocation of Aboriginal culture in his lifetime that his own creativity collapsed. His life e▮
miserably in 1984—a tragic loss to Australian art. The artist's growing despair, evoked in the Death Spirit fi▮
that stalks the great Possum Dreaming tracks crossing the Napperby land, indicates the depth of dismay be▮
this work. The delicately superimposed skeleton appears to float and become detached from the vast swe▮
the ancestral land itself.[14]

11 The painting is interpreted here as encountered in a
 vertical plane, on the walls of a gallery or museum;
 but it should be noted that such works originate on the
 ground (not on a wall), and often incorporate complex
 orientations of viewpoint spatially and geographically.
12 *Napperby death spirit Dreaming* arose as a
 commission—originally to Clifford Possum—by Geoffrey
 Bardon on a canvas provided in 1980. It was intended to
 be used in a film Bardon was planning to make.
 (See Johnson, p. 163.)
13 Not surprisingly, the painting formed the centrepiece in
 the installation of the celebrated Dreamings exhibition
 at the Asia Society Galleries, New York, in Australia's
 bicentennial year of 1988. See *Dreamings: The Art of
 Aboriginal Australia* (exh.cat.), ed. P. Sutton, Braziller &
 the Asia Society Galleries, New York, 1988; Australia, 1988.
14 Clifford Possum Tjapaltjarri often included similar
 skeleton figures, rising perspectively from the main
 ground of the painting or dissolving into a dot screen
 within it.

The presence of the lyrically dark Sun and Moon Dreaming as a concluding episode in this work, when read laterally, provides a final shift of consciousness: the painting 'concludes' with a turn towards the sky, towards the movement of the planets and diurnal rhythm of night and day, the wax and wane of life. The cycle of existence is completed with the Death Spirit hovering as a leitmotif near the last scene of this encyclopaedic representation of the created world. Inescapably, the skeletal figure is personally suggestive (according to Geoffrey Bardon) of the artist's own welling mortality. The whole work is both an affirmation and an encompassing lament. It mourns the fracturing of an entire people's cultural history, the loss of authority, self-determination and continuity.

In retrospect, the Papunya movement threw a radically new kind of painting up onto the screen of consciousness in Australian cultural expression. Within a few years it had produced a startlingly alternative configuration of human experience in this huge country, bringing a texture and resonance to artistic expression that was devoid of internal alienation or conflict about its own cultural heritage.

Countering the explorer vision of a stark and hostile land, to be conquered only by implacable will, sinew and dominance of nature's vagaries, there appeared an art of subtle knowledge, quietness and intimacy with the desert environment. This was an art that burst forth in myriads of images of affinity. The paintings expressed diversity and plenitude rather than sameness and aridity. It was an art of vivid description, communal narrative and proximity rather than remoteness. It expressed a front-of-mind relationship with country, and cherished homelands alive with history rather than vacant land, way 'out back'.

10.04 Clifford Possum Tjapaltjarri (Anmatyerre), *Old man's love story*, 1973

Uplifted by cultural desire, reinforced by the authorizing narratives of their song cycles, the Papunya painters burst forth consciousness, creating pictures of searing delicacy and beauty.

In contrast, the visual language of artists emerging through Papunya was persuasively shaped by its cultural background, yet abundant in its visual possibilities.[15] Papunya painting arose in conditions that were implacably urgent. Anchored in the local, in a vast area of land that had been imagined as empty and devoid of social locality, Papunya painting ignored the free-floating space of international art and staked its own claim to an alternative vision of Australia's history and cultural potential. Amidst despair this efflorescence of creativity defied all descriptions that the centre was empty or dead. Papunya painting was powerfully 'other' to western art. At the same time it had almost miraculously seized the materials of western abstraction and taken them in an unanticipated direction.

It is one of the most remarkable episodes in Australian cultural history that the Aboriginal painters gathered at the Papunya settlement in the 1970s—coping with sordid conditions, social bewilderment, disempowerment and disease—could concentrate so intensely with new media in their hands (as well as suddenly awakened opportunity), and accomplish such a potent transformation of cultural language in a new, portable form.

It will always seem astonishing that in such circumstances, these painters found means to reassert their cultural integrity and authority so eloquently. Uplifted by cultural desire, reinforced by the authorizing narratives of their song cycles, the Papunya painters burst forth into wider consciousness, creating pictures of searing delicacy and beauty. As the wider public gradually took stock of these changes, and their influence spread to other desert Aboriginal communities, it became clear that the history of Australian painting was changed forever. ¤

15 A number of non-Aboriginal interprete
at first questioned the authenticity of
works—invariably through a lack of a
with traditional Aboriginal communiti

The Field was not conceived for farming, it ignored the land, yet one artist—Tony Coleing—did infiltrate landscape sculptures into that exhibition. To signify international modernity and the end of the British and Australian cultural cringe towards France, the show presented our 1960s shift to American style, a blossoming of cheery abstract art grown from the formalist theories of Clement Greenberg.

Very little acclimatization had occurred. However, a few Australians, shortly after their works appeared in *The Field*, found a way of giving the style either a peculiar local visuality—for example, the extreme ocean-view horizontal of David Aspden's *Little Bay painting*, 1969—or else an expression of peculiarly local body-experience—for example, Ron Robertson-Swann's hot, salty painting *Sydney summer*, 1968, a human-height canvas that expressed the thrust of a swimmer into Bondi surf. Unlike indoor, gym-haunted New Yorkers, our Greenbergians had a feeling for wide-open space and for the beach, and thereby moved the style away from interior-designer decoration towards outdoor physical glow.

A different sort of acclimatization is present in Robert Rooney's *Kind-hearted kitchen-garden IV*, 1968, the only painting in *The Field* with a title to raise hope of the natural world, though it was a tease. The headings that spanned a double-page spread in a dictionary became the chanced upon name for a series based on the aesthetically 'serial' look of a display in a Melbourne hardware store. Though not intended, it might also embody affection for a father's home improvements, a new kitchen. Dale Hickey's *Untitled*, 1967, was another seemingly abstract serial painting that in fact drew upon the look of local building-trade materials. The exploitation of New York high style in these crisp nods towards Melbourne low style still holds a cheeky freshness; they are not period pieces.

Greenberg himself was brought to Australia in 1968, the year of *The Field*, by the newly established Power Institute of Fine Arts at the University of Sydney. Inviting questions after a public lecture, he copped an outraged cry from a student (Brian Thomson, now a leading theatre designer): 'How can we talk about this stuff [flatness, opticality], when Andy might be dying!' The Warhol gun-down by Valerie Solanis of SCUM (Society for Cutting Up Men) gave late-modernist aesthetics a glimpse of the postmodernist future. Feminist, populist, politically engaged, an-aesthetic and culturally relativist subject matter would dominate late-twentieth-century art theory; not formalesque art structures but power structures.

Anthropocentric views of the world have received some postmodern interrogation, though less eagerly conducted than scrutiny of our own human cultures. Misplaced exercise of human power over nature can nevertheless end in unexpected, devastating mishaps, reminders that the differing natural resources on each continent had once created their differing prehistoric cultures. Perhaps nature still has the last word over culture. Especially on our strange Australian continent, it's time for ecocentric attitudes.

In April 2002 an Australian Bureau of Statistics report, *Measuring Australia's Progress*, provoked *Sydney Morning Herald* economics editor Ross Gittins to conclude his discussion of it:

> We're wealthier, healthier, better housed and better educated, but it's coming at the expense of the environment...The line from politicians and economists for strong economic growth so that we can spend more on fixing the environment is illogical. It's really saying 'I'm stuffing up the environment only so I can afford to fix it'...Our present mode of economic operation is unsustainable. We're keeping warm by burning the floorboards.[1]

A year before *The Field* two events had signalled the pressing concerns for Australia today. The federal referendum that overwhelmingly approved full citizenship for Aboriginal Australians is well remembered. But there was also our greatest eco-shock, the February 1967 bushfires that penetrated the city of Hobart and—hitherto unthinkable—caused sixty-two deaths.

We now take a hard look at how to live with the world's most fire-loving vegetation, the world's poorest soils and most erratic climate. We have begun to realize that since Australia is a land in which humans could never have evolved, our presence here might be unusually destructive. Hardly a week goes by now without serious

1 R. Gittins, 'We Fiddle While our Home Burns', *Sydney Morning Herald*, 24 April 2002.

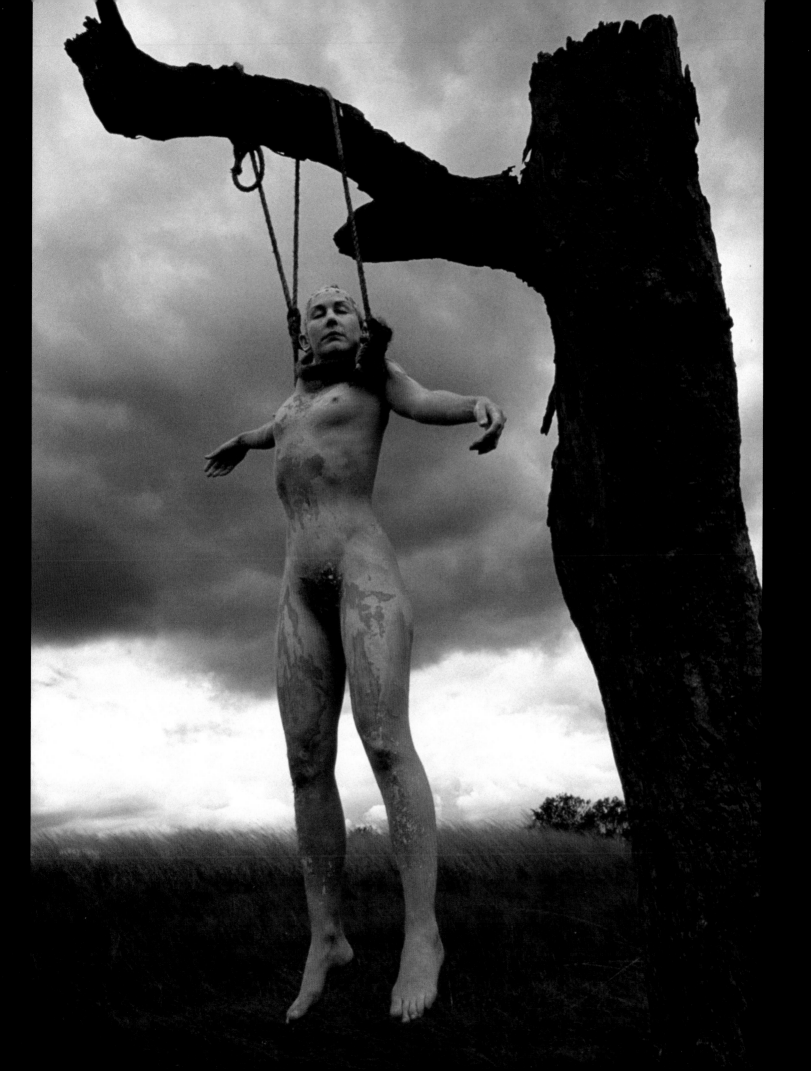

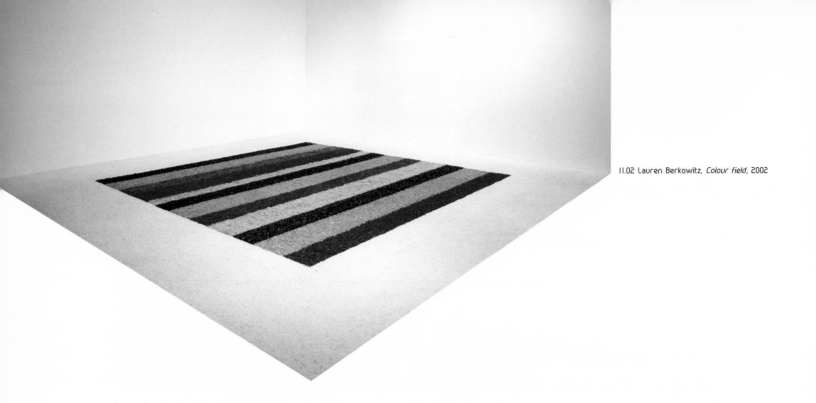

11.02 Lauren Berkowitz, *Colour field*, 2002

media discussion of salt build-up in soils, plant and animal extinctions, plant and animal exotics turned feral, loss of biodiversity (ninety per cent of the world's plant species are endemic to Australia, and scarcely studied), pollution, wastefulness and the death of forests. Many younger artists explore the issues.

This great shift in our self-knowledge was crystallized in 1994 by Tim Flannery's book *The Future Eaters*. Although he has now gone quiet on the estimate, Flannery then told interviewers that six million might be a safe population for Australia to sustain; about one-third of the present figure. Jared Diamond's *Guns, Germs and Steel*, 1997, subsequently placed our prehistoric cultural formations in a world context. Flannery, a biologist and Director of the South Australian Museum, Adelaide, is today a frequent reviewer of environmentalism for *The New York Review of Books*, through which his influence on American thought might be deeper than was Greenberg's on Australian art.

A new kind of art history aided the shift. Tim Bonyhady has presented evidence over twenty years that some of our best painters—Eugene von Guérard and others in the nineteenth century; Arthur Streeton, Russell Drysdale, Sidney Nolan, Arthur Boyd and Fred Williams in the twentieth—at times expressed conservationist concerns. Their focus was usually upon deforestation, drought, flood, fire and soil erosion.

Poisoned world Contemporary art-making has preferred newer concerns. In the late 1960s 'Ecology art' already had a minor presence in international avant-gardism, no doubt a consequence of Rachel Carson's founding text, *Silent Spring*, published in 1962, about pesticides and humankind's poisoning of our own habitat. American works by Alan Sonfist, and Helen & Newton Harrison entered the Power Gallery of Contemporary Art (now the Museum of Contemporary Art, Sydney) as tokens of the movement.

More than painting and sculpture, Australian installation and performance art, especially when presented at the Mildura Sculpture Triennials, began to address local issues. Jill Orr's *Bleeding trees*, 1979, (11.01) is a comparable example in this *Fieldwork* exhibition. For Bonita Ely's *Murray River punch*, a 1980 Adelaide Festival performance in Rundle Mall, the artist became a super-smart saleslady mixing and offering free samples of a drink that blended deoxygenated water, fertilizer, human urine and faeces, dried European carp, salt, superphosphate, insecticide and chlorine. Ely is from Robinvale, on Australia's greatest river, and knew that the Murray–Darling basin contributed effluent from as far away as Toowoomba, Dubbo, Wagga and Albury to Adelaide's water supply.

In 1980 Ivan Durrant, having learnt that the herbicide 2, 4, 5-T (similar to Agent Orange used in the Vietnam War) was causing human birth deformities at Yarram in Gippsland, made a pink floor-sculpture representation of these monster babies in a pool of blood. Utterly disgusting, it is Australia's most compelling demonstration of Rachel Carson's worst fears.

11.04 Brenda Croft, *In my mother's garden*, 1998

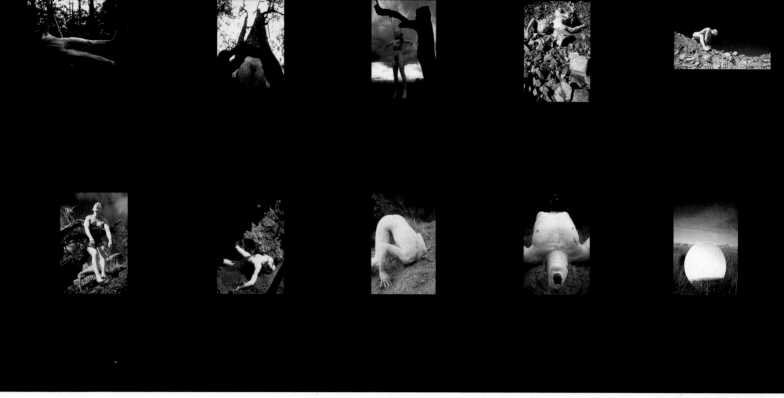

Anti-nuclear action was the more prevalent form of international environmentalism. At the 1980 Venice Biennale Tony Coleing set up *Who wants to be a millionaire?*, a stall in the Australian pavilion from which a salesperson in a prime-minister mask sold 'Export Only' yellowcakes of polyurethane uranium. Bonita Ely, too, had performed a uranium piece, the ritualistic *Jabiluka UO2*, 1979, after mining on Aboriginal land raised concern. An Australian rock band, Midnight Oil, sings so effectively about rape of significant sites that eX de Medici's painting, *Nothing's as precious as a hole in the ground*, commissioned in 2001 by the National Portrait Gallery, places the five musicians before a panorama of the open-cut Ranger Mine in Kakadu National Park.

Here in *Fieldwork* are counter-culture anti-uranium posters from 1979 and, by Ti Parks, *Polynesian 100*, 1973, first shown at a Paris Biennale as a protest against exploitation of French colonies on the far side of the globe. A process piece, the 100 photographs of sand—spray-painted in French tricolour blue, white and red, dusted in ash black, and sprinkled with a confectionery cover-up of hundreds and thousands—were a daily countdown to a nuclear test at Tahiti: on the beach at St Kilda, Melbourne, we were waiting for radioactive fallout and the end of our southern-hemisphere world. In 1978 Richard Larter referred to much earlier American nuclear tests in safely distant Pacific territories when he made a lithograph in which a cartoon woman exclaims: 'Radio-active coral ear rings from Bikini Atoll!'

> A process piece, the 100 photographs of sand… were a daily countdown to a nuclear test at Tahiti…

Nu-clear landscape, old clear landscape, 1989, in the collection of the National Gallery of Victoria, is a five-metre canvas by Coleing in which a figure in a spacesuit with accompanying air tank is wallpapering clear-air arcadian scenery over a dark wasteland, cleared of life. This sardonic masterpiece of environmental double take can stand for Coleing's continuing centrality to Australian eco-disaster art. Cinematic in scale, it is lushly coloured, cartoonish as a *Star Wars* fantasy, excitingly, inventively transformative, and emphatically unsubtle. It is targeted exactly upon our times and the hard-to-reach audiences for whom grossness is good.

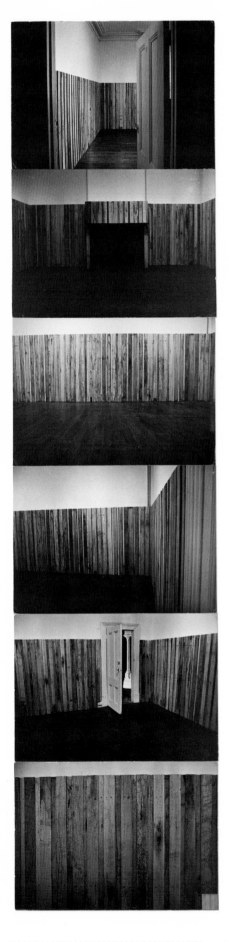

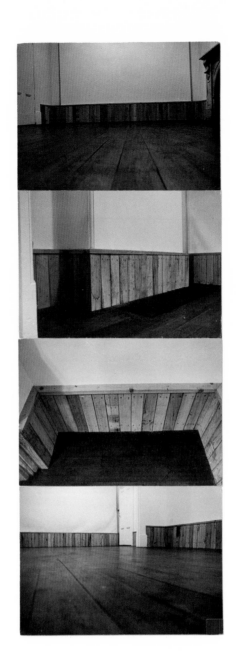

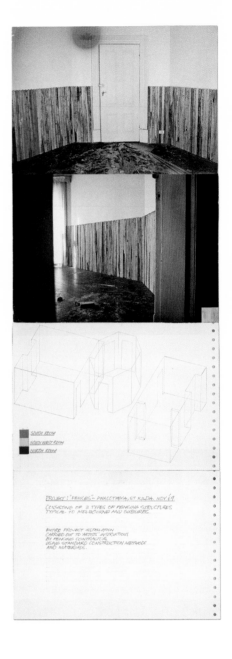

11.05 Dale Hickey, *Fences*, 1969

Know the place Re-entry to Australia after overseas absence brings its peculiar characteristics to sharp attention. In 1967, after five years in Europe, Coleing was struck by the fine wiriness of native grasses, and by the vast, low sprawl of Australian shrubbery observed in bushfire land at Bulahdelah. He was heading to the New South Wales north coast beyond Kempsey, to his childhood dairy-cattle country. So his two maverick *Untitled* floorpieces (both 1968) in *The Field* were more than an eccentric take on Anthony Caro's Greenberg-approved sculpture. The ten-metre sprawl was intended to evoke tensely fronded shrubbery from Bulahdelah. The brash, two-metre high, green plastic blades of grass were perhaps a row of lush un-Australian fodder for the European cows of Smithtown. For a few brief years from 1968 Coleing continued his reacquaintance with Australia in graceful, nature-based *Frondescence* sculptures (around 1969), or, from 1972 to 1975, in *To do with blue* sculptures of playful wind movement and calm, chunky, suspended clouds.

11.03 Bea Maddock, *TERRA SPIRITUS... with a darker shade of pale*, 1993-98 (detail)

The first-impression shock of Australia's strange, arid-land delicacy is more commonly conveyed in traditionally intimate media: not sculpture but drawing and photography. It is strongly present in the scientific illustrations of plants and animals produced on eighteenth- and nineteenth-century exploring expeditions and in the similar works by natural-history-minded first settlers. Every decade or so a bicentennial anniversary becomes a pretext for an exhibition presenting such work from James Cook's voyages, or the First Fleet, or the voyages of Matthew Flinders and Nicolas Baudin or the inland expedition of Burke and Wills. Land-art photopieces by short-term European visitor Hamish Fulton in the 1970s show similar enthralment by the fine-grained leaves and rocks of high-country Tasmania. Likewise Nikolaus Lang's large coloured-earth carpets and wallpieces display astonishment in the face of South Australia's pink and yellow sands and ochres.

John Wolseley settled in Australia in 1976 already equipped with a delicate style based on scientific natural-history illustration, but more than other visitors or residents of the time he has gone beyond the essential first task of observing the continent's peculiar earths, plants and animals in isolation. His work is fully ecological, concerned with systems, relationships and change, not only with minute insect and plant life but also with the largest geological processes of continental drift that relate Australian nature to Indonesia, South America and Antarctica. An extravagantly elaborate 1995 installation of drawings, photographs and plant specimens is extravagantly titled *The great tectonic arc: Concerning the moving apart of Gondwana and the present position of Australia and Patagonia and how the great tree families Araucaria and Nothofagus evolved and were named and celebrated followed by their radical depletion*.[2]

The presence of a nineteenth-century Museum of Economic Botany in the Adelaide Botanic Gardens near her home stimulated Fiona Hall to consider the money trail attached to plants that travel the world as new foodstuffs or drugs. John Hughes's complex drowning-in-drought *Human tide* installation, 2000, at the Ivan Dougherty Gallery, University of New South Wales, was a memorable eco-piece.

However, an installation made in 2002 by Lauren Berkowitz might stand for the many eco-savvy works now cropping up in Australian art: beautiful, complex, delicate and eventually very disturbing. Her *Colour Field* (11.02) was a white-bordered carpet of colour stripes, knowingly similar to American-style stripe paintings in *The Field* exhibition, held about the time Berkowitz was born. Unlike the bland impersonality of acrylic paint, her stripes were finely textured and radiant from within: the surprising materials turned out to be a white salt border and bands of dried leaves and flower petals, laboriously collected. In an exhibition called *Eden & the Apple of Sodom* (the latter being an exotic plant that by 1802 was already a weed in Sydney), irresponsibility in an Australian garden of paradise was figured in this carpet. The eleven glowing colours came from exotics gone feral: Paterson's Curse, English broom, Spanish broom, bridal creeper, bulbil watsonia, montbretia, pampas grass, white-flowered fumitory, quaking grass, three-cornered garlic, and the olive.[3] All right if kept firmly in place, but when running wild these and 3000 other such weeds are Australia's biggest cause of land degradation. When they leave home, pretty flowers and valuable foodstuffs can turn into dangerous predators. Once they left central Africa, humans, too, might run wild like weeds.

2 S. Grishin, *John Wolseley: Land Marks*, Sydney, 1998.
3 E. Green, *Eden & the Apple of Sodom: Lauren Berkowitz, Antony Hamilton, Janet Laurence* (exh. cat.), University of South Australia Art Museum, Adelaide, 2002.

Spirit 'Pagans? They're the ones that worshipped rocks and trees.' So said an immigrant Italian-Australian; Roman Catholicism remains aware that pre-Christian and pre-Muslim ways served ancient Greco-Roman civilizations well enough. Present-day Australians seem to be tending back towards rocks and trees, as evidenced in their support for Green politics.

The world's first Green political party, the United Tasmania Group, was formed in 1972 to protest the drowning of a uniquely beautiful wilderness by a hydroelectricity dam. No seats were won in that year's state parliamentary elections and Lake Pedder was lost, but the next campaign, led by Bob Brown, who eventually entered the state parliament in 1983, was won on a wave of nationwide support for saving the wild Franklin River from yet another hydro dam. Bob Hawke's federal government came to power largely on a promise to save the Franklin, support for the idea being generated by a poster of Peter Dombrovskis's magically beautiful photograph of Rock Island Bend. Printed in a million newspapers, it asked: 'Could you vote for a party [whose Tasmanian branch] will destroy this?'

A New Ethic, the Tasmanian policy document of 1972, not only questioned the economic 'Damania' of hydro-industrialisation. As a botanist, its author Richard Jones also put the ecocentric argument that humans must again begin to see themselves as only part of the 'web of life'. Further, he wrote of non-material values that might offer 'spiritual refreshment'.[4] Ask Bob Brown, resoundingly re-elected in 2001 to the Australian Senate, and he too concedes that beyond the dubious economics of the dams and the forest-felling, beyond the loss of potentially beneficial but unstudied biodiversity, and beyond the sheer beauty of these places, there is also for him a spiritual dimension in entering into wilderness.

... humans must again begin to see themselves as only part of the 'web of life'.

If rocks, mountains, grottoes and forest groves gained spiritual significance in prehistoric cultures, and if grove-like stonehenges and mountain-like rock pyramids were later built, we might accept that spiritual reverence for Australia's own special places lies behind today's growing Green vote. Dombrovskis's potent image that saved the Franklin was of a sacred rock. Martin Thomas writes of the misty gorge in *Uncertain Ground*:

> The channel is twisted then parted by a grey stone sentinel, an island outcrop coiffed by some hoary punk with upright hairdo of forest green ... the very picture of bifurcation. A forked passageway, it rings the question 'this or that', "to be or not to be"...'

And then he notes a report of the photographer's corpse found, hands clasped across his chest after a massive coronary, alone with his camera in the wilderness: 'It looked as if he were praying.'[5]

Cape Raoul and Cape Huay, like Rock Island Bend, are virtually inaccessible but spectacularly magical sites. Groves of columnar dolerite rock sprout on extremities of the Tasman Peninsula looking out to Antarctica. David Stephenson directs his sober photographic gaze at the Tasmanian geological sublime of Cape Huay as well as at Antarctic ice in *Fieldwork*. On wild coves that accumulate driftwood, Gay Hawkes scavenged silver branches and timbers to recycle into a *Cape Raoul chair*, 1991. Unlike her many comfortably usable art-chairs made from

4 M. Mulligan & S. Hill, *Ecological Pioneers: A Social History of Australian Ecological Thought and Action*, Melbourne, 2001, pp. 245–50.

5 M. Thomas (ed.), *Uncertain Ground: Essays between Art and Nature* (An initiative of the Australian Perspecta 1997 Consortium), Sydney, 1999.

waste, this one stands a dramatic three metres high and has an elevated seat; it is thus a throne that a sacred Queen of the Rocks might take to the theatrically stepped headland when she looks across the Southern Ocean to a lost fragment of Gondwana.

In Western Australia, in tall-timber karri forests near a different sweep of the Southern Ocean, Howard Taylor grumbled about a practical architect father who had gone spiritual, becoming a minister of religion. So the artist resisted any suggestion that his paintings and sculptures might be propitiating sacrifices to an all-powerful sun disc that brings both fresh seasonal growth and less predictable drought and fire. His *Double self-portrait*, 1959, and the wall sculpture *Forest figure*, 1977, are images of a human with upraised, branching, woodgrained arms that signal a willingness to live alongside trees or, alternatively, of a veined green tree that yearns to be human, and then fly, like an airman. Scrutinize our greatest masters of landscape art, like Taylor, and you can usually find a deep, peculiarly Australian eco-piety.

... a forty-metre, fifty-one-sheet panoramic drawing, a coastal profile of the entire outward edge of her native island, Tasmania.

One of the climactic masterpieces in *Fieldwork* is Bea Maddock's *TERRA SPIRITUS... with a darker shade of pale*, 1993–98 (11.03), a forty-metre, fifty-one-sheet panoramic drawing, a coastal profile of the entire outward edge of her native island, Tasmania. It was inspired in 1987 by a first sight of the southern headlands, returning from a voyage to Antarctica on which she learned how the larger continent was Australia's geological mainland.

Starting first from an idea of making the land white, a reversal of the optical truth that landscape foregrounds are dark and backgrounds pale, she eventually embarked on six years' work, completed in 1998. Her white, rocky headlands look out to the white-ice coasts of Antarctica, and to the white-sailed ships that first came this way to a land long inhabited by black Tasmanians, who believed spirit beings were white-skinned. The legal fiction of *terra nullius*, by which British settlers took possession of 'un-owned' Australian land, had been recently cast out by the High Court's Mabo judgement, so in *TERRA SPIRITUS* Maddock affirmed pre-settler presence. Large rows of Aboriginal place-names float out like smoke from the island's interior to greet the European fleets; the names are softly hand-drawn but otherwise this monochrome drawing is all scar-like incision into the red-coated paper; and the red is natural ochre prized by Indigenous Australians, though in this case it was dug from Maddock's own privately discovered pit in her hometown Launceston.

Earth from a very particular place speaks to those who look upon *TERRA SPIRITUS*. It speaks of that particular place, and of the human culture to which the place had given birth. The first Australian humans had to change their ways greatly as they adapted to a land extremely different from Asia. If our settlers of the past 200 years had attended more carefully to particularities of place our present phase of extinctions and our unsustainable society might be less alarming. We are trying to mend our ways. At least we are developing a healthy sense of fright, and fright is one of the purposes of art. ¤

At least we are developing a healthy sense of fright, and fright is one of the purposes of art.

Things are not at all so comprehensible and expressible as [people] would mostly have us believe; most events are inexpressible, taking place in a realm which no word has ever entered, and more inexpressible than all else are works of art, mysterious existences, the life of which, whence ours passes away, endures.[1]

There is a correspondence between Bill Henson's photographs and Peter Booth's paintings, although this major installation of their work in *Fieldwork* is the first time that this correspondence has been made in such a way that we can examine the artists' practices together, and see that their works are, for all their differences, profoundly connected.[2] Beyond the obvious visual affinities — of subject matter and of mood — the deeper connections are each artist's abiding analysis of the nature of what it means to be human, and their individual expression of liminal emotions and events that are as real as they are difficult to capture in visual form.

The main premise of both artists is to acutely observe the world. Their second premise is a profound desire of a specific nature — the desire to depict, as Henson observes, 'things that leave one questioning … that animate the speculative capacity'.[2] Given this, Henson's and Booth's art will clearly resist simple interpretations, for their gestures are, instead, directed towards the vastness of unproscribed imaginings and these, the artists seem to say, constitute our inner worlds.

Henson and Booth frequently modulate the light in their images to represent liminal human emotions and to provide access to the potential imaginary landscapes these emotions occupy. The absence of light, as much as illumination itself, is the doorway (quite literally, in Booth's painting) to extreme physical and psychological states.

Both artists are fascinated by the phenomenon of crowds. In the massing of humanity, Booth articulates the chaos of crowds and the often bizarre distinctiveness of its individual members. His work from the late 1970s to 1980s, in particular, makes real the sublimated, dark, irrational desires and violent impulses of which humans are capable, and which the anonymity of the crowd can set free. In contrast, the individuals in Henson's crowd series are more self-contained. These unknown individuals nonetheless touch a common chord of humanity in us through the familiarity of their gestures.

> Darkly and inexpressibly are we moved: joy-startled, I see a grave face that, tender and worshipful, inclines towards me.[3]

Henson has observed, 'I'm always trying to visualise … feelings, and to give physical form to them. Something that is elusive, fragile and always sliding away from you into the night air.'[4] To capture what is fleeting and transitory, Henson has chosen to work with photography — a medium that is uniquely placed to record the 'real' with a mute power that, through the canny internationality of an artist, can make even the mundane seem meaningful. The infinite mutability of people and their worlds — a landscape that is transformed by a flicker of light; the small gesture of a hand that touches our hearts — is reflected in Henson's creation of large groups of images that seek to capture shifting moments. Henson has noted of one series, 'I think of these works as one continuous image', and it is possible to extend this statement to all his photographs produced to date. In this installation, drawn from images produced between 1980 and 1998, it is evident that Henson has consistently explored certain key ideas, albeit in disparate ways, throughout his career.[5]

1 M. D. Herter Norton (trans.), *Letters to a Young Poet: Rainier Maria Rilke*, New York, 1934, p. 17.

2 Bill Henson quoted in S. Hogan, 'Bill Henson: Interview' in *Photofile*, no. 37, November 1992, p. 34.

3 Novalis (Friedrich von Hardenberg), *Hymns to the Night (1)*, 1880. Trans. G. MacDonald, 1897 <www.ev90481.dial.pipex.com/etexts.htm>.

4 Bill Henson quoted in J. Hawley, 'Through a glass darkly', *The Age: Good Weekend*, 11 March 2000, p. 46.

5 Bill Henson quoted in Hogan, p. 34.

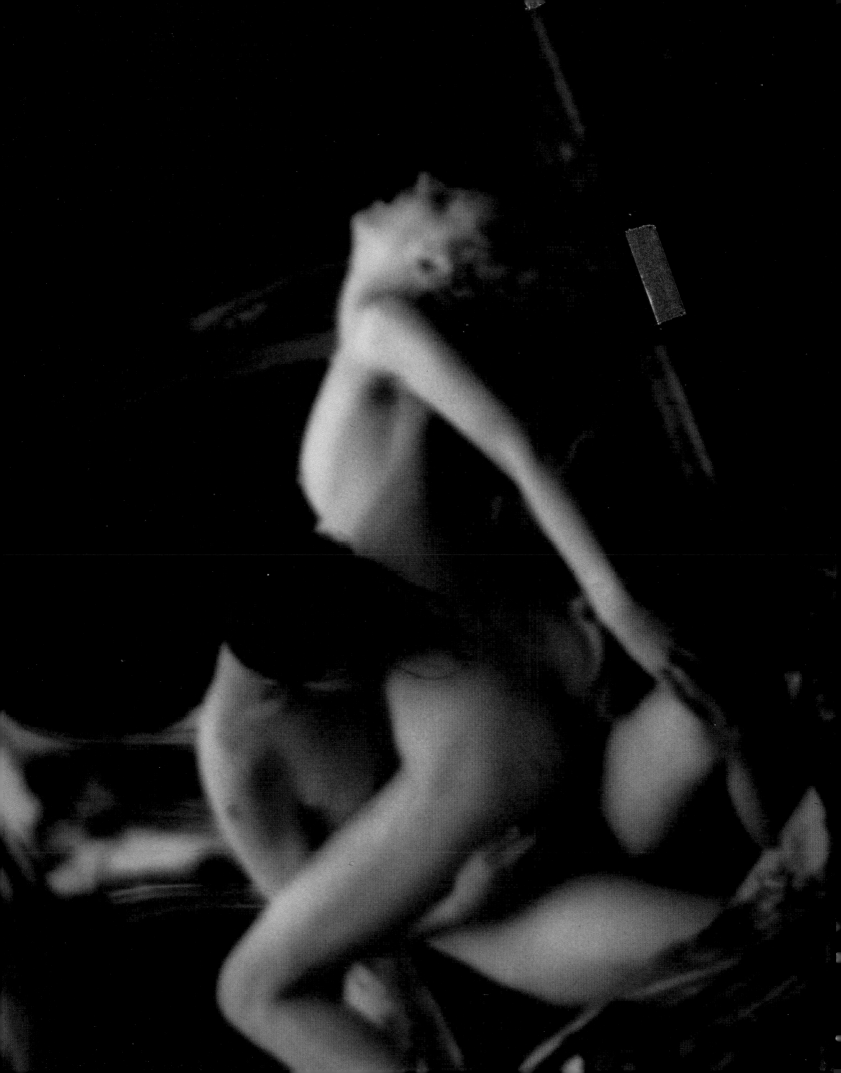

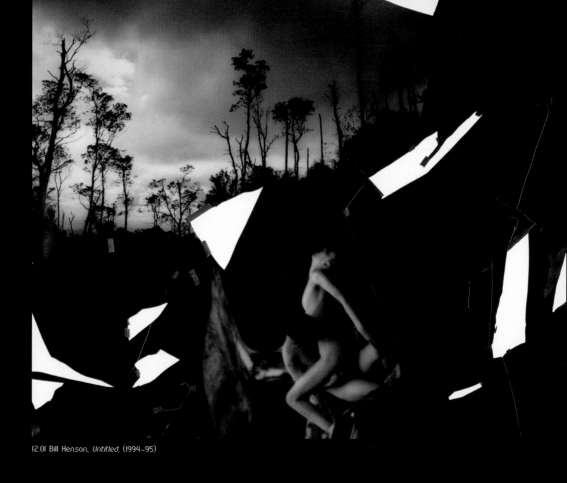

12.01 Bill Henson, *Untitled*, (1994–95)

One ongoing source of fascination for Henson is the human face. In reference to his distinctive approach to photographing people he writes of, 'intimacy without familiarity, the feeling of something that is powerfully apprehended and yet is something you can never know'.[6] Our desire for personal revelation in a portrait is invariably confounded in Henson's work. Here, among the crowd, in darkened landscapes or the ruins of an urban world, we see people who are resolutely immersed in their own inner spaces. While their gestures and expressions may hold overtones of the sexual, the violent or the melancholy, their eyes invariably allow us little access to their real feelings. In short, the illusion of familiarity that photography engenders is just that — a deception that belies the rich and intensely private realm we all carry inside us. And yet, the impenetrability of Henson's subjects on one level is matched by an affecting intimacy. The pale bodies of the young people that appear in his cut-screens *Untitled*, 1994–95 (12.01), or his more recent series *Untitled*, 1998–99 (12.02), have a vulnerability that is both intense and often moving. In a similar way, the 'moments' he captures as people move in a crowd, *Untitled*, 1980–82, or listen to music, *Paris Opera project*, 1990–92, suggest a commonality of human experience that transcends the place or time in which the photographs were taken.

In reference to his distinctive approach to photographing people he writes of, 'intimacy without familiarity, the feeling of something that is powerfully apprehended and yet is something you can never know'.

6 Hawley, p. 46.

12.03 Bill Henson, *Untitled*, 1997–98

12.02 Bill Henson, *Untitled*, 1998–99

Henson has noted that the most interesting of images are those that are ultimately ambiguous, allowing the viewer a space for wonder and the possibility of being.[7] In his own work this 'uncertainty' is accentuated by Henson's choice of light. Increasingly he has been drawn to take images at twilight—a time of day when the lines between what is known and unknown are at their most uncertain. Henson has written that, 'The air seems charged with something between expectation and anxiety—*Erwartung*, the Germans call it. You feel a sharpened awareness of yourself in nature

The special qualities of twilight attracted Romantic artists and poets: the German writer and philosopher, Novalis, for instance, called it 'the mysterious way [which] leads inwards'.

and in the landscape'.[8] The special qualities of twilight attracted Romantic artists and poets: the German writer and philosopher, Novalis, for instance, called it 'the mysterious way [which] leads inwards'.[9] It is this sense of drawing inward, of loosening the bounds of the day to enter into a different and more internalized space that seems evident in many of Henson's most powerful works. His photographs may frequently operate on the knife-edge of emotions but throughout his career there has always been, in even his most contentious works, an emphasis on the sanctity of personal experience.

I certainly realise that there is something within all of us which is as large, and as substantial, as the reality we see outside ourselves.[10]

7 ibid, p. 43.
8 ibid, p. 43.
9 Novalis (Friedrich von Hardenberg), *Miscellaneous Observations*, *17* (a group of poems) cited in M. Mahony Stolijar (trans., ed.), *Novalis: Philosophical Writings*, Albany, 1997, p. 25.
10 H. Kennedy, 'Booth: Painting the Inner Reality', *The Age*, 16 March 1985, p. 7.

12.04 Peter Booth, *Painting*, 1977 (detail)

The inner reality that Peter Booth speaks of is conditioned by empirical observation of the surrounding world, introspection and the emotional intensity of memory, and a belief that his individual works, like Henson's, are part of a continuum of vision and practice that gives meaning to his existence.

The inner reality that Peter Booth speaks of is conditioned by empirical observation of the surrounding world, introspection and the emotional intensity of memory, and a belief that his individual works, like Henson's, are part of a continuum of vision and practice that gives meaning to his existence. The subconscious realm of dreams and the unpredictable visions that accompany traumatic physical episodes are also a key to the processes of synthesis and transformation central to Booth's art, and the creation of 'another kind of reality that you can step into'.[11] This 'other reality' has often been interpreted as prophetic of apocalypse and biological mutation, yet Booth's work (arguably) has always been, and remains, closer to aspects of our real world than we might imagine or acknowledge.

Since its appearance in *The Field* in 1968, Peter Booth's work has occupied a singular position in Australian art. His paintings evolved through three decades of cultural turbulence and fluctuating critical reception, arriving today at a point at which it is possible for the artist and the viewer to see the major, recurring themes that have shaped his work: the narrative possibilities and symbolic potential of urban chaos; the bleak, romantic landscapes; social and environmental degeneration; and finally, the renewal and resilience that the natural world somehow retains.

Booth's creative energies call on his extraordinary skill as a painter and draughtsman. He works prolifically on paper and refers to drawings 'until the painting takes over. It must follow its own course'.[12] The importance of drawing as a practice and discipline was central to Booth's teaching at the Victorian College of the Arts from 1983 to 1986 and, before that, at Preston Institute, during which time his influence informed a generation of younger artists. This was a period of intense discussion about what would be contemporary Australian art's international context, and at that time Booth achieved widespread national attention when one of his works was acquired by the Metropolitan Museum of Art in New York.

Booth's representation in *Fieldwork* draws on paintings and works on paper produced between 1971 and 2002. The earliest, a typically untitled painting from 1971, exemplifies the meditative black voids commonly referred to as the 'doorway' paintings, a format that Booth explored on varying but usually large scale until 1974. While appearing to share the formal characteristics of minimalist art, the sensuous and at times urgent textural fields

12.04 Peter Booth, *Painting*, 1977

of this early period are conceptual precursors to the painterly, figurative works that have emerged prolifically in works on paper since around 1976 and in the first major canvas, *Painting*, 1977 (12.04). In contrast to the reductive coolness of the minimalist, post-pop and colour-field painting that surrounded him in *The Field*, the expressive surfaces of Booth's black paintings asserted that his art was (and remains) emphatically about a necessity to find in painting the material equivalent to philosophical and spiritual beliefs. For Booth, black is

> strong and beautiful — the colour of the universe ... The abstract paintings reflected my state of mind then. Whether a picture is abstract or figurative is not the issue — it's what the painting says about the human condition. [13]

A holistic sense of the universal underpins Booth's relationship to the planet and to all sentient beings and, as Helen McDonald noted, Booth's art acknowledges 'the complexity of human subjectivity', [14] and cannot be simply reduced to the particular political standpoints that the artist has supported, to environmentalism, globalisation, peace or animal welfare. The position of the individual in space, and in relation to the crowd, has been a consistent

> A holistic sense of the universal underpins Booth's relationship to the planet and to all sentient beings ... [his art] acknowledges 'the complexity of human subjectivity' ...

theme in Booth's work, and may justify a biographical explanation, though Booth is loathe to prescribe definitive readings of his works. Like Henson, he encourages ambiguity and the uncertainty of individual encounters with his works.

If both Henson and Booth construct and follow paths that lead within, their visionary and imaginative realms draw on ceaseless scrutiny of their immediate environments, of the world at large, and of Melbourne in particular. Their re-ordered realities can be under-stood, finally, as an attempt to bridge the gap between the dream and the real, and to assert that all human beings have the deeper potential to

> Their re-ordered realities can be understood, finally, as an attempt to bridge the gap between the dream and the real, and to assert that all human beings have the deeper potential to understand their place in the order of things.

understand their place in the order of things. This is the personal possibility of revelation that author Roger Cardinal had in mind when he suggested that the role of the artist is 'not to destroy lucidity, but to amplify and perfect it by testing it against the unknown, like pointing a lamp at the darkness'. [15]

11 ibid.
12 J. Zimmer, 'Weather Helps to Paint his Pictures', *The Sunday Herald*, 15 April 1990.
13 ibid.
14 H. McDonald, *Peter Booth: Small Paintings 1992–1995*, Melbourne, 1995, p. 5.
15 R. Cardinal, 'Night and Dreams' in K. Hartley (ed.), *The Romantic Spirit in German Art, 1790–1990* (exh. cat. London, 1994, p. 194.

forcefield

Edward Colless

13.01 Marc Newson, designer, Eckhard Ressig, manufacturer, *LC2 Lockheed lounge*, 1985–86

A popular screensaver on computers flashes its relentless cascade of phosphorescent green particles in a black void, like luminous rain dribbling down a city window at night. Flaring, evaporating, scrolling and shuffling with the random rhythms of a distant but dense panorama of neon street signs, these chains of alphanumeric symbols scrambled with Japanese Katakana-like script are an indecipherable yet seemingly global code. As they creep down the screen, it feels as if the computer is talking to itself, either idly occupying its downtime or processing an all-consuming problem on the sly. Either way, it seems that the machine is self-willed. Designed by the Sydney visual effects team Animal Logic, the screensaver is a recasting of their emblematic screen insert for the 1999 Wachowski Brothers cyber-noir fantasy film, *The Matrix*.[1]

In the movie, this shimmering field of virulent machine code is the naked form of a computer-generated virtual world that has long since replaced the real world. What appears to be the familiar environment of human bodies, of a present-day cityscape, of the sun and sky, is only a collective hallucination, fabricated and operated by a vast computer network. This virtual reality is a prison house for the human nervous system, a delusion induced and administered by a complex of artificial intelligence machines. In the real world, the oblivious humans are farmed by these machines for the electrical activity of their brains, which are wired into the matrix, while their frail but actual organic bodies languish lifelong in goop-filled floatation tanks that are stacked in their millions like ripe chrysalises budding off towering service cores.

The lesson is not that with enough will-power, or with the stage-skill of Uri Geller, you can bend the spoon with your mind; rather, it is that there is no spoon.

Only those who rebelliously break out of the system, and for their crime get literally flushed out like excrement into a sewer, get to see the real world—obliterated, sunless and desolate. These rebels with hacker code names or tags for names—Morpheus, Trinity, Tank and Neo—see the matrix in its unadorned state, the phantasmic world dissolved into strings of data as if seeing through the macroscopic forms of nature to their multiple and repeated sequences of DNA.

The virtual world generated by the matrix resembles Plato's allegorical cave in which a race of slaves, imprisoned for generations in a kind of camera obscura, forgets that the flickering two-dimensional shadows on the wall of its cave are cast by objects that inhabit the sunlit world outside. Enslaved in a world of representations, they mistakenly believe those shadows to be the real things. As Morpheus in *The Matrix* ponderously suggests, echoing Plato to the viewer as much as to the movie's other characters, are *we* not those slaves? Hypnotized by the screen, those of us seduced by the matrix code mistake the realm of the virtual—or artificially generated appearances—for the real. Neo's apprenticeship, under grandmaster Morpheus, requires freeing himself from the realm of appearances. The lesson is not that with enough will-power, or with the stage-skill of Uri Geller, you can bend the spoon with your mind; rather, it is that there is no spoon.

Despite the mystical overtones of Neo's spectacular training, the lesson is more prosaically Calvinist than it is an exercise in Zen poetry. The real world that Neo wakes up to turns out to be subterranean, dirty and austere, a prison far more claustrophobic than the matrix. The real world is a place where the food is ironically synthetic (since there is no sun) and its colourless, rationed servings taste like nothing. It is, Morpheus explains in one of the script's more renowned appropriations of Jean Baudrillard, 'the desert of the real'.[2] For Morpheus and the rebels, bleak as this prospect is, the real—or the ruined, eroded zones that are left of it—is humanity's true home, the truth behind a simulated world. It is a sentiment Morpheus might share with Dorothy, when she wakes up in the monochromatic Depression-engulfed world of Kansas after her visit to the dream world of Oz. But it is hardly an opinion that Baudrillard would agree with.

Baudrillard's desert of the real is not the sort of blasted distopia that the virtual world engineered by the matrix conceals from its inhabitants. There is no conspiracy of misrepresentation in Baudrillard's uses of the term 'simulation', and hence no possibility of revelation. Morpheus, however, is the angel of illumination. 'Free your mind', he insists. This means being born again, delivered into the truth of this real, miserable poverty,

1 Designed by Simon Whitely and Lynne Cartwright for Animal Logic, the graphic insert is used for the cockpit computer screens on board the rebel ship *Nebuchadnezzar*. It is utilized for the FX sequence in the film's climactic scene at which three agents and the hotel corridor in which they are standing are visualized by Neo as a field of machine code (produced by animated textures on varying scales and at varying speeds). Created for the opening titles sequence, the matrix code has both a metonymic relation to the film's *mise-en-scène* as well as functioning emblematically for the promotional and marketing identity of the movie through the screensaver. The screensaver is viewable and can be downloaded at whatisthematrix.warnerbros.com/cmp/screensaver. Other downloads of FX work carried out by Animal Logic for *The Matrix* are available through their website: see www.animallogic.com

2 J. Baudrillard, 'The Precession of Simulacra', *Simulations*, trans. P. Foss, P. Patton and P. Beitchman, New York, 1983, p. 2. The remark is made in response to Jorge Luis Borges's fable 'Of Exactitude in Science', in which Borges imagines a map of an empire that is of the exact scale and detail of the territory it charts. This map covers the empire, but over time erodes to reveal the real beneath it. Eventually, only shreds of the map survive, and these are in remote parts of the real territory, such as in desert regions. Bauldrillard inverts the allegory, proposing that today, rather than the map resembling the territory, the territory resembles the map — that is to say, the simulacrum precedes the real — and that rather than the map eroding, it is the real which is becoming denuded and disappearing, becoming a desert.

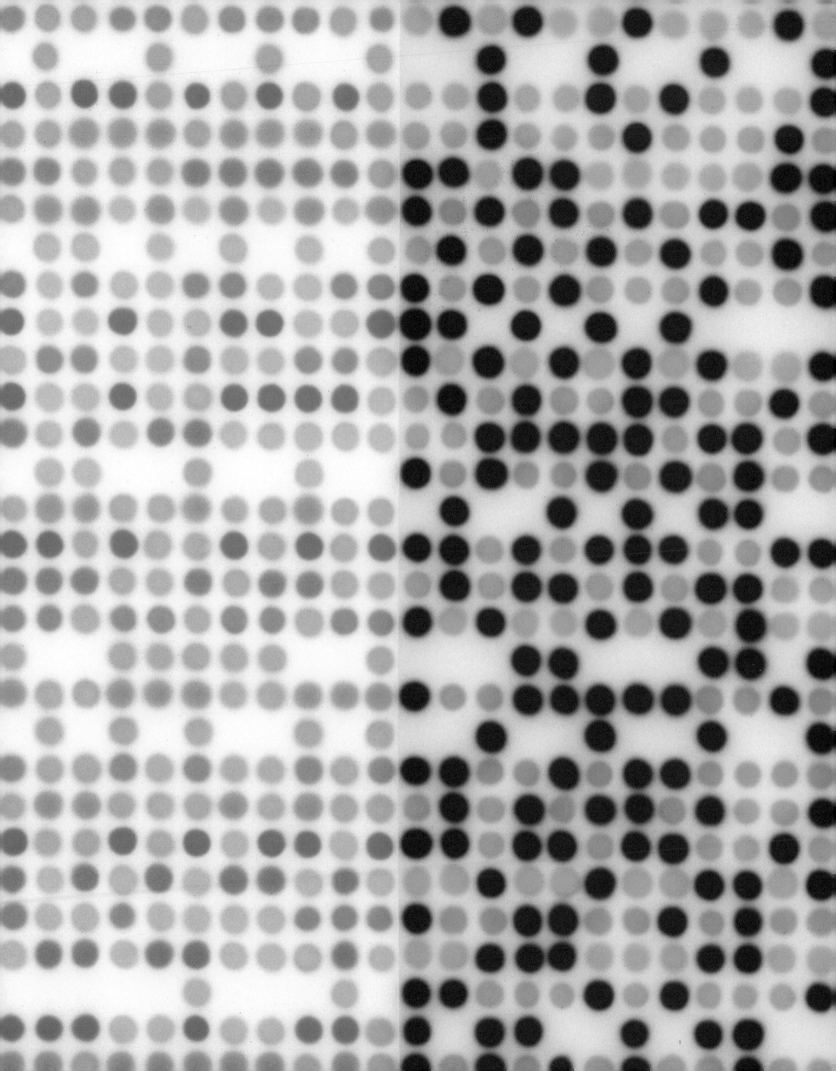

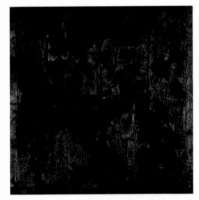

13.02 John Nixon, *Self portrait (non-objective composition)*, 1981

13.03 John Nixon, *Self portrait (non-objective composition)*, 1983

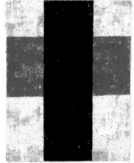

13.04 John Nixon, *Self portrait (non-objective composition)*, 1982

because the world of big business, of B&D nightclubs, of beautiful women in red dresses flirting with you on the street... all this is a veil, a trap, a lie. It is all the work of *the code*. The sensuality that the matrix's virtual world offers is enticing: sea, sex and sun (since there is none of that left in the real world) or, as the traitor Cypher remarks, an illusory steak that tastes 'juicy and delicious'. But this sensuality is phoney pleasure, a distraction from the ongoing battle with the system and its agents. To enjoy it, you have to forget your real body and its enforced passivity. Virtual reality is created to keep you pacified like a couch potato in front of TV. Ironically, for a movie received so well by a generation of cyber enthusiasts and post-political tech-heads, the moral of this tale is as quaintly Luddite in inspiration as it is facile in its techno-phobic recitations of Baudrillard's theoretical commentaries on simulation, written at the beginning of the 1980s.

Indeed, not only is the 1980s a crucial point of reference for this film; one could also say that the film itself is, ironically, more a theoretical commentary on the culture of the 1980s than an imaginary drama of a post-millennial future. Neo stashes his illegal software in a cavity carved out of the pages of a faux-antique, leather-bound book titled *Simulacra & Simulation*. It is a farcical, generic hiding place but also a facetious homage. Baudrillard's *Simulacres et simulation* was published in 1981, and quickly became notorious by reputation in hip, Anglophone cultural circles, even before the translation into English of one of its more provocative chapters, 'The Precession of Simulacra', in 1983.[3]

While the formats of Neo's software are identifiable as late 1990s technology (CDs, mini-DV tape, mini-disc), their hiding place is an historical anomaly: stored in a hollowed-out text that could justifiably be considered an inaugural manifestation of the postmodernism of the 1980s, but which appears as an absurd anachronism. Like most of the communication technology in the movie's sim-city (its 1980s telephones, for instance), Baudrillard's book appears in the movie as a relic, rendered in an anachronistic form by the matrix. His book exists in the simulated world as an empty signal, quite likely unread by the scriptwriters and directors and so indicated through an un-authored cover only, but gesturing almost emblematically toward a repertoire of aesthetic issues fashionable in the 1980s that the movie characterizes and caricatures.

One of the sharper articulations of this fashion was offered at a 1981 conference called Foreign Bodies, at Sydney University, dedicated to assessing the Australian appropriations of European and American postmodern theory and criticism. In an atmosphere inspired by the contest between neo-Marxist critiques of modernity and anti-Marxist, post-structuralist experiment, Paul Foss (later, after Paul Taylor, to become editor and then publisher of *Art and Text*) furnished a provocatively postmodern, nihilistic image of Australian identity under the title 'Theatrum Nondum Cognitorum'. Within an explicitly rhetorical invocation of Baudrillard's 'Precession of

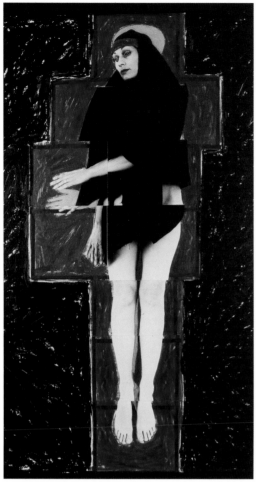

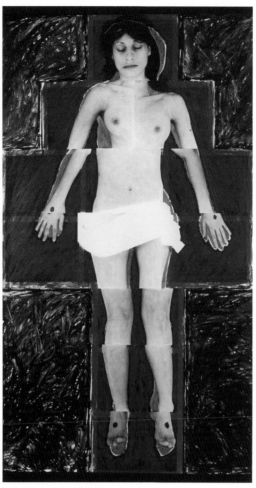

13.06 Julie Rrap, *Madonna*, 1984

13.07 Julie Rrap, *Christ*, 1984

Simulacra', Foss asserted that 'the whole of Australia is pure invention. There is no such country, there are no such people...'[4] The genealogy of this 'antipodal simulacrum'[5] included the paradoxical aestheticist formula proposed by Oscar Wilde: nature follows art; the world is an invention of art. Australian geography and its inhabitants are images fabricated by the geopolitical necessity of European expansion, they are simulacra concealing what they are not. Australian inhabitants are non-people in a non-place. There is no pristine, original — or, dare one say, ab-original — Australia which is subsequently detoured or defaced by colonisation, misrepresented and thus redeemable by the overthrow and purging of colonial representation. There is only the absorbing, nihilistic power of the simulacrum. Paraphrasing Wilde, Foss found himself simultaneously restating Baudrillard:

> All abstraction, all romance...effaces [sic] the gap existing between image and real, so that the first is no longer able to refer to the other....One only 'speaks true' by confusing reference with the order of appearance. When all is said and done, however, nothing underlies appearances except their power to fascinate or dazzle. The reality of images is the reality of seduction.[6]

It is easy to see how this sort of argument would have scandalized the leftist, critical view of culture, so prominent in the preceding decade in Australia, in which culture was generally taken to be a field of competing 'ideological' representations, reflecting in varying degrees the reality of political struggle.

3 J. Baudrillard, *Simulacres et simulation*, Paris, 1981. *Simulations*, trans. P. Foss, P. Patton and P. Beitchman, New York, 1983. This translation contained only the essays 'The Precession of Simulacra' and 'The Orders of Simulacra'. Foss and Patton's translation of 'The Precession of Simulacra' was also published in *Art and Text*, no. 11, Spring 1983, giving the text more exposure to the Australian art world. The full text of the book was published as *Simulacra and Simulation*, trans. S. Faria Glaser, Ann Arbour, 1994.

4 P. Foss, 'Theatrum Nondum Cognitorum', *Foreign Bodies Papers*, Local Consumption series 1, Sydney, 1981, p. 16. Reprinted in *What is Appropriation? An Anthology of Critical Writings on Australian Art in the '80s and '90s*, ed. R. Butler, Brisbane/Sydney, 1996, p. 120.

5 Foss, in *Foreign Bodies Papers*, p. 35; in Butler, p. 128

6 ibid., p. 15; in Butler, p. 119.

Throughout the 1970s critical attention had been particularly focused on the so-called cultural imperialism of the USA, and to a lesser extent of Europe. The strategies of imperialism were associated with an ideology of progress, manifested in modernism, which regarded certain traditional, indigenous milieux or regional environments as culturally deficient or retarded in their development. Cultural provincialism, for instance, in Terry Smith's diagnosis for *Artforum* in 1974, was an ideological effect of a political and economic strategy that made a regional culture dependent on the culture of a dominant, internationalist metropolitan centre.[7] The effort to overcome this provincial status in exclusively cultural terms, however, only maintained the state of political subservience in a 'relentless entrapment'.[8] This was because the provincial artist only recognized the cultural significance of a metropolitan style — and adopted its stylistic features — precisely at the moment when that style was at its most prominent. Consequently, what would always be missing from provincial art was the supporting fibre of the social, economic and political heritage that sustained and validated the foreign, big-city style in its authentic setting. Lacking something it could never have, provincial art was condemned to repeat its desire and failure in the cultural sphere.

Australian culture was particularly prone to this 'vicious circle',[9] merely reproducing the signs of European or American modernism without the underlying substance or originating essence. Australians were precisely like Plato's slaves in the cave, misrecognizing their own spectral realm of appearances for the real thing. 'Having never been 'in on' the seminal impulses which generated his adopted style', said Smith of the expatriate artist returning to Sydney or Melbourne after an apprenticeship in New York, Paris or London, 'he no longer knows how to continue within its framework; and the local art world is incapable of acting as a dynamic audience'.[10]

> 'Having never been 'in on' the seminal impulses which generated his adopted style', ... 'he no longer knows how to continue within its framework; and the local art world is incapable of acting as a dynamic audience'.

13.08 Anne Ferran, *Untitled*, 1990

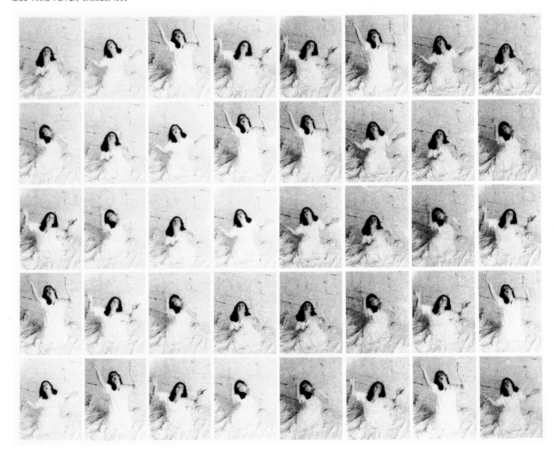

7 T. Smith, 'The Provincialism Problem', *Artforum*, vol. 13, no. 1, New York, September 1974, p. 54. Reprinted in *What is Appropriation? An Anthology of Critical Writings on Australian Art in the '80s and '90s*, ed. R. Butler, Brisbane/Sydney, 1996, p. 131.
8 ibid., p. 57; in Butler, p. 135.
9 ibid., p. 59; in Butler, p. 137.
10 ibid., p. 57; in Butler, p. 135.

13.10 Jon Campbell, *So you wanna be a rock 'n' roll star,* 1990

The result, said Smith, was a succession of shipwrecked, unassimilated arrivals of cargo patched sadly together as 'Australian' culture, but amounting to a history of 'irresolutions'[11] which did not produce strong, independent diversity but instead weak hybrids. Modern art in Australia, Smith implied, had been an illusion: a series of shallow but compulsive imitations of a foreign cultural superiority. Australian modernism, one might conclude, was something like a fan in pursuit of a celebrity. It had been the mirror of its own subservient cringe. Provincialism was a mode of alienation in which artists and critics exchange their own productivity for identification with a fashion. For Smith, the provincial artist is constitutionally unsuccessful and conflicted because 'his self-image is accepted, not invented'.[12]

Ironically, Foss's portrayal of the 'antipodal simulacrum' was not in actual disagreement with the critical negativism in Smith's account of the Australian 'provincialism problem'. If anything, it pushes that negativism toward nihilism — which is the point at which it becomes politically scandalous. Baudrillard's *Simulacres et simulation* (in both its 1981 and 1999 appearances) could be, in Smith's terms, jetsam imported into Australian cultural situations but in excerpted form, quoted out of its context of a historical, social background in European politics and philosophy. In this allegedly diminished mode Baudrillard's work is adopted, and

Rather than attempting to overcome the alienation from our artistic productivity, endemic to the provincial cringe, what if we exploited it by trafficking in those spectral signs and mere images — in effect, by mocking our own identity as a masquerade?

misquoted, by a new generation of Australian artists and critics who are as equally isolated from that text's seminal impulses as any preceding generation was detached from the sources of the culture it attempted to emulate. Baudrillard's work is reduced to his name and a vocabulary of key words: these become tags or brandnames, no longer critical but simply consumable; signs for the commodity status of his work as it is imported into Australian academic institutions and the cultural market.

This commodifying of intellectual practice, however, could equally be thought of as an abolition of the representational bond of that practice to reality. It would have seemed a shocking, and to some exciting, thought at the start of the 1980s that a theoretical activity, such as Baudrillard's, could be comprehended not as critique but as a performance, detached from any instrumental or signifying relation to the real. Consider how the signs of Baudrillard circulate, or perform, in Terry Smith's vicious circle of Australian intellectual and cultural

11 ibid., p. 57; in Butler, p. 134.
12 ibid., p. 56; in Butler, p. 133.

provincialism. What would happen if, rather than struggling to break free of the logic of infinite regress that impaired our connection to an object of desire (French post-structural theories, or European transavantgardism, or New York post-photographic practice, etc), we instead capitalized upon it? What if we were to treat our cultural imports — and exports, for that matter — as signage? Rather than proposing to validate cultural activity by critically distinguishing its authentic or true images from its false ones, what if we were to speak (as Foss suggested) by 'confusing reference with the order of appearance'? Rather than attempting to overcome the alienation from our artistic productivity, endemic to the provincial cringe, what if we exploited it by trafficking in those spectral signs and mere images — in effect, by mocking our own identity as a masquerade?

Appropriating a term from Roland Barthes, Paul Taylor did something like this in his editorial articles for the first issues of his magazine *Art and Text* throughout 1982, characterising Australian culture as 'second-degree', as a pseudo-culture of appropriated fragments and quotations of international modernism.[13] 'I write: that is the first degree of language', noted Barthes in 1975, 'I write that *I write*: that is language to the second degree.'[14] By quoting an original statement, the second degree dislocates and reverses the meaning and enjoyment of that utterance. It cannot ever be interpreted as direct, authentic speech. This lack of originality is relished as a mode of parody. The aesthetic of the second degree, hinted Barthes, is kitsch, which requires 'endless detachment', the abolition of the language's 'good conscience'. In the second degree, culture is beyond good and evil; and to the abolition of morality, one might add the annulment of politics.

After the stale, earnest cultural politics of the 1970s, this new wave of second-degree criticism and art was exhilarating. The colonial powers of Europe and then America had represented Australia as their antipodal reflection. However, instead of resisting that image, Australian culture could be said to have conformed to it. But like a monkey's imitation of its keeper (whose superiority is reflected back in a nullifying communication between species), this was all a surface phenomenon; it was a mask, with nothing — at least, nothing decipherable or significant — underneath it. This act of imitation was a meaningless subjugation. Australian culture repeated the authority of its overseas sources, but as a performance, as a false reproduction: shallow, trashy, perverted. In other words, Australian culture could be said to have been drag culture: parodying what it imitated by excessively copying its components, and so resulting in a travesty of provincial deference.

This argument itself thus parodied the provincial cringe in Australian cultural history by pushing it to an extreme, in a tactic that could be called hyper-conformism. We may never have had a tradition of the new because we always dressed in second-hand styles and images, like an impoverished country cousin. Why not reverse the pathos of this situation, by parlaying it into the second degree? As many of his critics pointed out, Taylor's efforts to do so, in a critical idiom and through curating exhibitions such as *Popism* (for the National Gallery of Victoria in 1982), were more provocations than successful or edifying demonstrations.[15] It was not entirely his fault. Much of the art of that decade which Taylor endorsed, and many of its artists, retreated from the annihilating threshold of simulation, to a consoling and more rewarding art that maintained critique, a truth behind appearances, an expression within the symptom.

One can hardly blame them. Consider the reach of such a challenge when the artist or critic must exploit the failure to be authentic and original and, like a drag queen, make their work so false in its appearance, so nihilist in its performance, that it has no instrumental relation to any so-called real thing.

13.11 Geoff Lowe, *Deception: The man from Ironbark*, 1984

13 P. Taylor, 'Australian "New Wave" and the "Second Degree"', *Art and Text*, no. 1, Autumn 1982, p. 24: 'The art of the Australian artists discussed here is simple in form but wryly sophisticated, and in its quotation from the recent past (particularly the artists' teenage years), it detaches itself from its cultural history and inspires instead a pleasure of dislocation. Roland Barthes, in describing a form of pleasure he called "second degree", prompts my description of this art in his terms ...'.

14 R. Barthes, *Roland Barthes by Roland Barthes*, trans. R. Howard, New York, 1977, p. 66. Taylor was apparently directed to this section of Barthes's book by the artist Vivienne Shark Le Witt.

15 For example, M. Holloway, 'Popism', *Art Network*, no. 7, Sydney, Spring 1982. Reprinted in Butler, 1996.

16 P. Taylor, 'Popism — the Art of White Aborigines', *On the Beach 1*, Sydney, 1982, p. 30. Reprinted in *What is Appropriation? An Anthology of Critical Writings on Australian Art in the '80s and '90s*, ed. R. Butler, Brisbane/Sydney, 1996, p. 86.

17 Barthes, p.66.

Barbie dolls, for instance, do not resemble real human girls. Like drag queens, they resemble each other. Barbie dolls are signs for a feminine gender, which comes into existence by imitating Barbie. Barbie is hyperreal, inducing rather than representing the reality of feminine gender. The sign-form of Barbie is equivalent to its commodity-form: it does not represent or respond to a desire, it induces the reality of desire. But do not think of this as the manufacture or production of false desires that constitute a false consciousness — a feature of the alienation of humanity from its essence as a desiring being. A Barbie doll's resemblance to other Barbies is established without reference to any original, not even to an originating model of Barbie. Instead, the relation that allows us to recognize Barbie is determined by a coded resemblance in the series. Rather than issuing from some genesis of production, Barbie appears suddenly, everywhere and from nowhere in particular — she is pure appearance; appearance dispersed throughout the repetitions of the code; appearance erasing all historical articulations of the sign: its repression, its deviation, its sublimation, its subversion. The code effaces the real. Rather than just make a forgery that tries to escape detection (which would be to speak the false as if it were true), fabricate an *explicitly* phoney art; an art whose images are only images of other images, ad infinitum; an art of appropriation and image-scavenging that will be as radically superficial as a drag queen's costume or Barbie's femininity.

Taylor drew attention to an area of culture that already conducted itself on just this principle: 'Disco's modus operandi is repetition within the fertile space of the cover version, the re-staging of an original in terms of a specific use-value (dance).'[16] It would take the emergence of house music later in the decade, employing the dilated plateau-effects of the disco break-beat, to demonstrate this with far more force than visual art could perform. But, nonetheless, Taylor intuitively gestured to a critical condition of appropriation art. The crucial assignment of any production method for cover versions or for second-degree language is a purposeful forgetting of the original, its authority and its status. As Barthes put it, 'tolerate only languages which testify, however frivolously, to a power of dislocation'.[17]

Remembering the original — locating it — is an act of veneration and an acknowledgement that no subsequent version will ever be quite what that original was: not as good or bad, nor as silly or profound. The original is the best, even if we strain to admit this against an improved, updated and modernized version. This is because, regardless of how it is evaluated, the original is nonetheless the source of value for all its copies. As long as we recognize the original within its cover version, no matter how remotely, then that cover will appear a poor representation of its source. It is poor not because it is aesthetically less valuable, but because, regardless of its differences, it is dependent on its source. The original will always be there, at the head of the family of its copies or versions — as the font of all of its appearances — commanding their resemblance to it as their essence, because they will always refer deferentially back to it. Any work of art that recollects its descent from the world, or from another work of art, is like a fragment removed or broken off an original state. It exhales its history as a process of fragmentation and diminution. History, notably the history of art, is the lineage of these fragments, traced back to their original totality. The historical consciousness of art, no matter how revisionist, expects an end of art through a redeeming recovery of the work of art's origin.

far left:
13.12 Jenny Watson, *House painting: Box Hill North (small version)*, 1976

left:
13.13 Jenny Watson, *House painting: Box Hill North (large version)*, 1977

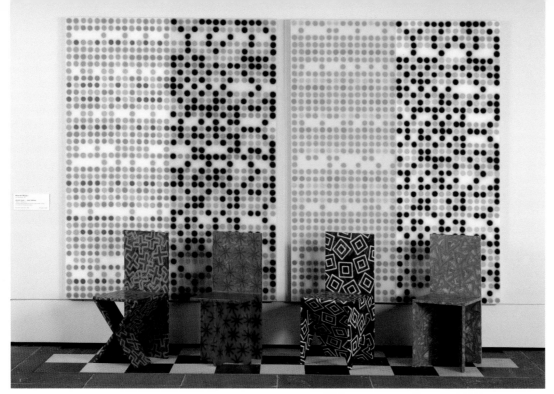

13.14 Howard Arkley, *Muzak mural—chair tableau*, 1980—81

An art of appropriation, however, would require the eclipse of all originals, and the disappearance of originality itself. It would be, consequently, a parody of art's history (radically eclectic, radically plural and, in a sense, style-less because it would be amnesiac); and it would be a post-historical art (detached from the historical narratives of art and thus, unrelated to either an origin or a destination, it would be nomadic). It would also be an unexpressionist art. It would not simply lack the repertoire of psychologically meaningful gestures of expressionism, nor even merely oppose the rhetorical performance of expressionistic art. More than that, it would be an art totally void of expression, but no less capable of appropriating the empty signs of expression.

In dubbing this possible 'new wave' of 1980s art Popism, Taylor sought an association with Andy Warhol's expressionless, serial art, indistinguishable from the commodity form of the consumer icons it duplicated. 'I want to be a machine', Warhol is famous for saying. This art of expressionless appropriation would be an art, indeed, that is not just pieced together from the residue of pirated art, but that is ultimately nothing but a simulation of art itself. In other words, an art that is an evidently false image of precisely what it is not: art. It would be the *code* of art: a practical routine for generating an endless supply of weightless and insignificant copies of art. This is not art about art, for there is no art surviving this nihilism, other than as a fraudulent image sustained in a post-historical anachronism.

This is how that *Matrix* screensaver works, by exposing the code itself beneath the quaint anachronism of a virtual page or a virtual photo on a virtual desktop. You see no longer the representation of work, or the work of representation, but the code exposed in its pure expressionless appearance. But the matrix depicted on your terminal is only the tiniest part of a network of all the screens in the world, and the code links all the terminals. The matrix that you see on screen is the secret but empty sign for the network of machines that allows them to communicate their resemblance to each other. In *The Matrix*, it is the forcefield of virtual communication that supplants the world of so-called real social, political, cultural and economic relations. The matrix is the emblem for all conspiracy theories, the grand unified theory of conspiracy theories. A paranoid theory of everything, in which everything in the world is the sign of a conspiracy to overthrow the world.

Why do we enjoy this screensaver? Because this expressive paranoia seems better than the inexpressive 'desert of the real', better than the joyful disappearance of art into its null simulation…

Why do we enjoy this screensaver? Because this expressive paranoia seems better than the inexpressive 'desert of the real', better than the joyful disappearance of art into its null simulation, a disappearance that we all have lived through since the 1980s, but which many of us prefer not see. The works of art from the 1980s are visible only as an eclipse of that brilliant and blindingly powerful disappearance of art. With all its sound and fury, this is an art in mourning, a shadowy endgame, an insistent phantom. It is like a theology answering to the death of God. But while that extinction of the divine seemed catastrophic to some, it was liberating to others. If God is dead, everything is permitted. And if art had disappeared, anything goes. ¤

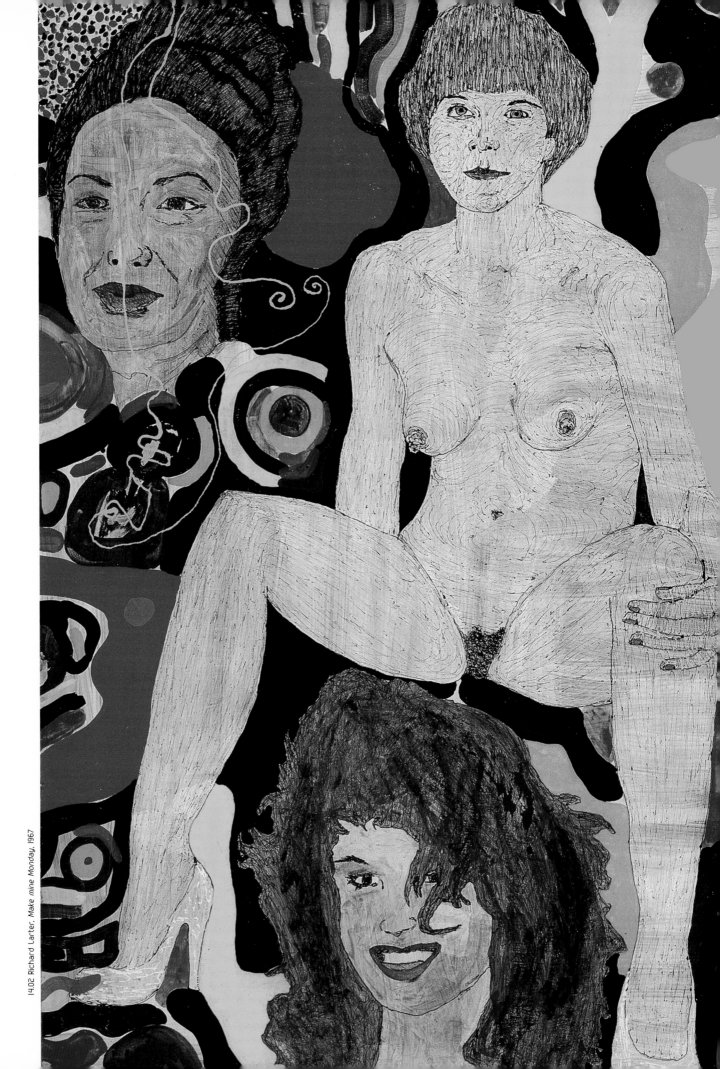

Jennifer Phipps

14.02 Richard Larter, *Make mine Monday*, 1967

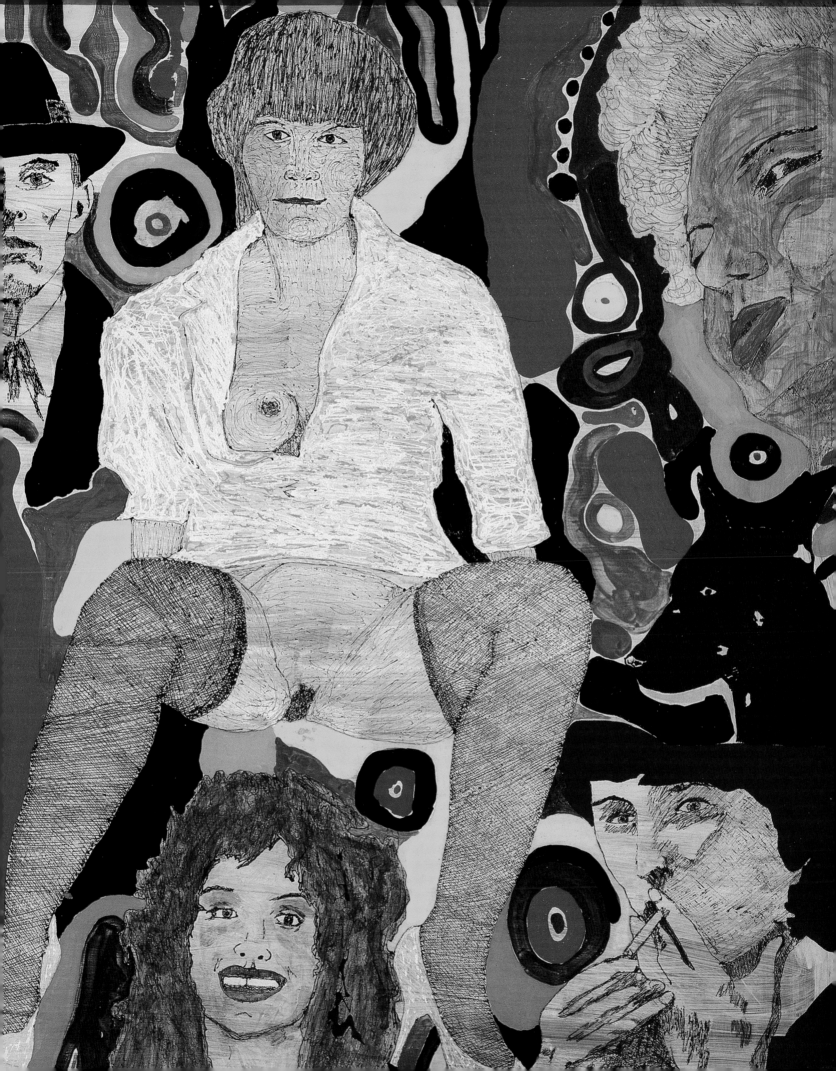

14.05 Richard Larter, *Scatter shift II*, 1980

Who is Richard Larter? Rarely shown — barely known. Said to be a prolific painter — but how few paintings to be seen. Has made over 17 films, but who has seen even one of them? Has produced over 100 collage books, but where are they? Who is Captain Nerf and what is the Utzon-Utzon Mahouly Raga Band or the Orgiastic Rass Band? Is there such a thing as the Richard Larter Blues Band? Did Pat and Richard perform — 'Minders Mind Not', 'Is Art Dead?', 'As Is', 'Living to Learn Together' and 'A Whole Lot of Shaking Going on?' Why did Pat win the Sandie Shaw External Appearance Award? What — you don't know the answers? Well don't worry, neither does the art establishment.[1]

Pat Larter's handwritten, photocopied flyer — made in all probability for exchanges with mail artists around the world — dates back to the late 1970s and succinctly sums up Pat and Richard Larter's art. In her list of Richard's paintings, films and prints — and her allusions to their joint performance art — Pat Larter reminds us that she and Richard always retained their peripheral status as artists. Her words, however, disguise the characteristic Larter ideology. Their vision was an art based on ideas and images from mainstream culture, from investigations around the nooks and crannies of sex, and from their rage against hypocrisy, violence and injustice.

The young Sydney poet Gary Catalano called Richard Larter the great Captain Nerf — a hero Catalano concocted from Captain America, the Easy Rider film character, Captain Earth, and from many comic strips.[2] The band is a tribute to Joern Utzon, the architect of the Sydney Opera House, driven out of Australia by the New South Wales political establishment. Mahouly is László Maholy-Nagy — the Bauhaus artist and designer who worked extensively with collage, a preferred medium of the Larters — or it is an Indian sounding word to match Raga, the classical Indian musical form favoured by hippies, while Rass is a Rastafarian word associated with sanitary products. Dutch mail artist Kees Franke, who also 'mailed' as Spudz and first performed *Art core meltdown* with Pat, gave Pat the Sandy Shaw Award ten years in a row. It is not just that Franke was an admirer of the barefoot teenage singer of 'Always something there to remind me' and 'Puppet on a string'. Music and images from popular music are constants in the Larters' art — Richard's painting *Root ripples stocks*, 1975 (14.01), has Tina Turner as the Acid Queen, singing to the head and shoulders of Pat.

Pat's anarchic comedic performances, camping it up in bowler hats and evening tailcoat, military uniforms, gas-masked with guitar, parodied male roles and male chauvinism. As body art and as a process performance, Silvia Jansons painted clothes onto a nude Pat Larter until Pat reached black invisibility. Pat adopted the persona of porn star, the little maid in white cap and apron who did everything she was told.

Pat was also very active in the mail art movement that emerged from Fluxus, just beginning when the Larters immigrated to Australia in 1962. Fluxus' founder George Maciunas described his movement as Neo-Dada. Fluxus was against the star system, the cult of the individual, sensational innovation, unique, valuable art works, and it maintained a common front against serious culture.[3] Pat's speciality was:

> Fluxamusement ... To establish artist's nonprofessional, nonparasitic, nonelite status in society, but must demonstrate that anything can substitute art and anyone can do it ... this substitute art amusement must be simple, amusing, concerned with insignificances, have no commodity or institutional value.[4]

In the 1970s, from her small study in rural Luddenham, New South Wales, Pat Larter built up an international reputation in mail art. Mail art continues, but lost its momentum in the 1980s. Since they felt they were outsiders, excluded from the art establishment, the Larters found mail art exchanges ideal to discover what was going on around the world. Pat assembled mail exhibitions that toured internationally. Cosi Fanni Tutti and Genesis-P-Orridge, of COUM Transmissions, were favourite mail art pen pals. Pat used rubber stamps, word puns, collages from popular media, photographs and photocopies of herself, performing and modelling.

Pat's anarchic comedic performances, camping it up in bowler hats and evening tailcoat, military uniforms, gas-masked with guitar, parodied male roles and male chauvinism.

1 P. Larter, *Bulk head epic* (mail art stamp), Larter Archive, Art Gallery of New South Wales Library.
2 R. Larter, conversation with the author and letter to the author, 18 March 2002.
3 T. Kellein, 'Fluxus an Addendum to Pop?' in *Pop Art*, ed. M. Livingstone, London, 1991, p. 225.
4 C. Phillpot & J. Hendricks, *Fluxus: Selections for the Gilbert and Lila Silverman Collection* (exh. cat.), MOMA, New York, 1988, p. 14.

The film *Portrait* is a cooperative performance between Pat and Richard and issues as much from Fluxus as it does from mainstream pop art. Pat agreed to be filmed for thirty seconds twice a week for a year. The artists decided before each shoot how the filming would be done — mostly a shot of head and shoulders. Pat changes over the year, almost becoming a different person: her hair grows; she wears home clothes or going-to-town clothes; sometimes her smile is radiant or drop-dead glamourous, lipstick mugging at the camera, or serious, contemplative, but always self-aware, performing for the camera. The Larter goat wanders by in the background as Richard films Pat on their Luddenham farm. The Larters' films succeed each other, like much avant-garde film as experienced by the early Surrealists in Paris who rushed from one cinema to another to see random bits of film which, in their imaginations, made up one film. The films are non-linear — there is no story line — and they have all the surrealist logic of the psyche:

> Pat and I were heavily into film culture and we were attempting a serious effort to make worthwhile underground or independent movies. So it is hardly surprising that this... should intrude into our paintings. We were into jump-cutting shock juxtapositions of images in film so likewise in painting. ...[that is why you discern *Page Three coffee: TATTOOS* as action, movement].[5]

The Situationists are the other strong influence behind Richard Larter's art. Before leaving London, Pat and Richard were close to the English Situationists, like Bernard Cohen who exhibited in 1960 and 1961.[6] Cohen, John Hoyland and others showed large-scale abstracts which challenged the established English painters by the size of their works and their ability to create a more dynamic relationship between the work of art, its environment and the audience.[7] Marx and Freud — social transformation and subjective liberation — are the two great projects of situationism. From an underground movement that began in France in the 1950s, situationist artists believed that art is linked integrally to the social and political, that the subversive use of mass production objects provided the materials and subject of art, and that artists were best placed to convert art from a precious object to a principle permeating daily life.[8]

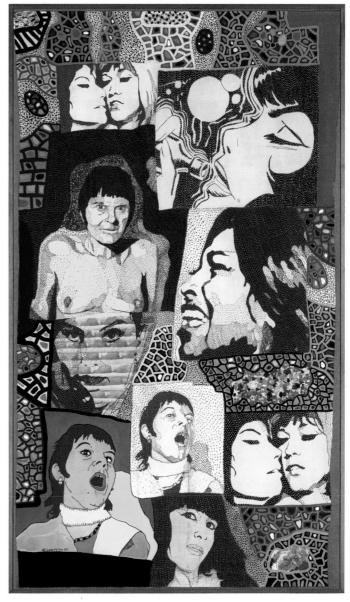

14.01 Richard Larter, *Root ripples stocks*, 1975

Make mine Monday, 1967 (14.02), is painted from enamel squirted onto the canvas with a veterinary syringe. The syringe gave Richard Larter such fine control of the paint that his handiwork was like writing, creating brilliant colour effects. Two nude Pats in a blonde wig sit, legs wide, facing us, as if they are still frames from a film. These are the most vibrant parts of the painting. A suited, hatted man looks between them, dull and uncomprehending, while glamorous women's faces frame the whole picture. The widely differing images in *Make mine Monday* and *Root ripples stocks* are painted flat, all of a different scale, time and place to each other. The painted collages are joined or filled in with patterns and shapes of widely differing colours and forms. Pat appears three times in *Root ripples stocks*. Two German porn-film stars from a cheap girlie magazine are repeated in different scales, colours and textures. Richard's reading of psychology taught him that he must attract people's attention with arresting images to get them to look at the painting as a whole experience.[9] According to the artist, *Roots ripples stocks*, like most of his paintings' titles, is a made-up name, because his dealer said his paintings had to have titles.

Make mine Monday, 1967, is painted from enamel squirted onto the canvas with a veterinary syringe. The syringe gave Richard Larter such fine control of the paint that his handiwork was like writing, creating brilliant colour effects.

5 R. Larter, letter to the author, Canberra, December 2001.
6 ibid.
7 N. Lynton, 'Painting: Situation and Extensions' in *English Art Today*, vol. 1, Milan, 1976, p. 34.
8 P. E. Sussman, *On the Passage of a Few People through a Rather Brief Moment in Time: The Situationist International 1957–1972*, Boston, 1989
9 R. Larter, oral history tape made by H. Topliss, National Library of Australia, Canberra.

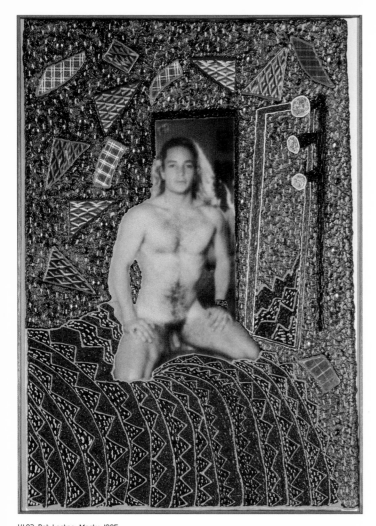

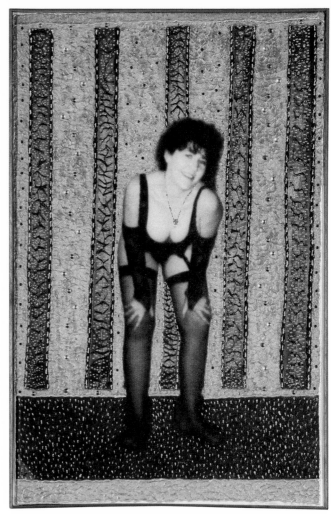

14.03 Pat Larter, *Marty*, 1995

14.04 Pat Larter, *Tania*, 1995

Richard Larter's images are selected from an enormous number of magazines, newspaper and books in the studios of the artists, described by Bruce James as a midden of popular culture, soft and hard-core pornographic magazines, photographs of Pat and models, within which Richard conducts his archaeology of human psychology.[10] His images are often of violence, of political demagogues, posed against the humanity of life-affirming sexy pin-up girls. Pat's portrait, as model or simply her head, is in the majority of Richard's image-collage paintings. Pat is in charge of all the others peopling the canvas. 'I like working the edge, flirting with danger, nearly falling into kitsch: this is where the most interesting things are happening'.[11] The Larters defied public propriety.

Before the Larters' marriage in 1953, Pat Larter, a diminutive fifteen year old with sapphire blue eyes, worked in a London medical prosthetics supply business. Stock included prostheses for limbs, breasts, erectile aids to enable men to impregnate their wives. Pat learnt early of the pathos and vulnerability of incomplete and damaged human beings. Demonstrating prostheses was part of her work, including the occasional evening session. Pat also worked as an artist's model, and studied English at night classes at Toynbee Hall where Richard took night classes in drawing.

Occasionally Pat and her artist-model friend Beryl would sit in the Colony Room on either side of the contemporary artist Francis Bacon. The Colony Room was a small drinking club in London's Soho, favoured by gay men and artists. The execrably tough manager, Muriel Belcher, who greeted men with 'Hello c--ty!', offered different services to club members, including finding them company. Francis Bacon, sitting between two beautiful girls of barely legal age, one tiny and dark, one tall and fair, added a risqué edge. With them, the brightest baubles in the room,[12] Bacon, whose stature as a contemporary painter neared the heroic, was abominably rude to any young art student who approached. So Pat sat with Bacon, while Richard could only wait outside.[13]

Pat Larter's aesthetic was cheeky, irreverent, challenging respectability, with a libertarian sexuality and a libertarian social attitude. She understood camp and empathized with those whose sexual and sensual sides dominated their life. Pat stopped modelling for Richard in the early 1990s and, with her own studio in their

10 B. James, review of 'The Pat Larter Archive', *Sydney Morning Herald*, 7 August 1999, p. 12.
11 R. Larter, 'Crux Criticorum', in *Shadow Cabinet* zine, as 'Madness or Freedom' in *Incondite Incantations*, 2000, p. 104.
12 R. Larter, letter, December 2001.
13 R. Larter, conversation with the author, December 2001.
14 R. Larter, letter, December 2001.
15 ibid.

house in Yass, New South Wales, began exhibiting paintings. *Marty*, 1995 (14.03), and *Tania*, 1995 (14.04), extend Pat's aesthetic of exuberant decoration and youthful sass.

Pat's 'Marty' was a friend of Peter Moloney [a long time collaborator with Pat, a painter and mail artist]. The photo-session is the subject of a video by Peter Moloney showing Pat and Marty at work, posing and photographing. The work is an M.M.T. scan that Pat has over-painted with her signature style with metallic, iridescent, slick 'Tulip' paint and glitter, with inserts made from laser, metallic papers. Her painting of Tania (who was an overworked nurse having a respite from a nonstop night shift at Liverpool Hospital) is, for me, a wonderful reminder of gales of laughter coming from the photographic studio (Windsor's of Bondi Junction). Tania and Pat had fun with the photo session. Again, an M.M.T. superscan of Windsor's tatty wall-paper is given a pulsating substance by Pat's use of Tulip brand acrylic of the 'SLICK', 'IRIDESCENT', 'METALLIC' varieties, with added mirror glass and overlaid with sprinkled-on glitters made fast by Jo Sonja's acrylic varnish. It shows what fun it was to work with Pat Larter.[14]

... an M.M.T. superscan of Windsor's tatty wall-paper is given a pulsating substance by Pat's use of Tulip brand acrylic of the 'SLICK' 'IRIDESCENT', 'METALLIC' varieties, with added mirror glass and overlaid with sprinkled-on glitters ...

Richard Larter has always painted and exhibited abstract and figurative pictures at the same time. He is committed to experiments with process and materials equally in both modes:

I feel basically both *Scatter shift* and *Summer's end* are based on scanning or, to use film language, panning, the eye travels along a horizontal journey across the picture plane, note is taken of changes of colour tone and line that the eye encounters on it across the picture journey, I actually owned and used an office scanner (bought secondhand) to produce prints ... I drew them and scanned them onto a Gestetner skin (plastic) which I printed with a mini roller. I guess it is only to be expected to turn up as a painterly method in what are basically landscapes.[15]

Richard's hobby is reading mathematics and physics books. A voracious reader, he uses the ideas he gleans from physics as the basic ideas for his paintings. *Scatter shift*, 1980 (14.05), refers to Compton's scattering, which provided the first clear and independent evidence of particle light behaviour and which illustrates the particle concept of electro-magnetic radiation. *Scatter shift II*, 1980 and *Summer's end*, 1988, have a white ground with background areas of black, blue and pink. On these are the colours of the spectrum that make up white light. The paintings themselves are puns on the spectrum, painted by coating a foam roller or an acrylic filament pad in white, then dotting or striping the white paint with the colours of the rainbow. Rolling — *Scatter shift II* — or wiping — *Summer's end* — produces repetitive colour dots or sweeps of rainbows.[16]

So these paintings are the artist's meditations on the physics of light — on Rayleigh scattering or on the Tyndall effect that explains why the sky is blue ...

So these paintings are the artist's meditations on the physics of light — on Rayleigh scattering or on the Tyndall effect that explains why the sky is blue (short blue light wavelengths are scattered most by air molecules), why the light immediately around the sun is white and why sunsets are red (long wavelengths become visible when they travel through thick atmosphere). *Scatter shift II* also refers to change in jazz rhythm, and is Larter's expression of light-particle physics, music and landscape.

Thomas Bernhard's mordant short story, *Question in the Provincial Parliament*, reports on a politician discussing local child suicide rates, which are the highest in the world.[17] The deaths are somehow caused by the fame of the unsurpassed beauty of the town, Salzburg. Now, however, a working-class child has committed suicide. As the previous suicides had all been middle-class schoolchildren, did this mean that, without Parliament noticing, the working class had become middle class? Bernhard points out his bourgeois politician's presumptions: even in death, the working class aspires to middle-class status, and social position is more important than child suicide. This is a biting satire on hypocrisy.

The Larters aspire to the same confrontational shock: Richard Larter — the enemy of prudery and cant — once famously said that it was OK to thump your wife, but disgusting to look at her vulva.[18] ¤

16 R. Larter, 'Crux Criticorum'.
17 T. Bernhard, *The Voice Imitator*, Chicago, 1997.
18 R. Larter, interview with M. Cathcart, ABC Radio National, 8 January 2001.

In 1982 the Hobart-born, Melbourne-raised, Sydney-matured and New York-based artist David McDiarmid declared:

> I am interested in popular culture. My work is the intersection between folk art, women's work (needlepoint, patchwork quilts) and contemporary materials. I use loud, cheap and vulgar plastics to make 'pretty' pictures — pieces of wall decoration. Good taste can be a prison.[1]

Much of McDiarmid's art defies classification, existing as it does in the spaces between the accepted categories of high and low art, craft, fashion, design, popular culture and community expression.

A common thread running through McDiarmid's oeuvre from 1975 until his death in 1995 was his desire to bear witness through art to the gay experience of the culture and history of his times. McDiarmid's art embraces the complex, intermeshed histories of art, craft, fashion, music, recreational drugs, sex, social mobility, gay liberation and identity politics, and the impact of HIV/AIDS across the turbulent decades of the 1970s, 1980s and 1990s — in Melbourne, Sydney, San Francisco and New York. Any consideration of McDiarmid opens windows onto narratives about beauty, sexuality, courage, liminality, the immanent and the incandescent, agitprop, pop, and mystery.

While made in 1990, *Body language* (15.01) uses materials that first appeared in McDiarmid's art a decade previously, and it looks back to earlier events that shaped the path of his life. It was around 1980 that McDiarmid had found rolls of holographic plastic film while fossicking in New York's Canal Street district. The colour-embedded layers of this flashing silver film, often replete with hidden holographic images, provided him with the ideal material for making works of art that sought to capture the new rhythms he was experiencing in life. In a series of 'mosaic paintings' fashioned from cut and collaged strips of holographic foil, McDiarmid embraced the often-derided aesthetic of the decorative to construct visual metaphors for the new worlds of music and dance that he was exploring.

In 1979, shortly after moving to New York, McDiarmid had discovered the Paradise Garage, a black and Hispanic gay dance club whose exhilarating atmosphere has been aptly described as akin to 'an expression of a collective joy that went beyond mere pleasure, a sense of shared abandon that was religious in nature and centuries old in origin'.[2] For the next few years David would live virtually solely for the Garage, and structure his life around weekend nights on its dance floor.

Paradise Garage was located at 84 King Street in Lower Manhattan, near Battery Park. Somewhat unpre-possessing from the outside, the Garage's sole concession to disco glitz was a signature neon sign depicting a muscular dancer waving a tambourine above his head. This sign serves as a reminder that dancing in gay clubs of the late 1970s and early 1980s was a far more communal affair than it is in either straight or gay discos today, and it was accepted practice for dancers to bring along tambourines, whistles and cow-bells to rattle, blow and strike in time with certain songs, as well as to wave coloured handkerchiefs in the air or twirl decorative fans in rhythmic unison.

1 D. McDiarmid, artist's statement in *The Australian Experience — Elements of Change* (exh. cat.), Crafts Council of Australia Gallery, Sydney, 1982.

2 F. Owen, 'Paradise Lost', *Vibe*, November 1993, p. 62.

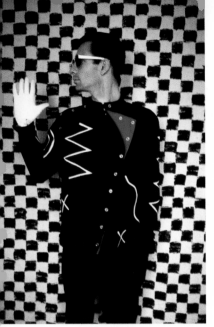

David McDiarmid in New York, 1979

Inside the Garage, the club's members came to feel they were part of a unique family, and bonds of friendship and affection grew up within the walls of this musical Paradise that would have been engendered in no other setting. McDiarmid's friend Sally Gray, taken to Paradise Garage for the first time in the summer of 1979, found the experience of dancing there to be

> a 'Dream' come true, 'Cinderella' dancing with numerous 'princes' at a 'magic' ball where one was 'transformed' out of one's workaday mundane hung-up puritanical struggling contradictory reality... I also had a feeling of having found my 'tribe'. The people I could dance with as I've longed to dance all my life (dreamed of dancing). Here were the partners who could 'understand', 'read' my dancing & respond, and I could get energy from their skin, their bodies to keep me going.[3]

The Garage produced an experience which it is hard to recapture today, and perhaps impossible to understand for anyone who has not passed such a night anywhere, totally enmeshed in a seemingly never-ending fantasy whirl of hallucinogenic drugs, hypnotically intoxicating music and sexual magic — real and imaginary. Aside from its obvious hedonism, the dance floor was for McDiarmid and his circle a place of community, affirmation, love, respect and sanctuary. The success of the Garage depended almost exclusively upon its DJ, Larry Levan, a figure still legendary in the annals of dance music. Legions of 'Garagers' still recall:

> Levan showed just how much creative control a DJ could exercise, and with one of the most devoted and energetic groups of clubbers ever, used the Garage to preserve and amplify much of disco's original underground spirit. In doing this he carved out an oasis of shared pleasure in a city that was [in the time of AIDS] becoming increasingly ruthless, and grew to enjoy such a passionate relationship with the people on his dancefloor that they worshipped him more or less as a god.[4]

For many patrons, preparation for 'service' at the Paradise Garage included the ingestion of MDA. A euphoric and mildly hallucinogenic drug, MDA imparts feelings of calm, inner beauty and complete confidence; it also has a phenomenally sensual effect upon the muscles of the anus, making it the ideal gay man's dance-floor drug. When combined with acid (LSD), MDA induces a powerful awareness of rhythms, patterns, colours and visual associations. Under the spell of these drugs the eye's sensory recording enmeshes itself inextricably with the beat and strobing sounds of dance music in a joyous blur of true synaesthesia.

A wondrous collaged mosaic of light, the holographic silver foil shapes cut and pasted into *Body language* look back to the transcendental evenings McDiarmid had spent on the dance floor of the Paradise Garage.

A wondrous collaged mosaic of light, the holographic silver foil shapes cut and pasted into *Body language* look back to the transcendental evenings McDiarmid had spent on the dance floor of the Paradise Garage. The refractions of light that occur as one moves in front of the work echo brilliantly the relentless beat of dance music, the sweat-laced sheen of bodies driven to exhaustion under the spell of a DJ's divinity, the shriek of whistles blown by hundreds of gay men back and forth across the dance floor, the mathematical precision of coloured

3 Diary of Sally Gray, Friday 6 July 1979, private collection.
4 B. Brewster & F. Broughton, *Last Night a DJ Saved My Life. The History of the Disc Jockey*, New York, revised edition, 2000, pp. 271–2.

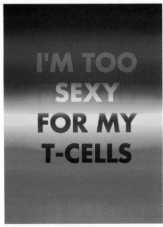
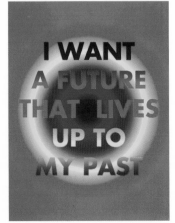
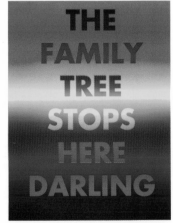

15.02, 15.03, 15.04 David McDiarmid: *I'm too sexy for my T-cells*; *I want a future that lives up to my past*; *The family tree stops here darling*, 1994

handkerchiefs and fans thrown and twirled through the air by dancing diva-queens, and the luminescent pulse of the mirror-ball high above the dancers' heads. At the centre of *Body language*, the dancer's buttocks are spread, for the gay viewer at any rate, in a come-hither gesture of amorous invitation, and the all-seeing eye of MDA winks out from the sensuously splayed anal font.

If this body bespeaks the euphoria of the dance, the language tattooed upon it points to a dark swathe which was, all too soon, to cut through the disco crowds of McDiarmid's world. As early as 1982 New York was awash with rumours of the new 'gay cancer'—yet to be identified as the universal scourge of HIV/AIDS. When the Paradise Garage closed in 1987, its demise was prompted by the AIDS diagnosis of its proprietor, Michael Brody. The party was over. In 1987 McDiarmid was also diagnosed as HIV-positive. He left New York for good, and returned home to Sydney to live.

Body language both celebrates the world of gay dance culture, and memorializes friends who have passed from it. In 1984 Herb Gower became the first of McDiarmid's friends to die from AIDS-related complications. His name is inscribed on *Body language*, along with the names of other friends of the artist who would succumb to AIDS in the 1980s — Paul, Brian, Carlos, Tony, Alan, Carl, Chris, Keith... The swastika within which the letters AIDS are entwined on the head of this 'body' is not, however, meant to equate the scourge of AIDS and the homophobia it has engendered with the dark forces that today are universally associated with this symbol. For McDiarmid uses not the Nazi swastika, but the left-directional Hindu sauvastika. As both sign of the violent goddess Kali and symbol of night, and of magic, this sauvastika poignantly recalls how so many of the Paradise Garage's patrons were innocently and unwittingly engaged in an ironic Dance of Death.

Body language was first seen publicly in *Kiss of Light*, McDiarmid's solo exhibition at the Syme Dodson Gallery in Sydney in 1991 that considered the taboo of HIV-positive sexuality. At that time McDiarmid wrote of his post-AIDS view of the world:

> In the Age of AIDS, it is important for us to remember our past. To maintain a sex-positive view, despite the denial that comes too easily from fear. [My] pictures of men are for those of us who might forget who we are.[5]

Body language is about sexuality and defiance, as much as it is about fragility and loss. While its imagery is sexually explicit, the work is also an elegy to brilliant young lives cut tragically short. ¤

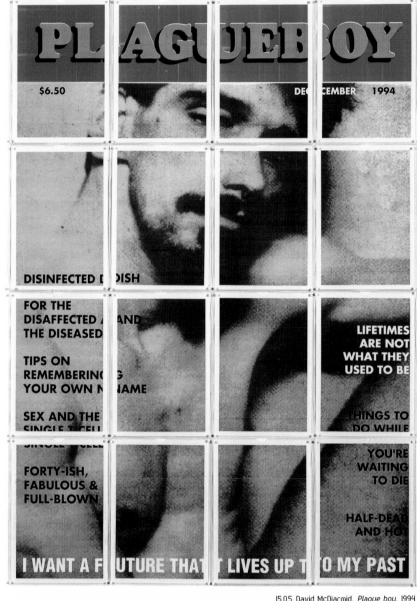

15.05 David McDiarmid, *Plague boy*, 1994

5 D. McDiarmid, *Kiss of Light* (exh. cat.), Syme Dodson Gallery, Sydney, 1991.

By 1990 Australian postmodern art was already a past-tense period style. Its institutional and academic success, though, had been so complete, so quintessentially 1980s in its overkill, that it would be more accurate to speak of postmodernism's aftermath than its aftershocks, for nothing would really be artistically shocking from this point on, except in the eyes of the belatedly and self-consciously scandalized.

The 1990s, instead, saw the re-emergence of political and social narratives in art backed by artists' stubborn persistence, evident in exhibitions such as the 1997 and 1999 Sydney Perspectas or the 2000 Adelaide Biennial, in the belief that identity and issues matter, and that a real sense of agency or belonging beyond simulacra might still be possible. At the same time, art's affective ability almost disappeared, more or less just as French postmodern theorist Jean Baudrillard's Australian disciples predicted. From the ashes of postmodern style, the optimistic evolution of postcolonialisms and multiculturalism focused on the art world's almost mystical valorization of difference. But at that very moment, a conservative reaction was about to sweep such debates two decades backwards.

The 1990s saw a frantic succession of new technologies, each of which artists immediately annexed. But the new media intersected with the inexorable force of a globalism that reorganized and recentralized the international art world, creating a new gap between, on the one hand, local artists facing outwards towards a global art economy completely at ease with the most radical reformulations of identity and art, and on the other hand, regional artists looking inwards, towards provincial continuity.

Many artists identified social or personal transformation with art — a dubious identification historically — and this was symbolized, for many, by participation in events like the 2000 Sydney Harbour Bridge walk for Indigenous reconciliation. But such noble sentiments were a minority, as was proved by the wide public approval for the imprisonment of asylum seekers during 2001. A gulf between artists and unpleasant facts was not peculiar to the 1990s, but its increasing scale would, perhaps, not have been expected at the start of that decade.

Why point this out? Because the shape and fate of art is not divorced from society so inexactly that we can't begin to recognize the extremity of the 1990s gap between artistic vision and the external world through the hyperactive cinematic lens of The Matrix (directors Andy and Larry Wachowski, 1999), a film that eerily summarized all of the contradictions and disparities of the 1990s. The gap between the script and reality — between how history was expected to turn out and where artists really found themselves in 2002 — accounts for a natural art-critical solidarity, and a general reluctance to admit the fiercely combative and irreconcilable differences during the 1990s between contemporary artists as seemingly like-minded as Imants Tillers, Gordon Bennett, Tim Johnson and Narelle Jubelin. History, identity and place are joined under the sign of the postcolonial, but not, in fact, like happy families.

DF91

16.01 Imants Tillers, *Quest: I the speaker*, 1988

Imants Tillers's great painting *Quest: I the speaker*, 1988 (16.01), imagines such a family—a family of images, analogies and correspondences penetrating each other across space and time. A decade or more after its making, we picture Tillers's imagination a little differently; we've come to be suspicious of cultural convergence—and of the appropriation of others' voices, whether ethical or not. When Tillers painted *Quest: I the speaker*, hostile critics questioned his technical and artistic ability; nowadays, we are more likely to wonder at his presumptuous identification with others. This doubt is just as much a reflex as any other, and is not necessarily correct, for Colin McCahon, whom Tillers quoted with fervent sincerity across the surface of this painting, did not need to be protected from Tillers's eclectic adoration. As it turns out, Tillers was acutely aware of what we might call his 'speaking position', and his title confirms just this. About the same time, Anne Zahalka was photographically restaging a famous painting of an Australian surf beach, *The surfers*, 1989 (16.02) swapping blond Anglo surf lifesavers and girlfriends with a rainbow cast of different ethnicities.

> Zahalka's and Tillers's works ... took the grammatical forms of post-modernism — its compulsive translation and retranslation of received texts, its appropriation of motifs and quotations.

Zahalka's and Tillers's works and, more crudely, their careers, seemed to represent the optimistic intersection of postmodernism and multiculturalism. At the end of the 1980s both were contributing to a rapidly evolving and instantly appreciated, immediately collected, corpus of new art that took the grammatical forms of postmodernism—its compulsive translation and retranslation of received texts, its appropriation of motifs and quotations. They subordinated postmodern ambiguity under the systematic exposition, almost parodic in its stamina, of an authenticity that was, nevertheless, always located outside the text, which is to say outside the work of art.

Was this to be the distinctively Australian solution to our geographic position and short post-settlement history? It was not necessarily the only approach, as Bonita Ely's enormous genealogical list, *Histories*, 1992, showed (16.03). Ely's vast print, a combination lithograph and woodcut, was neither modernist nor postmodernist, for her relation to sources was fixed by pre-modern analogy rather than postmodern allegory, by a highly mobile, fluid conception of signature style that altered from work to work, and also by a complete disinterest in either postmodern irony or modernist redemption through art.

1990 **John Cain resigned as premier of Victoria in August amid major woes in the state's financial and manufacturing sectors. Joan Kirner took over as Victoria's first female premier. In Sydney, the Biennale was stripped of its heart when room could not be found for a shipping container full of great Neo-Dada and Fluxus works. By the end of the year, the country was officially in recession.**

Almost immediately, the works of Gordon Bennett and Juan Davila made it clear that user-friendly multiculturalism would be tested to the limit, and that the new-found broad-mindedness of the art world and art audiences would be forensically examined for closet racism. Bennett quite consciously dissected Tillers's works in the course of many paintings. Comparing *Quest: I the speaker* with, say, Bennett's *Possession Island*, 1991, or *Home décor*, 1997 (16.04), we can note that Bennett asked a series of acid questions about why we would

celebrate the renaissance of Aboriginal art and why we *would* contribute to its de-specification, its removal from its localized, semi-private meanings. Bennett's particular and very political strategy of appropriation was viewed by different writers as an analytic device, as deliberate plagiarism, as an assertion of identity, as a denial of originality and authorship, and as a savage critique of western art history's modes of representation.

An encounter with Bennett's paintings in their material fact, rather than in reproduction, was a surprise because, like Davila's *Portrait of Bungaree*, 1991 (16.05), they were carefully crude and cartoon-like. There was a reason: roughness and ugliness showed up the rupture *inside* a painting — between its specificity and its modernism — and recapitulated the ubiquitous history of shoddy exploitation. Thus, the two artists' very different works consisted of palimpsests of quotations from their contemporaries or from the art of the recent past.

Most crucially, Bennett and Davila probed the magnanimous tolerance of the Australian art world, exaggerating the 'appropriated' imagery of 1980s postmodern art. Effectively, Bennett's and Davila's paintings attacked the postmodern art of the 1980s, and forced us to ask hard questions about other artists' and critics' fuzzy good intentions. Like caricaturists both artists overlaid one-line meanings with strategies of striking collage, wildly inventive exaggeration and operatic rhetoric that could be used to resist or evade the West's dominance over the safely political meanings of art. Both artists managed a double act, producing something as determinedly old-fashioned and conservative as figurative paintings on canvas, but from a position outside western painting and without assuming the cloak of the 'authenticity' of so-called traditional modes of either postcolonial or Indigenous art production. Both understood that these were all completely contested terms, and that authenticity was a stylistic device.

Quite obviously, however, the key, emerging importance of both Western Desert synthetic polymer painting and Arnhem Land bark painting within a still-evolving global narrative of abstract painting was overlooked. It still remains relatively under-theorized, apart from Ian North's highly original essays.[1]

16.11 Jeff Gibson, *Screwballs (Frustration/aggression)* 1992

1991 **Economic recession wiped out the lifestyles and the collectors of many painters, and many important galleries disappeared. The collapse of the art market eventually opened doors for new ways of exhibiting and making art. Paul Keating took over as prime minister. This, for the art world, heralded outspoken support for the arts. Keating avoided wealth redistribution in favour of a high artists' focus on identity.**

16.02 Anne Zahalka, *The surfers*, 1989

1 Australian art history was marked by fierce polemical positions regarding Indigenous art from this time on. These were represented, on the one hand, by Eric Michaels, Terry Smith and Roger Benjamin, and by Tony Fry, Anne-Marie Willis and Ian McLean on the other. Davila's and Bennett's clear-sighted refusal of easy cultural convergence was depressingly vindicated again and again as the decade went on. Many theorists, including Elizabeth Gertzakis and Ghassan Hage, wrote about the continuing dominance, tokenism and almost humorous dysfunction of the predominant Anglo-Celtic cultural hegemony. Although I have come to reluctantly share their bleak perspective, I think that Howard Morphy proposed a quite different, but more productive, inversion of diaspora: 'World art history would be rewritten in relation to present Aboriginal art practice. Australian art would be seen from this perspective, as one stage in the history of Aboriginal art.' H. Morphy, *Aboriginal Art*, London, 1998, p. 420. For an attempt to imagine another critical position beyond the neo-colonial double-bind, see Ian North, 'StarAboriginality', in C. Green (ed.), *Postcolonial: Where Now?*, Artspace Visual Arts Centre, Sydney, 2001.

16.03 Bonita Ely, *Histories*, 1992

Narelle Jubelin's precisely calibrated, fastidiously assembled installation, *Trade delivers people*, 1989–90, appeared right on time, as if to answer the questions posed by Bennett and Davila. How could a white artist describe Australian history? Jubelin took two diametrically opposed artistic strategies — the neo-formalist readymade that could be traced to late-postmodern artists like American Meyer Vaisman and, before him, to Dada master Marcel Duchamp himself; and the model of 'artist as exhibition curator' that evolved during the conceptualist 1970s.

Trade delivers people, in fact, effectively defined a whole genre within 1990s Australian art at its inception — it preceded works by Janet Laurence, John Wolseley, Elizabeth Gertzakis, Peter Cripps, Susan Norrie, Louise Weaver, Danius Kesminas, Mike Stevenson and Ricky Swallow — in which the roles of artist and curator were blurred in the course of artists' 'interventions' in museums and archives. When the work was acquired by the National Gallery of Victoria, Jubelin was engaged to expand the number of its components, by identifying objects within the collection that would henceforth become 'part' of her work (16.06). Completing new petit-point embroideries to match, she widened her description of the international system of colonial exchange in which Australia was linked to India and beyond, to an Empire in competition with that of other colonial powers — here, to pre-World War I Germany. Her critical strategy — upon which the work's legibility as something more than a pretty display depended — was basically to demystify political and social relationships through visual puns and identifications. Her collaborative relationship with institutions reflected Australian museums' willingness to rewrite Australian history, and artists' immediate identification with this project.

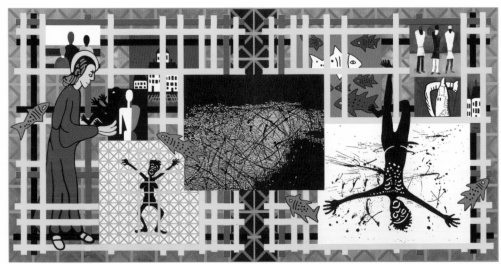

16.04 Gordon Bennett, *Home décor (Preston + de Stijl = citizen) panorama*, 1997

By the early 1990s, as a comparison between Tillers, Davila and Jubelin shows, it was no longer possible to reduce the artistic relationship between societies at the periphery (like Melbourne) and those at the 'centre' to that of postmodern copies and appropriated originals; postmodernism, at least as a style, was finished.

As long ago as 1978, in his book, *Orientalism*, the influential Palestinian–American critic Edward Said analysed the tension inherent in colonizing discourse: a conflict between an imperial vision of domination that fixes others' identities that he called 'orientalism'; and the need to acknowledge specificity in place and time that then allows for difference and change.[2] In Said's schema, the displacing returned gaze of the West's colonized double constantly threatened its civilizing mission; the imperfect imitations of the postcolonial subject disrupted postmodernism's discursive authority and displaced its fixed identities.

This insight became rapidly overfamiliar during the early 1990s as postcolonialism inflected most critics' understanding of Australian art. The implication was that modernism and postmodernism were culturally conditioned and that, translated to an Australian or ex-colonial environment, they could not embody any trace of avant-garde agency, the power that European non-objective abstract artists aspired to early in the twentieth century. This, in turn, implied that postcolonial artists such as Juan Davila or Dale Frank would be interested in the avant-garde's opposite — kitsch, which unambiguously appeared in Frank's grand, glossy painting of an abstracted orifice, *The artist's fairyfloss sold on the merry-go-round of life (sucker dealer): sucker dealer and the righteous anus*, 1991 (16.07). Frank's distance from the 1980s was stained by signs of that decade's reverence for ambivalence, and thus the rhetorical sincerity of his painfully glutinous paintwork and allusive (presumably biographical) title, rather than presenting a rupture from 1980s author-free appropriation and simulation, was a logical continuation of the same set of critical problems and concerns.

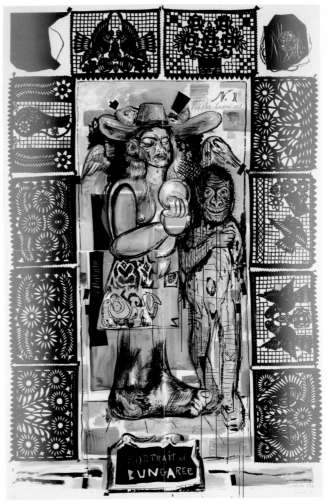

16.05 Juan Davila, *Portrait of Bungaree*, 1991

Most Australian artists would henceforth be torn between a desire to make images of identity, and an almost diametrically opposed desire to make simple, straightforward objects. Rex Butler, in *An Uncertain Smile*, carefully set out the paradoxes: a stream of artists, running from Frank through so-called 'grunge' artists (including Adam Cullen and Hany Armanious), wished to rewrite the logic of appropriation art.[3] They wanted to acknowledge two conditions simultaneously: that a work of art always has an intention (this is art) and at the same time a hidden or extra dimension (this can only ever be a work of art in front of an audience). Butler described this paradox as the problematic of intentionality — the work of art must both *be* and *be about*; it must exist and be self-critical. Frank's picture was so grossly but cleverly rhetorical, and its title so over-insistent and determining, that his

They wanted to acknowledge two conditions simultaneously: that a work of art always has an intention (this is art) and at the same time a hidden or extra dimension (this can only ever be a work of art in front of an audience).

big, yellow-green painting placed the undecidability of art (the impossibility of *really* determining *the actual* meaning) on its very glossy surface. In other words, artists sought to destabilize the status of the art object but simultaneously banked on this status. The camp ambivalence that Butler so painstakingly explained persisted through the decade, underwritten by the task of perpetual neo-modernist mourning.

1992 **The film *Strictly Ballroom*, released to great box office success, reconfigured Australian identity with an arch, highly strategic eye towards marketing Australian identity as a successful cultimulti creole blend. The Earth Summit in Rio provided a sombre assessment of the world's state of ill-health, including grim predictions of climate change. The High Court ruled that the people of the tiny Murray Island had retained title over their land. The Mabo ruling triggered years of political manoeuvring over the legislative framework with which to deal with native title. Public discussion shifted from land rights to native title, but subsequent legislation enshrined a logic that implicitly relied on a culturally static view of Aboriginality. In Victoria, Jeff Kennett was elected to government, kicking the Federation Square precinct into existence and fast-tracking the NGV's historic redevelopment.**

2 E. Said, *Orientalism*, 1978, London, 1985.
3 R. Butler, *An Uncertain Smile: Australian Art in the '90s*, Artspace Visual Arts Centre, Sydney, 1996.

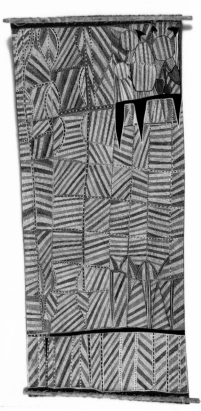

16.12 John Mawurndjul (Kuninjku)
Mardayin cermonial designs from Kakodbebuldi,
1990

It must now, surely, be granted that cultural practices develop out of local circumstances, and it could have been remembered that some localities (for historical, political, economic and ideological reasons) are thought to be of global significance while others are regarded as minor. This is particularly the case when Europeans compare European art history with that of Australia or South America, whether by diasporic whites or blacks. Historically, European artists have treated colonies as an exotic source for their own work but, more recently, descendents of the Anglo-Celtic diaspora have not quite shared this perspective, though the distinction is largely lost on both artists and audiences.

Postcolonial status is both a perspective and a position, imposed by geography and history on both non-Aboriginal and Aboriginal artists, with different effects. Rosalie Gascoigne's *Clouds III*, 1992, and her magisterial *Plainsong*, 1988, (16.08) should be seen in relation to Emily Kam Kngwarray's later paintings, despite the biographical differences. Both artists aestheticized essentially arbitrary, sensory processes, yet both hid the secret traces of presence and present-ness under an almost compulsive drive to orderliness. Both artists would have been appropriate, complex subjects for feminist scholars of the generation influenced by Luce Irigaray, for though Gascoigne was usually portrayed through her own self-representation as a 'bush sculptor'—an untrained, intuitive artist—her tightly organized arrangement of debris dispersed sensual incident across the whole visual field.

1993 **Weary Dunlop died and was commemorated in his native Melbourne by a Peter Collett sculpture. The *Native Title Act* was passed in December. The first Asia Pacific Triennial opened at the Queensland Art Gallery, Brisbane, to become the most important international art exhibition in Australia, eclipsing Sydney's Biennales.**

Tim Johnson painted *Amnesty*, 1993 (16.09), within the optimistic context of seismic shifts like the Mabo ruling and native title legislation. He had, of course, been intimately involved with Aboriginal artists at Papunya from 1980 on, as one of the few committed collectors of Papunya Tula paintings, as an adviser and friend of the artists, and as their occasional assistant and pupil. In the course of his experiments in cross-cultural artmaking, he began to incorporate Aboriginal motifs beside schematic renditions of campfires, landscapes and portraits of his Papunya friends, all rendered from his slides and photographs, embedded in atmospheric fields of dots and calligraphic marks like early pictures by Jackson Pollock or by Mark Tobey. *Amnesty* took Pollock's Abstract Expressionist conception of the painting as an arena, translating this into the antipodean idea of a painting as an Edenic place of cultural reconciliation and collaboration. Johnson described the Australian desert as 'a metaphor for a more universal kind of consciousness in which many realities are possible' and then related this directly, as we see in *Amnesty*, to 'the Buddhist Pure Land theme that has been a subject of my painting for a number of years'.[4]

Since Johnson had carefully negotiated permission from his Aboriginal friends to use their designs and since they participated with him in sustained collaborations upon many pictures, he could never be justly accused of casual, cultural appropriation. But just as Gauguin's Tahiti had been his own erotic fantasy—it never existed as he dreamed it—so artists from the Anglo-Celtic diaspora, artists from outside the 'centre', had to struggle to avoid stereotyping themselves. The exceptions, perhaps, were recent immigrants such as photographer David Stephenson or painter John Wolseley, who lived out an older role, that of topographical artist and nomadic observer of ecological change.

Some writers have implied that Johnson was naive, whilst others have exempted him from criticism on the grounds of his sincerity. We should ask, instead, what he gained from his access. In a 1991 interview Johnson described how Papunya provided him with a 'more substantial' (Nicholas Zurbrugg's term) body of material than 'mass-media imagery.'[5] From Johnson, who was one of very few contemporary artists with a deep, real investment in popular culture and electric rock music, this was highly significant. It slowly became clear, as Johnson implied and as sociologist–art critic Vivien Johnson explained in her remarkable, detailed books on Papunya artists, that the periphery may be exotic but it had never been 'pure' on either side of the racial divide.[6] The artists who seemed most 'authentic' (Western Desert painters, for instance) had often been willingly and knowingly engaged in cross-cultural contamination and innovation—in a constructive hybridity like that of cross-cultural folk or rock music. At the same time, Johnson was remarkable—and almost alone—in overcoming the dominant white culture's well-meaning timidity, which was the flip side of its arrogance.

4 T. Johnson, artist's statement, 'Apropos', in *Tim Johnson* (exh. cat.), Mori Gallery, Sydney, 1999.

5 T. Johnson (1991) reprinted in *Tim Johnson: Chicago International Art Exposition, 14–19 May 1992* (exh. cat.), Mori Gallery, Leichhardt, 1992. The statement had been extracted from Johnson's interview with Nicholas Zurbrugg, *Art and Australia*, vol. 29, no. 1, 1991.

6 V. Johnson, *The Art of Clifford Possum Tjapaltjarri*, Sydney, 1994; V. Johnson, *Michael Nelson Jagamara*, Sydney, 1997; V. Johnson, *Aboriginal Art in the Age of Reproductive Technologies*, Sydney, 1996.

16.06 Narelle Jubelin, *Trade delivers people: second version*, 1989-93 (detail)

The Brisbane Asia–Pacific Triennial, which commenced at this time, trod the same tightrope. Like Johnson, the three Asia–Pacific Triennials forged real connections across several cultures. Such meetings did not necessarily result in better art (though they resulted in spectacular and historically important exhibitions), but they highlighted the particular place of contemporary Australian art, in contrast to modern art in Asian countries, as grounded in socially sanctioned dissent. Both Johnson's and his Papunya Tula friends' works, however, could still be compared rather than contrasted to modern Asian art: both modern Asian art and Desert painting were linked with the experience of modernity, but they were not necessarily the result of a straightforward diffusion of influence at all.

As Australian artists and critics encountered the heterogeneous and regionally specific fields of Asian modernism and Asian contemporary art, they began to understand, in turn, that the ongoing, rapid evolution of Aboriginal art in non-urban areas continued despite its general independence from the so-called mainstream of white Australian art. In other words, non-urban Indigenous artists made innovations in terms of the renovation of painting — as opposed to their celebration of country — without any connection to the Melbourne or Sydney artists to whom their works would be productively compared.

In his pioneering and immensely influential book, *Australian Painting*, Bernard Smith developed the history of Australian art through painting though, as we now know, he incorrectly presumed the indexicality of that medium as an accurate representation of Australian art.[7] Smith traced a series of transitions and responses to European modernity, in response to which other historians, such as Ian Burn, began to work out opposing perspectives. Smith's ground breaking history was based on time lags, indexicality and causality, but every culture is located in a more complex matrix of relationships than this. To characterize these relationships, we need to return to the image of a matrix.

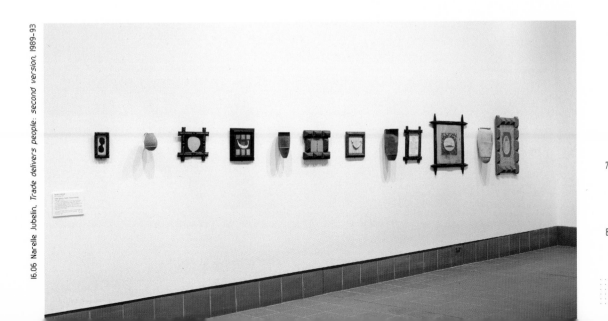

16.06 Narelle Jubelin, *Trade delivers people: second version*, 1989-93

7 B. Smith, *Australian Painting 1788–1960*, Melbourne, 1962; reissued as B. Smith and T. Smith, *Australian Painting 1788–1990*, Melbourne, 1991; the later chapters on art since the 1970s are by T. Smith; also see I. Burn, *Dialogue*, Sydney, 1991.

8 B. Smith, *European Vision and the South Pacific 1768–1850: A Study in the History of Art and Ideas*, Oxford, 1960.

16.13 Louise Hearman, *Untitled #563*, 1997

Understanding 1990s Australian art, in particular, requires understanding its shape as a matrix rather than through the provincialism problem. The matrix includes largely autonomous micro-narratives that encompass the most significant art, bigger and smaller neighbours, an acknowledgement of our own sphere of influence, the ability to chart cross-national and two-way influences and, finally, a comprehension of irreversible, unavoidable imperial dominance. Even so, there are limits to relativism. Smith, throughout *European Vision and the South Pacific*, had argued with masterly logic that the eighteenth-century European centre was altered by antipodean contact that problematized neoclassical style.[8]

At this point, looking at Johnson, Jubelin, Davila, Bennett, and above all at Kngwarray and Gascoigne, appreciating their specificity and their connectedness to other artists, we begin to see the edge of the postmodern and postcolonial frameworks — the limits of relativism — as the means to understanding 'our' own art history.

Film-maker and photographer Tracey Moffatt was 'our' most celebrated Australian artist of the decade, but her work did not make sense as self-disclosure — certainly not outside a narrow regional context — for at least one important reason, aside from her own, fierce refusal of regional or ethnic categorization and her enormous visual debt to global film history. Moffatt calibrated her work so precisely that she was able to communicate to international audiences in what, effectively, were memorably iconic image-grabs 'about' the quasi-autobiographical subject matter of families profoundly affected by the tragedy of racism during the period of the stolen generations. Although this suggests that her works, from *Something more*, 1989, to her *Up in the sky* series, 1997, would be understood through the culture of redemption and through her Aboriginality, I think this is not true at all. Moffatt's beautiful, powerful photographs were clear-sighted, bleak and consciously global in concept, for her ethical allegories about social connection were staged without any sense of redemption, least of all through a celebratory idea of regional art.

1994 **A February poll showed that sixty-three per cent of Australians were in favour of an Australian republic. Paul Keating unveiled 'Creative Nation', a package of arts initiatives including a film studio for Sydney and $84 million for multi-media, for a technology that almost immediately disappeared as the focus of new media development. Athlete Cathy Freeman celebrated her victory in the Commonwealth Games by folding herself in both the Aboriginal and Australian flags during her victory lap.**

16.14 Hany Armanious, *Untitled work*, 1996

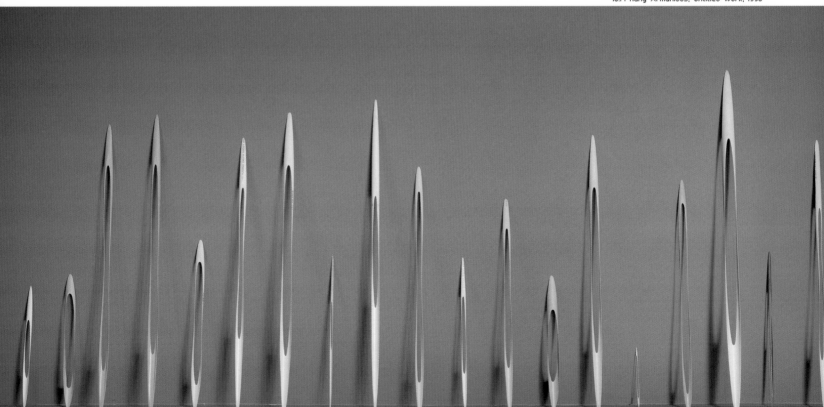

Mikala Dwyer, Constanze Zikos, Mutlu Çerkez and Kathy Temin were part of a loosely linked mid-1990s Melbourne and Sydney milieu that owed its initial neo-formalist character to the impact of artists Tony Clark and John Nixon. Clark and Nixon were important both as charismatic teachers, alert to the creative possibilities and prestige of carefully curated alternative spaces, and as exemplars of a modernist painting that, one might have thought, would have been sideswiped by 1980s post-modernism. On the contrary, Nixon's genuine link to 1970s conceptualism, and Clark's to the postmodern rediscovery of an anti-modernist, classicizing Return to Order, showed a younger generation a way to connect themselves to earlier periods of art, and above all to the 1970s.

Zikos's *Fake flag*, 1994, even preserved that period's satiric, socially critical trajectory (16.10). *Fake flag* is both a satiric, postcolonial emblem and, in its glossy blankness and bulk, a neo-minimalist object. Its media are weirdly mixed: laminate, enamel paint, crayon, metallic and plastic self-adhesive tape on composition board. The combination implies its archaeological and subversive presence and, as critic Robert Schubert accurately wrote, 'The effect is one which ironically suggests that the Greeks invented, among other cultural practices, Frank Stella's Day-Glo patterns, or more particularly Richard Artschwager's Formica sculptures. And all this while taming this counter-memory with the popular material of Greek-migrant suburbia'.[9]

For the most part, though, a prevailing art school amnesia about local histories was further entrenched by 1995, as state galleries withdrew from historically focused or survey shows of contemporary art, in favour of the guest-curated biennales and triennials that proliferated worldwide. Worse still, most static art (painting, sculpture, even installation) in both artist-run spaces and commercial galleries bore little sign of any reflection on mid-decade political change, although they were clear and obvious exceptions, especially the work of Indigenous artists. The list of seven years of shows at First Floor — one of the best alternative artist-run spaces in Melbourne — showed no significant indication of vast social shifts in Australia, or even locally. At the level of the language of art itself, there was now little reflection of the world outside as there had been in the conceptualist 1970s. More precisely, there was scant indication of protest against trends in the world outside the studio, except through now-academic recapitulations of the semiotics and semantics of consumer culture.

16.08 Rosalie Gascoigne, *Plainsong*, 1988

9 R. Schubert, 'Constanze Zikos', *Agenda*, nos 26–27, November–December 1992 and January–February 1993, p. 14.

16.09 Tim Johnson, *Amnesty*, 1993

1995 **Helen Demidenko was awarded the 1995 Miles Franklin Award for *The Hand that Signed the Paper*, which she presented as a genuine account of her family's life in the war-torn Ukraine of the Holocaust. Her real identity as Helen Darville, daughter of two Anglo-Australians, was revealed. The book had been a fiction, and researchers found many passages closely adapted from other writers' books. This reinforced a reactionary view that the politics of both ethnicity and postmodernism were fraudulent.**

Faced by the developing reaction against political correctness, which gradually solidified into the sterile culture wars of the late 1990s, a number of artists and writers began to take issue with the very idea of 'postcolonial' and 'multicultural', explicitly questioning the Australian art-critical understanding of such issues as the terms hardened into a curatorial lingo and into loose, catch-all rubrics of hybridity and celebration. They dimly began to grasp the penalty for failing to distinguish between cultural *theft* and trans-cultural *appropriation*. Theft included many clear instances of cultural deception and Indigenous copyright robbery by unscrupulous or naive whites; these are charted by Vivien Johnson and her students. Trans-cultural *appropriation*, however, should have been defended — except where it caused damage — as part of the fair-dealing exemption at the core of intellectual freedom and copyright law. The penalty for overlooking this distinction was linked to contemporary art's inability to communicate on social issues beyond the sentimental or to the converted, and to the arts community's naivety about who would benefit from an increasingly regulated art industry. An initially empowering and vital argument, based on postcolonial theory and marginal experience, had confused identity with inheritance, and memory — especially the recovery of the past — with the deepest truth. But the past is not inherently true, because the truth may be even worse than the past that we can recall, as the amnesic killer, Lenny (Guy Pierce), understands in the film-noir revaluation of memory *Memento*, 2000.

16.15 Tracey Moffatt, *Night cries: A rural tragedy*, 1990 (film stills)

16.10 Constanze Zikos, *Fake flag*, 1994

1996 Archaeologists discovered signs of human activity in Australia dating back 176,000 years; previous estimates of first human habitation were 40,000–60,000 years ago. In Perth a jury found Alan Bond guilty of fraud in 1983 deals surrounding the acquisition of Manet's *La promenade*. Paul Keating's Labor government was defeated at election; among the Coalition victors was Pauline Hanson, a Liberal candidate unendorsed once her radical right views become widely known; she became a highly public advocate of reduced immigration and economic nationalism, and a critic of both globalization and native title.

Narelle Jubelin had reverently and cleverly collected and assembled the signs of exchange — of trading, money and art — but it turned out that these established and reinforced the displacements of identity that accompanied the collision of cultures and historical periods in the millennial present. Globalization and digital culture were now the real environments of younger artists — Ricky Swallow, Patricia Piccinini, Ronnie van Hout — who were about to emerge into public view. Western culture had extended itself so far that the boundaries of its territory had become impossible to define and the immense size of its empire could not be imagined because it apparently included everything and everybody.

Even so, the irreconcilable, unstable melange of cross-generational voices and post-studio methods suggested two simultaneous extremes: the fracturing of artistic identity and the historically continuous fact of ongoing cultural exchange that was often even desirable and voluntary. ¤

16.16 Kathy Temin, *Duck-rabbit problem*, 1991

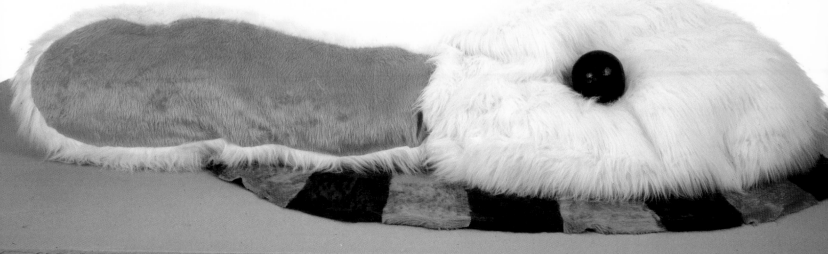

I have not so much seen this work as encountered it, looking up from a crawling position. In order to see *Hanging eyes 2*, 2000 (17.01) I had to clamber through a cylindrical opening in the gallery wall that led to a dark room. Ahead of me as I emerged from the crawl-space were the hanging forms—overwhelming, evil-looking garments. Their ocular protuberances appeared to be heavy, organic versions of the coloured plastic cylinders in *iffytown*, 1999, another component of Mikala Dwyer's combinatory installation I had just seen.[1]

As its title suggests, Dwyer's *Hanging eyes 2* is a variation on an earlier work. It has appeared in several guises, sometimes shown alone, at other times—as described above—as part of a complex installation. It marks a shift towards sculpture away from the first *Hanging eyes*, 1999, which almost physically emerged out of painting. Some of the 'garments' in the earlier piece were formed from a square of canvas painted with concentric circles in bright colours, like the target paintings of Kenneth Noland or Jasper Johns, but hung up from one point so they fell into a more sensual, three-dimensional form. The targets were placed asymmetrically on the canvas squares, or broke away from the picture plane in the form of cylindrical attachments.

Dwyer exaggerated this sculptural quality in *Hanging eyes 2*, which is no longer so much about painting as about the physical and psychological effects of objects. It is a collection of formidable garment-like forms that look too big, shrinking us. In previous exhibitions Dwyer has installed this work with tiny forms that we tower over, using dislocations of scale to draw us into a shape-shifting mindspace. The 'hanging eyes' are figural, and larger than life-size. Each form falls from a sharp peak like a Ku Klux Klan hat extended to make a coverall garment. The purpose of these garments is ambiguous, though decidedly disturbing. Are they for the viewer to wear? Or are they bodies themselves—anonymous figures in pointy-headed cloaks of disguise, or an overwhelming row of judges, watching the viewer? Like other works by Dwyer, they could also be remnants or precursors to a performance—transformational clothes to wear to witness the imaginary spaces of art.

Dwyer's manipulation of scale and figurative allusions create a space of fantasy wherein we may imagine the targets of *Hanging eyes 2* as monstrous bulging eyes, the tubes as distended, deflated limbs or arms, the hanging forms as bodies and the whole row as a coat rack, an entry point to a new experience. The work slyly invites us to assume the tactile and proximate view of childhood, where the body and its surroundings are not separated. While drawing us into this fantasy, the work simultaneously makes us aware of the mechanics of our perception. We know that what we see are only objects and materials. This double view makes us become the subject of our own experience—in some installations underscored by the artist's use of mirrors.

Dwyer's works are thus about relationship, and we accordingly decipher them in relational terms. In several works incorporating the sculpted letters I O U, Dwyer has characterized this exchange in terms of debt, although it is never clear who owes whom (17.02). Some works suggest the artist's debt to painting, suspended in squares of hung material, while others spell out a relationship between parent and child, or artist and audience. This emphasis on the viewer's psychological and physical response to objects is a strong characteristic of installation art.

Like many works by Dwyer, *Hanging eyes 2* questions the dominance of rectilinear geometry, with structures that are simultaneously regular and irregular, geometric and organic. The artist employs a serial arrangement of primary shapes—squares, cylinders—reminiscent of minimalist artists such as Donald Judd or Carl Andre, but her geometric forms are soft and floppy, deflating any expectation of pure form. Dwyer's milieu is that of art by women since the 1960s that attempts to find an alternative basis for geometry in the body: Louise Bourgeois, Eva Hesse, Lygia Clark. Although her work is not figurative, Dwyer often uses materials or forms that have a strong association with the body. Or she constructs idiosyncratic, personal spaces within the gallery that re-orient the viewer's physical experience of architectural space. Through her experiments with so-called primary forms, Dwyer confronts the duality of being: order and containment versus chaos and porosity. *Hanging eyes 2* shows an easy relationship between visceral and geometric, natural and artificial—dynamics that are at the heart of her development as an artist. Dwyer's work asks us, 'What is exactly the relationship between the body and geometry?' as it steers a course between the two. It accords with an observation made of Hesse's work, that 'chaos possesses a structure and, even if not revealed to us, has its own order'.[2]

1 *iffytown*, 1999, and *Hanging eyes 2*, 2000, were among other works grouped to form a single installation in a survey exhibition, *Mikala Dwyer*, Museum of Contemporary Art, Sydney, 2000.

2 M. J. Jacob, 'Containment and Chaos: Eva Hesse and Robert Smithson', *XXIV Biennale de Sao Paulo* (cat. text), viewed January 2002. Website www.uol.com.br/bienal/24bienal/nuh/inuhhesmit02a.htm

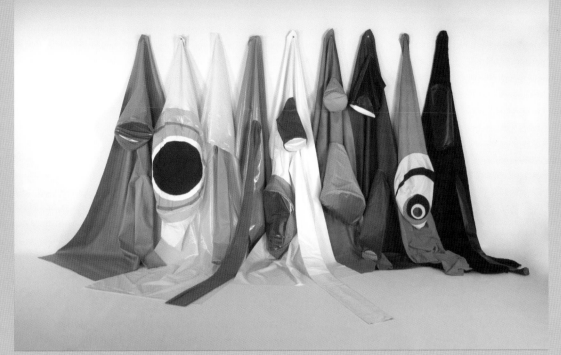

17.01 Mikala Dwyer, *Hanging eyes 2*, 2000

Dwyer employs materials that help transform the impersonal forms of geometry. Upholstery vinyl, tarpaulin canvas, fake fur and baize are used in *Hanging eyes 2*. The shift from canvas to these heavier materials emphasizes the role of gravity in shaping the work. There is a physicality and heaviness to vinyl; gravity visibly creates the body-weight of the hanging forms. The work slips from painting to sculpture, oriented as much to the floor as the wall. Unlike Noland's paintings, the targets are not frontally oriented, but droop down like tired eyes, off voluminous folds of hanging fabric squares. *Hanging eyes 2* thus has a visceral as well as optical relationship with the viewer, which is further emphasized by the tactility of fabrics we associate with furniture and clothing. And the shiny, decorative range of fabrics contrasts with the usually monochromatic, opaque surfaces of minimalist art, gently mocking its aspirations to neutrality.

The nine parts that make up *Hanging eyes 2* relate to other groupings by the artist which she describes as 'add-ons' — corks pinned together as little accumulations of drinking history; organza squares pinned together to form mutant geometries.

Such works, and indeed Dwyer's entire oeuvre, are composed of many parts that do not add up to a whole. Instead, there are peculiar and shifting relations between things. Objects and materials are arranged, stitched or pinned together to form interconnected groups that each seem open-ended and provisional. The order of the hanging parts has been changed with each showing of *Hanging eyes 2*; at times it has been shown alone, at other times in relation to other objects. While Dwyer's work may enter the art museum, it can never do so completely. It somehow preserves a provisional quality, embodying an inchoate world that is anathema to the fixity, order and containment of a museum.

Its placement in this museum context — indeed, within this collection — nevertheless asserts new relationships, for the first time *not* determined by the artist. One could assert many, as the work has internalized and assimilated many sources. Appropriately for a work from the year 2000, it stands on the cusp of two centuries, looking back — particularly to the 1960s — and yet heralding recent preoccupations with fantasy and illusion.[3] It is a painting becoming a sculpture; it is the remnants of a body art performance; it is a feminist response to minimalism; it is a colour-field painting and a horror-movie prop. *Hanging eyes 2* is a mature work that has emerged out of installation art and yet is a work in itself, that resembles though is not directly influenced by the tactile and relational art of Clark and Hesse. It holds its lineages lightly and is amenable to many different contexts — like the coat rack it resembles, it will accommodate a variety of clothes. ¤

17.02 Mikala Dwyer, *IOU*, 1997

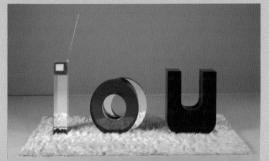

3 This contemporary focus on fantasy and models has been explored in international survey exhibitions such as *The World May Be (Fantastic)*, Biennale of Sydney, 2002, and an Australia-wide survey *Gulliver's Travels*, CAST touring exhibition, 2002

Antarctica is the most remote of all continents and was the last great land mass to be explored. It sits, mysterious and tantalising, at the southern extreme of the planet. David Stephenson's series, *The ice*, photographed in Antarctica during 1991 and 1993, is both a strikingly beautiful body of work and a powerful study of the sublime.

Like Herbert Ponting's and Frank Hurley's photography in the opening years of the twentieth century, Stephenson extends the sublime tradition of French nineteenth-century photographer Gustave Le Gray's (1820–82) seascapes 'to the realm of solidified water'.[1] It is a forceful testimony to the power of the Antarctic landscape, a place where there seems to be too much light and the crystalline form of water — ice — reflects the entire spectrum of light, rendering the world white. In 1993 Stephenson wrote of his Antarctic experience:

> Standing at the edge of the ice, facing the source, the Pole, one stares at a blue-white horizon which extends for thousands of kilometres, composed entirely of a single mineral, water, in a single state. No pictures or description can prepare one for the total alien strangeness of the view, unlike anything one has ever encountered anywhere else before.[2]

The resulting photographs are vast abstracted fields of white and blue, void of detail, the frozen surface wavering in an icy haze to a distant, unmarked horizon. The images are remarkable for their restraint.

Unlike the exploding plethora of images generated by documentary photographers, scientists and eco-tourists, Stephenson's photographs are not a celebration of a pristine, picturesque wilderness. This should in no way suggest that Stephenson is not partisan to the calls of conservationists to fight for the sanctity of the few remaining wilderness areas on Earth. Indeed, shortly after arriving in Tasmania in 1982, he became part of the environmental debate around the proposed Lower Gordon Dam that so divided the community at the time, joining other artists to document what they feared would be the dying days of the last great wild river.

18.01 David Stephenson, *Untitled*, 1992

1 J. Calardo, *À prova de água / Waterproof* (exh. cat.), Zurich: Edition Stemmle, Balém Cultural Centre, Lisbon, 1998, p. 32.
2 D. Stephenson, *Romantic Projection: The Indifference of Nature*, Art Gallery of New South Wales, Sydney, 1993.

18.02 David Stephenson, *Untitled*, 1992

However, what differentiates Stephenson's Antarctic photographs from more reverential landscape photographs is their almost complete absence of detail. *The ice*'s wilderness does not celebrate the abundant biodiversity of a pristine 'green cathedral'.

The ice belongs instead to the tradition of the sublime landscape as theorized by Edmund Burke (1729–97). According to Burke, pain and terror were the essential elements of the sublime. Stephenson identified the central significance of the sublime to his practice when he declared, 'for more than two decades I have been exploring a contemporary expression of the sublime — a transcendental experience of awe with the vast space and time of existence'.[3]

In his Antarctic photographs nothing indicates the scale of the scene before the viewer. It could equally be an uninterrupted vista, stretching kilometres, or the foreground at the artist's feet. The horizon is lost. Nothing indicates the presence of humanity and this absence is disconcerting, for Stephenson never allows us the comfort of markers by which we may judge the scale of the scene. We are engulfed, surrounded, swallowed up in what the early Polar explorer Roald Amundsen called the 'white chaos, in which all lines of demarcation were

3 D. Stephenson, artist statement, *Sublime Space: Photographs by David Stephenson 1989–1998* (exh. cat.), National Gallery of Victoria, Melbourne, 1998.
4 R. Amundsen, *The South Pole: An Account of the Norwegian Antarctic Expedition in the 'Fram', 1910–19,*

The questioning nature in this group of works is overt. How do we interpret the presence of so much real, fake and printed hair? Is it erotic, disturbing or political, and what role do conventional aesthetic tastes play in any of it?

Douglas McManus's experimental and, at times, very radical approach is evident in his four-part textile-based installation. The work unsettles conventional concepts of masculinity, desire and fashion in a potent fusion of graphic imagery and innovative production techniques. The four works, all created in 1999–2000 for the *Material Boys — [un]Zipped* exhibition,[1] are *Individual non-conforming*, *Fashionable conforming*, *Conservative inconspicuous*, and *Hair couture 2000* (19.01). Together they combine two of the artist's primary concerns: the aesthetics of hairiness in the male world, and the introduction of new techniques for textile design and production.

In his paper titled 'Nano Fibre Futures' delivered at a 2001 textiles conference, McManus declared, 'Digital is dead!'[2] He suggested that textiles' future lies with molecular nanotechnology, through the exploration of dynamic physical properties in programmable matter or, in layman's terms, in the creation of textiles from the molecular level upwards.

McManus's practice has been centred for a long time on an exploration of the future of textile and fashion design. This future will move beyond existing digital technology, and call upon scientists, engineers and artists to work together towards 'intelligent' textiles and clothing. Garments made from these textiles will advance our ideas of interactivity, for they will have the capacity to self-clean, heat and cool, self-repair. They will house complex computer and communications systems.

McManus categorizes himself as an unapologetic 'textile futurist'. He is a key figure in the development of printed textile forms in Australia. The mid 1990s marked the point at which McManus was able to consolidate his exploration in the future possibilities of printed textile design through the application of computer aided design (CAD) and digital print development.[3] The computer-generated and digital photographic print technologies that have underpinned McManus's practice for the past decade enable him to manipulate the surface of the cloth in extreme ways.

As an extension of his research, McManus co-founded Digital Fashion Futurists, a Web-based conceptualist fashion collective that organizes events, and commissions and disseminates information on digital technology in fashion.

1 *Material Boys — [un]Zipped*, Sydney Gay and Lesbian Mardi Gras, Object Galleries, Sydney, 2000.

2 Textiles and the Digital Conference, College of Fine Arts, Sydney, 20–21 July 2001.

3 Digital printing is the process that enables designers to scan, create and manipulate images on a computer and send them directly to a large-format printer, which automatically transfers complex colour prints onto a textiles substrate using inkjet head technology and UV resistant inks.

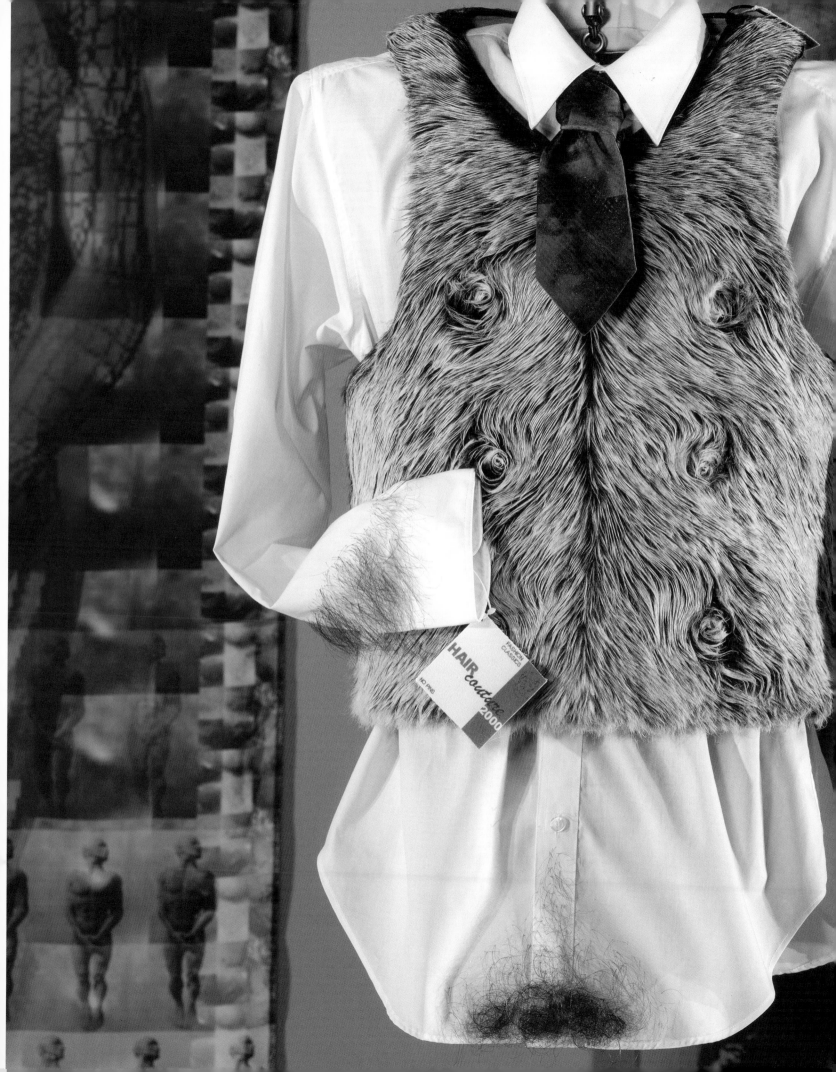

Douglas McManus, *Individual non conforming*, 1999–2000 (detail)

Douglas McManus, *Fashionable conforming*, 1999–2000 (detail)

Douglas McManus, *Conservative inconspicuous*, 1999–2000 (detail)

Individual non conforming, Fashionable conforming and Conservative inconspicuous

The large format images of semi-clad male bodies portrayed in the foreground of these three works reflect McManus's ongoing speculations on the male form and its potential objectification. The artist recalls:

> [Since] the age of 13, having been caught by my father drawing images of two men having sex, and 'frocking up' Ken and Barbie, my creativity and sexuality have been inextricably intertwined. A significant recurring theme in my work is the exploration of male preoccupation with physicality.[4]

The life-size images are positioned on a virtual patchwork of images. The montage is generated from a series of photos and body scans of McManus and friends. The figures are combined with digital wire meshes and found imagery from the Web, with the intent to communicate 'the transient nature of self in cyberspace'.[5] McManus is interested in the ways in which men represent themselves in the virtual world. His research and subsequent inspiration centre on the amateur photos featured on gay subculture Internet sites, and the ways in which they explore the eroticism of body and facial hair.

> I decided to translate the patchwork of backgrounds created from sections of cheap web images of pubic hair, chest and facial hair to parody the trash aesthetic of most of these websites.[6]

The explicit imagery contained within the grid creates a background mosaic, rich in detail and textural quality, which echoes the luscious beauty and personal content of the traditional patchwork form. Building on the innate tactile appeal of the works, the artist's selection of a fabric type based on regenerated cellulosic fibre, with its unusual 'wet' sheen surface treatment, is suggestive of the erotic quality of skin. On closer inspection, the individual images contained within each of the textiles reveal layered meanings. These subvert traditional perceptions of accepted male beauty, questioning accepted models of good taste and the broadly unacceptable presence of excess body hair. The titles of each of the three textiles — *Individual non-conforming*, *Fashionable conforming* and *Conservative inconspicuous* — demonstrate this intention directly.

The idea of a wheel or cycle of fashionable aesthetics is another long-standing theme that McManus developed through earlier works based on images of retro-inspired female hairstyles and dress.[7] In *Individual non-conforming*, McManus presents his own wheel of fashion, employing recognized conventions based on the changing seasons of fashion.

For this, McManus has sampled illustrations from a book on the history of hair fashions, redrawing them with extra hair. The resulting imagery adapted by McManus contrasts four illustrations of alternative hairstyles — the werewolf, the 1970s porn star, the bearded daddy and the afro lover. Each image is drawn from a repertoire of trashy stereotypical views of masculinity that McManus identifies as a primary catalyst for his work.

McManus makes a personal speculation on ways of 'representing states of being 'hairy' in the new millennium' by categorising each hairstyle under the headings of eccentric, fashionable, individual and conservative.[8]

4 *Material Boys — [un]Zipped* (exh. cat.), p. 16.
5 D. McManus interview via email by the author, 18 March 2002.
6 McManus, interview.
7 He exhibited earlier *Hair couture* works at *Fibrespace*, Planet Furniture, 1999, and *Well Hung*, Platform, Melbourne, Midsumma Festival, 2000.
8 *Material Boys — [un]Zipped* (exh. cat.), p. 16.

McManus's installation culminates in a three-dimensional examination of body hair in *Hair couture 2000*.

The suspended torso is dressed in classic, white business shirt and tie, layered with a sculpted fake fur vest and decorative human hair fringing. McManus has used the male tie in past installations to make statements about male sexuality in the realm of a corporate, patriarchal world. This work re-asserts the conflicted role of business attire as a potent masculine symbol while at the same time restricting male dress to a level of bland uniformity.

Conceived in four parts, which come together in this installation, each individual work demonstrates the artist's desire to rethink and present anew the predominant stereotypical meanings contained within male dress, male body hair and masculine representations of self. He does so by harnessing the techniques and technologies that he has adopted and developed throughout his textiles design practice. The resulting works combine as a powerful reflection on the key themes and forms of McManus's work to date. ¤

19.01 Douglas McManus, left to right, *Individual non conforming, Fashionable conforming, Hair couture, Conservative inconspicuous 2000*, 1999–2000

no compass? a postscript to fieldwork Jason Smith

::20 ::

This business of making accessible the richness of the world we are in, of bringing density to ordinary day-to-day living in a place, is the real work of culture. It is a matter, for the most part, of enriching our consciousness — in both senses of that word: increasing our awareness of what exists around us, making it register on our senses in the most vivid way; but also of taking all that into our consciousness and of giving it a second life there so that we possess the world we inhabit imaginatively as well as in fact.[1]

To interpret the most recent phase of contemporary Australian art (works produced between 1997 and 2002) requires a particular fluidity and flexibility, for it is so close in time to the present. Looseness is completely necessary to this enterprise, therefore, throughout *Fieldwork* a strict chronological sequence has been subtly subverted in favour of contextual juxtapositions, and this too has demanded a fluid approach. Common to each of the texts that interpret *Fieldwork* is the continued importance of history — of disparate cultural and social developments and circumstances — in the contemporary realities of artists.

My emphasis is on the culmination of *Fieldwork*: its representation of artists working during the rhetorically loaded end of the tumultuous twentieth century into the anticipatory, turbulent first years of the twenty-first century. The particular works included at the end of *Fieldwork*, therefore, have been brought together as representative of the predominant conceptual tendencies and modus operandi — in other words, the strategies — that contemporary artists use to communicate and convince. These works also signal the continuity and productive evolution of particular conceptual positions across the decades contained within the exhibition's review. Rather than amplifying particular ideologies, the works reaffirm art as a practice, as a type of work — as *Fieldwork* — that is above all an emphatically open enquiry into ways of being in the world.

The curatorial and audience-orientated processes of occupying a newly constructed art gallery — in this case The Ian Potter Centre: NGV Australia — insist, more than usual, that the first role of the art gallery is to enable its visitors to inhabit the world *imaginatively* as well as in *fact*. Another of its obligations is to provoke an imaginative life — an ever-expanding vision and inquisition of the world — in which the material and conceptual *facts* of the work of art, and the lifework of the artist, are instrumental in articulating the unpredictable evolution of cultures, and in transforming capacities for perception and an intellectual engagement with the seemingly indefinable role of art. Of course, the individual subjectivities and experiences that people bring to their encounters with works of art means that this is not always the case. But David Malouf's suggestion that the 'density' of daily life be excavated, and brought before us in all its complexity, is an important introduction for *Fieldwork*'s examination of the most recent contemporary art practice. Though the idea of the art gallery inhabiting the world 'imaginatively as well as in fact' might not be new to those who work in them, or to those who recall the many genuinely transformative intellectual and emotional experiences that they have had in exhibitions and before works of art, Malouf's scheme is worth adhering to. Gallery curators continually re-evaluate and elaborate contexts, and therefore *meaning*, in works of contemporary art.

[One of the gallery's obligtions is] to provoke an imaginative life—an ever-expanding vision and inquisition of the world—in which the material and conceptual *facts* of the work of art, and the lifework of the artist, are instrumental in articulating the unpredictable evolution of cultures, and in transforming capacities for perception and an intellectual engagement with the seemingly indefinable role of art.

1 D. Malouf, *A Spirit of Play: The Making of Australian Consciousness*, Sydney, 1998, p. 35.

20.01 Jan Nelson, *International behaviour*, 2000

20.02 Sally Smart, *Treehouse (The unhomely body)*, 1997–98

2 Z. Stanhope, 'The mirror in the archive box', *Artlink*, vol.19, no. 1, March 1999, p. 9. This edition of *Artlink* was devoted to a range of artistic, theoretical and curatorial perspectives on the nature of archives, museums and collections.

3 ibid., p. 12.

4 Malouf. These are Malouf's chapter headings for the book.

One of the premises of *Fieldwork* has been to play with the connotative range of the term: to examine the intellectual and practical fieldwork of artists and, as well, the fieldwork that the National Gallery of Victoria has undertaken over three decades in its representation and collection of visual culture. Increasingly, the NGV has recognized the importance of enabling audiences to understand that there have been multiple art histories. Nevertheless there has been intensifying scrutiny within academic, professional and more public arenas of the fundamental processes and policies of galleries, and the strategies through which collections are assembled, displayed, interpreted and made accessible to the public. Here, at the end of three decades of art, we see the cumulative manifestation of the impact of three decades of history and change. The work of art, therefore, is the tip of an iceberg. As Zara Stanhope has noted:

> institutions have been gently but persistently encouraged to embrace the identities, activities and politics of their constituents, having been provoked by reminders of past ignorance or exclusion of individuals, people and their histories.[2]

20.03 Matthew Jones,
Diary 13 November–16 November 2000, 2000

To return to David Malouf, his 1998 ABC Boyer Lectures, titled *A Spirit of Play: The Making of Australian Consciousness*, surveyed aspects of social and cultural development in Australia since European settlement. Examining the translation of practices and visions from the historical centres of Europe to the then unknown historical landscape and multiple cultures of Indigenous Australia, Malouf asserted that the evolution of post-settlement Australian peoples and institutions has been 'from the beginning, and continues to be, a unique and exciting experiment'.[3] His account continually counterpoints the conditions of Australia's colonial history — geographical and political isolation, individual and collective crises in identity, the inevitable transformation of cultural and social mores, an absolute reliance on 'inventiveness' — with our turbulent present. The indexical terms that Malouf charted, as aspects of Australian culture, were as follows: The Island; A Complex Fate; Landscapes; Monuments to Time; The Orphan in the Pacific; and A Spirit of Play.[4] These categories can, I think, be mapped onto recent art practices if we are to begin to mine the connected aesthetic and political contexts within which recent art has occurred, for one of the most profound characteristics of recent art has been the erosion of more conventional categories of media and practice. Contemporary art intersects with, and crosses into other cultural

20.04 Gwyn Hanssen Pigott, *Exodus II*, 1996

forms. There has also been an insistence in recent practices and writings on connections between art and daily life, on registering what it means to be human in the world, and the conditions of our personal and emotional lives. At the same time, artists insist on the wider scope, relevance and theoretical density of their connections with communities and systems beyond the confines of the art world.

One of the most important legacies of artists' activities of the past three decades, that underpins the contemporary practices represented in *Fieldwork*, is a prevailing resistance to the restrictiveness of the enclave, and to narrowly defined concepts of nation and a 'national' art. In increasingly sophisticated, multilateral programs, often initiated and driven by the artists themselves, recent Australian art has been brought into dialogue with international work with total frequency and apparent ease.

David Malouf takes the Australian continent and its oceanic borders as the island under his examination. The concept of borders and the transgression of them remains important to Australian artists, who now defer ideas about the 'tyranny of distance' conditioning Australia's relation to the international world to more complex considerations of the decentered and diasporic communities of which they are a part. In his ongoing investigations into the connections between social constructions, cultural production, the inherent turbulence of 'living with difference', and hybridity as a condition of the contemporary world, Nikos Papastergiadis recently emphasized that

> the idea of the contemporary can no longer be categorized within national or formalist boundaries. We now need new institutional and art historical categories for understanding the production, relations and reception of contemporary art. The context of art can no longer be defined as if the world was neatly divided into exclusive geographic or cultural zones.[5]

Fieldwork represents the multiple zones of contemporary visual culture. It proposes 'the field' as an open space of possibilities, but for which there can never be any prescribed direction. The exhibition also makes transparent that the NGV does, however, propose certain ways of seeing through its collection priorities and exhibition formats. This postscript began with a question: Is there a compass to orientate ourselves as we encounter contemporary art? I would suggest that a role of the gallery is indeed to be just that. ¤

5 Nikos Papastergiadis, 'Ambient Fears', 2001 *Fallout* (exh.cat.), Victorian College of the Arts, December 2001.

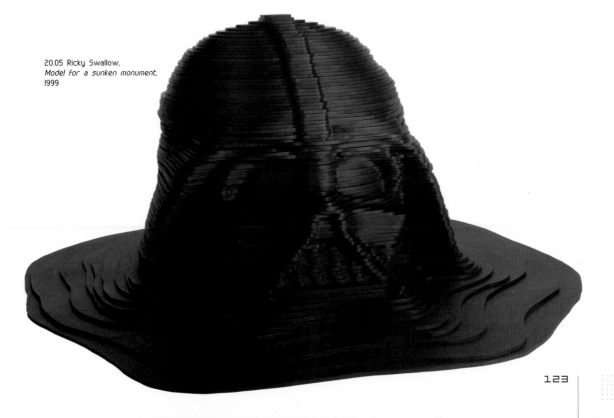

20.05 Ricky Swallow,
Model for a sunken monument,
1999

ACKNOWLEDGEMENT
My thanks to Isobel Crombie and Charles Green
for their advice for this text.

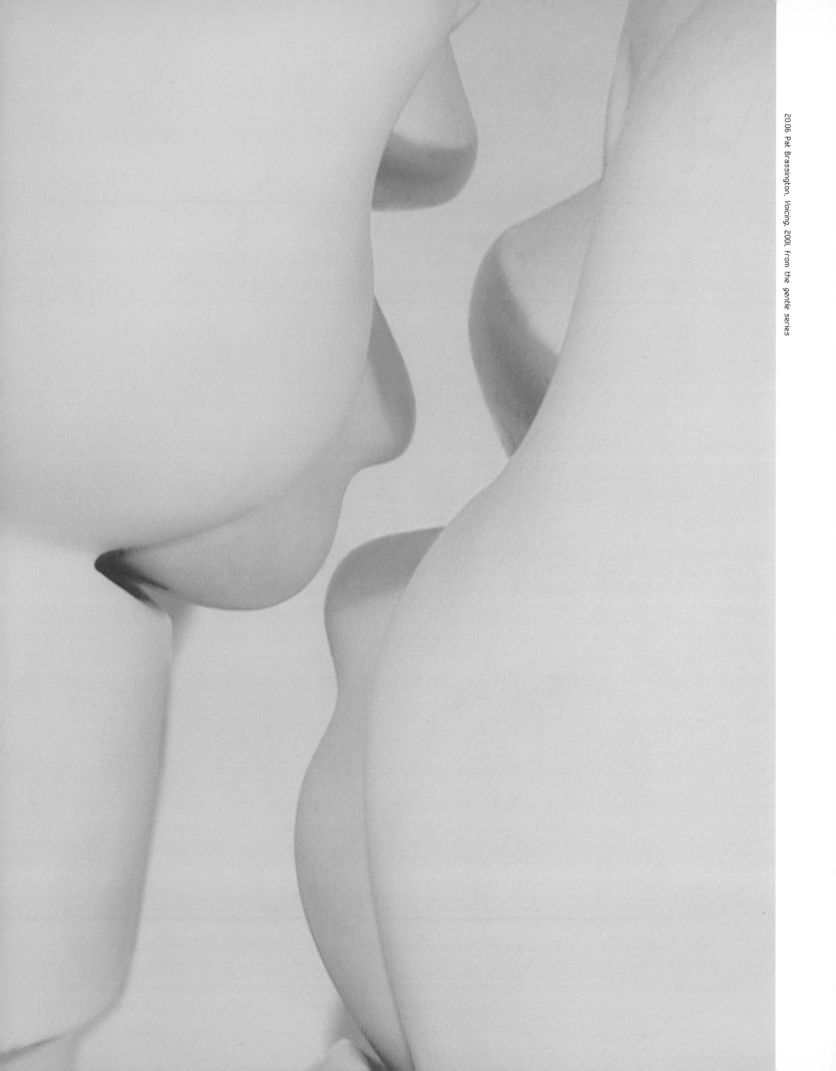

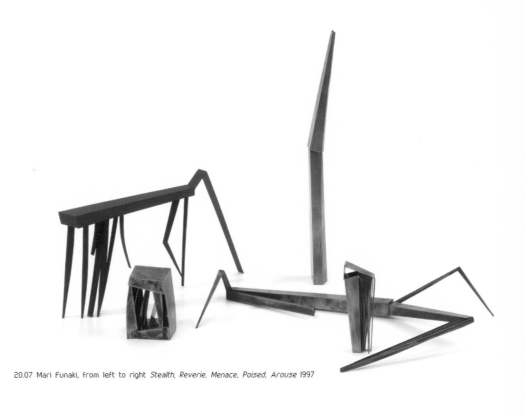

20.07 Mari Funaki, from left to right *Stealth, Reverie, Menace, Poised, Arouse* 1997

20.08 Scott Redford, *Surfing life (Glen)*, 1994

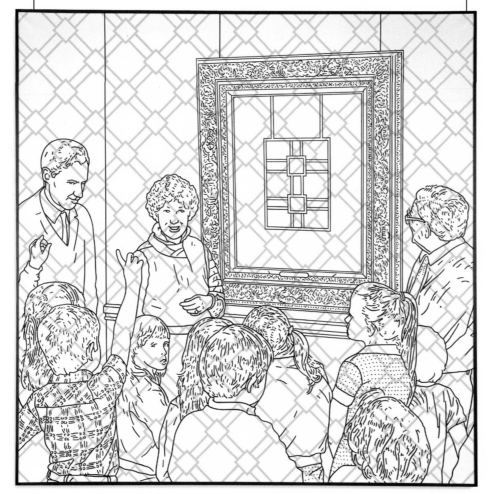

20.10

Title	detail A Person Looks At A Work Of Art/ someone looks at something ...
Medium	A Person Looks At A Work Of Art/ someone looks at something ... CULTURAL CONSUMPTION PRODUCTION
Date	- 1985–1987 -
Artist	Peter Tyndall

20.09 Emily Kam Kngwarray (Eastern Anmatyerr), *Body paint: awely,* (1993)

20.11 Mutlu Çerkez, *Poster design variations for artists' publications*, 2001.

20.11 Mutlu Çerkez, *Poster design variations for artists' publications*, 2001 (detail)

Announcing the publication of

MUTLU ÇERKEZ

POSTER DESIGN VARIATIONS

Poster design variations for
LED ZEPPELIN The 1980s part one
Left justified
11 September 2021 (2001)

Poster design variations for
LED ZEPPELIN The 1980s part one
Centre justified
12 September 2021 (2001)

Poster design variations for

Burma, 6 November 2000.................Burmese Army launch attacks on rebel KNU (Karen Nationalist Union). Heavy casualties.

Pakistan, 6 November 2000...........Female suicide bomber kills 4 and injures 4 in bomb explosion at newspaper office.

Yemen, 12 October 2000.................Suicide attack on USS *Cole* kills 17 sailors and wounds 37.

Angola, 31 October 2000.................Russian airliner shot down by UNITA rebels killing 42 passengers and 6 crew.

Cote d'Ivoire, 6 Nov 2000................Hundreds of Muslims massacred in violent street brawls after Presidential election results.

Ecuador, 9 December 2000................Oil pipeline bombed by Ecuadorian terrorists, killing 8 people in passing bus.

Manila 30 December 2000...............Six bomb explosions by MILF militants, kills 14 and injures over 100.

Colombia, Nov 2000........................United Self Defence Forces massacre 80 local people for alleged support of revolutionaries.

Algeria, 19 December 2000..............Islamic "horror squad", Katibat El Ahoual, murders 15 schoolboys in dormitory.

Algeria, 19 - 20 Dec 2000................240 dead after 48 hour terrorist rampage by Islamic "horror squad".

Spain, 20 December 2000.................23 victims killed by car bombs and shootings by ETA, Basque Separatists, during the year.

Jamaica, Jan - Dec 2000..................Police kill 140 civilians - the highest per capita rate in the world.

Gaza Strip, Dec 2000........................350 killed and 1000s wounded in violent clashes between Palestinians and Israelis, this year.

UK, 9 January 2001...........................High rates of leukaemia is found in UK troops who served in Kosovo and Bosnia Herzegovina

Afghanistan, 19 Jan 2001................Over 300 civilians including children massacred by Taliban troops in Bamiyan provence.

Spain, 11 January 2001....................ETA bomb blast kills 4 in Catalonia.

Tanzania, 26 January 2001...........280 dead in clashes between Civic United Front and police on island of Zanzibar.

Angola, 2 February 2001.................UNITA group shoot down Angola Armed Forces airliner killing 22 passengers and crew.

Afghanistan, 2 Feb 2001...................600 people freeze to death in refugee camps in Herat.

Moscow 5 February 2001.................Chechnyan terrorists bomb metro station killing 15 civilians.

Belfast, 9 February 2001...................44 pipe bombs used in wave of loyalist attacks on Catholics this month.

Iraq, 16 February 2001......................US and UK forces launch airstrikes on military targets in Baghdad.

Afghanistan, 20 Feb 2001.................Over 1,000,000 refugees facing severe famine.

Indonesia, 28 Feb 2001....................Thousands of Madurese people mutilated and decapitated in ethnic massacre in Kalimantan.

Burundi February 2001....................National Liberation Forces launch attacks on Government forces. 208,620 refugees flee.

Afghanistan March 2001..................UIFSA (United Islamic Front for Salvation of Afghanistan) and Talibaan Forces intensify battles.

Indonesia, March 2001.....................Thousands dead and 77,000 displaced from Dayaks and Madurese outbreaks of ethnic violence.

Macedonia, March 2001...................Fighting between ethnic Albanian guerrillas and police ignites fear of a new Balkans war.

Guinea, 9 -18 March 2001................180,000 refugees and 100s of rebels killed in fighting and military bombardments.

Kuwait, 20 March 2001....................Hidaya Sultan al-Sulim, a prominent campaigner for women's rights, shot dead.

Afghanistan 23 March 2001...........Taliban leaders loyal to Osama bin Laden seize control of Taliban military.

Nepal, April 2001..............................Escalation of Maoist guerrilla campaign in Kathmandu claims 1,500 lives since 1998.

Palestine, April 2001.........................Israeli and Palestinian mortar attacks, bombings and shootings continue to escalate.

Lebanon, 15 April 2001....................Israel launches air attacks on Syria.

Benin, 16 April 2001..........................Nigerian freighter carrying a cargo of 250 children sold into slavery, is commandeered.

Iraq 18 April 2001.............................Iran launch missiles attacks against military camps.

Bangladesh, 18 April 2001..............Border clashes between India and Bangladesh claims 16 Indian lives.

Congo, 26 April 2001.........................6 Red Cross workers hacked to death near town of Bunia.

Macedonia, 28 April 2001...............8 Macedonian soldiers killed and mutilated, and 16 maimed in bloody border ambush.

Burma, 4 May 2001...........................Bomb blast in Mandalay market kills 8.

Burma, 15 May 2001.........................24 Buddhist monks killed by Muslim youths in religious riots.

Kashmir, 24 May 2001......................120 dead in violent street brawls.

UK, 26-29 May 2001..........................Three nights of fires, rioting and looting by Muslim Asian youths injures 1000s in Lancashire.

Tajikistan, 29 May 2001...................Over 30 civilians killed and 20 maimed in recent weeks by land mine accidents.

Indonesia, 30 May 2001..................Islamic militants kill 78 and injure thousands, in attacks on Christian villages.

Palestine 1 June 2001.......................Suicide bomber destroys Tel Aviv discotheque killing 20 Israelis and injuring 120.

Bangladesh 3 June 2001..................10 dead and 26 injured from bomb blast during mass at Baniar-char.

Africa, 3 June 2001............................300 dead in bloody street clashes, in Bangui, between Government troops and rebels.

Indonesia, 14 -15 June 2001...........67 dead from sectarian violence between Islamic Laskar Jihad militia and military police.

Sudan, 15 June 2001.........................Government militia attack SPLA rebels on 7 fronts displacing 26,000 people.

Bangladesh 16 June 2001................Bomb blast at ruling Awami League headquarters kills 22 and injures 100.

Afghanistan, 21 June 2001..............Taliban troops launch major large-scale offensive to capture key northern positions.

Rwanda, 23 June 2001.....................Hutu rebels based in Congo, step up incursions into North West Rwanda, killing 1,500 Tutus.

Kenya, July 2001................................35 killed in fighting between Kishii and Masai groups.

Afghanistan, 3 July 2001..................Taliban enforces decree that anyone converting to another religion will be executed.

Afghanistan, Jan -July 2001............Hundreds of Shi'ite Muslims killed in systematic executions by Sunni Muslim Taliban forces.

Third World, 17 July 2001.................3,500,000 children die each year from diseases preventable by simple vaccine.

Mogadishu, 27 July 2001..................Armed police battle to regain control of city from clan-based militias.

West Bank, 30 July 2001..................Hostilities between Palestinians and Israelis continue with 9 dead in bomb blast.

Moscow, 5 August 2001....................Chechnyan terrorists bomb pedestrian overpass, killing 12 civilians.

USA, 11 September 2001......... 3,000 civilians die when 2 hijacked planes crash into World Trade Centre, New York

2012 Elizabeth Gower, *September 14, 1901–September 11, 2001*, 2001 (detail)

Burma, 6 November 2000.....Burmese Army launch attacks on rebel KNU (Karen Nationalist Union). Heavy casualties.

Pakistan, 6 November 2000.....Female suicide bomber kills 4 and injures 4 in bomb explosion at newspaper office.

Yemen, 12 October 2000.....Suicide attack on USS Cole kills 17 sailors and wounds 37.

Angola, 31 October 2000.....Russian airliner shot down by UNITA rebels killing 42 passengers and 6 crew.

Cote d'Ivoire, 6 Nov 2000.....Hundreds of Muslims massacred in violent street brawls after Presidential election results.

Ecuador, 9 December 2000.....Oil pipeline bombed by Ecuadoran terrorists, killing 8 people in passing bus.

Manila 30 December 2000.....Six bomb explosions by MILF militants, kills 14 and injures over 100.

Colombia, Nov 2000.....United Self Defence Forces massacre 80 local people for alleged support of revolutionaries.

Algeria, 19 December 2000.....Islamic "horror squad", Katibat El Ahoual, murders 15 schoolboys in dormitory.

Algeria, 19 - 20 Dec 2000.....240 dead after 48 hour terrorist rampage by islamic "horror squad".

Spain, 20 December 2000.....23 victims killed by car bombs and shootings by ETA, Basque Separatists, during the year.

Jamaica, Jan - Dec 2000.....Police kill 140 civilians - the highest per capita rate in the world.

Gaza Strip, Dec 2000.....350 killed and 1000s wounded in violent clashes between Palestinians and Israelis, this year.

UK, 9 January 2001.....High rates of leukaemia is found in UK troops who served in Kosovo and Bosnia Herzegovina.

Afghanistan, 19 Jan 2001.....Over 300 civilians including children massacred by Taliban troops in Bamiyan province.

Spain, 11 January 2001.....ETA bomb blast kills 4 in Catalonia.

Tanzania, 26 January 2001.....280 dead in clashes between Civic United Front and police on island of Zanzibar.

Angola, 2 February 2001.....UNITA group shoot down Angola Armed Forces airliner killing 22 passengers and crew.

Afghanistan, 2 Feb 2001.....600 people freeze to death in refugee camps in Herat.

Moscow 5 February 2001.....Chechnyan terrorists bomb metro station killing 15 civilians.

Belfast, 9 February 2001.....44 pipe bombs used in wave of loyalist attacks on Catholics this month.

Iraq, 16 February 2001.....US and UK forces launch airstrikes on military targets in Baghdad.

Afghanistan, 20 Feb 2001.....Over 1,000,000 refugees facing severe famine.

Indonesia, 28 Feb 2001.....Thousands of Madurese people mutilated and decapitated in ethnic massacre in Kalimantan.

Burundi February 2001.....National Liberation Forces launch attacks on Government forces. 208,620 refugees flee.

Afghanistan March 2001.....UIFSA (United Islamic Front for Salvation of Afghanistan) and Taliban Forces intensify battles.

Indonesia, March 2001.....Thousands dead and 77,000 displaced from Dayaks and Madurese outbreaks of ethnic violence.

Macedonia, March 2001.....Fighting between ethnic Albanian guerrillas and police ignites fear of a new Balkans war.

Guinea, 9 - 18 March 2001.....180,000 refugees and 100s of rebels killed in fighting and military bombardments.

Kuwait, 20 March 2001.....Hidaya Sultan al-Sulim, a prominent campaigner for women's rights, shot dead.

Afghanistan 23 March 2001.....Taliban leaders loyal to Osama bin Laden seize control of Taliban military.

Nepal, April 2001.....Escalation of Maoist guerrilla campaign in Kathmandu claims 1,500 lives since 1998.

Palestine, April 2001.....Israeli and Palestinian mortar attacks, bombings and shootings continue to escalate.

Lebanon, 15 April 2001.....Israel launches air attacks on Syria.

Benin, 16 April 2001.....Nigerian freighter carrying a cargo of 250 children sold into slavery, is commandeered.

Iraq 18 April 2001.....Iran launch missiles attacks against military camps.

Bangladesh, 18 April 2001.....Border clashes between India and Bangladesh claims 16 Indian lives.

Congo, 26 April 2001.....6 Red Cross workers hacked to death near town of Bunia.

Macedonia, 28 April 2001.....8 Macedonian soldiers killed and mutilated, and 16 maimed in bloody border ambush.

Burma, 4 May 2001.....Bomb blast in Mandalay market kills 8.

Burma, 15 May 2001.....24 Buddhist monks killed by Muslim youths in religious riots.

Kashmir, 24 May 2001.....120 dead in violent street brawls.

UK, 26-29 May 2001.....Three nights of fires, rioting and looting by Muslim Asian youths injures 1000s in Lancashire.

Tajikistan, 29 May 2001.....Over 30 civilians killed and 20 maimed in recent weeks by land mine accidents.

Indonesia, 30 May 2001.....Islamic militants kill 78 and injure thousands, in attacks on Christian villages.

Palestine, 1 June 2001.....Suicide bomber destroys Tel Aviv discotheque killing 20 Israelis and injuring 120.

Bangladesh 3 June 2001.....10 dead and 26 injured from bomb blast during mass at Banisr-char.

Africa, 3 June 2001.....200 dead in bloody street clashes, in Bangui, between Government troops and rebels.

Indonesia, 14 -15 June 2001.....67 dead from sectarian violence between Islamic Laskar Jihad militia and military police.

Sudan, 15 June 2001.....Government militia attack SPLA rebels on 7 fronts displacing 26,000 people.

Bangladesh 16 June 2001.....Bomb blast at ruling Awami League headquarters kills 22 and injures 100.

Afghanistan, 21 June 2001.....Taliban troops launch major large-scale offensive to capture key northern positions.

Rwanda, 23 June 2001.....Hutu rebels based in Congo, step up incursions into North West Rwanda, killing 1,500 Tutsi.

Kenya, July 2001.....35 killed in fighting between Kishii and Masai groups.

Afghanistan, 3 July 2001.....Taliban enforces decree that anyone converting to another religion will be executed.

Afghanistan, Jan -July 2001.....Hundreds of Shi'ite Muslims killed in systematic executions by Sunni Muslim Taliban forces.

Third World, 17 July 2001.....3,500,000 children die each year from diseases preventable by simple vaccine.

Mogadishu, 27 July 2001.....Armed police battle to regain control of city from clan-based militia.

West Bank, 30 July 2001.....Hostilities between Palestinians and Israelis continue with 9 dead in bomb blast.

Moscow, 5 August 2001.....Chechnyan terrorists bomb pedestrian overpass, killing 12 civilians.

USA, 11 September 2001.....3,000 civilians die when 2 hijacked planes crash into World Trade Centre, New York

Now we know that the seemingly infinite, disparate variety of living matter on earth, of which we are but a part, is life's giant, polymorphic skin, encasing us all, inside which we dwell in kindred, genetic proximity.[1]

Fiona Hall says that her work slides around 'in the territory of the structure of things'.[2] This 'structure of things' is the territory of power—in all its forms—that organizes politics, economics, science and the natural environment. In *Dead in the water*, 1999 (21.01), Hall tells us that these structures are now breaking down, and that contemporary cultural systems and biodiversities are, as a result, both immensely fragile and critically endangered.

This work is the latest (and most refined) in a series of sculptural tableaux encased within museum-style display cases. In all of these Hall examines the connections between western, eastern and Indigenous cultural histories. The products of meticulous research and fieldwork, her installations draw on a vast range of scientific, literary, popular and material sources. They evaluate, with almost dizzying erudition, the ways that colonialism, physical anthropology, economic botany, taxonomic schemes and the history of museums determine systems of knowledge and human interactions with both natural and built worlds.

Dead in the water elaborates a consistent theme in Fiona Hall's art: the uneasy relationship between culture and nature, and the mass consumption and objectification of both. More specifically, at its heart is the impact of human activity on the landscape and oceans, and on the order of the world at large. Through a canny use of metaphorically rich materials and incisive titles, Hall communicates multiple perspectives and meanings. The title of this exhibition derives from Hall's 1998 installation *Fieldwork*, in which her 'slipping taxonomies' critiqued the culture of collecting and displaying discrete and bizarrely converging histories and cultural discourses.

Dead in the water comprises thirteen individual elements constructed from polyvinyl chloride plumbing pipe, silver thread and glass beads. The display case has a dividing shelf—an implied waterline. Perforated pipe ends sit above the waterline, connected below to marine-like invertebrates and delicate coral forms that indicate biological fragility and ecological instability. Each of the woven components emerges organically, as Hall's remarkable technical skill and virtuosity impress themselves upon her chosen materials. This lace-like tubing emphasizes the aesthetic and visual seduction that she places in direct metaphoric liaison with colonization, environmental change and degradation. The perforated plumbing pipes reiterate concepts of fragility and distrust in systems that order knowledge and imply stability. Hall calls plumbing pipes 'a conduit to the underworld of the ocean'.[3] The simple implication is that humans have little consideration for the waste that goes down the drain. But Hall's solid, utilitarian pipes are useless, signalling the erosion and cultural entropy of ideal systems in the modern world. The dependable and easy international world of plastic dissolves down a drain with devastating consequences.[4]

The use of glass beads, quite similarly, encapsulates fragility and translucency. Hall's abiding interest in the historical processes of colonization, dispossession and social evolution means that she sees the historical currency of glass beads—once used as a corrupt but ostensibly legitimate form of exchange. Hall calls to account the shortcomings and problematics in those exchanges.

The colonization of marine environments by human waste and economic imperatives provides an appropriate metaphor by which to examine prevailing issues relating to Australia's colonial past and concepts of reconciliation—not only between Indigenous and non-Indigenous peoples, but across the social complexity of Australia and beyond to the relationship between human beings and other species. In a world of communities bleached of difference and cultural autonomy, we are, literally, dead in the water.

Simultaneously beautiful and terrifying, *Dead in the water* hints at the continually shifting dynamics of cultural and natural evolution, contrasts these with the stasis and death that they signal, and locates itself at the exact but blurred boundary between nature and culture. Her enquiry is acute and critical, for she is committed to the issues of our time. Hall's post-colonial intellect, her holistic view of the world and its species, and her unique creative powers, present to us the same imperative described by Homi Bhabha:

> [T]he aesthetic and ethical challenge to live in disjunctive and temporal landscapes that lead us to restructure the past, so that the history of the present — of our late modernity and/or postmodernity — can entertain the possibilities of the future as an open question, a negotiation with the passions and pitfalls of freedom.[5]

1 Fiona Hall, artist's statement, February 2002.

2 See J. Ewington, 'Fiona Hall: Blooming Taxonomist', in *1999 Clemenger Contemporary Art Award* (exh. cat.), National Gallery of Victoria in association with the Museum of Modern Art at Heide, 1999, p. 20.

3 Fiona Hall, conversation with the author, 14 February 2002.

4 Take one example: more than ten years after the catastrophic Exxon Valdez oil spill in Prince William Sound, Alaska, native fauna are still in the process of recovery and adaptation from what remains an environmental catastrophe.

5 H. K. Bhabha, 'Postmodernism / Postcolonialism', in *Critical Terms for Art History*, R. Nelson & R. Shiff (eds), Chicago, 1996, p. 322.

25.01 Callum Morton, *Gas and Fuel*, 2002

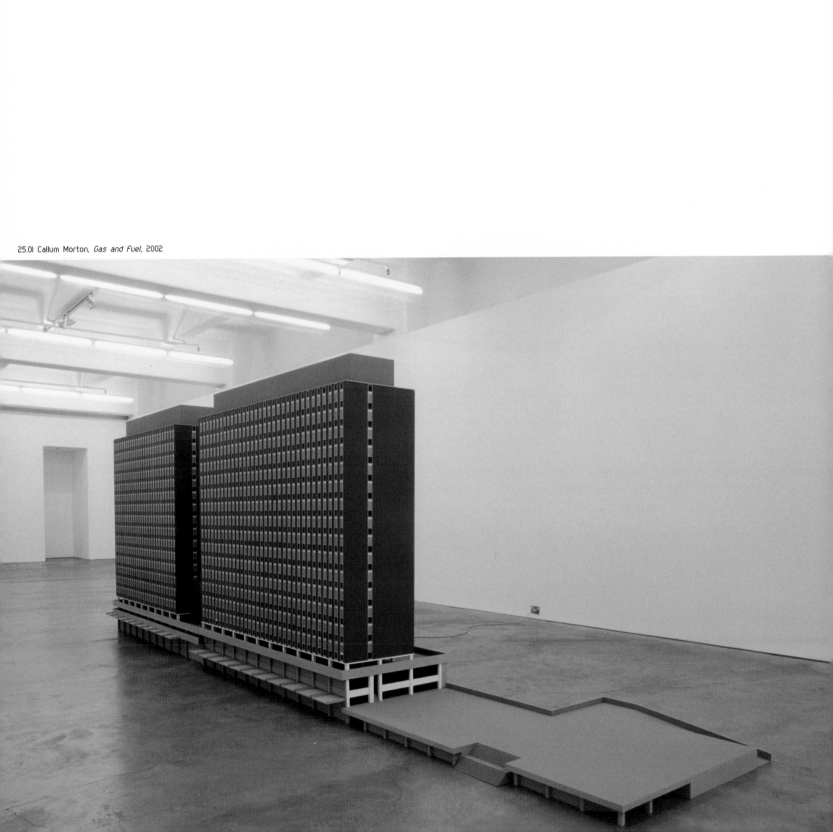

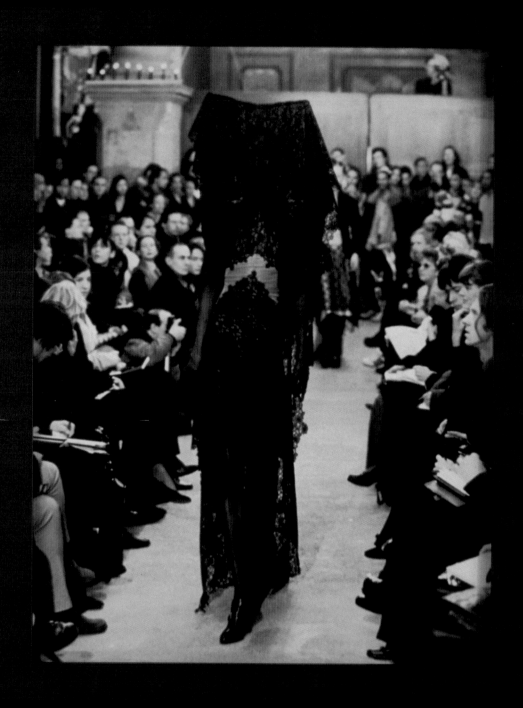

24.01 Susan Norrie, *Inquisition: Inquisition eleven*, 1996–99

Susan Norrie started this enquiry into the contemporary value of painting; now we must take it up. My analysis may have unpacked *Inquisition*, but this not how its beautiful and compelling whole is experienced. Freud's notion of the 'uncanny' has often been invoked in connection with Susan Norrie's work, but the final effect of *Inquisition* is to leave us, the viewers, unnerved. For while we may understand why Susan Norrie pursued her enquiry, it is not at all clear what the answers to her questions might be. ▫

24.01 Susan Norrie, *Inquisition: Inquisition ten*, 1996–99

of cultivation: beads threaded, painted fabric exquisitely pleated. All these beautifully crafted objects are impeccable, speaking (quietly) of taste, decorum, the coded elaboration of fashion, and the modern fetishization of 'the feminine' in western social languages. Susan Best has playfully called Norrie's working material 'basic black', invoking modern fashion from Beau Brummell's suit to Coco Chanel's little black dress to Yves Saint Laurent's *le smoking*. (We have come full circle.) But this black more forcefully invokes traditional mourning. If modern black mourns for the peacock colours of the *ancien régime*, Norrie's pleating, beads and lace summon the spectres of Victorian femininity in thrall to social, physical and psychic constraints.[9]

Inquisition works through a spectacular tension in two senses. The objects are literally contained, each housed in a beautiful frame or case which protects but also keeps its presiding demons under wraps. Who are these monsters? What horrors do they know? Perhaps in the heart of feminine decorum and good taste lurks a spectre that haunts culture. This femininity is a double-edged blade, creating and sustaining social order but able to contemplate its destruction in a moment. (The 1996 *Inquisition* series included a framed object based on an eighteenth-century European saboteur's knife.) Thus, threatened excess is everywhere. In *Inquisition one*, 4000 glass beads suggest discreet seduction, like Givenchy's model draped in lace. But they also threaten chaos with a particularly feminine inflection should the threads break and the beads scatter. For if black depends on white, and sight suggests blindness, then creation requires destruction, and the existence of objects inevitably tempts nothingness.

Thus to the third key: the body in painting. In western painting the artist's body and the observers' bodies are traditionally repressed in favour of represented bodies. This order of bodily depictions was always gendered, and if vision is in itself quite indifferent to gender, feminist re-readings of Freud and of Lacan have shown how vision is intensely gendered in western culture.[10] For years Norrie has worked against these standard presumptions through a strategy of displacement, almost always eliminating the represented feminine body — showing it here almost dis-embodied but engaged in blatant surveillance — in favour of evoking feminine corporeality through materials

This is the true (radical) meaning of the proliferation of 'feminine' signifiers in *Inquisition*: they lure one away from the *image* of the feminine body towards a consideration of feminine subjectivity.

and absences. This is the true (radical) meaning of the proliferation of 'feminine' signifiers in *Inquisition*: they lure one away from the *image* of the feminine body towards a consideration of feminine subjectivity. As Gregory Burke has noted: 'It is ultimately through her enactment of a body that escapes representation that Norrie's work can be felt to resist the synthesised pulse of post-modernity'.[11]

The final body in Norrie's *Inquisition* is our own, whether feminine or masculine. In *Inquisition* we are followed, 'shadowed' quite explicitly, through ghosted reflections in glass frames and cases. Note: most are scaled to the human torso. Paradoxically, darkness is privileged so the image may be born. In the struggle to see, *Inquisition* obliges us to acknowledge ourselves. We must enact our own becoming, or — to use a photographic term — preside over our own development. *Inquisition* thus enforces its title.

Eventually we must participate in the essential mystery of painting, which is to mirror existence, if not through mimesis, then through analogy and experiment. 'Once you saw but through a glass darkly, but now see face to face ...' says the famous epistle of Saint Paul to the Corinthians.[12] While Saint Paul permitted women to worship, he did not encourage them to speak. Working with the problem of the feminine body in painting, Susan Norrie is resisting an ancient repression.

The Pauline text recalls the *Inquisition* of the title. Susan Norrie interrogates the contemporary status of painting together with other artists, historians and philosophers. One key text is Yve-Alain Bois's 'Painting: The task of mourning', which considered millenarianist claims that 'painting is dead'. Bois notes: 'mourning has been the activity of painting throughout this century'.[13] But Bois concluded that while certain kinds of painting are defunct, the desire for it remains and future possibilities exist. Norrie's *Inquisition* faces the death of painting in order to explore the possibility of life for art. In this she does not *follow* theoretical texts; her work itself is a theoretical speculation on painting, carried out through the artist's practice, and in this Norrie reveals herself as a *strategic* artist in Bois's terms. Bois reiterates the crucial question of Hubert Damisch: 'What does it mean for a painter to think?' and 'above all, what is the mode of thought of which painting is the stake?'[14] That is precisely the task that Norrie pursues in *Inquisition*.

9 See S. Best, 'Hooks and Eyes: Susan Norrie's *Inquisition*', in the *Seppelt Contemporary Art Award 1997* (exh. cat.), Museum of Contemporary Art, Sydney, 1997, pp. 20–3.

10 See the classic text by L. Mulvey, 'Visual Pleasure and Narrative Cinema' in *Visual and Other Pleasures*, Bloomington, 1989, pp. 14–26; and the useful summaries by M. Olin, '*Gaze*', and W. Chadwick, '*Gender*', in R. Nelson and R. Shiff (eds), *Critical Terms for Art History*, Chicago, 1996, pp. 208–19 & 220–33.

11 G. Burke, 'Pretexts: Accents of the Modern in the Work of Susan Norrie', in *Virtual Reality* (exh. cat.), (curator Mary Eagle), National Gallery of Australia, Canberra, 1994, pp. 10–11.

12 First Epistle of Saint Paul to the Corinthians, Chapter 13, Verse 12.

13 Bois, p. 243.

14 ibid., p. 245.

010320640

24.01 Susan Norrie, *Inquisition: Poisonous fly paper painting II*, 1996–99

24.01 Susan Norrie, *Inquisition: Inquisition nine*, 1996–99

Not coincidentally, black is the quintessential emblem of modernist art. All monochromes trouble representational painting, but black especially does this, since it actually and symbolically denies sight. Norrie invokes Malevich's *Black square*, 1915, and more recently, Ad Reinhardt's late black paintings from 1953 to 1967. These blacks had complementary whites in the social order of modernity: white architecture, Malevich's own *Suprematist composition: White on white*, c. 1918, and Robert Rauschenberg's white paintings of the early 1950s. Susan Norrie's installation of black paintings imperiously summon these ghosts. Here, white, in a positively subversive logic, is the shadow of black.

Next, Susan Norrie considers black and white photography, which recapitulated the earlier tonal regime of European art. As Roland Barthes noted: 'Photography has been, and is still, tormented by the ghost of Painting'.[4] Norrie's deployment of photography is neither casual nor opportunist but depends on its status as an enduring tribute to older European ways of seeing. Following its Enlightenment legacy, photography is still generally accepted as the technology of truth. However, Norrie has reproduced a photograph whose documentary status is challenged by its haute-couture excess, and the registers of consumer desire and luxury it invokes. The lace mantilla worn by Alexander McQueen's Parisian model resembles the Spanish costumes Goya depicted when Enlightenment reformers were challenging the autocratic regimes of Europe. The image thus signals the precise moment when '[t]he sleep of reason produces nightmares', to quote the most celebrated etching from Goya's great suite, *Los caprichos* 1799.[5] In its turn, this *painted* photograph signals a set of intersecting discourses about painting, photography and death: the famous comment by the nineteenth-century painter Paul Delaroche, on first seeing a photograph, that '[f]rom today painting is dead'; the myriad historical uses of photography to document death; Roland Barthes's celebrated discussion of the relationship between photography and death.[6]

4 R. Barthes, *Camera Lucida: Reflections on Photography* (trans. R. Howard), London, 1984, p. 30.

5 Goya's *Los caprichos* is held in the collection of the National Gallery of Victoria.

6 R. Barthes, especially pp. 92–7.

7 A voluminous literature in philosophical aesthetics attested to the centrality of this issue in the 1960s and 1970s. Important publications included N. Goodman, *Languages of Art*, Indianaopolis, 1968 and R. Wollheim, *Art and its Objects, An Introduction to Aesthetics*, New York, 1968. See also H. Rosenberg, *The Anxious Object: Art Today and its Audience*, New York, 1964. In Australia the early works of Peter Kennedy, Mike Parr, Tim Johnson, Vivienne Binns and Robert Rooney explored the ontological status of the work of art. Other significant post-conceptual Australian artists of Norrie's generation include Aleks Danko, Joan Grounds and Peter Tyndall, to name only a few. The issues raised by post-object art were explored in Australia by the Sydney theorist Donald Brook, whose writing and teaching was extremely influential in the late 1960s and early 1970s.

8 See the following for the relationship of Norrie's painting to her later critiques of it: C. Moore, 'Susan Norrie', *Flash Art*, Summer 1989, p. 165, and I. Periz 'Susan Norrie', *Art + Text*, no. 48, 1994, p. 68.

The second key to *Inquisition* lies in intensely cross-referential dialogues between materials and objects, through which Norrie signals (and constitutes) her interrogation of painting. This is a both a contestatory and complementary set of discourses, with the opposition (and complicity) that exists between tactility and sight constantly invoked. Unusually so. For painting habitually displaces objects in favour of representations — that is the mystery of western painting in a nutshell. With *Inquisition*, the issue is whether the paintings are representations recalling things, or things in themselves. In pursuing these questions, Norrie is an inheritor of 1960s conceptual art and its great theme, the status of the art object.[7] Norrie poses the question: 'What is a painting?' in practical terms, with 'paintings' so substantial that their status is immediately called into question. *Inquisition* rebukes sight, inviting touch — if only the intervening glass did not frustrate (quicken) pleasure. The exquisite epitome of desire is to stimulate, then refuse. *Inquisition* reminds us that illusionist painting exists precisely to summon what is *not* there, and that one may look but never touch.

That said, Norrie's objects are as significant as those depicted in Dutch seventeenth-century *vanitas* paintings, which indicated the fleeting nature of life by showing harbingers of death. Her objects are discreet, precise, controlled. Above all, they are feminine, in continuation of her long affair with the troubling sensorium and troubled subjectivity of contemporary woman.[8] Everywhere are marks

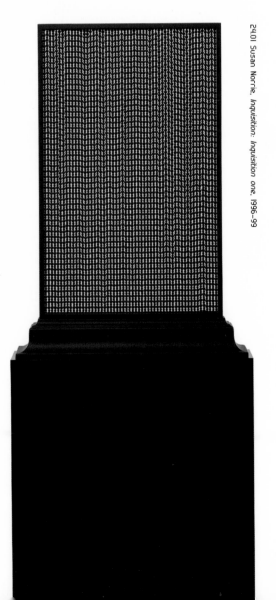

24.01 Susan Norrie, *Inquisition: Inquisition one*, 1996–99

Susan Norrie is a painter of high ambition. She works through the legacy of the great traditions of European painting, yet her strategy as an artist is to interrogate these traditions rather than accept them. This installation is from the *Inquisition* series, 1996–99 (24.01), and continues Norrie's long-standing examination of the ontological status of painting, the vicissitudes of its traverse through modernity, and its ambivalent potential as a contemporary practice.[1]

Inquisition: the word signals formal enquiry at the highest level. But if the Spanish Inquisition proceeded from deadly certainty, inquisitiveness has one important origin in resistance. 'Painting' invokes 'anti-painting': the 'death of painting' has been reported for nearly 100 years, and the radical reconsideration of painting has been the great work of modern art. Norrie's *Inquisition* is particularly apt for the National Gallery of Victoria, which houses the greatest collection of European painting in Australia; and the National Gallery School attracted Norrie to Melbourne in the 1970s precisely because of its (then unfashionable) emphasis on painting. These works — these anti-paintings, these *meta*-paintings — have thus returned to their spiritual home.

I suggest three keys to *Inquisition*. First, it problematizes the centrality of the optical aspect of painting, since, quite simply, Norrie has deliberately made the work difficult to see. Light is the key to sight and painting. In European art, light and dark are conventionalized as black and white, and this fundamental dichotomy — with all its metaphorical baggage — is invoked by Susan Norrie. Almost every element of *Inquisition* is black: objects, materials, frames. This insistent blackness is sober, stringent, eventually scary. There is no relief from its implacability, nor its stern refusal to seduce the viewer. The painter's traditional lexicon is colour but here this is denied in favour of a more perverse beauty. The apparent uniformity of this blackness is deceptive, both perceptually and semiotically. The viewer is impelled to look closely to make sense of the work; they must peer thorough the glass, squinting against reflected lights. In *Inquisition ten*, for instance, they will find paint so thickly textured that eventually, paradoxically, the separate strokes of paint — at first indistinguishable — become individuated. Or rather, each stroke demands to be considered — and then the problem of differentiating what *appears* the same must be confronted. This thickness reverses oil painting's translucent veils of colours. Here, paint deliberately obscures rather than reveals, and Norrie indicates — many elements of *Inquisition* are indexical — that she is aware of the debates surrounding thickly painted surfaces in late modern paintings.[2]

Black requires white, seen here in two distinct cultural registers. The first is the white of modernity, particularly the 'white cube' of the modernist museum. As Brian O'Doherty wrote in 1976, this is a determining context for modern art:

> An image comes to mind of a white, ideal space that, more than any single picture, may be the archetypal image of twentieth century art; it clarifies itself through a process of historical inevitability usually attached to the art it contains.[3]

Susan Norrie's black paintings inhabit this white context both conceptually and physically, since her reconsideration of the history of painting would be inconceivable without the modernist museum which still sustains contemporary art.

1 The *Inquisition* series was first shown in *Susan Norrie: Selected Works*, Mori Galley, Sydney, 4–21 December 1996. It comprised the *Inquisition/one – Inquisition/eight*, plus *Poisonous fly paper painting II*, all 1996. In 1997 *Inquisition/one-seven*, with the addition of *Untitled*, 1997, a photographic image on vinyl of British SAS troops storming a London building, were shown in the Seppelt Contemporary Art Award, Museum of Contemporary Art, Sydney. This group was the winner of the award. The National Gallery of Victoria's suite from the *Inquisition* series was acquired in 1999.

2 See Yve-Alain Bois, 'Painting as Model', pp. 245–57, in *Painting as Model*, Cambridge, 1990, especially pp. 250–2.

3 B. O'Doherty, *Inside the White Cube: The Ideology of the Gallery Space*, (introduction by T. McEvilley) Santa Monica/San Francisco, 1986, p. 14. The essays in this volume were first published in *Artforum* in 1976.

23.02 Raafat Ishak, *Good government*, 1999–2000

23.01 Raafat Ishak, *Good information*, 1999–2000
(detail)

Ishak's paintings transform easily from being a labyrinth of line, colour and symbol to more elaborate stories. The flexibility of Ishak's symbolism reflects his particular way of seeing things (people, objects and images) as always being in a state of mobility and transformation. This perspective is informed by Ishak's own experience as someone who has adapted from life in one culture (Egyptian) to a new one (Australian).

Ishak's is a peculiar and contradictory artistic practice. On the one hand, his work is preoccupied with the line, with being well defined and systematic. It reveals an interest in systems of government and governance, obedience and social control. On the other hand, his subject matter is elusive and as faint as the pale colours he uses. His paintings are always evocative rather than definitive. This is because Ishak finishes his paintings, not by making them into a diagram of a particular social situation or idea but by making them operate primarily as a visual image.

This is painting as Henri Matisse understood it, as fundamentally 'decorative' (a concept as misunderstood and undervalued in his own day as it is in ours); that is, through pattern and colour a painting should foremost be pleasing to the eye. Like Matisse, Ishak finds inspiration in the Middle East, where art and text frequently decorate interiors, working together both as pure embellishment and to convey a message. For Ishak, the patterns and colours of his paintings are just as important as the message he seeks to convey. Unless his paintings work as on both levels, they remain incomplete. ¤

This essay is based on conversations with Raafat Ishak during February and March 2000.

Raafat Ishak came into public view as a young artist during the late 1990s. He started exhibiting at artist-run spaces, notably First Floor artists' and writers' space in Fitzroy, Melbourne. Ishak's paintings stood out from the cigarette butts and op-shop clothing installations left over on the gallery after the grunge movement. In comparison, his pale networks of linear images drawn directly on bare canvas were austere and subtle.

Ishak and his contemporaries — artists such as David Jolly, Ricky Swallow and Jonathan Nichols — were creating works that indicated a move away from the feral and often pungent materialism of grunge, returning to pictorial values. Rather than go for the seemingly haphazard, found-it-in-the-back-yard-and-now-it's-in-the-gallery look, these artists began making paintings and sculptures in a comparatively traditional way. They transformed basic materials using engaging techniques, for example, Jolly's paintings on glass, Nichol's portraits sourced from the Internet, and Swallow's cardboard models. The work of Jolly, Swallow, Nichols and Ishak collectively marked a return to the creation of paintings and sculpture that operate within their own physical parameters, rather than engaging more directly with the surrounding space of the gallery, like an installation.

Ishak arrived on the scene at a time when there was a lot of talk about 'the diaspora' (an academic term for immigration) as it related to contemporary art. Artists and their work were being discussed in the light of various issues relating to the migration of people from one country and culture to another. The diaspora discussions were becoming tedious, over-determined and every day sounded more and more like PR for international trade and relations. While Ishak, as an artist from an Egyptian background, chose to deal with this subject matter in his art, his treatment of it is understated and private. He has not made a career out of playing the role of 'the Egyptian/Australian artist'.

Although Ishak's art sits comfortably in a number of contexts, his work is highly idiosyncratic. The painting technique exemplified in *Good information*, 1996–2000 (23.01), is a foundation by which the artist and viewer can understand Ishak's artistic practice. Ishak has drawn in oil paint on bare canvas, going over each line three times, like he's repeating the thought that inspired it. As the paint has been built up, the line has become a ridge and the thought set. This has then become part of a system of other lines and ideas that make up the painting and the creative process.

The qualities of this technique are an important part of the symbolism of Ishak's work. All these straight lines make the picture look very cool, logical and elegant. They are also a bit pedantic and controlled. That is not to say that their meanings are clearly defined. Ishak is courting a level of obscurity. Obscurity gives him freedom from tying meaning down to one thing. So, as much as they are emphatically inscribed, the symbols and images are floating and free on the canvas. They are precise but variable.

This linear, diagrammatic style marks the influence of Australian artist Peter Tyndall. Tyndall's oeuvre is collectively titled, 'A person looks at a work of art. Someone looks at something'. From the mid 1970s, Tyndall's art drew people's attention to the way that the meaning of a work of art is informed by the context in which it is displayed. Tyndall's adherence to a system of painting and his dedication to representing a broader social system (the way we understand images and art) informed Raafat Ishak's own interest in the way that both social and aesthetic systems operate simultaneously within an artistic practice.

Good information is labyrinthine in form *and* meaning. Vignettes from vernacular Australian life are represented with a quiet subtext of power and politics. In one panel Kylie Minogue (whom Ishak sees as the quintessential Aussie girl) is represented as a street fighter and the Queen of Hearts. In another panel a suburban home juxtaposed with a helicopter suggests safety, under surveillance.

Sometimes a narrative emerges. For example, one panel suggests that a guy smoked some dope (the pipe), had a stoner's epiphany (see the eye in the base of the pipe?) and decided to write a letter to his Egyptian mother (script in upper right corner) to tell her, completely without cynicism, that in Australia they look up to football coaches as authority figures.

22.02 Brent Harris, *Study for Swamp (no. 2) E*, 1999

The work of Louise Bourgeois is another useful touchstone for Harris. The complex psychology of her own life, particularly her early family life, has been the constant source and inspiration for her art. For Bourgeois, the creation of art motivated by the personal has been cathartic, enabling her to address, expose and ultimately transcend past destructive experiences. The powerful references to the body, fleshy, sensual and sexual, that feature in her work are an essential element within this process, and one of the links with Harris's art which has frequently made ambiguous allusions to bodily and sexual forms. It is also in Bourgeois's engagement with her personal psychology and her expression of what Harris describes as her 'libidinal energy' that he finds a connection with his own work.

The Japanese tradition of *ukiyo-e* woodblock prints, has also been important in Harris's recent work, specifically the graphic quality of the prints.

> I think it's rather obvious that I should look at Japanese work ... because it's very linear and it ... operate[s] with flattened areas of colour ... I still find it an incredibly active space. I was focusing on Japanese prints while I was making *[Swamp]*, but it's not really an analytical investigation of the space, as much as looking ... just looking and absorbing the dynamic way that the surface of the prints is activated.

The Japanese artist's ability to describe a subject using only a few lines and juxtaposed planes of colour is very relevant for Harris, whose distinctive visual language reduces representational detail to a point where the imagery is caught in a state of permanent flux. This flux is borne of the spatial and optical tension that exists in the paintings, as well as the pull between abstraction and figuration.

While the Swamp paintings retain the austere formal qualities characteristic of Harris's art since the late 1980s, they are distinguished from his past work by significant new elements. A relaxation and greater fluidity of form coincides here with the emergence of imagery that, although ambiguous, is increasingly figurative in its references. The tendency towards figuration signifies the most fundamental difference in both this and subsequent work — the conscious expression of strongly personal content. While the cool abstraction, crisply defined forms and uninflected surfaces prevail in *Swamp*, they can longer camouflage the disruptive and deeply felt elements — emotional states, memories and personal history — with which they are imbued. ¤

7 After looking at Munch woodcuts, including those held in the National Gallery of Victoria's collection, Harris adopted the 'jigsaw' technique for a pair of woodcuts, *The untimely (no. 7)* and *The untimely (no. 3)*, 1998.

Swamp (no. 2), 1999, (22.01) makes this bodily reference most directly with an additional fine black line defining the legs of a standing female figure. The figure is bending so that the top of its form, a mass of long hair, sweeps close to the ground. Strangely, the 'feet' and 'hair' of the figure are joined, and appear to be connected to another form situated just beyond the left edge of the picture. This fluid mutability suggests that the figure is undergoing a transition, or perhaps is not yet fully formed.

> There's a continual positive and negative play, particularly in *[Swamp] no. 2*. The black shape that's in between the figure stands as a separate sort of abstract form. For me, that shape comes forward, trying to form itself. It's possible that black central shape could in fact become a face. So that's a becoming form...I see *Swamp* as the *becoming* of the body.

For Harris, the 'body' in *Swamp (no. 2)* is a weeping woman. Symbolic of the mother, her hair-like form represents an outpouring of emotion—grief, sadness, rage and loss—that is universal. She is also inextricably linked to other family members—the child, represented by the abstract black shape encompassed by her bending form, and the father, perhaps the figure alluded to just beyond the painting's edge.

Harris also sees the *Swamp* paintings as being about the family, particularly in the context of his subsequent series, *Grotesquerie*, 2001–02, which is explicitly about his childhood experience of family and the complex power relationships that existed within it. Defining family members and depicting them in a distinctly figurative manner, *Grotesquerie* reveals the transition Harris has made since painting *Swamp*. Where *Swamp* reflected the point at which Harris started 'to engage [his] feelings of sadness about the family', *Grotesquerie* reveals a greater emotional involvement with the subject—the result of a more direct confrontation with his emotional experience. In this sense, the metaphor of a 'becoming' body that is depicted in *Swamp*, and extended in *Grotesquerie*, mirrors the development of Harris's conscious involvement with the subject: 'The subject is becoming stronger for me and the subject matter is becoming more personal...and it seems that it's therefore becoming more figurative'.

As a visual representation of human frailty and emotion, *Swamp (no. 2)* recalls the work of Edvard Munch and Louise Bourgeois; artists in whom Harris is interested and whose work he has occasionally made reference to in his own. The shrouded form in Harris's painting is particularly reminiscent of the figures in Munch's woodcuts, such as *The kiss*, 1898, printed using the 'jigsaw' method.[7] In this technique, different colours are printed from sections cut out of a single block, flattening out the imagery and, as in Harris's work, establishing

Harris's use of abstracted natural forms to communicate emotions, moods and ideas...equates with Munch's symbolist practice.

a dynamic spatial tension between the foreground and background elements. Harris's use of abstracted natural forms to communicate emotions, moods and ideas also equates with Munch's symbolist practice. The strongest association, however, is in the way the figure's physical form so clearly communicates its psychological state.

 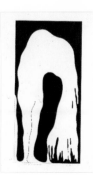 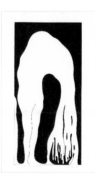

22.02 Brent Harris, *Study for Swamp (no. 2) A–G*, 1999

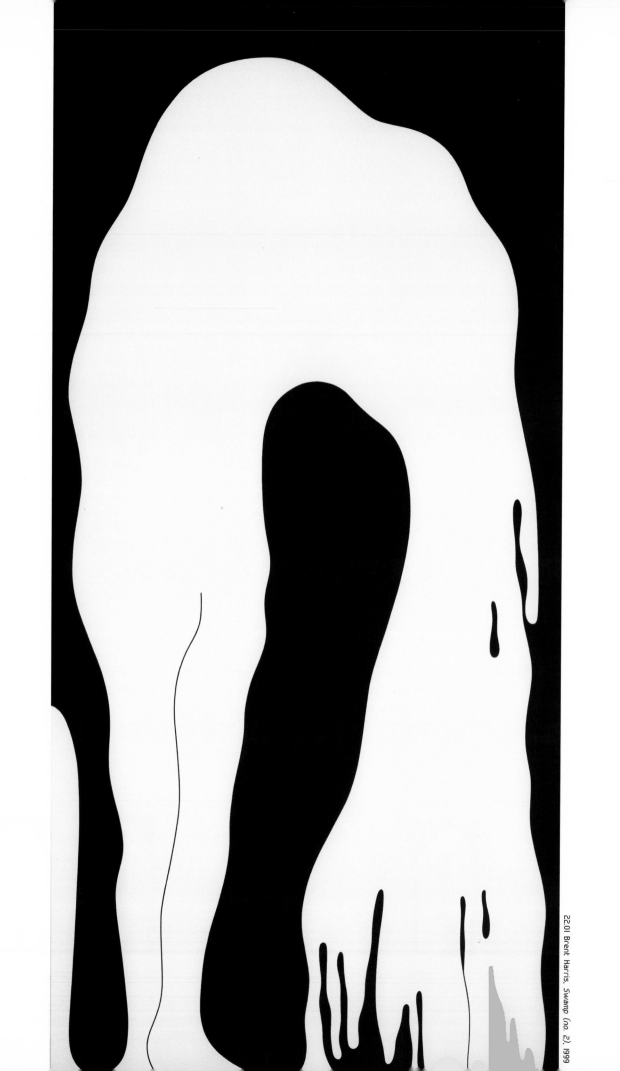

try looking at that melancholy thing and let yourself go thinking about it.[1] **Kirsty Grant**

Brent Harris's recent paintings and works on paper have made frequent reference to watery themes and places, both in terms of their titles—*Oceania*, 1997; *Drift*, 1998; *Swamp*, 1999—and their imagery, which has moved away from the hard-edged geometric abstraction of his earlier work and become more fluid. These works are also linked by personal content and the expression of emotion, often unformed and indefinable, which has become an increasingly important source of Harris's abstract imagery. In terms of subject matter and meaning, these paintings, prints and drawings represent a significant departure from his previous work.

Swamp, 1999, a series of seventeen paintings,[2] developed in large part from a suite of prints entitled *Drift*, published in 1998.[3] Based on drawings Harris made during an extended visit to New York in 1997, in response to a series of 'mad, messy doodles' by German artist Martin Kippenberger, and encouraged by the use of spit-bite aquatint which was allowed to run freely across the etching plate, the prints are characterized by an accidental quality and apparent randomness of line, form and composition. A loose narrative also emerges in *Drift* through the repeated image of a bird that, to Harris, symbolizes the artist and his journey. For the first time, Harris identified and located himself in the picture. Enabling him to find 'a way…to connect with emotions', *Drift* signified the beginning of the conscious expression of Harris's personal psychology within his art.

It was after he read about the Freudian concept of 'oceanic feeling' that elements of Harris's psychology and these watery themes came together.[4] Although such imagery had appeared in his work previously, discovering this theoretical concept enabled him to unite the visual character of his work with its emotional content and meaning. Described by Freud as being like 'a sensation of eternity…something limitless [and] unbounded', oceanic feeling is also the basis of religious sentiment, for which Freud believed one requires 'an indissoluble bond…with the external world'.[5] On the simplest level, there is sometimes a literal connection between the forms depicted in the work and Harris's occasionally symbolic representation of the ocean(ic). For Harris, however, the concept prompts further associations, in particular the idea of 'becoming', or metamorphosis from formlessness to identity. There is also an implicit connection for him between 'oceanic feeling' and sadness—'It just immediately makes me feel a sadness. It's like the welling up of tears, a welling up of emotion [and like] the way the ocean moves'.[6]

Harris has said that '*Swamp*'s images were found through feeling'. Working from this point, he began with a series of speculative charcoal drawings where outlines of the shapes were repeatedly drawn in, erased and modified. At several points when the final form appeared to be emerging, he made more highly finished drawings in coloured pencil, approximating more closely the contrasts of colour and spatial distinctions that can be seen in the paintings. The emotional content and formal qualities of Harris's art are intimately linked in a radical break from his earlier work. The former has now assumed a more fundamental role within the creative process specific to his art.

Throughout the *Swamp* paintings, languid white forms emerge from a dense black ground. Dark and impenetrable, the swampy ground gives rise to strange forms, which bend and sway as if being moved about by gentle currents. Some are organic plant-like forms, which have grown to form dense veils against the darkness. In others, strange mutations have occurred and suggestions of human form—legs, feet and arms, a breast, testicles—emerge out of the watery darkness.

1 Bala Starr, *Drift*, poem published in Brent Harris's 1998 print portfolio of the same name.

2 Seven *Swamp* paintings and the set of related aquatints were exhibited at Tolarno Galleries, Melbourne, in October 1999. A further eight paintings were shown at Kaliman Gallery, Sydney, May–June 2001. In addition, there were two unexhibited paintings in the series.

3 The *Swamp* series also relates to two earlier paintings, *Territory*, 1993, (Collection: BP Australia) and *Oceania*, 1997, (Private Collection, Melbourne). The production and publication of *Drift*, a suite of ten intaglio prints, was funded by a grant from the Australia Council.

4 Harris first read about 'oceanic feeling' in Rosalind E. Krauss, *The Optical Unconscious*, Massachusetts, 1993, chapter 6.

5 Sigmund Freud, *Civilization and its Discontents*, New York, 1961, pp. 10–15.

6 All quotes are from an interview with the artist, 23 November 2001.

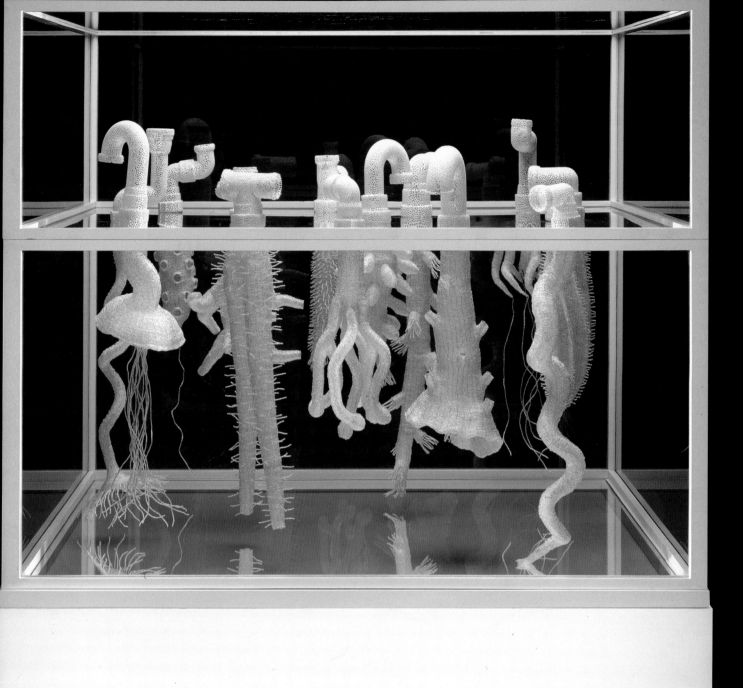

Ian Burn (Australia 1939–93), *Mirror piece*, 1967. Mirror glass, wood and photocopies on cardboard (15 panels), ed. 19/35, (1–14) 27.6 x 21.6 cm (each sheet), (1–14) 29.2 x 22.8 cm (each panel), (15) 57.4 x 39.4 cm (mirror), (1–15) variable (overall). Purchased, 1972 (A20.1-15-1972)

Ian Burn (Australia 1939–93), *Four glass/mirror piece*, 1968. Mirror, glass, in wooden frame. Twenty-two pages of photocopies, bound in cardboard and cloth cover, with metal fastener. Purchased through the NGV Foundation with the assistance of the Rudy Komon Fund, Governor, 2001 (2001.559.a-b)

Dale Hickey (born Australia 1937), *Fences*, 1969. Synthetic polymer paint, graphite, coloured pencils, ballpoint pen, black and white photographs, cardboard, masking tape, variable dimensions. Gift of Bruce Pollard, 1980 (AC67.1-14-1980)

Robert Hunter (born Australia 1947), *Untitled no. 8*, 1968. Synthetic polymer paint on canvas, 158.4 x 158.4 cm. Gift of N. R. Seddon, 1968 (1827-5)

Robert Hunter (born Australia 1947), *Untitled*, 1970. Synthetic polymer paint and masking tape on paper (6 panels), (a) 172.7 x 158.4 cm irreg. (image and sheet), (b) 172.7 x 158.4 cm irreg. (image and sheet), (c) 172.7 x 158.4 cm irreg. (image and sheet), (d) 172.7 x 158.4 cm irreg. (image and sheet), (e) 172.7 x 158.4 cm irreg. (image and sheet), (f) 172.7 x 158.4 cm irreg. (image and sheet). Purchased, 1977 (A2-1977)

Callum Morton (born Canada 1965, arrived in Australia 1967), *Gas and Fuel*, 2002. Wood, acrylic paint, aluminium, perspex, paper and sound, 220.0 x 91.0 x 600.0 cm. The Corbett and Yeuji Lyon Collection. Promised gift through the NGV Foundation by Corbett and Yeuji Lyon

John Peart (born Australia 1945), *Corner square diagonal*, 1968. Synthetic polymer paint on shaped canvas, 229.2 x 227.6 x 12.6 cm. Purchased through The Art Foundation of Victoria with funds provided by the National Gallery Society of Victoria, Governor, 1985 (AC11-1985)

Mel Ramsden (born Great Britain 1944, arrived in Australia 1963, worked in Great Britain 1964–67, New York 1967–77, Great Britain from 1977), *Secret painting*, 1967–68. Synthetic polymer paint on canvas and gelatin silver photograph from artist's negative on composition board, 86.4 x 156.5 cm (installed). Purchased, 1972 (A21.a-b-1972)

Robert Rooney (born Australia 1937), *Corners*, 1972. Gelatin silver photograph, photo corners and ballpoint pen on cardboard, (60.2 x 107.0 cm) irreg. Purchased, 1981 (AC9-1981)

Anatjari Tjakamarra (Ngaatjatjarra/Pintupi (c. 1938–92), *Big Pintupi Dreaming ceremony*, (1972). Synthetic polymer paint on composition board, 51.5 x 43.3 cm. Purchased through The Art Foundation of Victoria with the assistance of North Broken Hill Pty Ltd, Fellow, 1987 (0.51-987)

Long Jack Phillipus Tjakamarra (Warlpiri/Luritja born c. 1932), *Emu Dreaming*, (1972). Synthetic polymer paint on composition board, 64.7 x 62.8 cm. Purchased from Admission Funds, 1987 (0.22-1987)

Long Jack Phillipus Tjakamarra (Warlpiri/Luritja born c. 1932), *Possum man and possum woman travelling*, 1973. Synthetic polymer paint on composition board, 122.5 x 93.0 cm. Presented through the NGV Foundation by Mr Rodney Menzies, Governor, 2001 (2001.619)

Mick Wallangkarri Tjakamarra (Arrernte/Luritja c. 1910–96), *Water Dreaming with bush tucker*, (1972). Synthetic polymer paint on composition board, 59.4 x 58.0 cm. Purchased through The Art Foundation of Victoria with the assistance of ICI Australia Ltd, Fellow, 1988 (0.12-1988)

Mick Wallangkarri Tjakamarra (Arrernte/Luritja c. 1910–96), *Old man's Dreaming on death or destiny*, (1971). Synthetic polymer paint on composition board, 60.9 x 45.7 cm. Purchased through The Art Foundation of Victoria with the assistance of North Broken Hill Pty Ltd, Fellow, 1987 (0.49-1987)

Walter Tjampitjinpa (Pintupi c. 1912–80), *Water Dreaming*, 1971. Enamel paint on fruit box lid, 47.5 x 22.3 cm. Private collection

Walter Tjampitjinpa (Pintupi c. 1912–80), *Water Dreaming at Kalipinypa*, (1971). Enamel paint on composition board, 61.6 x 73.2 cm. Purchased through The Art Foundation of Victoria with the assistance of Alcoa of Australia Limited, Governor, 1993 (0.21-1993)

Uta Uta Tjangala (Pintupi c. 1920–90), *Big snake ceremonial travelling Dreaming*, (1972). Synthetic polymer paint on composition board, 67.7 x 46.0 cm. Purchased through The Art Foundation of Victoria with the assistance of ICI Australia Ltd, Fellow, 1988 (0.10-1988)

Uta Uta Tjangala (Pintupi c. 1920–90), *Untitled*, (1972). Synthetic polymer paint on composition board, 83.8 x 63.6 cm. Gift of Mrs Douglas Carnegie OAM, 1989 (0.87-1989)

Mick Namarari Tjapaltjarri (Pintupi c. 1926–98), *Water Dreaming*, 1971. Synthetic polymer paint on composition board, 61.0 x 56.0 cm. Private collection, courtesy Lauraine Diggins Fine Art

Johnny Lynch Tjapangati (Anmatjerre c. 1922–82), *Honey ant Dreaming*, 1973. Papunya, Northern Territory. Synthetic polymer paint on composition board, 60.0 x 84.0 cm. Private collection

Timmy Payungka Tjapangati (Pintupi c. 1942–2000), *Untitled*, (1972). Synthetic polymer paint on composition board, 61.5 x 46.2 cm. Gift of Mrs Douglas Carnegie OAM, 1989 (0.85-1989)

Charlie Tarawa Tjungurrayi (Pintupi 1921–99), *Old man's Dreaming at Mitukatjirri*, (1972). Gouache on composition board, 32.7 x 65.1 cm. Gift of Mrs Douglas Carnegie OAM, 1988 (0.31-1988)

Charlie Tarawa Tjungurrayi (Pintupi 1921–99), *Snake Dreaming*, 1971. Synthetic polymer paint on floor tile, 28.2 x 28.6 cm. Private collection

Shorty Lungkarda Tjungurrayi (Pintupi c. 1920–87), *Men in a bushfire*, (1972). Synthetic polymer paint on composition board, 64.2 x 50.1 cm. Purchased through The Art Foundation of Victoria with the assistance of North Broken Hill Pty Ltd, Fellow, 1987 (0.55-1987)

Shorty Lungkarda Tjungurrayi (Pintupi c. 1920–87), *Waterhole in a cave*, (1972). Synthetic polymer paint on canvas, 61.5 x 45.4 cm. Purchased through The Art Foundation of Victoria with the assistance of ICI Australia Ltd, Fellow, 1988 (0.11-1988)

Shorty Lungkarda Tjungurrayi (Pintupi c. 1920–87), *Untitled*, (1972). Synthetic polymer paint on composition board, 74.0 x 41.2 cm. Gift of Mrs Douglas Carnegie OAM, 1989 (0.86-1989)

Yala Yala Gibbs Tjungurrayi (Pintupi c. 1928–98), *Snake and water Dreaming*, (1972). Earth pigments and synthetic polymer paint on composition board, 56.5 x 49.9 cm. Gift of Mrs Douglas Carnegie OAM, 1989 (0.9-1989)

Yala Yala Gibbs Tjungurrayi (Pintupi c. 1928–98), *Wiltja Dreaming*, 1972. Synthetic polymer paint on composition board, 79.0 x 32.5 cm. Private collection

Johnny Warangkula Tjupurrula (Luritja c. 1925–2001), *Nintaka and the mala men*, (1973). Synthetic polymer paint on composition board, 69.5 x 65.3 cm. Purchased through The Art Foundation of Victoria with the assistance of ICI Australia Ltd, Fellow, 1988 (0.9-1988)

Johnny Warangkula Tjupurrula (Luritja c. 1925–2001), *A bush tucker story*, (1972). Synthetic polymer paint on composition board, 91.4 x 66.2 cm. Purchased through The Art Foundation of Victoria with the assistance of the North Broken Hill Pty Ltd, Fellow, 1987 (0.48-1987)

Johnny Warangkula Tjupurrula (Luritja c. 1925–2001), *Old man and naughty boys' Dreaming*, 1972. Synthetic polymer paint on composition board, 51.0 x 58.6 cm. Private collection

Dick Watkins (born Australia 1937, worked in Hong Kong 1974–79), *The Mooche*, 1968. Synthetic polymer paint and oil on canvas, 167.5 x 167.5 cm. Laverty collection, Sydney

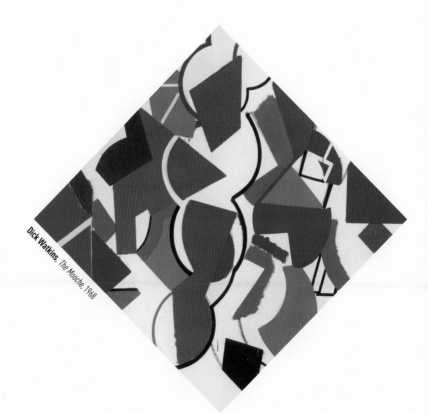

Dick Watkins, *The Mooche*, 1968

Christo and Jeanne-Claude (both born USA 1935), *Woolworks – wrapped wool bales*, 1969. Murdoch Court, National Gallery of Victoria

Marina and Ulay Abramovic (born Yugoslavia 1946 and Germany 1943), *Untitled #1* (Documentary photograph of performance in Lindsay Court, National Gallery of Victoria), 1982

Marina and Ulay Abramovic (born Yugoslavia 1946 and Germany 1943), *Untitled #2* (Documentary photograph of performance in Lindsay Court, National Gallery of Victoria), 1982

Marina and Ulay Abramovic (born Yugoslavia 1946 and Germany 1943), *Untitled #3* (Documentary photograph of performance in Lindsay Court, National Gallery of Victoria), 1982

Robert Boynes (born Australia 1942), *Laid out*, 1978. Synthetic polymer paint on canvas, 97.0 x 243.8 cm. S. E. Wills Bequest, 1979 (A17-1979)

John Davis (Australia 1973–99), *Greene Street piece*, 1973–75. Graphite and black and white photographs on cardboard, (1) 47.9 x 32.8 cm (image and sheet), (2) 47.6 x 32.8 cm (image and sheet), (3) 47.4 x 32.5 cm (image and sheet), (4) 47.5 x 32.8 cm (image and sheet). Gift of Shirley Davis, 1980 (AC58.1-4-1980)

Domenico de Clario (born Italy 1947, arrived in Australia 1958), *Untitled* (4 documentary photographs of elemental landscape installation), 1975.

Sue Ford (born Australia 1943), *Lynne*, 1964; *Lynne*, 1974 (1964–74, printed 1974), from the *Time* series (1962–74). Gelatin silver photograph, 11.1 x 20.1 cm. Purchased with the assistance of the Visual Arts Board and the Kodak (Australasia) Pty Ltd Fund, 1974 (PH168.a-b-1974)

Sue Ford (born Australia 1943), *Toni*, 1964; *Toni*, 1974 (1964–74, printed 1974), from the *Time* series (1962–74). Gelatin silver photograph, 11.1 x 20.1 cm. Purchased with the assistance of the Visual Arts Board and the Kodak (Australasia) Pty Ltd Fund, 1974 (PH169-1974)

Sue Ford (born Australia 1943), *Annette*, 1962; *Annette*, 1974 (1962–74, printed 1974), from the *Time* series (1962–1974). Gelatin silver photograph, 11.1 x 20.1 cm. Purchased with the assistance of the Visual Arts Board and the Kodak (Australasia) Pty Ltd Fund, 1974 (PH170-1974)

Sue Ford (born Australia 1943), *Ross*, 1964; *Ross*, 1974 (1964–74, printed 1974), from the *Time* series (1962–74). Gelatin silver photograph, 11.1 x 20.1 cm. Purchased with the assistance of the Visual Arts Board and the Kodak (Australasia) Pty Ltd Fund, 1974 (PH171.a-b-1974)

Sue Ford (born Australia 1943), *Jim*, 1964; *Jim*, 1974 (1964–74, printed 1974), from the *Time* series (1962–74). Gelatin silver photograph, 11.1 x 20.1 cm. Purchased with the assistance of the Visual Arts Board and the Kodak (Australasia) Pty Ltd Fund, 1974 (PH172-1974)

Richard Larter (born Great Britain 1929, arrived in Australia 1962), *Portrait*, 1975–76. Film, super 8 colour, 32 minutes. Purchased, 1977 (A9-1977)

Richard Larter (born Great Britain 1929, arrived in Australia 1962), *Summer's end*, 1988. Synthetic polymer paint on canvas, 176.4 x 121.9 cm. Presented through the NGV Foundation by Elizabeth and Colin Laverty, Governors, 2001 (2001.377)

Richard Long (born England 1945), *Driftwood circle*, 1977–78. Murdoch Court, National Gallery of Victoria

Chips Mackinolty (born Australia 1954), *Land rights dance*, (1977). Colour photo-stencil screenprint, 74.8 x 49.6 cm (image), 76.0 x 51.0 cm (sheet). Michell Endowment, 1980 (DC22-1980)

Earthworks Poster Collective (1972–79), **Chips Mackinolty** (born Australia 1954), *Second triennial May Day palace revolution ball*, 1977. Colour photo-screenprint, ed. 550, 73.8 x 49.0 cm. (image), 74.8 x 49.0 cm (sheet). Michell Endowment, 1980 (DC24-1980)

Earthworks Poster Collective (1972–79), **Chips Mackinolty** (born Australia 1954), *Workers' health centre*, (1977). Colour photo-screenprint, 75.0 x 56.6 cm. (image), 76.2 x 58.0 cm (sheet). Michell Endowment, 1980 (DC23-1980)

Mandy Martin (born Australia 1952), *Big boss*, 1977. Colour photo-screenprint, 2nd edition, first state 8/12, 88.0 x 47.8 cm (image), (90.8 x 49.2 cm) (sheet). Michell Endowment, 1977, transferred to the Permanent Collection, 1996 (1996.399)

Mandy Martin (born Australia 1952), *Nothing but his hands*, 1977. Colour screenprint, first state, 4/30, 90.0 x 55.6 cm (image), 94.0 x 56.6 cm (sheet). Michell Endowment, 1977. Transferred to the Permanent Collection, 1996 (1996.400)

Ann Newmarch (born Australia 1945), *Look rich*, 1975. Colour photo-screenprint, 1/40, 55.2 x 70.8 cm (image), 75.6 x 59.6 cm (sheet). Michell Endowment, 1978 (DC7-1978)

Ann Newmarch (born Australia 1945), *Children*, 1977-1987. Suite of 10 colour photo-screenprints, 56.0 x 720. cm (each sheet). Purchased 2001 (2001.527.1-10)

Ann Newmarch (born Australia 1945), *Women hold up half the sky!*, 1978. Colour photo-screenprint, 79.3 x 54.8 cm (image), 91.5 x 65.0 cm (sheet). Purchased, 2001 (2001.528)

Jill Orr (born Australia 1952), *Bleeding trees*, 1979. Type C photographs (ten images), Installation variable. Purchased with the assistance of the Visual Arts Board, Australia Council, 1980 (AC64.a-j-1980)

Paul Partos, (born Australia 1943), *Untitled*, (1976, dated 1977). Oil paint, decal lettering, pencil, brass pins and nylon elastic on canvas, 202.4 x 155.4 cm (framed). Purchased, 1977

Ti Parks (born England 1939, worked in Australia 1964–74), *Polynesian 100*, 1973. Metallic paint, ballpoint and fibre-tipped pen, bitumen, film negative, cloth, and paper on colour photographs, 27.8 x 35.8 (sheet) (each) (100 units). Purchased, 1977 (A30-1977)

Earthworks Poster Collective (1972–79), **Toni Robertson** (born Australia 1953), *Definitely*, (1977). Colour photo-screenprint, 48.2 x 68.0 cm (image), 56.0 x 76.0 cm (sheet). Michell Endowment, 1980 (DC25-1980)

Earthworks Poster Collective (1972–79), **Toni Robertson** (born Australia 1953), and **Chips Mackinolty** (born Australia 1954), *Hiroshima Day anti-uranium rally*, 6 August 1977. Colour photo-screenprint, 88.0 x 55.7 cm irreg. (image). Michell Endowment 1980; accessioned 2002

Stelarc (born Cyprus 1946, arrived in Australia 1948), *Events for stretched skin no. 1*, 1976. From photo-documentation of *Events for stretched skin*, 1976 by Shiego Anzai, 40.8 x 60.0 cm. Purchased with the assistance of the Visual Arts Board of the Australia Council, 1984 AC12.5-1984

Stelarc (born Cyprus 1946, arrived in Australia 1948), *Untitled*, 1979. Photograph, 20.3 x 25.4 cm. Collection of the artist

Stelarc (born Cyprus 1946, arrived in Australia 1948), *Untitled*, 1979. Photograph, 20.3 x 25.4 cm. Collection of the artist

Harald Szeemann (born Switzerland 1933), *Harald Szeemann in Australia: I want to leave a well done child here (Kaldor project)*, 1971. National Gallery of Victoria

Clifford Possum Tjapaltjarri (Anmatyerre 1932–2000), *Old man's love story*, 1973. Synthetic polymer paint on composition board, 45.7 x 61.8 cm. Private Collection

Tim Leura Tjapaltjarri (Anmatyerre 1929–84), *Yam spirit Dreaming*, 1972. Synthetic polymer paint on composition board, 52.3 x 75.0 cm. Private collection

Tim Leura Tjapaltjarri (Anmatyerre 1929–84), *Sun, moon and morning star Dreaming*, 1973. Synthetic polymer paint on composition board, 45.5 x 60.8 cm. Private collection

Tim Leura Tjapaltjarri (Anmatyerre 1929–84), and **Clifford Possum Tjapaltjarri** (Anmatyerre c. 1932–2002), *Napperby death spirit Dreaming*, 1980. Synthetic polymer paint on canvas, 207.7 x 670.8 cm. Felton Bequest, 1988 (O.33-1988)

Jenny Watson (born Australia 1951), *House painting: Box Hill North (large version)*, (1977). Oil on canvas, 177.8 x 213.6 cm. Michell Endowment, 1977 (DC9-1977)

Jenny Watson (born Australia 1951), *House painting: Box Hill North (small version)*, (1976). Oil on canvas, 91.4 x 106.6 cm. Michell Endowment, 1977 (DC10-1977)

The Women's Domestic Needlework Group, Set of 10 posters produced to complement *The D'Oyley Show: An exhibition of women's domestic fancywork*, Watters Gallery, Sydney, October 1979. Colour screenprint and photo-screenprint. Michell Endowment 1980

1. *Women who toiled*, 1979. Colour photo-screenprint, 72.9 x 47.6 cm (image), 78.8 x 50.9 cm (sheet). Michell Endowment, 1980 (DC16.1-1980)
2. *The song of the skirt*, 1979. Colour photo-screenprint, 49.3 cm x 77.1 cm (image), 51.0 x 77.8 cm (sheet). Michell Endowment, 1980 (DC16.2-1980)
3. *The forgotten workers*, 1979. Colour photo-screenprint, 73.6 x 49.4 cm (image), 79.0 x 51.4 cm (sheet). Michell Endowment, 1980 (DC16.3-1980)
4. *Sweating the women*, 1979. Colour photo-screenprint, 72.9 x 48.0 cm (image), 79.0 x 51.2 cm (sheet). Michell Endowment, 1980 (DC16.4-1980)
5. *Australian flora and fauna*, 1979. Colour photo-screenprint, 73.6 x 48.9 cm (image), 79.0 x 51.1 cm (sheet). Michell Endowment, 1980 (DC16.5-1980)
6. **Marie McMahon** (born Australia 1953), *Aboriginal land rights, not mining*, 1979. Colour photo-screenprint, 73.1 x 48.6 cm (image), 78.7 x 50.9 cm (sheet). Michell Endowment, 1980 (DC16.6-1980)
7. *Shepparton 1912*, 1979. Colour photo-screenprint, 73.9 x 48.6 cm (image), 79.0 x 51.4 cm (sheet). Michell Endowment, 1980 (DC16.7-1980)
8. *Fancywork: The archaeology of lives*, 1979. Colour photo-screenprint, 73.9 x 50.0 cm (image), 78.6 x 51.1 cm (sheet). Michell Endowment, 1980 (DC16.8-1980)
9. *That as their daughters, daughters updid grow, the needles art to their children show*, 1979. Colour photo-screenprint, 73.8 x 49.4 cm (image), 79.0 x 51.0 cm. Michell Endowment, 1980. (DC16.9-1980)
10. *D'Oyley power*, 1979. Colour photo-screenprint, 73.5 x 49.2 cm (image), 79.0 x 51.1 cm (sheet). Michell Endowment, 1980 (DC16.10-1980)

Ann Newmarch, *Women hold up half the sky!*, 1978

Peter Booth (born Great Britain 1940, arrived in Australia 1958), *Painting*, (1977). Oil on canvas, 182.5 x 304.0 cm. Gift of the artist in memory of Les Hawkins, 1978 (A24-1978)

Peter Booth (born Great Britain 1940, arrived in Australia 1958), *Untitled*, 1971. Synthetic polymer paint on canvas, 245.0 x 184.5cm. Purchased, 1971 (A8-1971)

Peter Booth (born Great Britain 1940, arrived in Australia 1958), *Drawing (large cannibal)*, (1979). Brush and ink, silver casein, 62.0 x 101.4 cm. Purchased through The Art Foundation of Victoria with the assistance of the Rudy Komon Fund, Governor, 1985 (P102-1985)

Peter Booth (born Great Britain 1940, arrived in Australia 1958), *Drawing (hybrid man/insect with four legs)*, (1982). Black chalk and pastel, 25.8 x 34.6 cm. Purchased through The Art Foundation of Victoria with the assistance of the Rudy Komon Fund, Governor, 1985 (P112-1985)

Peter Booth (born Great Britain 1940, arrived in Australia 1958), *Drawing (figure on all fours with red shoes)*, (1982). Black chalk and pencil, 24.6 x 34.0 cm. Purchased through The Art Foundation of Victoria with the assistance of the Rudy Komon Fund, Governor, 1985 (P115-1985)

Peter Booth (born Great Britain 1940, arrived in Australia 1958), *Drawing (Saltimbanques)*, (1982). Black chalk, gouache and watercolour, 22.4 x 30.2 cm. Purchased through The Art Foundation of Victoria with the assistance of the Rudy Komon Fund, Governor, 1985 (P113-1985)

Peter Booth (born Great Britain 1940, arrived in Australia 1958), *Winter*, 1993. Oil on canvas, 280.0 x 305.0 cm. Presented by the National Gallery Women's Association, 2002

Peter Booth (born Great Britain 1940, arrived in Australia 1958), *Painting*, 1979. Oil on canvas, 182.5 x 304.5 cm. Private collection

Peter Booth (born Great Britain 1940, arrived in Australia 1958), *Untitled*, 2002. Charcoal and casein, 63.5 x 101.5cm. Donated through the NGV Foundation in memory of Ann Frances Byrne, 2002

Bill Henson (born Australia 1955), *Untitled*, from the *Untitled 1980–82* series, 1980–82, Gelatin silver photograph, 43.0 x 38.8 cm. Anonymous gift, 1993 (PH2-1993)

Bill Henson (born Australia 1955), *Untitled*, from the *Untitled 1980–82* series, 1980–82, Gelatin silver photograph, 43.0 x 38.8 cm. Anonymous gift, 1993 (PH4-1993)

Bill Henson (born Australia 1955), *Untitled*, from the *Untitled 1980–82* series, 1980–82. Gelatin silver photograph, 32.8 x 47.0 cm. Anonymous gift, 1993 (PH7-1993)

Bill Henson (born Australia 1955), *Untitled*, from the *Untitled 1980–82* series, 1980–82. Gelatin silver photograph, 37.9 x 38.8 cm. Anonymous gift, 1993 (PH9-1993)

Bill Henson (born Australia 1955), *Untitled*, from the *Untitled 1980–82* series, 1980–82. Gelatin silver photograph, 43.0 x 38.9 cm. Anonymous gift, 1993 (PH11-1993)

Bill Henson (born Australia 1955), *Untitled*, from the *Untitled 1980–82* series, 1980–82. Gelatin silver photograph, 43.0 x 38.8 cm. Anonymous gift, 1993 (PH13-1993)

Bill Henson (born Australia 1955), *Untitled*, from the *Untitled 1980–82* series, 1980–82. Gelatin silver photograph, 29.1 x 47.1 cm. Anonymous gift, 1993 (PH16-1993)

Bill Henson (born Australia 1955), *Untitled*, from the *Untitled 1980–82* series, 1980–82. Gelatin silver photograph, 43.0 x 38.8 cm. Anonymous gift, 1993 (PH17-1993)

Bill Henson (born Australia 1955), *Untitled*, 1980–82. Gelatin silver photograph, 43.1 x 33.8 cm. Purchased from Admission Funds, 1988 (PH65-1988)

Bill Henson (born Australia 1955), *Untitled*, 1980–82. Gelatin silver photograph, 43.1 x 39.0 cm. Purchased from Admission Funds, 1988 (PH66-1988)

Bill Henson (born Australia 1955), *Untitled* 1980–82. Gelatin silver photograph, 37.9 x 38.8 cm. Purchased from Admission Funds, 1988 (PH67-1988)

Bill Henson (born Australia 1955), *Untitled*, 1980–82. Gelatin silver photograph, 32.6 x 37.4 cm. Purchased from Admission Funds, 1988 (PH68-1988)

Bill Henson (born Australia 1955), *Untitled*, 1980–82. Gelatin silver photograph, 28.4 x 47.1 cm. Purchased from Admission Funds, 1988 (PH69-1988)

Bill Henson (born Australia 1955), *Untitled*, 1997–98. Type C photograph, 104.4 x 155.0 cm (image), 127.9 x 180.0 cm (sheet). Purchased through the NGV Foundation with the assistance of Mrs Mem Kirby, Fellow, 2000 (2000.223)

Bill Henson (born Australia 1955), *Untitled*, 1998–99. Type C photograph, 104.5 x 155.0 cm (image), 127.0 x 180.0 cm (sheet). Purchased through the NGV Foundation with the assistance of Mrs Mem Kirby, Fellow, 2000 (2000.222)

Bill Henson (born Australia 1955), *Untitled*, from the *Untitled 1994–95* series, 1994–95. Type C photograph, paper tape, painted pins on glassine on plywood, 200.3 x 244.6 cm. Purchased through The Art Foundation of Victoria with the assistance of the Moët & Chandon Art Acquisition Fund, Governor, 1996 (1996.196)

Bill Henson (born Australia 1955), *Untitled*, from the *Paris Opera Project* series, 1990–91. Type C photograph, 124.8 x 124.6 cm (irreg.). Purchased, 1993 (PH174-1993)

Bill Henson (born Australia 1955), *Untitled*, from the |*Paris Opera Project* series, 1990–91. Type C photograph, 125.0 x 124.7 cm irreg. Purchased, 1993 (PH175-1993)

Bill Henson (born Australia 1955), *Untitled*, from the *Paris Opera Project* series, 1990–91. Type C photograph, 124.6 x 124.5 cm irreg. Purchased, 1993 (PH177-1993)

Bea Maddock (born Australia 1934), *TERRA SPIRITUS ... with a darker shade of pale*, 1993–98. Hand-ground ochre and blind letrerpress on 52 sheets, 39.2 x 80.5 x 4.0 cm (framed – each sheet). Private collection

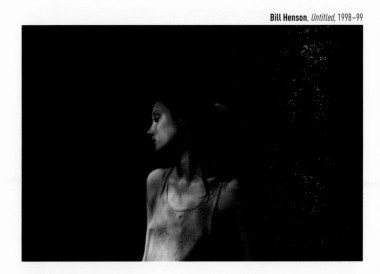

Bill Henson, *Untitled*, 1998–99

Howard Arkley (Australia 1951–99), *Tattooed head*, (1988). Air-brushed acrylic paint and pencil on two sheets of rag paper, 86.0 x 122.0 cm (each sheet), 172.0 x 122.0 cm (overall). Purchased through The Art Foundation of Victoria with the generous assistance of the Leon and Sandra Velik Endowment for Contemporary Drawing, 1989 (P91-1989)

Howard Arkley (Australia 1951–99), *Muzak mural–chair tableau*, 1980–1981. Synthetic polymer paint on canvas and wood chairs, vinyl tiles on composition board, 240.0 x 330.0 x 90.2 cm. Michell Endowment, 1982 (DC18.a-h-1982)

Kate Beynon (born Hong Kong 1970, arrived in Australia, 1974). *Li Ji: Warrior girl*, 2000. VHS videotape, 14 minutes. Purchased through the NGV Foundation with the assistance of the Joan Clemenger Endowment, Governor, 2001 (DC7-2001)

Jon Campbell (born Ireland 1961, arrived in Australia 1964), *So you wanna be a rock 'n' roll star*, 1990. Enamel on acrylic on plywood, 213.0 x 222.0 cm. Presented through the NGV Foundation by Shell Australia Limited, Honorary Life Benefactor, 2002

Brenda Croft (born Australia 1965), *In my mother's garden*, 1998. Laser print, 22.0 x 32.6 cm (image), 30.9 x 46.0 cm (sheet). Purchased, 1999 (1999.187)

Brenda Croft (born Australia 1965), *Caress*, 1998. Laser print, 21.5cm x 32.7 cm (image), 31.1 x 46.2 cm (sheet). Purchased, 1999 (1999.188)

Brenda Croft (born Australia 1965), *Bereft*, 1998. Laser print, 21.5 x 32.7 cm (image), 31.1 x 46.2 cm (sheet). Purchased 1999 (1999.189)

Alex Danko (born Australia 1950), **Joan Grounds** (born USA, 1939, arrived in Australia 1968), *We should call it a living room*, 1974–75. 16 mm colour film, sound, 9 minutes. Purchased 2002 (2002.32)

Juan Davila (born Chile 1946, arrived in Australia 1974), *Rat man*, 1980. Oil on canvas, 197.6 x 274.0 cm. Purchased 1984 (AC84-1984)

Anne Ferran (born Australia 1949), *Untitled*, (1990). Type C photograph, 95.4 x 120.8 cm. Purchased, 1991 (PH83-1991)

Rosalie Gascoigne (born New Zealand 1917, arrived in Australia 1943, died 1999), *Plainsong*, 1988. Sawn retro-reflective signs on plywood, 145.0 x 88.0 cm. Private collection

Pat Larter (born Great Britain 1936, arrived in Australia 1962, died 1996), *Marty*, 1995. Coloured inks, synthetic polymer paint, plastic, glitter and self-adhesive plastic collage on canvas, 126.0 x 90.0 cm. Purchased 1997 (1997.341)

Pat Larter (born Great Britain 1936, arrived in Australia 1962, died 1996), *Tania*, 1995. Coloured inks, synthetic polymer paint, plastic and glitter on canvas, 132.0 x 85.4 cm. Purchased, 1997 (1997.342)

Richard Larter (born Great Britain 1929, arrived in Australia 1962), *Root ripples stocks*, 1975. Synthetic polymer on canvas on composition board, 189.4 x 110.6 cm. Purchased with the assistance of the National Gallery Society of Victoria, 1976 (A2-1976)

Richard Larter (born Great Britain 1929, arrived in Australia 1962), *Scatter shift II*, 1980. Synthetic polymer paint on canvas, 184.4 x 161.4 cm. Purchased, 1981 (AC5-1981)

Richard Larter (born Great Britain 1929, arrived in Australia 1962), *Portrait of Pat*, 1983. Synthetic polymer paint on canvas, 183.0 x 142.5 cm. Purchased through The Art Foundation of Victoria with the assistance of Mr A. C. Goode, Fellow, 1997 (1997.343)

Richard Larter (born Great Britain 1929, arrived in Australia 1962), *Make mine Monday*, 1967. Enamel paint on composition board, 120.8 x 181.4 cm. Purchased 1982 (AC4-1982)

Geoff Lowe (born Australia 1952), *Deception: The man from Ironbark*, 1984. Oil and synthetic polymer paint on canvas, 152.0 x 106.6 cm. Purchased from Admission Funds, 1985 (AC20-1985)

David McDiarmid (born Australia 1952, worked in the USA 1979–84, died 1995), *Body language*, 1990. Self-adhesive plastic collage and enamel paint on plywood, 152.4 x 121.8 cm. Purchased, 1997 (1997.92)

Tracey Moffatt (born Australia 1960), *Night cries: A rural tragedy*, 1990. VHS 17 mins. Purchased, 1999 (1999.25)

Marc Newson, designer (born Australia 1963), **Eckhard Ressig**, manufacturer (born Germany 1953), *LC2 Lockheed lounge*, (1985–86). Fibreglass, aluminium, rubber, 89.0 x 170.0 x 65.0 cm. Purchased from Admission Funds, 1990 (D17-199)

John Nixon (born Australia 1949), *Self portrait (non-objective composition) black and red*, (1982). Oil and synthetic polymer paint on cardboard and plywood with wooden mallet, 77.4 x 57.0 cm. Purchased with the assistance of the Visual Arts Board, Australia Council, 1984 (AC10-1984)

John Nixon (born Australia 1949), *Self portrait (non-objective composition) black red and white*, (1983). Synthetic polymer paint on hessian, drawing pins, 65.8 x 50.0 cm. Purchased with the assistance of the Visual Arts Board, Australia Council, 1984 (AC11-1984)

John Nixon (born Australia 1949), *Self portrait (non-objective composition) black*, (1981). Oil on plywood, 56.8 x 57.0 cm. Purchased with the assistance of the Visual Arts Board, Australia Council, 1984 (AC9-1984)

John Nixon (born Australia 1949), *Self portrait (non-objective composition) yellow cross*, (1990). Enamel paint on plywood, 177.6 x 165.0 cm. Purchased through The Art Foundation of Victoria with the assistance of Chase Manhattan Overseas Corporation, Fellow, 1991 (A11-1991)

John Nixon (born Australia 1949) *Self portrait (non-objective composition) red vertical stripe*, 1984. Enamel on board, 44.5 x 37.5 cm. Private collection

John Nixon (born Australia 1949), *Self portrait (non-objective composition) black square*, 1984. Enamel on plywood, 66.0 x 66.0 cm. Private collection

Susan Norrie (born Australia 1953), *Flaunted fleeced*, 1984. Oil on plywood, 183.0 x 123.0 cm. The Baillieu Myer Collection of the 80s

Mike Parr (born Australia 1945), *Do Padera Coco (Self portrait as a pear) TO HAVE DONE WITH THE JUDGEMENT OF GOD*, (1983). Charcoal, margarine, 183.1 x 815.3 cm (overall). Purchased, 1985 (P94.a-c-1985)

Rosslynd Piggott (born Australia 1958), *Tattoo*, 1986–1987. Oil on canvas, 244.0 x 122.6 cm. Michell Endowment, 1987 (DC7-1987)

Julie Rrap (born Australia 1950), *Christ*, (1984). Cibachrome photograph, 194.5 x 104.7 cm. Michell Endowment, 1984 (DC15-1984)

Julie Rrap (born Australia 1950), *Madonna*, (1984). Cibachrome photograph, 194.7 x 104.6 cm. Michell Endowment, 1984 (DC14-1984)

Jenny Watson (born Australia 1950), *The Crimean Wars: Cinderella*, 1985. Oil, acrylic and gouache on cotton duck, 244.0 x 175.0 cm. Presented through the NGV Foundation by Shell Australia Limited, Honorary Life Benefactor, 2002

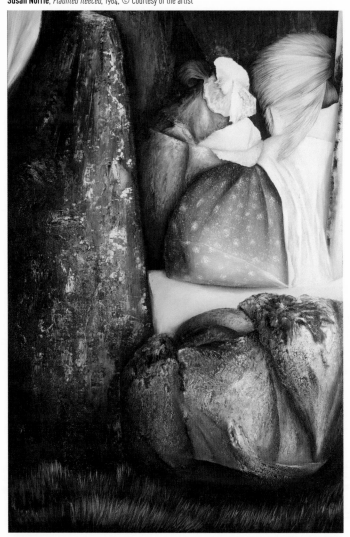

Susan Norrie, *Flaunted fleeced*, 1984. © Courtesy of the artist

Gordon Bennett (born Australia 1955), *Home décor (Preston + de Stijl = citizen) panorama*, 1997. Synthetic polymer paint on canvas, 182.7 x 365.3 cm (overall). Presented by the National Gallery Society of Victoria as the winner of the John McCaughey Memorial Art Prize, 1998 (1998.27.a-b)

Juan Davila (born Chile 1946, arrived in Australia 1974), *Election*, 2001. Transparent synthetic polymer resin, oil and collage on canvas, 175.0 x 260.0 cm

Tim Johnson (born Australia 1947), *Amnesty*, 1993. Synthetic polymer and metallic paint on canvas, 183.2 x 244.6 cm. Gerstl Bequest, 1995 (1995.6)

Narelle Jubelin (born Australia 1960), *Trade delivers people (second version)*, 1989–93. Cotton petit point, porcelain buttons, string, cotton lace, copper sheet, copper hanging devices, satin mount, wood frames, four pre-dynastic Egyptian earthenware pots from the collection of the National Gallery of Victoria, 82.2 x 690.0 x 21.0 cm (installation). Purchased 1993 (A10.a-d-1993) Purchased through The Art Foundation of Victoria with the assistance of the Rudy Komon Fund, Governor, 1991 (A4.a-c-1991 A4.e-1991) Presented by The Egyptian Exploration Fund, 1899 (768-D2), (D229-1982), (D196-1982), (D169-1982))

John Mawurndjul (Kuninjku born c. 1952), *Mardayin ceremonial designs from Kakodbebuldi*, (1990) Milmilngkan, Northern Territory. Earth pigments on bark, 179.3 x 91.8 cm irreg. Purchased from Admission Funds, 1990 (O.133-1990)

John Mawurndjul (Kuninjku born c. 1952), *Mardayin Burrk-dorreng*, (1990). Milmilngkan, Northern Territory. Earth pigments on bark, 160.3 x 73.4 cm irreg. Purchased from Admission Funds, 1990 (O.88-1990)

John Mawurndjul (Kuninjku born c. 1952), *Ngalyod 'rainbow serpent'*, (1997). Milmilngkan, Northern Territory. Earth pigments on bark, 183.0 x 82.5 cm. Purchased, 1997 (1997.401)

John Mawurndjul (Kuninjku born c. 1952), *Mardayin at Kakodbebuldi*, 2000. Earth pigments on bark, 157.5 x 64.5 cm. Laverty collection, Sydney

Jan Nelson (born Australia 1955) *International behaviour*, 2000. Oil on canvas, 152.4 x 198.1 cm. Purchased through the NGV Foundation with the assistance of The Peter and Susan Rowland Endowment, Governor, 2001 (2001.540)

Jan Nelson (born Australia 1955), *On days like these*, 2000. Oil on canvas, 46.0 x 61.2 cm. Purchased through the NGV Foundation with the assistance of The Peter and Susan Rowland Endowment, Governor, 2001 (2001.541)

Imants Tillers (born Australia 1950), *Quest: I the speaker*, (1988). Oilstick, synthetic polymer paint and gouache on canvas boards (170 panels), 254.0 x 646.0 cm (overall). Purchased from Admission Funds, 1988 (AC8.1-170-1988)

Ah Xian (born China 1960, arrived in Australia 1990), *Human, human–landscape*, 2000–2002. Resin, fibre glass cast, lacquer, 45.0 x 46.0 x 28.0 cm. Collection of the artist

Ah Xian (born China 1960, arrived in Australia 1990) *Human, human – flower and bird*, 2000–2001. Resin, fibre glass cast, lacquer, 45.0 x 46.0 x 28.0 cm.

Anne Zahalka (born Australia 1957), *The bathers*, (1989). From the *Bondi: Playground of the Pacific* series 1989. Type C photograph, 76.4 x 92.5 cm. Purchased, 1991 (PH172-1991)

Anne Zahalka (born Australia 1957), *The surfers*, (1989). From the *Bondi: Playground of the Pacific* series 1989. Type C photograph, 76.4 x 92.5 cm. Purchased, 1991 (PH173-1991)

Constanze Zikos (born Australia 1962), *Fake flag*, (1994). Thermo-setting laminate, enamel paint, crayon, metallic and plastic self-adhesive tape on composition board, 198.1 x 262.2 cm (overall). Purchased, 1999 (1999.29.a-h)

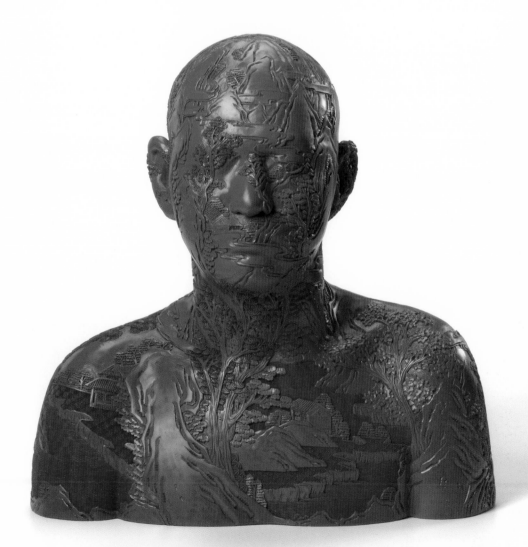

Ah Xian, Human, human–landscape, *2000-2002*

Hany Armanious (born Australia 1962), *Untitled work*, (1996). Polyvinyl chloride, 240.0 x 688.9 x 39.6 cm (overall). Purchased, 1997 (1997.396.a-s)

Pat Brassington (born Australia 1942), *Starlight*. From the *Gentle* series 2001. Inkjet print, 43.4 x 63.1 cm (image), 78.1 x 127.1 cm (sheet). Purchased with funds arranged by Loti Smorgon for Contemporary Australian Photography, 2001 (2001.164)

Pat Brassington (born Australia 1942), *Voicing*. From the *Gentle* series 2001. Inkjet print, 56.2 x 76.1 cm (image), 93.4 x 127.4 cm (sheet). Purchased with funds arranged by Loti Smorgon for Contemporary Australian Photography, 2001 (2001.165)

Mikala Dwyer (born Australia 1959), *Hanging eyes 2*, (2000). Vinyl, plastic, synthetic polymer paint on canvas, synthetic fur, felt, steel eyelets, 262.8 x 517.0 x 205.5 cm (installation). Purchased through the NGV Foundation with the assistance of the Rudy Komon Fund, Governor, 2001 (2001.560.a-i)

Mikala Dwyer (born Australia 1959) *IOU*, 1997–98. Transparent and opaque synthetic polymer resin, synthetic fur, mirror, television, 134.5 x 257.2 154.0 cm (variable) (installation). Presented through the NGV Foundation by Mr Peter Fay, Fellow, 2002 (2002.190)

Bonita Ely (born Australia 1946), *Histories*, 1992. Lithograph and woodcut, 215.0 x 500.0 cm. Courtesy Sutton Gallery, Melbourne

Dale Frank (born Australia 1957), *The artist's fairy floss sold on the merry-go-round of life (sucker dealer): Sucker dealer and the righteous anus*, 1991. Synthetic polymer paint on canvas, 240.0 x 199.8 cm. Purchased from Admission Funds, 1993 (A12-1993)

Rosalie Gascoigne (born New Zealand 1917, arrived in Australia 1943, died 1999), *Clouds III*, 1992. Weathered painted composition board on plywood, 75.4 x 362.2 cm (installation). Purchased, 1993 (A8.a-d-1993)

Jeff Gibson (born Australia 1958), *Screwballs*, 1992. Colour screenprint, 114.0 x 49.2 cm (image), 151.8 x 102.0 cm (sheet). Purchased 1994 (P119.1-1994)

Jeff Gibson (born Australia 1958), *Screwballs*, 1992. Colour screenprint, 111.8 x 48.2 cm (image), 151.6 x 102.0 cm (sheet). Purchased 1994 (P119.2-1994)

Jeff Gibson (born Australia 1958), *Screwballs*, 1992. Colour screenprint, 113.6 x 54.8 (image), 151.6 x 102.0 cm (sheet). Purchased 1994 (P119.3-1994)

Jeff Gibson (born Australia 1958), *Screwballs*, 1992. Colour screenprint, 112.5 x 50.6 (image), 151.6 x 102.0 cm (sheet). Purchased 1994 (P119.4-1994)

Louise Hearman (born Australia 1963), *Untitled #563*, 1997. Oil on composition board, 68.6 x 53.1 cm. Purchased, 1997 (1997.407)

Matthew Jones (born Australia 1961), *Diary 13–16 November 2000*, 2000. Oil on plaster board, 244.1 x 244.3 cm (overall). Purchased through the NGV Foundation with the assistance of the Joan Clemenger Endowment, Governor, 2001 (DC18.a-b-2001)

Douglas McManus (born Australia 1959), *Hair couture 2000*, 1999–2000. Leather, polyester, cotton, hair, 80.0 x 60.0 x 30.0 cm. Kaiser Bequest, 2000 (2000.103)

Douglas McManus (born Australia 1959), *Individual non-conforming*, 1999–2000. Rayon; digital print, 246.0 x 85.0 cm. Kaiser Bequest, 2000. (2000.104)

Douglas McManus (born Australia 1959), *Fashionable conforming*, 1999–2000. Rayon; digital print, 246.0 x 85.0 cm. Kaiser Bequest, 2000 (2000.105)

Douglas McManus (born Australia 1959), *Conservative inconspicuous*, 1999–2000. Rayon; digital print, 246.0 x 85.0 cm. Kaiser Bequest, 2000 (2000.106)

Scott Redford (born Australia 1962), *Urinal, Broadbeach*, 2000. From the *Urinal* series, 1988–2000. Type C photograph, 105.2 x 76.1 cm (image and sheet). Purchased with funds arranged by Loti Smorgon for Contemporary Australian Photography, 2002

Scott Redford (born Australia 1962), *Urinal, Surfers Paradise*, 2000. From the *Urinal* series, 1988–2000. Type C photograph, 101.5 x 76.1 cm (image and sheet). Purchased with funds arranged by Loti Smorgon for Contemporary Australian Photography, 2002

Sally Smart (born Australia 1960), *Fremmage frieze*, 1999–2000. Synthetic polymer paint on canvas, felt and fabric with collage elements, dimensions variable. Collection of the artist

Sally Smart (born Australia 1960), *Treehouse (The unhomely body)*, 1997–1998. Synthetic polymer paint and oil on felt and canvas, 300.5 x 759.6 cm (overall, irreg.). Purchased, 1999 (1999.52.a-l)

Kathy Temin (born Australia 1968), *Duck-rabbit problem*, 1991. Synthetic fur on composition board, cotton, dacron, polystyrene, wire and enamel paint, 52.5 x 187.8 x 124.0 cm (installation) (variable). Purchased through The Art Foundation of Victoria with the assistance of the Rudy Komon Fund, Governor, 1998 (1998.282.a-c)

Matthew Jones, *Diary 13 November–6 November 2000*, 2000

Mutlu Çerkez (born England 1964, arrived in Australia 1964), *Poster design variations for artists' publications*, 2001 Synthetic polymer paint on paper, 127.4 x 861.2 cm (framed) (overall). Purchased through the NGV Foundation with the assistance of Optus Communications Pty Limited, Member, 2001 (2001.839.a-e)

Mari Funaki (born Japan 1950, arrived in Australia 1979), *Arouse*, 1997. Heat-coloured mild steel, 13.0 x 5.0 x 3.7 cm. Private collection, Melbourne

Mari Funaki (born Japan 1950, arrived in Australia 1979), *Poised*, 1997. Heat-coloured mild steel, 41.5 x 5.0 x 3.5 cm. Private collection, Melbourne

Mari Funaki (born Japan 1950, arrived in Australia 1979), *Reverie*, 1997. Heat-coloured mild steel, 9.3 x 7.6 x 6.3 cm. Private collection, Melbourne

Mari Funaki (born Japan 1950, arrived in Australia 1979), *Stealth*, 1997. Heat-coloured mild steel, 19.7 x 37 x 3.6 cm. Private collection, Melbourne

Mari Funaki (born Japan 1950, arrived in Australia 1979), *Menace*, (1997). Heat-coloured mild steel, 6.2 x 47.0 x 26.0 cm. Private collection, Melbourne

Elizabeth Gower (born Australia 1952), *September 14 1901– September 11 2001*, 2001. Ink on drafting film, (seven panels), 380.0 x 70.0 cm (each panel) Collection of the artist

Fiona Hall (born Australia 1953), *Dead in the water*, 1999. Polvinyl chloride, glass beads, silver wire, vitrine, wood and transparent synthetic polymer resin, Purchased, 1999 (1999.356.a-e)

Brent Harris (born Australia 1956), *Swamp (no. 2)*, (1999). Oil on canvas, 274.0 x 133.7 cm. Allan R. Henderson Bequest, 1999 (1999.357)

Robert Hunter (born Australia 1947), *Untitled*, 1998. Synthetic polymer paint on plywood, 122.2 x 224.2 cm. Purchased, 1999 (1999.51)

Raafat Ishak (born Egypt 1967, arrived in Australia 1982), *Good information*, 1996–1999. Oil on canvas, 60.3 x 313.0 cm (overall). Purchased through the NGV Foundation with the assistance of the Joan Clemenger Endowment, Governor, 2001 (DC11.a-h-2001)

Raafat Ishak (born Egypt 1967, arrived in Australia 1982), *Good government*, 1999–2000. Oil, gesso, cardboard and embossing on canvas, 165.5 x 120.1 cm. Purchased through the NGV Foundation with the assistance of the Joan Clemenger Endowment, Governor, 2001 (DC10-2001)

Emily Kam Kngwarray (Eastern Anmatyerr c. 1910–96), *Body paint: Awely*, (1993). Synthetic polymer paint on paper, (6 sheets) 77.0 x 56.3 cm (each). Purchased through The Art Foundation of Victoria with the assistance of Alcoa of Australia Limited, Governor, 1994 (O.53–0.58-1994)

Susan Norrie (born Australia 1953), *Inquisition: Inquisition ten*. Oil on canvas, wood, glass, 83.0 x 64.0 x 10.7 cm (framed); *Inquisition nine*. Synthetic fabric, wood, glass, 116.2 x 69.1 x 10.8 cm; *Inquisition one*. Glass beads, glass, wood, lacquer 162.5 x 61.7 x 19.1 cm (overall); *Poisonous fly paper painting II*. Oil on canvas 275.2 x 136.5 x 6.0 cm; *Inquisition eleven*. Computer-generated print, wood, glass, 129.3 x 103.0 x 7.1 cm (framed); *Inquisition twelve*. Digitally manipulated video loop, (1996–99). Gurnett-Smith Bequest, 1999 (1999.358.a–g)

Gwyn Hanssen Pigott (born Australia 1953), *Exodus II*, (1996). Porcelain, 14.4 x 155.0 x 15.5 cm. Presented through the NGV Foundation by Dato Arthur Tan Boon Shih, Governor, 2001 (2001.339.a-w)

Scott Redford (born Australia 1962), *Surfing life (Glen)*, 1994. Synthetic polymer and enamel paint, foamfill and found objects on canvas on plywood, 181.3 x 283.0 cm. Purchased through The Art Foundation of Victoria with the assistance of the Joan Clemenger Endowment, Governor, 2000 (DC1-2000)

David Stephenson (born United States 1955, arrived in Australia 1982), *Untitled*, (1992), from *The ice* series, 1992. Type C photograph, 99.1 x 146.7 cm. Purchased, 1994 (PH38-1994)

David Stephenson (born United States 1955, arrived in Australia 1982), *Untitled* 1992, printed 2002 from *The ice* series, 1991–93. Type C photograph, 100.6 x 148.8 cm. Private collection

David Stephenson (born United States 1955, arrived in Australia 1982), *Untitled* 1992, printed 2002, from *The ice* series, 1991–93. Type C photograph, 100.5 x 148.5cm. Private collection

Ricky Swallow (born Australia 1974), *Model for a sunken monument*, (1999). Synthetic polymer paint on composition board, 108.2 x 222.0 x 242.2 cm (overall). Purchased through The Art Foundation of Victoria with the assistance of the Joan Clemenger Endowment, Governor, 1999 (DC3.a-l-1999)

Peter Tyndall (born Australia 1951), *detail A Person Looks At A Work of Art / someone looks at something ...* , 1985–87. A Person Looks At A Work of Art / someone looks at something ... CULTURAL CONSUMPTION PRODUCTION, 243.4 x 243.4 cm (canvas), 340.4 x 243.4 cm (installed). Purchased from Admission Funds, 1988 (AC2-1988)

Louise Weaver (born Australia 1966), *Sparkling dew-covered branch*, (1998). Polydamide thread, plane tree branch, light globe, glass beads and thread, 201.4 x 51.5 x 20.0 cm. Purchased through The Art Foundation of Victoria with the assistance of the Joan Clemenger Endowment, Governor, 1999 (DC4-1999)

Ricky Swallow, *Model for a sunken monument*, 1999

::01 left field | fieldwork in context

01.01 **Ah Xian** (born China 1960, arrived in Australia 1990), *Human, human-landscape*, 2000–02. Resin, fibreglass cast, lacquer, 45.0 x 46.0 x 28.0 cm. Private collection. © Courtesy of the artist

01.02 **Marina and Ulay Abramovic** (born Yugoslavia 1946 and Germany 1943), *Untitled #1* (Documentary photograph of performance in Lindsay Court, National Gallery of Victoria), 1982. © Marina & Ulay Abramovic, 1982/VG BILD-KUNST Licensed by VISCOPY, Sydney 2002

01.03 **Richard Long** (English 1945–), *Driftwood circle*, 1977–78. Murdoch Court, National Gallery of Victoria. © Courtesy of the artist

01.04 Christo & Jeanne-Claude (born USA 1935), *Woolworks – wrapped wool bales*, 1969. Murdoch Court, National Gallery of Victoria. © Christo 1969

01.05 **Domenico de Clario** (born Italy 1947, arrived in Australia 1958), *Elemental landscapes (installation detail)*, 1975. © Domenico de Clario, 1975/Licensed by VISCOPY, Sydney 2002

01.06 **Harald Szeemann** (born Switzerland 1933), *I want to leave a well-done child here: 20 Australian artists* (installation view), curated by Harald Szeeman as John Kaldor's *Art Project 2*, 1971. National Gallery of Victoria

01.07 **Aleks Danko** (born Australia 1950), *Art stuffing*, 1970. Hessian, paper, enamel paint, 86.0 x 56.4 x 28.8 cm. Gift of Geoffrey Burke, 1985 (S5-1985). © Courtesy of the artist

01.08 **Mike Parr** (born Australia 1945), *Do padera coco (Self portrait as a pear) TO HAVE DONE WITH THE JUDGEMENT OF GOD*, (1983). Charcoal, margarine, (a–c) 183.1 x 815.3 cm (overall). Purchased, 1985 (P94.a–c-1985). © Courtesy of the artist

::02 the discursive field | home is where the heart is

02.01 **Louise Weaver** (born Australia 1966), *Sparkling dew-covered branch*, (1998). Polydamide thread, plane tree branch, lightglobe, glass beads and thread, 201.4 x 51.5 x 20.0 cm. Purchased through The Art Foundation of Victoria with the assistance of the Joan Clemenger Endowment, Governor, 1999 (DC4-1999). © Courtesy of the artist

02.02 Installation photograph of the entrance to *The Field* exhibition, 1968

02.03 **John Mawurndjul** (Kuninjku born c. 1952), *Mardayin Burrk-dorreng*, (1990). Earth pigments on bark, 160.3 x 73.4 cm irreg. Purchased from Admission Funds, 1990 (O.88-1990). © John Mawurndjul, 1990/ Licensed by VISCOPY, Sydney 2002

::03 cultivating the field

03.01 **Denton, Corker, Marshall**, *Melbourne Gateway, Entrance to Tullamarine Freeway*, 1999. © Courtesy of Denton Corker Marshall. Photographer: Tim Griffith

03.02 Installation photograph from *The Field* exhibition featuring: **Alun Leach-Jones**'s *Noumenon XX first light*, 1967; **Col Jordan**'s *Knossus II*, 1968; **James Doolin**'s *Artificial landscape 68-1*, 1968, *Artificial landscape 67-6*, 1967 and *Artificial landscape 67-5*, 1967; **Rollin Schlicht**'s *Dempsey*, 1968 and *Twentieth century note*, 1968; **Sydney Ball**'s *Ispahan*, 1967; **Harald Noritis**'s *Come away*, 1968; **John White**'s *Broken marriage*, 1968. © Courtsy of the artists

03.03 **Clement Meadmore** (born Australia 1929, left Australia to live in the United States in 1963), *Duolith III*, (1962). Welded steel plate, 125.2 x 204.5 x 108.5 cm. Purchased 1962 (470-D5). © Courtesy of the artist

03.04 **Kumi Sugai** (born Japan 1919), *Composition*, c. 1955. Colour lithograph, ed. 93/100, 44.1 x 28.0 cm (image), 63.4 x 45.5 cm (sheet). Gift of James Mollison, 1965 (1460-5)

03.05 **Janet Dawson** (born Australia 1935), *Coffee table*, 1968. Plastic sheet on composition board, 122.0 cm diam. National Gallery of Australia, Canberra (84.175. a–b). © Janet Dawson, 1968/Licensed by VISCOPY, Sydney 2002

03.06 **Sydney Ball** (born Australia 1933), *Canto no. 21*, 1966. Oil on canvas, 178.0 x 152.5 cm. Purchased, 1966 (1648–5). © Courtesy of the artist

03.07 **James Doolin** (United States 1932–2002, worked in Australia 1965–67), *Artificial landscape 67/5*, 1967. Synthetic polymer paint on canvas, 129.6 x 101.8 cm. Purchased, 1969 (87-6). © Courtesy of the Estate of James Doolin

03.08 **James Doolin** (United States 1932–2002, worked in Australia 1965–67), *Artificial landscape no. 7*, 1969. Synthetic polymer paint on canvas, 206.0 x 137.0 cm. Kerry Stokes Collection, Perth. Photographer: Richard Stringer. © Courtesy of the Estate of James Doolin

03.09 **Mel Ramsden** (born Great Britain 1944, arrived in Australia 1963, worked in Great Britain 1964–67, New York 1967–77, Great Britain from 1977), *Secret painting*, 1967–68. Enamel paint on canvas and gelatin silver photograph on composition board, (a) 46.0 x 46.0 cm (canvas), (b) 86.4 x 86.6 cm (text), (a–b) 86.4 x 156.5 cm (installed). Purchased, 1972 (A21.a–b–1972). © Courtesy of the artist

03.10 **Ian Burn** (Australia 1939–93), *Four glass/mirror piece*, 1968, (detail). Mirror, glass, in wooden frame. Twenty-two pages of photocopies, bound in cardboard and cloth cover, with metal fastener, 93.8 x 63.1 cm (mirror), 40.5 x 35.6 x 1.2 cm

Dates of works of art in parentheses are those ascribed by the curator or are verified dates that are uninscribed on works of art

(book); variable (overall). Purchased through the NGV Foundation with the assistance of the Rudy Komon Fund, Governor, 2001 (2001.559.a–b). © Courtesy of the Estate of Ian Burn

03.11 Dick Watkins (born Australia 1937, worked in Hong Kong 1974–79), *The Mooche*, 1968. Synthetic polymer paint and oil on canvas, 167.5 x 167.5 cm. Colin and Elizabeth Laverty, Sydney. © Dick Watkins, 1968/Licensed by VISCOPY, Sydney 2002

03.12 Robert Hunter (born Australia 1947), *Untitled no. 8*, 1968. Synthetic polymer paint on canvas, 158.4 x 158.4 cm. Gift of N. R. Seddon, 1968 (1827-5). © Robert Hunter, 1968/Licensed by VISCOPY, Sydney 2002

03.13 Robert Hunter (born Australia 1947), *Untitled*, 1970 (detail). Synthetic polymer paint and masking tape (6 panels), (a–f) variable (installation). Purchased, 1977 (A2-1977). © Robert Hunter, 1968/Licensed by VISCOPY, Sydney 2002

03.14 John Peart (born Australia 1945), *Cool corner*, 1967. Synthetic polymer paint on canvas, 235.3 x 253.3 cm. Kerry Stokes collection, Perth. © Courtesy of the artist

03.15 John Peart (born Australia 1945), *Corner square diagonal*, 1968. Synthetic polymer paint on shaped canvas, 229.2 x 227.6 x 12.6 cm. Purchased through The Art Foundation of Victoria with funds provided by the National Gallery Society of Victoria, Governor, 1985 (AC11-1985). © Courtesy of the artist

03.16 Trevor Vickers (born Australia 1943, lived in Great Britain 1978–95), *Untitled*, 1968. Synthetic polymer paint on shaped canvas, 244.4 x 305.5 x 7.3 cm. Purchased from Admission Funds, 1987 (AC1-1987). © Courtesy of the artist

03.17 Paul Partos (born Czechoslovakia 1943, arrived in Australia 1949), *Vesta II*, 1968. Synthetic polymer paint on canvas, 249.2 x 249.2 cm. Visual Arts Board, Australia Council, Contemporary Art Purchase Grant 1975, Art Gallery of New South Wales. © Courtesy of the artist. Photographer: Ray Woodbury for AGNSW

03.18 Robert Rooney (born Australia 1937), *Corners*, 1972. Gelatin silver photograph, photo corners and ballpoint pen on cardboard, (60.2 x 107.0 cm) irreg. Purchased, 1981 (AC9-1981). © Courtesy of the artist

::04 the conundrum of a mirror piece |
'on being able to look at ourselves seeing'

04.01 Ian Burn (Australia 1939–93), *Four glass/mirror piece*, 1968, (detail). Mirror, glass, in wooden frame. Twenty-two pages of photocopies, bound in cardboard and cloth cover, with metal fastener, 93.8 x 63.1 cm (mirror), 40.5 x 35.6 x 1.2 cm (book); variable (overall). Purchased through the NGV Foundation with the assistance of the Rudy Komon Fund, Governor, 2001 (2001.559.a–b). © Courtesy of the Estate of Ian Burn

04.02 Ian Burn (Australia 1939–93), *Mirror piece*, 1967. Mirror glass, wood and photocopies on cardboard (fifteen panels), ed. 19/35, (1–14) 27.6 x 21.6 cm (each sheet), (1–14) 29.2 x 22.8 cm (each panel), (15) 57.4 x 39.4 cm (mirror), (1–15) variable (overall). Purchased, 1972 (A20.1-15-1972). © Courtesy of the Estate of Ian Burn

04.03 Installation photograph from *The Field* exhibition featuring: **Peter Booth**'s *Untitled painting*, 1968; **Col Jordan**'s *Daedalaus series 6*, 1968; **Ian Burn**'s *Four glass/mirror piece*, 1968; **Tony Bishop**'s *Short and curvy*, 1968; **Alun Leach-Jones**'s *XIX Indian summer*, 1967; **Norma Wight**'s *Untitled*, 1968. © Courtesy of Col Jordan, Alun Leach-Jones, Normana Wight and the Estate of Ian Burn. © Peter Booth, 1968/Licensed by VISCOPY, Sydney 2002. © Tony Bishop, 1968/Licensed by VISCOPY, Sydney 2002

::05 papunya tula 1971–73 |
a new way of seeing the land

05.01 Charlie Tarawa Tjungurrayi (Pintupi 1921–99), *Old man's Dreaming at Mitukatjirri*, (1972). Gouache on composition board, 32.7 x 65.1 cm. Gift of Mrs Douglas Carnegie OAM, 1988 (0.31-1988). © The artist, courtesy Aboriginal Artists Agency Ltd, Sydney

05.02 Mick Wallangkarri Tjakamarra (Arrernte/Luritja c. 1910–96), *Old man's Dreaming on death or destiny*, (1971). Synthetic polymer paint on composition board, 60.9 x 45.7 cm.

Purchased through The Art Foundation of Victoria with the assistance of North Broken Hill Pty Ltd, Fellow, 1987 (0.49-1987). © The artist, courtesy Aboriginal Artists Agency Ltd, Sydney

05.03 Yala Yala Gibbs Tjungurrayi (Pintupi c. 1928–98), *Snake and water Dreaming*, (1972). Earth pigments and synthetic polymer paint on composition board, 56.5 x 49.9 cm. Gift of Mrs Douglas Carnegie OAM, 1989 (0.9-1989). © The artist, courtesy Aboriginal Artists Agency Ltd, Sydney

05.04 Long Jack Phillipus Tjakamarra (Warlpiri/Luritja born c. 1932), *Emu Dreaming*, (1972). Synthetic polymer paint on composition board, 64.7 x 62.8 cm. Purchased from Admission Funds, 1987 (0.22-1987). © The artist, courtesy Aboriginal Artists Agency Ltd, Sydney

05.05 Uta Uta Tjangala (Pintupi c. 1920–90), *Big snake ceremonial travelling Dreaming*, (1972). Synthetic polymer paint on composition board, 67.7 x 46.0 cm. Purchased through The Art Foundation of Victoria with the assistance of ICI Australia Ltd, Fellow, 1988 (0.10-1988). © The artist, courtesy Aboriginal Artists Agency Ltd, Sydney

05.06 Johnny Warangkula Tjupurrula (Luritja c. 1925–2001), *A bush tucker story*, (1972). Synthetic polymer paint on composition board, 91.4 x 66.2 cm. Purchased through The Art Foundation of Victoria with the assistance of the North Broken Hill Pty Ltd, Fellow, 1987 (0.48-1987). © The artist, courtesy Aboriginal Artists Agency Ltd, Sydney

05.07 Johnny Warangkula Tjupurrula (Luritja c. 1925–2001), *Water Dreaming at Kalipinypa*, 1971. Enamel paint on composition board, 83.4 x 20.4 cm. Purchased through The Art Foundation of Victoria with the assistance of North Broken Hill Pty Ltd, Fellow, 1987 (0.47-1987). © The artist, courtesy Aboriginal Artists Agency Ltd, Sydney

05.08 **Johnny Warangkula Tjupurrula** (Luritja c. 1925–2001), *Nintaka and the mala men*, (1973). Synthetic polymer paint on composition board, 69.5 x 65.3 cm. Purchased through The Art Foundation of Victoria with the assistance of ICI Australia Ltd, Fellow, 1988 (O.9-1988). © The artist, courtesy Aboriginal Artists Agency Ltd, Sydney

05.09 **Walter Tjampitjinpa** (Pintupi c. 1912–80), *Water Dreaming*, 1971. Synthetic polymer paint on composition board, 36.7 x 22.8 cm. Private collection. © The artist, courtesy Aboriginal Artists Agency Ltd, Sydney

05.10 **Mick Namarari Tjapaltjarri** (Pintupi c. 1926–98), *Untitled (Water Dreaming)*, 1971. Synthetic polymer paint on composition board, 61.0 x 56.0 cm. Private collection. © The artist, courtesy Aboriginal Artists Agency Ltd, Sydney

05.11 **Walter Tjampitjinpa** (Pintupi c. 1912–80), *Water Dreaming at Kalipinypa*, (1971). Enamel paint on composition board, 61.6 x 73.2 cm. Purchased through The Art Foundation of Victoria with the assistance of Alcoa of Australia Limited, Governor, 1993 (O.21-1993). © The artist, courtesy Aboriginal Artists Agency Ltd, Sydney

05.12 **Timmy Payungka Tjapangati** (Pintupi c. 1942–2000), *Untitled*, (1972). Synthetic polymer paint on composition board, 61.5 x 46.2 cm. Gift of Mrs Douglas Carnegie OAM, | 1989 (O.85-1989). © The artist, courtesy Aboriginal Artists Agency Ltd, Sydney

05.13 **Anatjari Tjakamarra** (Ngaatjatjarra/Pintupi c. 1938–92), *Big Pintupi Dreaming ceremony*, (1972). Synthetic polymer paint on composition board, 51.5 x 43.3 cm. Purchased through The Art Foundation of Victoria with the assistance of North Broken Hill Pty Ltd, Fellow, 1987 (O.51-987). © The artist, courtesy Aboriginal Artists Agency Ltd, Sydney

05.14 **Johnny Lynch Tjapangati** (Anmatyerre c. 1922–82), *Honey ant dreaming*, 1973. Synthetic polymer paint on composition board, 60.0 x 84.0 cm. Private collection. © The artist, courtesy Aboriginal Artists Agency Ltd, Sydney

05.15 **Shorty Lungkarda Tjungurrayi** (Pintupi c. 1920–87), *Waterhole in a cave*, (1972). Synthetic polymer paint on canvas, 61.5 x 45.4 cm. Purchased through The Art Foundation of Victoria with the assistance of ICI Australia Ltd, Fellow, 1988 (O.11-1988). © The artist, courtesy Aboriginal Artists Agency Ltd, Sydney

::06 ti parks | polynesian 100

06.01 **Ti Parks** (born England 1939, worked in Australia 1964–74), *Polynesian 100*, 1973. Mixed media (100 photographs), 27.8 x 35.8 x 100.0 cm (overall). Purchased, 1977 (A30-1977). © Courtesy of the artist

::07 clockwork | sue ford: time series

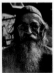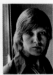

07.01 **Sue Ford** (born Australia 1943), *Jim*, 1964; *Jim*, 1974 (1964–74, printed 1974), from the *Time* series (1962–74). Gelatin silver photograph, 11.1 x 20.1 cm. Purchased with the assistance of the Visual Arts Board and the Kodak (Australasia) Pty Ltd Fund, 1974 (PH172.a–b-1974). © Courtesy of the artist

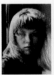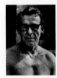

07.02 **Sue Ford** (born Australia 1943), *Annette*, 1964; *Annette*, 1974 (1964–74, printed 1974), from the *Time* series (1962–74). Gelatin silver photograph, 11.1 x 20.1 cm. Purchased with the assistance of the Visual Arts Board and the Kodak (Australasia) Pty Ltd Fund, 1974 (PH170.a–b-1974). © Courtesy of the artist

07.03 **Sue Ford** (born Australia 1943), *Ross*, 1964; *Ross*, 1974 (1964–74, printed 1974), from the *Time* series (1962–74). Gelatin silver photograph, 11.1 x 20.1 cm. Purchased with the assistance of the Visual Arts Board and the Kodak (Australasia) Pty Ltd Fund, 1974 (PH171.a–b-1974). © Courtesy of the artist

07.04 **Sue Ford** (born Australia 1943), *Lynne*, 1964; *Lynne*, 1974 (1964–74, printed 1974), from the *Time* series (1962–74). Gelatin silver photograph, 11.1 x 20.1 cm. Purchased with the assistance of the Visual Arts Board and the Kodak (Australasia) Pty Ltd Fund, 1974 (PH168.a–b-1974). © Courtesy of the artist

::08 'if you don't fight you lose' | the political poster as alternative practice in the 1970s

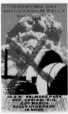

08.01 **Earthworks Poster Collective** (1972–79), **Chips Mackinolty** (born Australia 1954), *Second triennial May Day palace revolution ball*, 1977. Colour photo-stencil screenprint, 73.8 x 49.0 cm. (image). Michell Endowment, 1980 (DC24-1980). © Courtesy of the artist

08.02 **Earthworks Poster Collective** (1972–79), **Chips Mackinolty** (born Australia 1954), *Workers' health centre*, (1977). Colour photo-screenprint, 75.0 x 56.6 cm. (image), 76.2 x 58.0 cm (sheet). Michell Endowment, 1980 (DC23-1980). © Courtesy of the artist

08.03 **Unknown**, Atelier Populaire, Paris, *Renault avec Billancourt 5 Decembre: La lutte continue*, (1968). Screenprint in black, 67.8 x 65.4 cm (sheet). Purchased, 1998 (1998.119)

08.04 **Earthworks Poster Collective** (1972–79), **Toni Robertson** (born Australia 1953) and **Chips Mackinolty** (born Australia 1954), *Hiroshima Day anti-uranium rally, 6 August 1977*. Colour photo-screenprint, 88.0 x 55.7 cm irreg. (image). © Courtesy of the artist.

08.05 **Earthworks Poster Collective** (1972–79), **Toni Robertson** (born Australia 1953), *Definitely*, (1977). Colour photo-screenprint, 48.2 x 68.0 cm (image), 56.0 x 76.0 cm (sheet). Michell Endowment, 1980 (DC25-1980). © Courtesy of the artist

08.06 The Women's Domestic Needlework Group, Marie McMahon (born Australia 1953), *Aboriginal land rights, not mining*, 1979. Colour photo-screenprint, 73.1 x 48.6 cm (image), 78.7 x 50.9 cm (sheet). Michell Endowment, 1980 (DC16.6-1980). © Courtesy of the artists

08.07 Mandy Martin (born Australia 1952), *Big boss*, 1977. Colour photo-screenprint, 2nd edition, first state 8/12, 88.0 x 47.8 cm (image), (90.8 x 49.2 cm) (sheet). Michell Endowment, 1977, transferred to the Permanent Collection, 1996 (1996.399). © Mandy Martin, 1977/Licensed by VISCOPY, Sydney 2002

08.08 Ann Newmarch (born Australia 1945), *Women hold up half the sky!*, 1978. Colour photo-screenprint, 79.3 x 54.8 cm (image), 91.5 x 65.0 cm (sheet). Purchased, 2001 (2001.528). © Courtesy of the artist

08.09 Ann Newmarch (born Australia 1945), *Look rich*, 1975. Colour photo-screenprint, 55.2 x 70.8 cm (image), (75.6 x 59.6 cm) (sheet). Michell Endowment, 1978 (DC7-1978). © Courtesy of the artist

08.10 Robert Boynes (born Australia 1942), *Laid out*, 1978. Synthetic polymer paint on canvas, 97.0 x 243.8 cm. S. E. Wills Bequest, 1979 (A17-1979). © Robert Boynes, 1978/Licensed by VISCOPY, Sydney 2002

::09 stelarc and the alternate architecture of the artistic body

09.01 Stelarc (born Cyprus 1946, arrived in Australia 1948), *Untitled*, 1979. Photograph, 20.3 x 25.4 cm. Collection of the artist. © Courtesy of Stelarc and Shigeo Anzai

09.02 Stelarc (born Cyprus 1946, arrived in Australia 1948), *Untitled*, (c. 1974). Photograph, 20.3 x 25.4 cm. Collection of the artist. © Courtesy of Stelarc and Shigeo Anzai

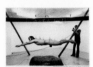

09.03 Stelarc (born Cyprus 1946, arrived in Australia 1948), *Events for stretched skin no.1*, 1976. From photo-documentation of *Events for stretched skin*, 1976 by Shiego Anzai, 40.8 x 60.0 cm. Purchased with the assistance of the Visual Arts Board of the Australia Council, 1984 (AC12.5-1984). © Courtesy of Stelarc and Shigeo Anzai

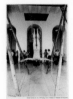

09.04 Stelarc (born Cyprus 1946, arrived in Australia 1948), *Events for stretched skin no. 4*, 1976, from photo-documentation of *Events for stretched skin*, 1976 by Shiego Anzai, 40.8 x 60.0 cm. Purchased with the assistance of the Visual Arts Board of the Australia Council, 1984 (AC12.7-1984). © Courtesy of Stelarc and Shigeo Anzai

09.05 Stelarc (born Cyprus 1946, arrived in Australia 1948), *Events for stretched skin no. 1*, 1976, from photo-documentation of *Events for stretched skin*, 1976 by Shiego Anzai, 40.8 x 60.0 cm. Purchased with the assistance of the Visual Arts Board of the Australia Council, 1984 (AC12.7-1984). © Courtesy of Stelarc and Shigeo Anzai

09.06 John Davis (Australia 1973–99), *Greene Street piece*, 1973–75. Graphite on black and white photographs on cardboard, (1) 47.9 x 32.8 cm (image and sheet), (2) 47.6 x 32.8 cm (image and sheet), (3) 47.4 x 32.5 cm (image and sheet), (4) 47.5 x 32.8 cm (image and sheet). Gift of Shirley Davis, 1980 (AC58.1–4-1980). © John Davis, 1973/Licensed by VISCOPY, Sydney 2002

::10 tim leura and clifford possum | napperby death spirit dreaming

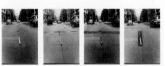

10.01 Tim Leura Tjapaltjarri (Anmatyerre 1929–84) and **Clifford Possum Tjapaltjarri** (Anmatyerre c. 1943–2002), *Napperby death spirit Dreaming*, 1980. Synthetic polymer paint on canvas, 207.7 x 670.8 cm. Felton Bequest, 1988 (O.33-1988). © The artist, courtesy Aboriginal Artists Agency Ltd, Sydney

10.02 Tim Leura Tjapaltjarri (Anmatyerre 1929–84), *Sun, moon and morning star Dreaming*, 1973. Synthetic polymer paint on composition board, 45.5 x 60.8 cm. Private collection. © The artist, courtesy Aboriginal Artists Agency Ltd, Sydney

10.03 Tim Leura Tjapaltjarri (Anmatyerre 1929–84), *Yam spirit Dreaming*, 1972. Synthetic polymer paint on composition board, 52.3 x 75.0 cm. Private collection. © The artist, courtesy Aboriginal Artists Agency Ltd, Sydney

10.04 Clifford Possum Tjapaltjarri (Anmatyerre 1932–2000), *Old man's love story*, 1973. Synthetic polymer paint on composition board, 45.7 x 61.8 cm. Private collection. © The artist, courtesy Aboriginal Artists Agency Ltd, Sydney

::11 terra

11.01 Jill Orr (born Australia 1952), *Bleeding trees*, 1979. Type C photographs (10 images), dimensions variable. Purchased with the assistance of the Visual Arts Board, Australia Council, 1980 (AC64.a–j-1980). © Courtesy of the artist

11.02 Lauren Berkowitz (born Australia 1965), *Colour field*, 2002. Salt and weeds, 600.0 x 600.0 cm. Photographed by John Gollings. © Courtesy of the artist

11.03 Bea Maddock (born Australia 1934), *TERRA SPIRITUS... with a darker shade of pale*, 1993–98, (detail). Hand-ground ochre and blind letterpress on 52 sheets, 39.2 x 80.5 x 4.0 cm (framed, each sheet). Private collection. © Courtesy of the artist

11.04 Brenda Croft (born Australia 1965), *In my mother's garden*, 1998. Laser print, 22.0 x 32.6 cm (image). Purchased, 1999 (1999.187). © Brenda Croft, 1998/Licensed by VISCOPY, Sydney 2002

11.05 **Dale Hickey** (born Australia 1937), *Fences*, 1969. Synthetic polymer paint, graphite, coloured pencils, ballpoint pen, black and white photographs, cardboard, masking tape, (1–14) (variable) (installation). Gift of Bruce Pollard, 1980 (AC67.1–14-1980). © Courtesy of the artist

11.06 **Gay Hawkes** (born Australia 1942), *Cape Raoul chair*, 1991, Sea-bleached and weathered wood and branches, 310.6 x 113.6 x 148.0 cm, Margaret Stewart Endowment, 1993, (DC5-1993). © Courtesy of the artist

::12 bill henson and peter booth | untitled

12.01 **Bill Henson** (born Australia 1955), *Untitled*, (1994–95), from the *Untitled* 1994/1995 series, 1994–95. Type C photograph, paper tape, painted pins on glassine on plywood, 200.3 x 244.6 cm. Purchased through The Art Foundation of Victoria with the assistance of the Moët & Chandon Art Acquisition Fund, Governor, 1996 (1996.196). © Bill Henson, courtesy of Roslyn Oxley9 Gallery

12.02 **Bill Henson** (born Australia 1955), *Untitled*, 1998-99. Type C photograph, 104.5 x 155.0 cm (image), 127.0 x 180.0 cm (sheet). Purchased through the NGV Foundation with the assistance of Mrs Mem Kirby, Fellow, 2000 (2000.222). © Bill Henson, courtesy of Roslyn Oxley9 Gallery

12.03 **Bill Henson** (born Australia 1955), *Untitled*, 1997-98. Type C photograph, 104.4 x 155.0 cm (image), 127.9 x 180.0 cm (sheet). Purchased through the NGV Foundation with the assistance of Mrs Mem Kirby, Fellow, 2000 (2000.223). © Bill Henson, courtesy of Roslyn Oxley9 Gallery

12.04 **Peter Booth** (born Great Britain 1940, arrived in Australia 1958), *Painting*, (1977). Oil on canvas, 182.5 x 304.0 cm. Gift of the artist in memory of Les Hawkins, 1978 (A24-1978). © Peter Booth, 1977/Licensed by VISCOPY, Sydney 2002

12.05 **Peter Booth** (born Great Britain 1940, arrived in Australia 1958), *Winter*, 1993. Oil on canvas, 280.0 x 305.0 cm. Presented by the National Gallery Women's Association, 2002. © Peter Booth, 1993/Licensed by VISCOPY, Sydney 2002

::13 forcefield

13.01 **Marc Newson**, designer (born Australia 1963), **Eckhard Ressig**, manufacturer (born Germany 1953), *LC2 Lockheed lounge*, (1985–86). Fibreglass, aluminium, rubber, 89.0 x 170.0 x 65.0 cm. Purchased from Admission Funds, 1990 (D17-199). © Courtesy of the artist

13.02 **John Nixon** (born Australia 1949), *Self portrait (non-objective composition) black*, (1981). Oil on plywood, 56.8 x 57.0 cm. Purchased with the assistance of the Visual Arts Board, Australia Council, 1984 (AC9-1984). © Courtesy of the artist

13.03 **John Nixon** (born Australia 1949), *Self portrait (non-objective composition) black red white on hessian*, (1983). Synthetic polymer paint on hessian, drawing pins, 65.8 x 50.0 cm. Purchased with the assistance of the Visual Arts Board, Australia Council, 1984 (AC11-1984). © Courtesy of the artist

13.04 **John Nixon** (born Australia 1949), *Self portrait (non-objective composition) black and red*, (1982). Oil and synthetic polymer paint on cardboard and plywood with wooden mallet, 77.4 x 57.4 cm. Purchased with the assistance of the Visual Arts Board, Australia Council, 1984 (AC10-1984). © Courtesy of the artist

13.05 **John Nixon** (born Australia 1949), *Self portrait (non-objective composition) yellow cross*, (1990). Enamel paint on plywood, 177.6 x 165.0 cm. Purchased through The Art Foundation of Victoria with the assistance of Chase Manhattan Overseas Corporation, Fellow, 1991 (A11-1991). © Courtesy of the artist

13.06 **Julie Rrap** (born Australia 1950), *Madonna*, (1984). Cibachrome photograph, 194.7 x 104.6 cm (image and sheet). Michell Endowment, 1984 (DC14-1984). © Courtesy of the artist

13.07 **Julie Rrap** (born Australia 1950), *Christ*, (1984). Cibachrome photograph, 194.5 x 104.7 cm (image and sheet). Michell Endowment, 1984 (DC15-1984). © Courtesy of the artist

13.08 **Anne Ferran** (born Australia 1949), *Untitled*, (1990). Type C photograph, 95.4 x 120.8 cm. Purchased, 1991 (PH83-1991). © Courtesy of the artist

13.09 **Rosslynd Piggott** (born Australia 1958), *Tattoo*, 1986–87. Oil on canvas, 244.4 x 122.6 cm. Michell Endowment, 1987 (DC7-1987). © Courtesy of the artist

13.10 **Jon Campbell** (born Northern Ireland 1961, arrived in Australia 1964), *So you wanna be a rock 'n' roll star*, 1990. Enamel and synthetic polymer paint on plywood, 213.0 x 222.0 cm. Presented through the NGV Foundation by Shell Australia Limited, Honorary Life Benefactor, 2002 (2002.253). © Courtesy of the artist

13.11 **Geoff Lowe** (born Australia 1952), *Deception: The man from Ironbark*, 1984. Oil and synthetic polymer paint on canvas, 152.0 x 106.6 cm. Purchased from Admission Funds, 1985 (AC20-1985)

13.12 **Jenny Watson** (born Australia 1951), *House painting: Box Hill North (small version)*, (1976). Oil on canvas, 91.4 x 106.6 cm. Michell Endowment, 1977 (DC10-1977). © Courtesy of the artist

13.13 Jenny Watson (born Australia 1951), *House painting: Box Hill North (large version)*, (1977). Oil on canvas, 177.8 x 213.6 cm. Michell Endowment, 1977 (DC9-1977). © Courtesy of the artist

13.14 Howard Arkley (Australia 1951–1999), *Muzak mural – chair tableau*, 1980–81. Synthetic polymer paint on canvas, (a–h) 240.0 x 330.0 x 90.2 cm. Michell Endowment, 1982 (DC18.a–h-1982). © The Estate of Howard Arkley, courtesy of Kalli Rolfe Contemporary Art

::14 richard larter | pat larter

14.01 Richard Larter (born Great Britain 1929, arrived in Australia 1962), *Root ripples stocks*, 1975. Synthetic polymer paint on canvas board, 189.4 x 110.6 cm. Purchased with the assistance of the National Gallery Society of Victoria, 1976 (A2-1976). © Courtesy of the artist

14.02 Richard Larter (born Great Britain 1929, arrived in Australia 1962), *Make mine Monday*, 1967. Enamel paint on composition board, 120.8 x 181.4 cm. Purchased, 1982 (AC4-1982). © Courtesy of the artist

14.03 Pat Larter (born Great Britain 1936, arrived in Australia 1962, died 1996), *Marty*, 1995. Laser print, synthetic polymer paint, plastic, glitter and self-adhesive plastic collage on canvas, 126.0 x 90.0 cm. Purchased, 1997 (1997.341). © Courtesy of the Estate of the artist

14.04 Pat Larter (born Great Britain 1936, arrived in Australia 1962, died 1996), *Tania*, 1995. Laser print, synthetic polymer paint, plastic and glitter on canvas, 132.0 x 85.4 cm. Purchased, 1997 (1997.342). © Courtesy of the Estate of the artist

14.05 Richard Larter (born Great Britain 1929, arrived in Australia 1962), *Scatter shift II*, 1980. Synthetic polymer paint on canvas, 184.4 x 161.4 cm. Purchased 1981 (AC5-1981). © Courtesy of the artist

::15 david mcdiarmid | body language

15.01 David McDiarmid (Australia 1952–95, worked in United States 1979–84), *Body language*, 1990, from the *Kiss of light* series. Self-adhesive plastic collage and enamel paint on plywood, 152.4 x 121.8 cm, 154.0 x 123.8 cm (framed). Purchased, 1997 (1997.92). © David McDiarmid, 1990/Licensed by VISCOPY Sydney 2002

15.02 David McDiarmid (Australia 1952–95, worked in United States 1979–87), *I'm too sexy for my T-cells*, 1994, from the *Rainbow aphorisms* series. Computer-generated colour laser print, 35.5 x 26.7 cm (image), 42.0 x 29.6 cm (sheet). Purchased, 1994 (P139.5-1994). © David McDiarmid, 1994/Licensed by VISCOPY, Sydney 2002

15.03 David McDiarmid (Australia 1952–95, worked in United States 1979–87), *I want a future that lives up to my past*, 1994, from the *Rainbow aphorisms* series. Computer-generated colour laser print, 37.4 x 28.4 cm (image), 38.4 x 29.4 cm (sheet). Purchased, 1994 (P139.6-1994). © David McDiarmid, 1994/Licensed by VISCOPY, Sydney 2002

15.04 David McDiarmid (Australia 1952–95, worked in United States 1979–87), *The family tree stops here*, 1994, from the *Rainbow aphorisms* series. Computer-generated colour laser print, 36.7 x 27.9 cm (image), 37.7 x 28.9 cm (print). Purchased, 1994 (P139.9-1994). © David McDiarmid, 1994/Licensed by VISCOPY, Sydney 2002

15.05 David McDIARMID (Australia 1952–95, worked in United States 1979–87), *Plague boy*, (1994). colour laser print, plastic, 16 panels, 121.9 x 88.1 cm (overall). Gift from the Estate of David McDiarmid, 2000. © David McDiarmid, 1994/Licensed by VISCOPY, Sydney 2002

::16 into the 1990s | the decay of postmodernism

16.01 Imants Tillers (born Australia 1950), *Quest: I the speaker*, (1988). Oilstick, synthetic polymer paint and gouache on canvas boards (170 panels), (1–170) 254.0 x 646.0 cm (overall). Purchased from Admission Funds, 1988 (AC8.1–170-1988). © Courtesy of the artist

16.02 Anne Zahalka (born Australia 1957), *The surfers*, (1989), from the *Bondi: Playground of the Pacific* series, 1989. Type C photograph, 76.4 x 92.5 cm. Purchased, 1991 (PH173-1991). © Anne Zahalka, 1989/Licensed by VISCOPY Sydney, 2002

16.03 Bonita Ely (born Australia 1946), *Histories*, 1992. Mixed media. Courtesy Sutton Gallery, Melbourne. © Bonita Ely, 1992/Licensed by VISCOPY, Sydney 2002

16.04 Gordon Bennett (born Australia 1955), *Home décor (Preston + de Stijl = citizen) panorama*, 1997. Synthetic polymer paint on canvas, (a–b) 182.7 x 365.3 cm (overall). Presented by the National Gallery Society of Victoria as the winner of the John McCaughey Memorial Art Prize, 1998 (1998.27.a–b). © The artist, courtesy of Bellas Gallery, Brisbane; Sherman Galleries, Sydney; and Sutton Gallery, Melbourne

16.05 Juan Davila (born Chile 1946, arrived in Australia 1974), *Portrait of Bungaree*, (1991). Colour photo-screenprint and pencil, (a) 120.6 x 78.3 cm irreg. (image), 121.4 x 80.0 cm (sheet), (b) 121.0 x 78.8 cm irreg. (image), 121.4 x 80.0 cm (sheet), (c) 121.3 x 80.2 cm irreg. (image sheet), (d) 119.7 x 78.8 cm irreg. (image), 121.1 x 80.0 cm (sheet). Gift of the artist, 1992 (P37.a–d-1992). © Courtesy of the artist and Kalli Rolfe Contemporary Art

16.06 Narelle Jubelin (born Australia 1960), *Trade delivers people: Second version*, 1989–93. Cotton petit point, porcelain buttons, string, cotton lace, copper sheet, copper hanging devices, satin mount, wood frames, four prednastic Egyptian earthenware pots from the collection of the National Gallery of Victoria, 82.2 x 690.0 x 21.0 cm (installation). Purchased 1993 (A10.a-d-1993) Purchased through The Art Foundation of Victoria with the assistance of the Rudy Komon Fund, Governor, 1991 (A4.a-c-1991 A4.e-1991) Presented by The Egyptian Exploration Fund, 1899 (768-D2), (D229-1982), (D196-1982), (D169-1982)]. © Courtesy of the artist and Mori Gallery

16.07 **Dale Frank** (born Australia 1957), *The artist's fairyfloss sold on the merry-go-round of life (sucker dealer): Sucker dealer and the righteous anus*, 1991. Synthetic polymer paint on canvas, 240.0 x 199.8 cm. Purchased from Admission Funds, 1993 (A12-1993). © The artist, courtesy of Anna Schwartz Gallery, Melbourne

16.08 **Rosalie Gascoigne** (born New Zealand 1917, arrived in Australia 1943, died 1999), *Plainsong*, 1988. Sewn retro-reflective signs on plywood, 145.0 x 88.0 cm. Private collection. © Rosalie Gascoigne, 1988/Licensed by VISCOPY, Sydney 2002

16.09 **Tim Johnson** (born Australia 1947), *Amnesty*, 1993. Synthetic polymer and metallic paint on canvas, 183.2 x 244.6 cm. Gerstl Bequest, 1995 (1995.6). © Courtesy of the artist

16.10 **Constanze Zikos** (born Australia 1962), *Fake flag*, 1994. Thermo-setting laminate, enamel paint, crayon, metallic and plastic self-adhesive tape on composition board, (a–h) 198.1 x 262.2 cm (overall). Purchased, 1999 (1999.29-a–h). © Courtesy of the artist

16.11 **Jeff Gibson** (born Australia 1958), *Screwballs (Frustration/aggression)*, 1992. Colour screenprint, ed. 5/20, 114.2 x 49.2 cm irreg. (image), 151.8 x 102.0 cm (sheet). Purchased, 1994 (P119.3-1994). © Courtesy of the artist

16.12 **John Mawurndjul** (Kuninjku born c. 1952), *Mardayin ceremonial designs from Kakodbebuldi*, (1990). Earth pigments on bark, 179.3 x 91.8 cm irreg. Purchased from Admission Funds, 1990 (O.133-1990). © John Mawurndjul, 1990/Licensed by VISCOPY, Sydney 2002

16.13 **Louise Hearman** (born Australia 1963), *Untitled #563*, 1997. Oil on composition board, 68.6 x 53.1 cm. Purchased, 1997 (1997.407). © Courtesy of the artist

16.14 **Hany Armanious** (born Australia 1962), *Untitled work*, (1996). Polyvinyl chloride, (a–s) 240.0 x 688.9 x 39.6 cm (installed). Purchased, 1997 (1997.396.a–s). © Courtesy of the artist

16.15 **Tracey Moffatt** (born Australia 1960), *Night cries: A rural tragedy*, 1990. Film, 17 mins. Purchased, 1999 (1999.25). © Tracey Moffatt, courtesy of Roslyn Oxley9 Gallery and Ronin Films

16.16 **Kathy Temin** (born Australia 1968), *Duck–rabbit problem*, 1991. Synthetic fur on composition, (a–c) 52.5 x 187.8 x 124.0 cm (overall) (variable). Purchased through The Art Foundation of Victoria with the assistance of the Rudy Komon Fund, Governor, 1998 (1998.282.a–c). © Courtesy of the artist

::17 mikala dwyer | hanging eyes 2

17.01 **Mikala Dwyer** (born Australia 1959), *Hanging eyes 2*, 2000. Vinyl, plastic, synthetic polymer paint on canvas, synthetic fur, felt, steel eyelets, variable measurements. Purchased through the NGV Foundation with the assistance of the Rudy Komon Fund, Governor, 2001 (2001.560. a–i). © Courtesy of the artist

17.02 **Mikala Dwyer** (born Australia 1959), *IOU*, 1997. Transparent and opaque synthetic polymer resin, synthetic fur, mirror, television, 134.5 x 257.2 x 154.0 cm (variable). Presented through the NGV Foundation by Mr Peter Fay, Fellow, 2002. © Courtesy of the artist

::18 david stephenson | the ice

18.01 **David Stephenson** (born United States 1955, arrived in Australia 1982), *Untitled*, (1992), from *The ice* series 1991-93. Type C photograph, 100.0 x 148.0 cm. Purchased, 1994 (PH38-1994). © Courtesy of the artist

18.02 **David Stephenson** (born United States 1955, arrived in Australia 1982), *Untitled*, (1992, printed 2002), from *The ice* series 1991-93. Type C photograph, 100.1 x 148.1 cm (image and sheet) edition 4/5. Purchased through the NGV Foundation, 2002. © Courtesy of the artist

::19 douglas mcmanus | hair and the new millennium

19.01 **Douglas McManus** (born Australia 1959), *Individual non-conforming*, 1999–2000. Rayon, digital print, 246.0 x 85.0 cm. Kaiser Bequest, 2000 (2000.104); *Fashionable conforming*, 1999–2000. Rayon, digital print, 246.0 x 85.0 cm. Kaiser Bequest, 2000 (2000.105); *Hair couture 2000*, 1999–2000. Leather, polyester, cotton, hair, 80.0 x 60.0 x 30.0 cm. Kaiser Bequest, 2000 (2000.103); *Conservative inconspicuous*, 1999–2000. Rayon, digital print, 246.0 x 85.0 cm. Kaiser Bequest, 2000 (2000.106). © Courtesy of the artist

::20 no compass? | a postscript to fieldwork

20.01 **Jan Nelson** (born Australia 1955), *International behaviour*, 2000. Oil on canvas, 152.4 x 198.1 cm. Purchased through the NGV Foundation with the assistance of The Peter and Susan Rowland Endowment, Governor, 2001 (2001.540). © Jan Nelson, 2000/Licensed by VISCOPY, Sydney 2002

20.02 **Sally Smart** (born Australia 1960), *Treehouse (The unhomely body)*, 1997–98. Synthetic polymer paint and oil on felt and canvas, (a–l) 300.5 x 759.6 cm (overall, irreg.) (installed). Purchased, 1999 (1999.52.a–l). © Sally Smart, 1998/Licensed by VISCOPY, Sydney 2002

20.03 **Matthew Jones** (born Australia 1961), *Diary 13 November – 16 November 2000*, 2000. Oil on plasterboard, 244.1 x 244.3 cm. Purchased through the NGV Foundation with the assistance of the Joan Clemenger Endowment, Governor, 2001 (DC18.a–b-2001). © Courtesy of the artist and Tolarno Gallery

20.04 **Gwyn Hanssen Pigott** (born Australia 1935), *Exodus II*, (1996). Porcelain, 14.4 x 155.0 x 15.5 cm. Presented through the NGV Foundation by Dato Arthur Tan Boon Shih, Governor, 2001 (2001.339.a–w). © Courtesy of the artist

20.05 **Ricky Swallow** (born Australia 1974), *Model for a sunken monument*, (1999). Synthetic polymer paint on composition board, (a–l) 108.2 x 222.0 x 242.2 cm. Purchased through The Art Foundation of Victoria with the assistance of the Joan Clemenger Endowment, Governor, 1999 (DC3.a–l-1999). © Courtesy of the artist

20.06 **Pat Brassington** (born Australia 1942), *Voicing*, 2001, from the *Gentle* series. Inkjet print, ed. 1/4, 56.2 x 76.1 cm. Purchased with funds arranged by Loti Smorgon for Contemporary Australian Photography, 2001 (2001.165). © Courtesy of the artist and Stills Gallery, Sydney. The artist acknowledges the assistance of DARF, University of Tasmania

20.07 **Mari Funaki** (born Japan 1950, arrived in Australia 1979), *Stealth*, 1997. Heat-coloured mild steel, 19.7 x 37.0 x 3.6 cm; *Reverie*, 1997. Heat-coloured mild steel, 9.3 x 7.6 x 6.3 cm; *Menace*, 1997. Heat-coloured mild steel, 6.2 x 47.0 x 26.0 cm; *Poised*, 1997. Heat-coloured mild steel, 41.5 x 5.0 x 3.5 cm; *Arouse*, 1997. Heat-coloured mild steel, 13.0 x 5.0 x 3.7 cm. Private collection, Melbourne. © Courtesy of the artist

20.08 **Scott Redford** (born Australia 1962), *Surfing life (Glen)*, 1994. Synthetic polymer and enamel paint, foamfill and found objects on canvas on plywood, 180.0 x 273.0 x 44.0 cm. Purchased through The Art Foundation of Victoria with the assistance of the Joan Clemenger Endowment, Governor, 2000 (DC1-2000). © Courtesy of the artist and Bellas Gallery

20.09 **Emily Kam Kngwarray** (Eastern Anmatyerr c. 1910–96), *Body paint: Awely*, (1993). Synthetic polymer paint on paper, 77.0 x 56.3 cm. Purchased through The Art Foundation of Victoria with the assistance of Alcoa of Australia Limited, Governor, 1994 (O.53–0.58-1994). © Emily Kam Kngwarray, 1993/Licensed by VISCOPY, Sydney 2002

20.10 **Peter Tyndall** (born Australia 1951), *detail A Person Looks At A Work of Art / someone looks at something …*, 1985–87. A Person Looks At A Work of Art / someone looks at something … CULTURAL CONSUMPTION PRODUCTION, 243.4 x 243.4 cm (canvas), 340.4 x 243.4 cm (installed). Purchased from Admission Funds, 1988 (AC2-1988). © Courtesy of the artist and Anna Schwartz Gallery

20.11 **Mutlu Çerkez** (born Great Britain 1964, arrived in Australia 1964), *Poster design variations for artists' publications*, 2001. Synthetic polymer paint on paper, 98.0 x 68.0 cm. Presented through the NGV Foundation with the assistance of Optus Communications Pty Limited, Member, 2001 (2001.839.a–e). © Courtesy of the artist and Anna Schwartz Gallery

20.12 **Elizabeth Gower** (born Australia 1952), *September 14, 1901–September 11, 2001*, 2001. Ink on drafting film (7 panels), 380.0 x 70.0 cm (each). Collection of the artist. © Courtesy of the artist and Sutton Gallery

::21 fiona hall | dead in the water

21.01 **Fiona Hall** (born Australia 1953), *Dead in the water*, 1999. Polyvinyl chloride, glass beads, (a–e) 106.5 x 129.1 x 129.2 cm. Purchased, 1999 (1999.356.a–e). © Courtesy of the artist

::22 brent harris | swamp (no. 2)

22.01 **Brent Harris** (born New Zealand 1956, arrived in Australia 1981), *Swamp (no. 2)*, (1999). Oil on canvas, 274.0 x 133.7 cm. Allan R. Henderson Bequest, 1999 (1999.357). © Courtesy of the artist

22.02 **Brent Harris** (born New Zealand 1956, arrived in Australia 1981), *Study for Swamp (no. 2) A–G*, 1999. Charcoal, 60.5 x 29.5 cm (comp.), 76.4 x 58.2 cm irreg. (sheet). Presented through the NGV Foundation by the artist, Member, 2001 (2001.129 to 2001.135). © Courtesy of the artist

::23 transcontextual tendencies | the paintings of raafat ishak

23.01 **Raafat Ishak** (born Cairo 1967, arrived in Australia 1982), *Good information*, 1999–2000. Oil on canvas, 60.3 x 30.2 cm, 60.3 x 313.0 cm (overall). Purchased through the NGV Foundation with the assistance of the Joan Clemenger Endowment, Governor, 2001 (DC11.a–h-2001). © Courtesy of the artist

23.02 **Raafat Ishak** (born Cairo 1967, arrived in Australia 1982), *Good government*, 1999–2000. Oil, gesso, cardboard and embossing on canvas, 165.5 x 120.1 cm. Purchased through the NGV Foundation with the assistance of the Joan Clemenger Endowment, Governor, 2001 (DC10-2001). © Courtesy of the artist

::24 susan norrie | inquisition

24.01 **Susan Norrie** (born Australia 1953), *Inquisition*: *Inquisition ten*. Oil on canvas, wood, glass, 83.0 x 64.0 x 10.7 cm (framed); *Inquisition nine*. Synthetic fabric, wood, glass, 116.2 x 69.1 x 10.8 cm.; *Inquisition one*. Glass beads, glass, wood, lacquer 162.5 x 61.7 x 19.1 cm (overall); *Poisonous fly paper painting II*. Oil on canvas 275.2 x 136.5 x 6.0 cm; *Inquisition eleven*. Computer generated print, wood, glass, 129.3 x 103.0 x 7.1 cm (framed). Gurnett-Smith Bequest, 1999 (1999.358.a–g). © Courtesy of the artist

end piece

25.01 **Callum Morton** (born Canada 1965), *Gas and Fuel*, 2002. Wood, acrylic paint, aluminium, perspex, paper and sound, 220.0 x 91.0 x 600.0 cm (overall) Promised gift through the NGV Foundation by Corbett and Yueji Lyon (The Corbett and Yueji Lyon Collection). © Courtesy of the artist and Anna Schwartz Gallery

Published by the National Gallery of Victoria
PO Box 7259, Melbourne, Victoria 8004

National Library of Australia Cataloguing-in-Publication data

National Gallery of Victoria.

Fieldwork: Australian Art 1968–2002.

ISBN 0 7241 0213 2

1. Art, Australian — Exhibitions. 2. Art, Modern — 20th century — Australia — Exhibitions. I. Title.

709.94

ngv

www.ngv.vic.gov.au

Contributing authors:

Edward Colless. Head of Art History and Theory, School of Art, Victorian College of the Arts, Melbourne

Isobel Crombie. Senior Curator of Photography, National Gallery of Victoria

Julie Ewington. Head of Australian Art, Queensland Art Gallery

Ted Gott. Senior Curator of International Art, NGV

Kirsty Grant. Curator of Prints and Drawings, NGV

Charles Green. Senior Lecturer, School of Fine Arts, Classical Studies and Archaeology, The University of Melbourne. Adjunct Senior Curator of 20th–21st-Century Art, NGV

Cathy Leahy. Senior Curator of Prints and Drawings, NGV

Frances Lindsay. Deputy Director, Australian Art, NGV

Linda Michael. Senior Curator, Monash University Museum of Art, Victoria

Bernice Murphy. Formerly Chief Curator and Director, Museum of Contemporary Art, Sydney. Art Vice-President, International Council of Museums, Paris. Independent curator and writer, Sydney, New South Wales

Jennifer Phipps. Curator of Australian Art, Late Modernism, NGV

Kate Rhodes. Assistant Curator of Photography, NGV

Judith Ryan. Senior Curator of Indigenous Art, NGV

Editors:	Lisa Prager, Margaret Trudgeon, Dianne Waite
Wordprocessor:	Judy Shelverton
Photography:	Pedrag Cancar, Christian Markel, Helen Skuse, Garry Sommerfeld and Narelle Wilson
Designer:	Kai Brethouwer
CTP & Printing:	The Craftsman Press
Paperstock:	Cover \| White A Artboard 360 gsm Endpapers \| Bright White Rives Design 120 gsm Section wraps \| Clear White XDT Translucent 90 gsm Text \| New Era Satin 150 gsm
Fonts:	Headings \| Din Light Body text \| Din Regular Notes \| Din Condensed Quotes \| Superbly 01 Captions \| Superbly 01 Page numbers \| Squarehead

Jason Smith. Curator of Contemporary Art, NGV

Katie Somerville. Curator of Australian Fashion and Textiles, NGV

Ann Stephen. Independent curator and historian of 20th-century and Australian art, Sydney, New South Wales

Stelarc. Performance artist. Principal Research Fellow in the Performance Arts, Digital Research Unit, Nottingham Trent University, UK

John Stringer. Curator of the Kerry Stokes Collection, Perth, Western Australia

Daniel Thomas. Curator of Australian Art, Art Gallery of New South Wales, 1958–78; Senior Curator of Australian Art, National Gallery of Australia, Canberra, 1978–84; Director, Art Gallery of South Australia, 1984–90; Independent art writer, Tasmania

Lara Travis. Independent art writer and curator, Melbourne, Victoria

Susan van Wyk. Curator of Photography, NGV